Advanced Photography

Sixth Edition

Advanced Photography

Sixth Edition

Michael Langford FBIPP, HonFRPS
Royal College of Art, London

Focal Press

Focal Press
An imprint of Butterworth-Heinemann
225 Wildwood Avenue, Woburn, MA 01801-2041
Linacre House, Jordan Hill, Oxford OX2 8DP
A division of Reed Educational and Professional Publishing Ltd

 A member of the Reed Elsevier plc group

OXFORD AUCKLAND BOSTON
JOHANNESBURG MELBOURNE NEW DELHI

First published 1969
Second edition 1972
Third edition 1974
Fourth edition 1980
Fifth edition 1989
Reprinted 1992, 1993, 1994, 1995
Sixth edition 1998
Reprinted 1999

© Michael Langford 1998

British Library Cataloguing in Publication Data
Langford, Michael, 1933–
 Advanced photography. – 6th ed.
 1 Photography
 I Title
 771

 ISBN 0 240 51486 6

Library of Congress Cataloguing in Publication Data
Langford, Michael John, 1933–
 Advanced photography/Michael Langford. – 6th ed.
 p. cm.
 Includes bibliographical references and index.
 ISBN 0 240 51486 6
 1. Photography. I. Title.
 TR145.L318 97-42017
 770–dc21 CIP

Composition by Genesis Typesetting, Rochester
Printed and bound in Great Britain

Contents

Introduction

This book is for students who understand the basic equipment and techniques of photography. It takes you on beyond basics in both depth and breadth – explaining the technical background to practise for serious enthusiasts and students of professional photography. Like the companion textbook *Basic Photography*, it approaches technical matters as a means to a practical end, rather than a separate area of study. Depth of content is determined by the need to understand the kind of data presented by manufacturers in selling lenses, lighting, films, processing equipment, etc. to experienced users. The book's breadth includes differences between amateur and professional photography; wide-ranging subject problems; the reproduction of photographs in print; and the growth and implications of digital methods of image-making.

For the most part, however, chapters are designed as modules – to be read individually and not necessarily in sequence. Each one is planned to increase your technical control in a particular area. For example, the chapter on tone control gathers together all the factors which influence the tonal qualities of your picture, from original subject contrast through exposure, processing, printing, to the way you finally display results. The lighting control chapter discusses colour, contrast, the mixing of sources such as flash and incandescent lamps, the use of IR or UV illumination, and choosing and buying lighting to set up a studio. Processing is looked at from an organization and management point of view, as well as the techniques themselves.

Photographic films are reviewed over two chapters. The first 'takes apart' modern published data, to help weigh up the details of one type of material against another. The following chapter takes a wider look at how camera materials work in relation to how we see. Colour printing from negatives and from slides is explained in detail from first principles, on the basis that so far you have only tackled printing in black and white. Throughout, the book complements rather than repeats the contents of *Basic Photography*. Each chapter ends with a summary, designed as a quick guide to coverage as well as for topic revision.

Since the previous, 5th edition of *Advanced Photography* the use of computers and growth of electronic (digital) photography has increased

enormously. Truly 'photographic' quality image sensors, programming software and outputting printers have appeared, benefiting partly from military satellite research (you can't wet-process in space) and partly from the technology developed for pre-press photomechanical reproduction within the graphic arts industry.

Growth of electronics has encouraged some prophets to proclaim that 'silver halide photography is dead'. But although hugely important, digital procedures and equipment are still only additional tools – for some time to come it will make good sense to use them in combination with silver halide systems and so benefit from the best practical features of each. Reflecting this, you will find that the 6th edition discusses digital imaging throughout its contents, alongside traditional methods. It appears, for example, within chapters on cameras; how camera materials work; lighting; tone control; and colour printing. (See index under *Digital*). Often, parts of the equipment and working techniques are common to both technologies and even when they are not, methods need to be compared and justifications made for hybrid uses of old and new. The digital image 'processing' of film originals for example is already an established practice. An overview of the way chains of digital components relate to one another and to silver halide materials can be found on pages 258 and 279

Anyone studying photography today – especially if you are a mature student trained in a previous era – must have some knowledge of digital work. The techniques associated are here to stay. Professional photographers particularly have to calculate if and when to take the plunge into this new technology, or whether to rely on facility houses. Digital photography offers challenging new business opportunities along with new kinds of images and faster, cleaner ways of producing results.

M.L.

1
Amateur and professional photography

This chapter reviews photography as an occupation – whether you are amateur or professional, and perhaps take pictures which are anything from strictly functional illustrations to expressive works of art. It looks broadly at the qualities you need for success in widely differing fields, and it discusses markets for all kinds of professional photography, comparing work as an employee with being a self-employed freelance or managing a business with staff of your own. Most of the types of photography outlined here are discussed further in greater organizational and technical detail in Chapter 8.

Differences in approach

Amateur

People often describe themselves as 'only' amateurs, as if apologizing for this status. After all, the word *amateurish* suggests the second rate. However, amateur simply means that you earn your living doing something else. Do not assume that amateur photography must always be inferior to professional photography. Each requires an attitude of mind which differs in several ways – but is not necessarily 'better' or 'worse'.

As an amateur, you may envy the professional, wishing you could combine business with pleasure into a kind of full-time hobby, using professional equipment and facilities. However, the professional knows that much of the hidden advantage of being amateur is the freedom you have to shoot what and when you like. You can develop your own ideas – experiment in approach, subject and technique – without much concern over how long any of this might take. You can be self-indulgent. (Throughout the history of photography many amateurs have been the visual innovators, such as J. M. Cameron, Paul Strand, Ralph Eugene Meatyard and J. H. Lartigue.)

As an amateur, you can work for an exhibition or a competition of your choice – or just for yourself or family. You can also enjoy the equipment and techniques as a refreshing change from your daily work. On the other hand, you lack the pressure of deadlines, the challenge of

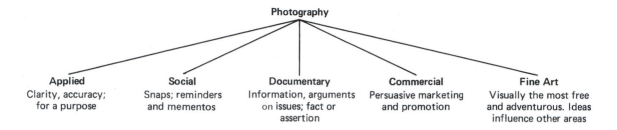

Photography

Applied	Social	Documentary	Commercial	Fine Art
Clarity, accuracy; for a purpose	Snaps; reminders and mementos	Information, arguments on issues; fact or assertion	Persuasive marketing and promotion	Visually the most free and adventurous. Ideas influence other areas

Fig. 1.1 The main areas of photography. Many other divisions are possible and sometimes work spans more than one area

commissions and commercial competition to keep you on your toes. It is easy to become complacent or set targets too low to be much of a challenge. After all, the world is not bounded by the judge's view of photography at the local camera club. If you want to take your hobby seriously you should find the time to keep yourself aware of trends by looking at published photographs and visiting galleries. In this way you can widen your knowledge of how different people use photography to express ideas and communicate information.

Professional

A professional photographer must be reliable. He or she also needs financial and organizational skills, just as much as visual and technical expertise, in order to stay in business. People rely on you as a professional to produce some sort of result, always. Failure does not simply mean you receive no fee – most work is commissioned, so you have let someone down. A client's money invested in models, props, special locations, etc. is thrown away, a publication deadline may be missed or an unrepeatable event remains undocumented.

You therefore have to ensure – as far as humanly possible – that everything in the chain between arriving to shoot and presenting the finished work functions without fail. You need to be an effective organizer of people, locations, transport, etc., able to make the right choice of time and day, and, of course, arrive punctually yourself. You must be able to anticipate hold-ups and avoid them. As a last resort, you should know how to act if a job has to be abandoned or re-shot. Pressures of this kind are both a worry and a stimulus – but, of course, they make a successful result all the more worthwhile. See page 43.

Working professionally also means that you have to produce results at an economical speed and cost. You must think of overheads such as rent and taxes, and equipment depreciation, as well as direct costs such as photographic materials and fuel. It is seldom possible to linger longingly over a job as if it was a leisure occupation. You also need to know how to charge – how to cost out a commission accurately and balance a reasonable profit margin against client goodwill (will they come again?), bearing in mind the competition and the current going rate for the job.

Equipment is no more or less than a set of tools from which you select the right 'spanner' for the picture you have in mind. Every item must give the highest quality results but also be rugged and reliable – vital gear may need duplicate back-up. The cost of fouling up an assignment because of equipment failure can be greater than the photographic equipment itself, so it is a false economy to work with

second-rate tools. You must know too when to invest in new technology, such as digital gear, and what it is best to buy.

One of the challenges of professional work is to make interesting, imaginative photographs within the limitations of a dull commercial brief. For example, how do you make a strong picture out of a set of ordinary plastic bowls – to fill an awkward-shaped space on a catalogue page? Eventually you should be able to refuse the more dead-end work, but at first you will need every commission you can find. In the same way, you must learn how to promote yourself and build up a range of clients who provide you with the right subject opportunities and freedom to demonstrate your ways of seeing, as well as income. Another relatively open way of working is to freelance as a supplier of pictures for stock libraries.

Photography is still one of the few occupations in which you can create and make things as a one-person business or department. It suits the individualist – one reason why the great majority of professional photographers are self-employed. There is great personal satisfaction in a job which demands daily use of visual and technical skills.

'Independent'

Photography does not just divide neatly into amateur and professional categories. After all, it is a *medium* – of communication, expression, information, even propaganda – and as such can be practised in hundreds of different ways. You can shoot pictures purely to please yourself and develop your style; for example, working for one-person exhibitions, books, and sponsored projects, awards and scholarships. It is possible to build up a national or international reputation in this way if your photography is good enough. You can sell pictures through galleries or agents as works of art.

To begin with at least most of these so-called 'independent' photographers make their living from another occupation such as teaching, writing or some other kind of photographically related full- or part-time job. Independent photography relies on the growing number of galleries, publications and industrial and government sponsors of the arts interested in our medium. In this, photography follows long-established patterns in painting, poetry, music, etc. If you are sufficiently motivated, then working for yourself free of commercial pressures can lead to exciting *avant-garde* results. Some independent photographers work for political or other ideological beliefs. Outlets here include pressure groups, trade unions, charities, arts centres, local community associations, specialist publishing houses and archives. It is one of the great strengths of photography that so many of these options are open to be explored.

How photographs are read

If you are really going to progress as any kind of photographer, in addition to technical expertise you need a strong visual sense (something you develop as an individual). This should go beyond composition and picture structuring to include some understanding of why people see and react to photographs in different ways. The latter can be a lifetime's study, because so many changing influences are at

work. Some aspects of reading meaning from photographs are blindingly obvious, others much more subtle. However, realizing how people tend to react to pictures helps you to predict the influences of your own work – and then to plan and shoot with this in mind.

The actual physical act of *seeing* first involves the lens of your eye forming a crude image on the retina. Second, it concerns your brain's perception and interpretation of this image. You might view exactly the same scene as the next person but differ greatly in what you make of what you see. In the same way, two people may look at the same photographic print but read its contents quite differently.

Look at Figure 1.2, for example. Some people might see this picture primarily as a political document, evidence of life under a particular regime. For others it is a statement documenting the subjugation of women. Some would find it insulting on ethnic grounds, or alternatively see it as a warm picture of relationships. Still others may simply consider the shot for its composition – the visual structures it contains. Again, the same picture could be read as containing historical information on dress or decor of a particular period, or it might even be seen as demonstrating the effect of a particular camera, film, or lighting technique.

None of us is wholly objective in interpreting photographs – everyone is influenced by their own background. Experience so far of life (and pictures) may make you approach every photograph as a work of art . . . or some form of political statement . . . or a factual record for measurement and research, etc. This kind of tunnel vision, or just general lack of experience, confuses visual communication between photographer and viewer. In a similar way, it is difficult to

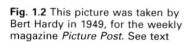

Fig. 1.2 This picture was taken by Bert Hardy in 1949, for the weekly magazine *Picture Post*. See text

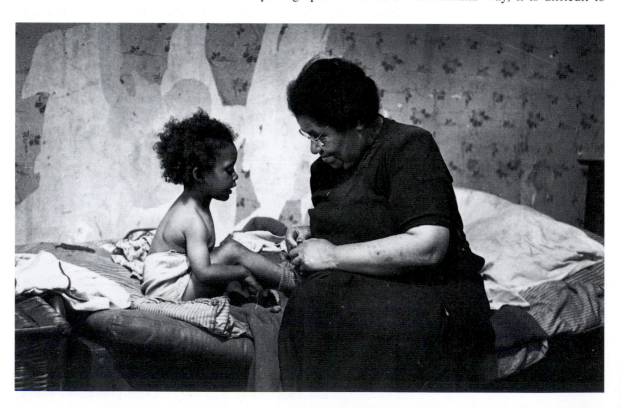

Fig. 1.3 Electron micrograph of a fractured turnip leaf, showing the cell structure. Magnification (in this reproduction) ×170. (Dr Jeremy Burgess/Science Photo Library)

imagine a colour you have not actually seen or to speak words you have never heard.

A shot like Figure 1.3, for example, which happens to be a leaf section greatly magnified would probably be viewed as an abstract pattern by someone unused to seeing electron photomicrographs. A scientist might recognize and look 'through' the picture as if seeing into the microscope eyepiece itself, picking on the subject's factual detail. A sculptor, architect or industrial designer might file it as a reference for particular three-dimensional forms it shows. The point is that none of us work entirely in a vacuum. Unless you are uncompromisingly working to please yourself you must think to whom your photography is directed and how it is likely to be received. This will help to clarify your aims in approaching subject and presentation.

Sometimes your visual communication must be simple, direct and clear – as in most product advertising. This may be aimed at known groups of receivers identified because they are readers of a particular journal, drivers past billboards or people buying at art store counters. Other photographs may be more successful and mind-provoking when they *suggest* rather than *state* things – see Figure 4.8, for example. The more obscure your image, the more likely it is to be interpreted in different ways – but maybe this is your intention?

Much also depends on the way your pictures are physically presented – how they relate to any adjacent pictures, whether they appear on pages you turn or are isolated in frames hung on the wall. Some photographers add slogans, quotations or factual or literary captions when presenting their work to clarify it, to give an extra 'edge' by posing questions, or even purposely to confuse the pictures. They often rate word and image as equally important. It is an approach which has worked well in the past (see examples by Duane Michals, Jim Goldberg and Barbra Kruger). In less able hands literary additions can become a gimmick or a sign of weakness, patching up an inability to express yourself through pictures. They can easily seem pretentious (flowery titles) or patronizing (rhetoric emphasizing something viewers are well able to appreciate for themselves). It is significant that in the advertising world copywriting is a very skilled profession, heavily

market-researched. Pictures and words are planned together, adding a great deal to total message impact.

Markets for professional photography

At one time second-rate 'professional' photographers could make a good living simply out of the mystique of working the equipment. They knew what exposure to give and how to use camera movements, and they employed much better lenses than were available to amateur photographers. Improvements in equipment and simplification of processes today allow talented amateurs to equal or surpass this level, while top professionals – with flair, imagination and business sense – reach greater heights than ever before. You can still find mediocre professional photography, of course. Some is produced by transients, people who drift into photography and just as quickly disappear again. Some professionals do stay in business but only by clinging to rock-bottom prices, which stunts growth.

Professional photography, a loose collection of individuals or small units, is structured mostly by the markets for pictures. The main markets are commercial and industrial; portraits and weddings; press and documentary; advertising and editorial illustration; and technical and scientific applied photography. These are only approximate categories – they often merge and overlap. A photographer in 'general practice', for example, might tackle several of them to meet the requirements of his or her local community. Again, you may be a photographer servicing the very wide-ranging needs of a stock-shot library issuing thousands of images in CD-ROM form to publishing houses or graphic design studios. Then there are specialsts working in quite narrow fields – architecture or natural history, for example – who operate internationally and compete for worldwide markets.

Commercial and industrial photography

This covers the general photographic needs of commerce and industry, often businesses in your immediate area but sometimes spread quite widely, as when serving companies within a widely dispersed group. Clients range from solicitors, real estate agents, local light industry and town councils up to very large manufacturing or construction organizations working on an international scale.

Your photography might be used to spread a good public relations image of the company. It will be needed to record processes, products and new building developments. Some pictures issued with 'press releases' will be reproduced on editorial pages of magazines (often specialist publications). Others are used in catalogues, brochures and internal company reports. Photographs may be an essential element in a staff training scheme, or needed as legal evidence or for archival records. Work will extend beyond supplying prints and transparencies, and is likely to include video work and sequences for presentation in some form of multi-media.

Large commercial/industrial studios dealing with a lot of public relations commissions may offer a total communications 'package'. This teams up photographers, graphic designers, advertising and marketing people, and writers. The result is that a complete campaign, perhaps from

the launching conference (announcing a new product to the client's sales force), through press information, general and specialist advertising to brochures and instruction manuals for the client's customers, can all be handled in a coordinated way 'in-house'. Development of electronic imaging encourages ever-larger amounts of brochure and catalogue photography to take place within graphic design studios. Here it is conveniently fed direct through desktop publishing channels into layouts for the printed page. See Chapter 11.

A few industrial organizations run their own small photographic departments employing one or more staff photographers. Such departments may be general purpose or form part of a larger public relations unit. The advantage to management is that they always have photographers available who are familiar with the company's personnel, its geographical layout and general publicity policy.

Portrait and wedding photography

Professional businesses of this kind deal with the public directly. Some operate out of High Street studios, but because so much of the work is now shot on location (for example, portraits 'at home') special premises are not essential. Some businesses operate from inside departmental stores, or link up with dress/car hire and catering concerns to cover weddings. In all instances it is important to have some form of display area where your best work can be admired by people of the income group you are aiming to attract.

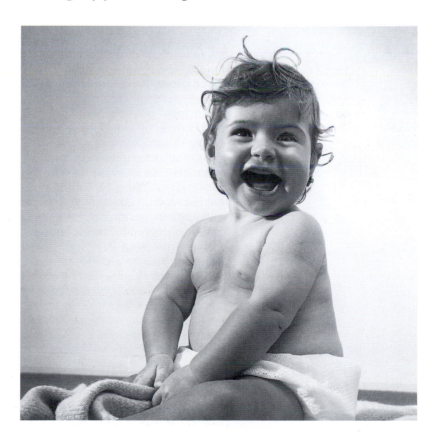

Fig. 1.4 Portrait taken in the child's home using a pair of flash units. A camera with waist-level finder makes it easier to shoot at floor level

To succeed in photography of this type you need an absorbing interest in people and the ability to flatter their appearance rather than reveal harsh truths about them. After all, it is the clients or their closer associates who pay your bill – unlike documentary or advertising pictures commissioned by magazines or agencies. The people you arrange in front of the camera require sympathetic but firm direction. It helps to have an extrovert, buoyant personality and the ability to put people at their ease (especially in the unfamiliar environment of a studio) to avoid self-conscious or 'dead'-looking portraits.

The work typically covers formal portraits of executives for business purposes; family groups; weddings; animal portraits; and sometimes social events and front-of-house pictures for theatrical productions. See Chapter 7.

Press photography and documentary

Press photography differs from documentary photography in the same way that single newspaper pictures differ from picture magazine features. Both are produced for publication and therefore have to meet firm deadlines. However, as a press photographer you usually have to sum up an event or situation in one final picture. You need to know how to get quickly into a newsworthy situation, seek out its essence without being put off by others (especially competitors) and always bring back technically acceptable results, even under near-impossible conditions.

Most press photographers work for local newspapers. Where there is relatively little 'hard' news, you work through an annual calendar of hand-shaking or rosette-waving local events, plus general-interest feature material which you generate yourself. Other press photographers work as staff on national or international papers where there is keen competition to cover public events. (See Figure 1.5, for example.) However, most 'hot' news events are now covered by television, with its unassailable speed of transmission into people's homes. New technology such as digital hand cameras and the ability to get pictures back to base by mobile phone are helpful, but newspapers still lose out due to the time needed to print and distribute them to their readers.

More photographers are employed by or work freelance for press agencies. These organizations often specialize – in sport, travel, personalities, etc. – or handle general-interest material. The agency's job is to slant the picture and written material to suit the interests of a very wide range of different publications and sell material to them at home and abroad. For pictures which are less topical, this activity merges with stock-shot library work, able to generate income over a period of years.

Documentary photography refers to work allowing you more of an in-depth picture essay, shot over a longer period than press photography and aiming to fill several pages in a publication. In the past this has been called photo-journalism, through its use in news magazines, but has now fallen into decline. Other outlets continue, however, including corporate house journals and prestige publications from leading names in oil, finance, shipping, etc.

As a documentary photographer you should be able to provide a well-rounded coverage of your story or theme. For example, bold start-and-finish pictures, sequence shots, comparative pairs and strong single images all help a good art editor to lay out pages which have variety

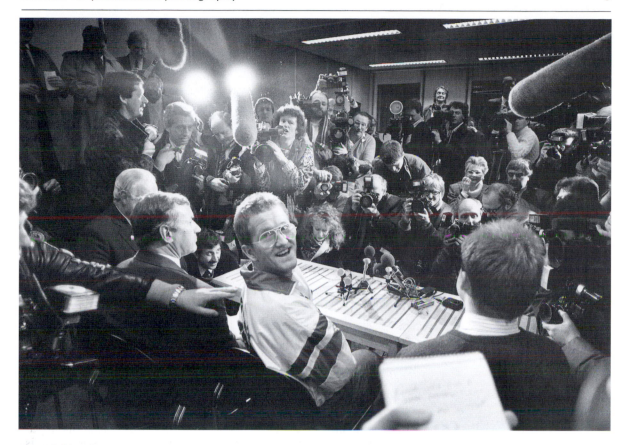

Fig. 1.5 Shooting pictures at a press conference often means tough competition from fellow photographers and television. It's difficult to get something striking and different. Showing the whole situation like this is one approach. (By John Downing/*Daily Express*)

and impact. (On the other hand, a bad art editor can ruin your set of pictures by insensitive hacking to fit them into available space.) One way into this area of photography is to find and complete a really strong project on your own initiative and take it to editors of appropriate publications for their opinions and advice.

Editorial and advertising photography

Editorial illustration means photography (often single pictures) to illustrate magazine feature articles on subjects as diverse as food, gardening, make-up, fashion, etc. It therefore includes still-life work handled in the studio. You have less scope to express your own point of view than is offered by documentary photography, but this allows more freedom of style than most advertising work. Editorial photography in prestigious magazines and books is a good 'shop window' for you and can provide a steady income, although it is not usually well paid.

Advertising photography is much more restrictive than outsiders might expect. At the top end of the market, however, it offers very high fees (and is therefore very competitive). The work tends to be a team effort, handled for the client by an advertising agency. You must expect to shoot to some form of sketched layout, specifying the height-to-width proportions of the final picture and the placing of any superimposed type. Ideally, you will be drawn into one of the initial planning stages with the creative director, graphic designer and client, to contribute ideas. Sometimes the layout will be loose and open – a

Fig. 1.6 An editorial still-life shot like this looks deceptively simple. It takes skill and patience to suggest the differences in decoration, shape and size, and also achieve a strong grouping. (By Annie Morris)

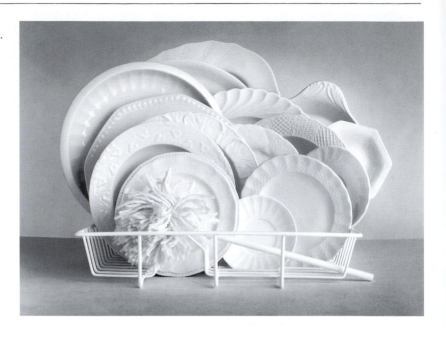

mood picture, perhaps – or it might be a tight 'pack shot' of a product, detailed down to the placing of individual highlights. At the unglamorous lower end of the market advertising merges into commercial photography, with income to match.

Whether or not you are chosen as a photographer for a particular campaign depends on several factors. For example, is your approach in tune with the essential spirit required – romantic, camp, straight and direct, humorous? Depending on the subject, do you have a flair for fashion, an obsession for intricate still-life shots, skill in organizing people or in grabbing pictures from real-life situations? Have you done pictures (published or folio specimens) having this kind of 'feel' or 'look' before, even though for some totally different application? Do you have any special technical skills which are called for, and are you careful and reliable enough – without lacking visual imagination? Can you work constructively with the team, without clashes of personality? Finally, are your prices right?

Most of these questions, of course, apply to the choice of a professional photographer for any assignment. However, in top advertising work the financial investment in models, locations, stylists and designers (as well as the cost of the final bought advertising space) is so high that choosing the wrong photographer could be a disaster.

Technical and scientific photography

This is a very different area, where meticulous technical skills and accuracy are all-important. Any expressionism or original personal style of your own will tend to get in the way of clearly communicating information. Photographs are needed as factual, analytical documents, perhaps for forensic or medical evidence, military or industrial research and development. You will probably be a staff photographer employed by the government, a university or an industrial research institute.

Photographic skills required include photomacro and photomicro still photography, high-speed recording and other forms of photo-instrumentation, including video. There is also a great deal of routine straight photography on location and in the laboratory.

You will be expected to have more than just photographic know-how. As a medical photographer you need a working knowledge of anatomy and an understanding of medical terms as well as concern for patients and an interest in medicine generally. As a scientific photographer you should have a sufficiently scientific background to understand advanced equipment and appreciate clearly what points scientist colleagues want to show in their reports and specialist papers. As a police photographer you should know what is or is not admissible in law and how to present evidence effectively to a court. On top of this, you must assess the potential of all new photographic materials and processes which might be applicable to your field. You will also be expected to improvise techniques for tackling unusual requirements.

To be a good 'applied' photographer you should therefore enjoy a methodical, painstaking approach to solving technical challenges. You will probably be paid according to a fixed, national salary scale which is not particularly high. However, there is better job security than offered by many other branches of professional photography.

Roles within a photographic business

Perhaps you are a one-person freelance or one of the team in an independent studio or in-house photographic department. Every professional photography business must combine a number of skills,

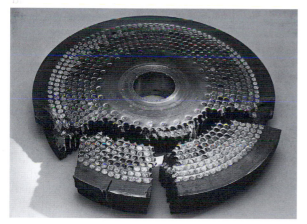

Fig. 1.7 Above: technical record of a fractured metal die, to illustrate an equipment failure report

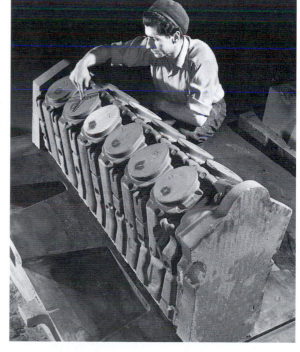

Fig. 1.8 Right: an informational picture showing preparation of the sand core for an engine casting. This was shot for education and training purposes

and for each skill you might require an individual employee, either on the payroll or 'bought in' (by using an outside custom laboratory, for example). For the lone freelance several or all of the following roles have to be filled by one person.

Manager/organizer

Managing means making sure photography goes on efficiently and economically. You must hire any necessary staff and/or outside services, check that quality control and reliability are maintained, watch finances. Like any other administrator, you will be concerned with safety; premises; insurances (including Model Release, page 298); and best-value purchase of equipment and materials. You must know when to buy and when to hire items. Every assignment must be costed and charged for accurately, remembering the competition and producing the work as economically as possible without dropping standards. As manager, you must understand essential book-keeping and copyright, and be able to liaise with the accountant, bank manager, tax inspector and lawyer. If you employ staff you must be concerned with their health and safety as well as having the ability to direct and motivate them, creating a team spirit and pride in the photography produced.

Photographer

Ideally, a photographer should be free to take photographs. In practice, apart from being technically reliable and visually imaginative you must be a good organizer and also be able to liaise directly with the client. Dealing with whoever is paying for your services is harmonious enough if you both see eye to eye, but, unfortunately, clients have odd quirks of their own. When it is obvious that this will lead to disaster (for which the photographer will eventually be blamed) considerable tact and persuasiveness are needed.

At a pre-briefing you should identify what the client has in mind, or at least the purpose of the picture and how and where it will be used. If the brief is very open-ended, float some ideas of your own and see how cooperatively these are received. If still in doubt, do the job, photographing the way you would like to see it done but cover yourself by shooting additional (for example, more conventional?) versions the client might expect. Often in this way you can 'educate' clients, bring them around to using more distinctive photography. But never experiment at the client's expense, so that they end up with results they cannot use. As a photographer, you should carry through each of your jobs whenever possible – if not printing yourself then at least supervising this stage. Finally, discuss the results directly with whoever briefed you in the first place.

Technicians

Technicians provide the photographer's back-up – processing, printing, special effects, finishing – to turn camera work into final photographs. Technical staff are employed full-time or hired as and when required for jobs, some as freelances or, most often, through their employment in professional custom labs. Technicians have specialized knowledge and skills highly developed by long practice in their particular area. Equally

they can offer new skills such as digital manipulation, producing what the photographer needs much faster than he or she can do alone. Technicians often give photographers valuable advice before shooting . . . and sometimes bail them out afterwards if some technical blunder has been made.

Working as a technician is sometimes creative but more often routine. You must produce work fast, and to highest professional standards. In return, there is more security and often better pay in being a first-class technician than an ordinary photographer. Too many people want to be photographers, overlooking equally satisfying jobs of this kind.

Ancillary roles

Supporting roles include photographer's agent – someone who gets commissions for you by taking and showing your work to potential clients. Agents seek out jobs, promote you and handle money negotiations. In return, they are paid a percentage of your fees. Stylists can be hired to find suitable locations for shots, furnish a studio set or lay on exotic props. Model agencies supply male and female models – attractive, ugly, 'characterful', young and old. Specialist photographic/theatrical sources hire trained animals, uniforms or antique cars for you – everything from a stuffed hyena to a military tank.

Turning professional

There is no strictly formal way into professional photography. You do not have to be registered or certified, or, for most work, belong to a union. Most young photographers go through an art college or technical college photography course. Some come into photography from design, fine art or some form of science course. Others go straight into a professional business as a junior member of staff and work their way up, perhaps with part-time study.

College photographic programmes range from basic technician certificate courses to diploma courses and Bachelor's (BA) and Master's (MA) degrees. Certificate courses tend to train you for the technical procedures and processes which make you immediately useful today as an employee. Diploma courses are also craft based but are more broadly professional. Most degree courses aim to help develop you as an individual – they are academic, like humanities courses, encouraging original ideas and approaches which pave the way to tomorrow's photography. However, certificates, diplomas and degrees themselves are only pieces of paper. Unless you are applying for a government-type photographic job with a pay scale formally linked to paper qualifications your best proof of ability is a portfolio of outstanding work. Organizations such as the Royal Photographic Society and various professional photographers' associations offer fellowships to individuals submitting pictures considered to reach a suitable standard of excellence. Make sure that your commercial portfolio contains not only photographs but also cuttings showing how your photography has been used in print. Pages from magazines, brochures, etc. all help to promote confidence in you in the eyes of potential clients.

Summary: Amateur and professional photography

● Amateur photography allows you greater freedom than professional work, but being a pro makes commercial factors – reliability, fast economic working methods and good organization – as important as your photographic skills. Often you have to create interesting pictures within a quite restrictive brief.

● In the same tradition as other creative arts, some fine *avant-garde* photographers operate as 'independents'. They build up international reputations through exhibitions, books, direct sale of prints, etc., yet earn their living at least in part at another job.

● To progress beyond a certain level in photography you need to learn how people read meaning into photographs – single pictures or sequences. Understanding how your work is likely to be received will help you to decide the best approach to your subject.

● Professional photography is mostly market structured – commercial and industrial, portraits and weddings, press and documentary, advertising and editorial, and technical and scientific.

● Commercial/industrial work covers promotional and record photography for firms and institutions. Your photography may be part of a complete communications 'package', including brochure design. Portrait/wedding photography is aimed directly at the public. You need to be good at flattering people through your photography and general manner.

● Press photography, very time based and competitive, means summing up a newsworthy event. Some publications still accept visual essays, offering space for in-depth documentary coverage of a topic. You can therefore think in terms of sequence – supply the art editor with a full coverage containing strong potential start-and-finish shots.

● Editorial/advertising photography means close working with designers. Catalogue work, particularly, justifies use of digital studio photography direct to DTP. Advertising work is heavily planned – you usually work to a layout within a team including a creative director, a graphic designer and a copywriter.

● Technical/scientific applications of photography call for factual, analytical records. You are likely to be an employed staff photographer, either working on industrial/university research projects or at a forensic or medical centre.

● There are several key roles in any photographic business or department. A manager administrates quality control, accounts, safety, equipment and materials. One or more photographers organize shoots, liaise with clients and carry out jobs efficiently, imaginatively and economically. Technicians follow through the photographers' work and service reprint orders. Ancillary roles include agent; stylist; and agencies for models, props, etc.

● Most people get into professional photography by taking an appropriate full-time college course, or they start in a studio and study part-time. However. 'getting on' depends more on evidence of your practical achievements than on paper qualifications.

2
Choosing lenses

Fine image quality depends a great deal on having a good lens, but you will find that even good lenses are only intended for a limited range of working conditions. Optics which excel under one set of circumstances can give quite poor results under another. This chapter explains some of the problems faced by lens designers and manufacturers, and shows how every product is a compromise between what today's technology will allow and what we as photographers will actually buy. It also helps you to understand the lens quality data in manufacturers' technical literature, and what to look for when buying a lens, new or second-hand. Special types of lenses are discussed too, in terms of practical handling and suitability for different kinds of photography.

The lens designer's problems

We all tend to take a modern lens for granted. It is just accepted as an image-forming collection of glass elements, somewhat overpriced and easily damaged. In fact, every good lens is really a skilfully solved set of problems concerning the control of light. Designing a lens means juggling image quality, the picture area covered, consistency over a wide range of subject distances, an acceptably wide aperture – and finally coming up with something which is not too large, heavy or expensive to manufacture.

Glass

The designer's raw material is optical glass, which starts as a molten mixture of chemicals, including barium, lanthanum and tantalum oxides. According to its chemical content, each type of glass has a particular (1) refractive index and (2) dispersive power (Abbe number).

Refractive index (RI) means the glass's light-bending power, measured for a wavelength of light near the middle of the spectrum (typically, 590 nm yellow-green, see Figure 2.1). The higher the RI, the more steeply oblique light entering the glass is changed in direction.

Substance	Mean RI*
Vacuum	1.000
Water	1.333
Magnesium fluoride	1.378
Fused silica	1.458
Hard crown optical glass	1.519
Common window glass	1.528
Lead crystal drinking glass	1.538
Dense flint optical glass	1.927
Diamond	2.419

*Measurement at wavelength 590 nm

Fig. 2.1 Some refractive index values

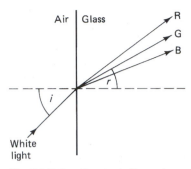

Fig. 2.2 Refraction and dispersion.
Mean refractive index with this glass is sine *i* divided by sine *r*. Dispersion (exaggerated here) is shown by the different RI for red and blue light. Glass dispersive power is given an Abbe number: the greater the dispersion the lower the number

The 'dispersive power' of the glass means the difference between its refractive indexes for red and blue light (see Figure 2.2). The greater this difference, the more white light is split into a wide spectrum of colours, just as a prism or droplets of rain disperse sunlight into a rainbow. Dispersion is an important factor in glass for photographic lenses because your subject matter is often multicoloured, and lit by a white-light mixed-wavelength source.

Mean refractive index and dispersive power are fairly independent. You can have two glasses which have the same refractive index but different dispersive power, and glasses which differ in refractive index but which have identical dispersive power. Figure 2.3 shows how this makes over 150 different kinds of optical glass available for the designer to choose. Glass used for lenses must also have the right physical properties to be machined and polished to the designer's chosen shapes without breaking. It must be completely colourless, unlike ordinary window glass, which shows a green tinge when you look through it end-on. Other requirements include general stability; freedom from defects such as bubbles, plus resistance to atmospheric conditions and reasonable handling during day-to-day use.

Design and manufacture

A photographic lens is built up from a series of lens elements. The designer works by calculating the necessary front and back surface contours of each element, its appropriate glass and the spacing of one element relative to another in the lens barrel (allowing for the aperture diaphragm and perhaps shutter). The aim in all this is to correct the mixture of optical errors – 'aberrations' – which always occur in images of a scene formed by simple lens elements alone. Closely check

Fig. 2.3 The 150 or so optical glass types produced for lenses by Schott, Germany. Glass for windows and lead crystal tableware are included for comparison. Enclosed zone defines the limits to manufacture 60 years ago

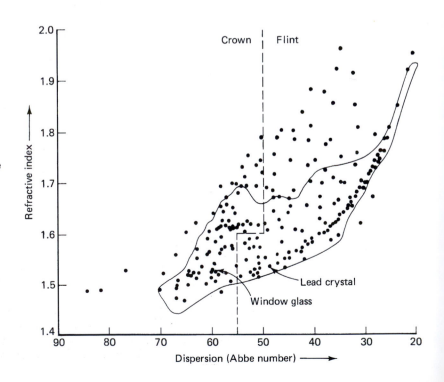

Fig. 2.4 Internal structure of a regular *f*/1.4 50 mm lens for a 35 mm SLR camera. Lens design is a complex, mathematical combination of different lens elements, precisely located in the barrel along with aperture and focusing mechanism

Glass Types, curvatures, number of elements, separation, coating; size and weight

Engineering Centring, spacing, focusing, zooming or floating of elements, aperture

the image of a scene formed by a single-element magnifying glass and you will see the slightly fuzzy, distorted, low contrast picture which is the collective effect of aberrations.

Some of the main aberrations are shown in Figures 2.5 to 2.10. It is not too difficult to reduce or eliminate each one *individually* by some means. For example, Figure 2.11 shows how the designer can correct chromatic aberration by combining a converging shape lens made in high refractive index, medium-dispersion glass with a diverging shape lens of glass having less refractive index but matching dispersion. The dispersion effects of converging and diverging elements then cancel each other out, although together they still converge light and so form an image.

Some aberrations are corrected by similar 'equal-but-opposite' combinations, some by stopping down, others by mathematical ratio of surface curvatures or an equal arrangement of elements in front of and behind the aperture. The handicap every designer faces is that the best way to correct one optical fault often worsens another. Matters can be helped by adding further lens elements (each offers a choice of two further surface curvatures and different glass), or you can fit a smaller aperture, or limit lens coverage to a narrower angle of view to cut out the worst aberrations which always tend to appear away from the centre of the image field. However, as elements are added light scatter builds up at every extra glass surface, and this gradually reduces image brilliance, despite the anti-reflective coating given to all modern optics. The lens also becomes heavy and expensive because of the cost of machining so many elements. Again, photographers want wider, not smaller, aperture lenses, and optics which have generous covering power, especially for camera movements.

Using sophisticated computing equipment, the designer calculates the paths of hundreds of light rays from a test target to each part of the picture format the lens is being designed to cover. Compromises have to be made. Ideally, image quality should remain excellent whether the lens is focused for close or for distant subjects, or when it is used at any

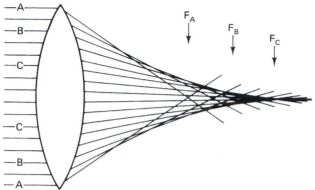

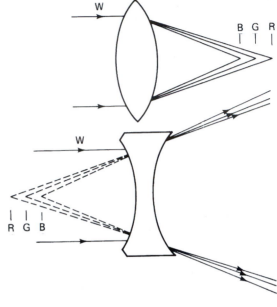

Fig. 2.5 Spherical aberration. Above: rays refracted by outer zones of a spherically shaped lens come to focus (F_A) nearer the lens than rays refracted through central zones

Fig. 2.6 Chromatic aberration. Right: dispersion of white light in simple converging (top) and diverging (bottom) lens elements causes different points of focus for each colour

Fig. 2.7 Curvature of field. Above: A is further from the lens centre than B. Therefore sharp image A_1 forms closer to the lens than B_1. The focal plane is saucer shaped: centre and edges cannot both be focused on a flat surface at any one setting

Fig. 2.8 Curvilinear distortion. Right: the rays most off-axis make too large an angle with the axis, 'stretching' the image of a square into a curved, pincushion shape. When refracted rays make too small an angle the opposite effect, barrel distortion, results. See Figure 2.22

Fig. 2.9 Coma. Each circular zone of the lens focuses oblique rays from an off-axis point at a different position relative to lens and lens axis. The patch of light formed (drawn as it appears at point of focus C) is pulled out like a comet. An oblique form of spherical aberration (Figure 2.5)

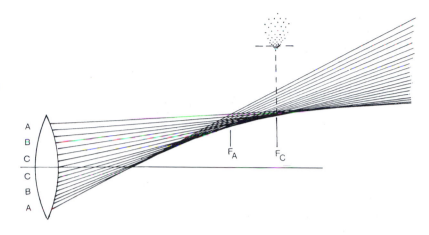

Fig. 2.10 Astigmatism. Light from an off-axis subject point is imaged spread out as either a radial line (at focal plane B) or a tangential line (plane A). Best compromise image is at intermediate plane X. Other off-axis points image as lines A_2 or B_2, etc.

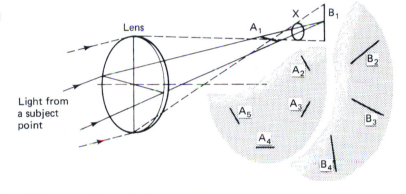

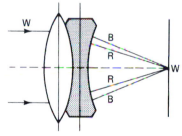

Fig. 2.11 Correcting chromatic aberration by combining positive and negative elements of different glass types. See text

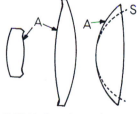

Fig. 2.12 Various lens elements, each having one aspheric-shaped surface (A). S shows how one of these contours would be if given a normal and more easily produced spherical surface

of its aperture settings. And the image should show no quality differences between the centre and corners of the picture format. At the same time, it is no good the designer pursuing ideal aberration correction if the resulting lens is uneconomic to make.

Each advance in lens manufacturing also helps the designer. For example, you can have groups of 'floating' elements which mechanically alter their position in the lens barrel as the lens is focused for different distances. Elements can be given 'aspheric' instead of spheric surface contours (see Figure 2.12) or, in the case of small elements, be made in glass which has a graduated refractive index between centre and edges. These developments allow lenses with a better and more consistent performance, using fewer rather than more lens elements. So the trend is towards lighter and more compact lenses, as well as more extreme focal lengths and wider maximum apertures.

Checking lens image quality

Lens quality is difficult to pin down by something simple such as a number. Sharpness is subjective – clarity judged by human vision – and has to include image contrast as well as how much fine detail is actually present. Look carefully at Figure 2.13, for example. You can do simple

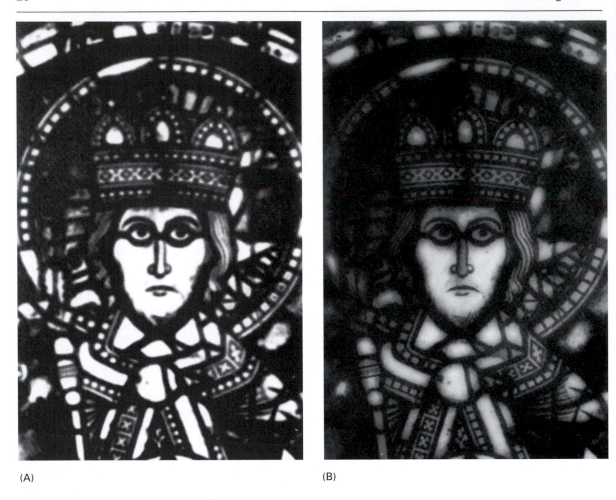

(A) (B)

Fig. 2.13 Image sharpness is subjective, depending on contrast as much as fine detail. Left-hand picture (A) was shot with a lens giving poor resolution but good image contrast. Right-hand picture (B) used a lens corrected to resolve finer detail but giving lower contrast. Viewed carefully from normal reading distance, (B) looks sharpest. But from two metres away (A) seems sharpest – your eyes no longer see the fine detail reproduced in (B) so this factor no longer matters. Courtesy Carl Zeiss

practical tests yourself to get an idea of the quality of a lens. This is helpful if you are trying out a second-hand lens before buying. On the other hand, manufacturers do much more sophisticated tests and publish typical performance as figures or graphs for each of their lens range.

D-I-Y lens tests

Irrespective of whether the lens is for small-, medium- or large-format photography, try to test it mounted in some larger-format camera which has a fine-etched focusing screen. A 35 mm or rollfilm format lens can be fitted onto a 4 × 5 inch viewcamera or a 4 × 5 inch camera lens on an 8 × 10 inch camera. Use bag bellows or a recessed lens panel if necessary to allow the lens close enough to focus. Have the lens axis dead centre and at true right angles to this enlarged focusing screen, which you trace out with the vertical and horizontal outlines of the format your lens must cover. Acceptable image quality outside this area will prove how much you could use the lens off-centre – by shift or swing movements, for example. Have a focusing magnifier to examine the appearance of the image on the screen.

Some image qualities are best checked if you use a large-area, detailed subject. Pin up several sheets of newspaper at right angles to the lens axis at, say 4 metres away (for a general-purpose lens) or any other distance you know you will often use. Have this improvised 'test chart' brightly and evenly lit. Then with the lens at widest aperture, focus for the centre of the format and examine image quality over parts of the screen further away from the axis. As you increase this distance the image may look less sharp, due to various off-axis aberrations and curved field. The latter is proved by refocusing – see if the outer zone grows sharper at the expense of the centre.

Slight curved field is a problem with some wide-aperture lenses, but is overcome when stopped down one to two stops. The position of sharp focus for the screen centre should be quite definite. If you have any uncertainty about this position, or see it change as you stop down, this suggests residual spherical aberration (Figure 2.5). You can also check for curvilinear distortion by having straight lines in the subject imaged well out in the image field and comparing these against a ruler laid flat across the screen.

Other faults are best seen using a rear-illuminated pinhole as a subject. Set this up at an appropriate distance and sharply focused centre frame, then slide it sideways, parallel to the screen until imaged well out in the field. A change in the *shape* of the spot of light and any colour fringing that appears could be the combined effects of astigmatism, coma and lateral colour. Some of this will disappear when you stop down.

Try altering the focusing when the spot is imaged well off centre. If you see reduced aberration fringes on two parts of the spot's circumference (in line with a line drawn outwards from the lens axis) at one focusing position, and on parts at right angles to these at another focusing position, astigmatism is probably present. A damaged lens may show no dents but still have one or more elements de-centred. (It only takes a few thousandths of a millimetre misalignment between the axis of some lens elements to produce noticeable loss of image quality.) To check this, image the pinhole centre-format. When you move either lens or screen forwards or back through the position for sharp focus the spot of light should widen to a truly symmetrical patch, not any other shape. Tests like this are interesting to do but really require more critical analysis than is possible by just looking at a camera focusing screen, however fine-grained it may be.

Understanding modulation transfer function

Modern lens manufacturers put their products through far more extensive tests than you can do yourself and publish what they call 'modular transfer function' (MTF) information. Do not be intimidated by this jargon, which comes from electronics rather than photography. Once you know how to read them, MTF data give plenty of practical information to judge lens quality against price. Unfortunately, graphs often appear in technical brochures without much explanation of terms, so it is worth looking at how they are drawn and what they mean.

MTF test procedure is somewhat like checking a hi-fi system, where you feed in signals covering a range of known sound frequencies then compare each one against its purity of output. However, for lens testing

Fig. 2.14 Typical test chart pattern for lens testing. The limit of good image sharpness is taken to be the point at which you can no longer tell whether bars are oriented horizontally or vertically. (Test it with your eyes at various distances)

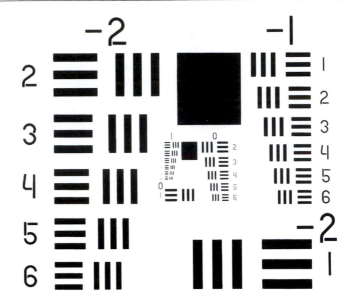

the 'subject' is a patchwork chart of grids such as Figure 2.14, each grid having a number of equal-width black and white lines. One black and one white line is considered a pair, so you can quote the number of line pairs per millimetre (lp/mm) to describe the fineness or coarseness of the grid subject. High numbers of lp/mm mean fine detail, which scientists call high spatial frequency. Low lp/mm represent coarse detail or low spatial frequency.

The next bit of terminology is *modulation*, which basically means the change between light and dark values. A microscope/computer system scans across the lens's image of chosen bars and the resulting signals are compared against direct readings off the chart. A perfect lens would image the grid with black lines perfectly black and white lines white. In practice, because of remaining aberrations and diffraction black lines become lighter and white lines darker, and original contrast boundaries between the two appear more graduated when the light from the subject is *transferred* through the lens. Modulation is therefore always less than 100%, and could even drop to the point where bars are completely indistinguishable from spaces (zero modulation).

What MTF graphs mean

The usual kind of lens modulation transfer function graph (Figure 2.15) shows modulation 0–100% on the left-hand axis. On the base line it maps out distance across the image patch, from the lens axis (left-hand end) out to some appropriate radius point to the right. For a lens designed to cover 35 mm format without movements this might be 22 mm. For a 6 × 6 cm format lens the equivalent would be 40 mm, and for 4 × 5 inch format about 80 mm. However, if your camera offers movements which shift or tilt the lens axis away from the centre of the film it is important to have information 'further out' than a circle only just covering the format. For example, Figure 2.15, for a 4 × 5 inch viewcamera lens, shows performance out to a radius of 177 mm, with

Fig. 2.15 Basic elements of an MTF graph for a camera lens designed to cover a 4 × 5 inch negative, allowing ample movements. The higher and straighter the plots the more consistent the image quality. (Note that image diagonal distances from the centre are in log values, which expand central area data relative to edges)

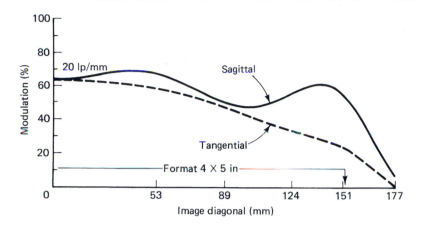

a marker showing the acceptable limit of off-axis use as about 155 mm.

Lens performance is plotted for a particular frequency of patterns perhaps 20 lp/mm. As you move further from the lens axis towards corners of the picture, performance (percentage modulation) drops. The better the lens, the less this drop-off will be. You also find that the plot line splits into two. One is marked S for sagittal, meaning response when the grid has its lines parallel to a radial line drawn outwards from the axis. The other, T for tangential, is for when the grid pattern is turned 90°. Any remaining aberrations such as astigmatism (Figure 2.10) cause differences in the two results. Again, the less they differ, the better the lens.

Plots for 35 mm format lenses are usually shown for 40 lp/mm. This figure is related to the resolution assumed necessary for the final image you view. For example, a 24 × 36 mm format picture shot with a 50 mm lens, then enlarged onto 8 × 10 inch paper 25 cm wide (magnification ×7) and seen from 30 cm typical normal viewing distance, looks natural in subject scale and perspective (see *Basic Photography*). However, at this reading distance the human eye can resolve, at best, about 5–6 lp/mm. Try it yourself looking at a ruler. (It is a stark reminder that limited eye ability forms the whole basis of depth of field.) So referring back to 35 mm format, eye resolution ×7 gives about 40 lp/mm necessary in the camera for the final image to look sharp.

Fig. 2.16 MTF graphs separately plot patterns running parallel to a radial line running from the lens axis, and others at right angles to these. Far right: performance over an image field at least 22 mm radius must be shown for a lens intended to cover 35 mm format

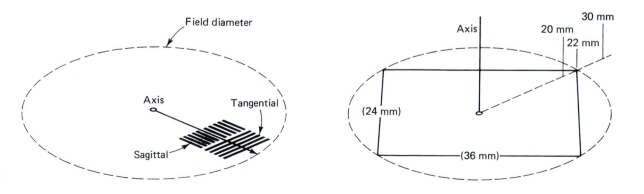

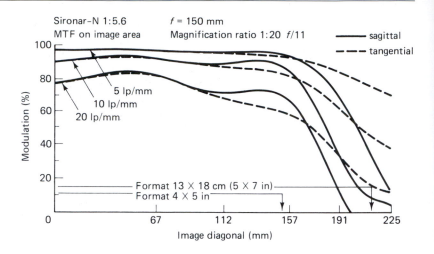

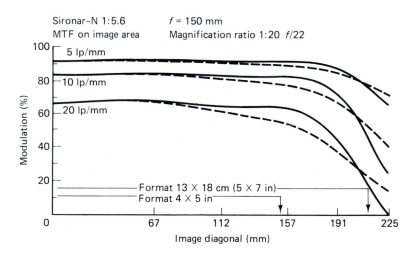

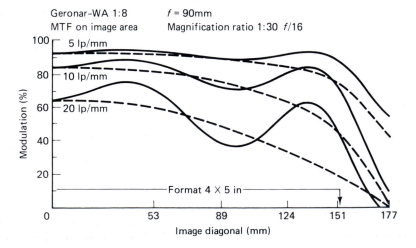

Fig. 2.17 MTF graphs for two large-format camera lenses. The Sironar-N is a high quality six-element lens. Graphs show changes when lens is at *f*/11 (top) and *f*/22 (middle graph). Image quality across the film becomes more consistent as stopping down reduces aberrations. However, the general level deteriorates slightly due to diffraction from the smaller aperture. The Geronar lens (bottom graph) is a budget-priced four-element wide angle. Courtesy Rodenstock

On larger formats this is different again – an 8 × 10 inch print from a 4 × 5 inch negative is enlarged ×2. About 20 lp/mm on the film will give a result which looks sharp to the eye. So MTF graphs for large-format lenses seldom show plots for spatial frequency finer than about 20 lp/mm. Clearly, these taking and viewing assumptions can be upset if you are to enlarge from only a part of the negative or make giant enlargements to be seen close up. The brightness of the illumination the final print receives when displayed also greatly influences eye resolution.

Most MTF graphs plot extra lines showing performance at 30 or 20 lp/mm, or even (large-format lenses) 10 and 5 lp/mm. Do not ignore them. With a good lens it is important that broad detail also maintains contrast across the image. Some of the finer detail is lost by the graininess of the light-sensitive material you expose it on (page 67) or the dot pattern of a halftone screen (page 272). In these instances it is the lower frequencies that communicate most of your image. When comparing MTF graphs for different lens brands remember too that manufacturers tend to present performance in the most favourable way. Compare carefully the scaling of graphs, such as spacings between figures on the modulation axis relative to those on the image field axis. Some manufacturers label the latter 'image height'.

Checking the small print

Alongside the graph should be the f-number used during testing. Often this is f/5.6 or f/22 for 35 mm and large-format lenses, respectively. If an MTF curve is shown for the widest aperture it will show poorer performance because of more pronounced aberrations; at smallest aperture it will again deteriorate mostly due to diffraction. In the case of a large-format camera lens, comparing graphs at different apertures tells you how the limits of coverage change. For example, stopped down appropriately, a normal lens for 4 × 5 inch format might well cover 5 × 7 inches or even 8 × 10 inches (both as a wide-angle lens), provided you do not use movements. Alternatively, the same graphs show how far movements on a 4 × 5 inch camera can bring the lens off-centre on the film before image quality suffers on one side of your picture. See also Figure 3.5.

Graphs should also state the distance of the subject test chart, usually as a ratio (typically, 20:1 for a 4 × 5 inch format lens, but for a macro lens 1:1, and for a 35 mm format enlarging lens 1:10). You should expect to see a macro lens giving best performance at around 1:1, whereas a general-purpose lens image would deteriorate when used so close. Enlarging lenses need characteristics similar to macro lenses (see page 33). However, do not expect any lens to give 100% modulation, even with a coarse frequency subject like 10 lp/mm, imaged on-axis and at optimum f-number. This is because the aperture always creates some diffraction, varying with different lens designs. Often plots for 40 lp/mm start on-axis at less than 50% modulation and then get worse.

Other MTF graphs

Another type of MTF graph (Figure 2.19) allows you to compare two lenses in a different way, plotting percentage modulation against a wide range of lp/mm. It does not tell you anything about image quality

50 mm f/1.8 lens for 35 mm SLR at 1:50

f-no.	Axis	Corner
1.8	45 lp/mm	40 lp/mm
2.8	50	45
4	56	50
5.6	63	56
8	70	63
11	63	56
16	56	50
22	50	45

Average resolution figures* at widest aperture

Lens type	Axis	Corner
4 × 5 in (all)	28 lp/mm	22 lp/mm
6 × 6 cm (80 mm)	32	25
35 mm (50 mm)	40	30

* Just-distinguishable lines before modulation drops to unacceptable level.

Fig. 2.18 Lines per mm resolution performance of typical camera lenses. The top table shows how image quality peaks at f-numbers about the middle of the range

Fig. 2.19 MTF plots (axial image) from two lenses, for different fineness of detail. Lens A is most suitable for a video camera – X denotes the cut-off frequency of 625-line television systems. See text. Lens B is more suitable for silver halide film photography, where acceptable modulation is needed down to about 40–50 lp/ mm. Bottom: type of test chart used. For photographs of a subject taken with these lenses, see Figure 2.13

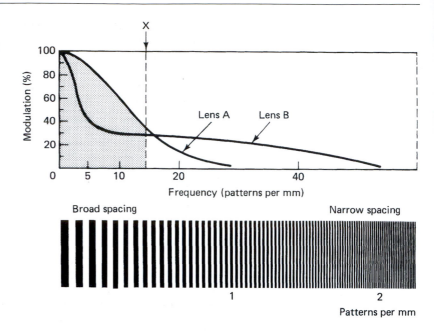

across the image field, but makes it easy to see how response worsens as detail becomes finer. As with previous MTF graphs, the greater the area shown *under* the plot line, the better the lens. One lens plotted on Figure 2.19 has its aberration corrections biased in such a way that the most contrasty, best-quality image occurs with *broad* detail, then it rapidly deteriorates with finer detail. A lens designed with these priorities is ideal for a video camera, where the limitations of the television medium (traditionally, 625 or 525 lines) are so crude that anything finer would be lost in the system. The other lens is designed for regular photography. Priority here has been given to corrections which give generally lower but more consistent percentage modulation down to much finer patterns, because silver halide systems are more able to record such detail. Still higher performance needs to be met in lenses intended for use with high-end CCD digital camera backs, see facing page. The graph proves again how lenses can be closely designed for a set function.

MTF graphs scaled in the same way are also published for different kinds of photographic films. As explained in Chapter 4, the resolving power limits of films range between about 200 lp/mm and 25 lp/mm according to speed, grain, level of exposure and type of development. So you can combine the performance of your camera lens and your film to get one graph plot representing the complete imaging system from subject to processed result. This is about the closest anyone can get to representing photographic image quality through diagrams or figures (see page 71).

Buying lenses

Each manufacturer sets its own minimum quality image acceptance standards, but every lens – even though one of hundreds of the same

design – is also an individual product. Glasses, shaping, spacing and centring can differ in minute ways as lenses come off the production line. So although quality control should ensure that no lens giving less than a minimum standard gets through, some lenses may in fact be considerably better. You will also find two manufacturers offering lenses of similar specification at quite different prices. One significant reason may be that the cheaper manufacturer sets slightly lower standards and operates less strict quality control. The result is more of a 'lucky dip' from which you may (or may not) draw a good lens.

Understanding some of the lens designer's problems shows you the importance of using a lens only within its intended performance range. A telephoto lens fitted with an extension tube *may* focus close enough for 1:1 copying, but your results will probably be poor quality. (This is not the same as a lens, such as a zoom, designed to offer 'macro mode' which shifts internal floating elements to correct for working at one close distance.) Again, some true macro lenses give indifferent results when focused for distant landscapes.

Most lenses give their best image quality stopped down to about the middle of their f-number range. The wider you open up, the less certain aberrations are corrected; but too much stopping down begins to lose quality because of diffraction (Figure 2.18). So the upper and lower ends of the f-number scale are limited by lens design and what the manufacturers regard as the limits of acceptable image quality. Sometimes two lenses of the same brand and with identical focal lengths are radically different in structure and price, because one opens up an additional stop or covers a larger area (allowing camera movements) without worsening quality.

Lenses for specialized purposes have their aberration corrections biased in a particular direction. For example, a lens for an aerial survey camera must give optimum quality for distant subjects and avoid any distortion of shape because results are used for measurement purposes. A lens for enlarging or copying has its corrections balanced to give best quality when subjects are close. A shift lens, or any lens for a camera offering shift movements, needs generous covering power (and to achieve this will probably not have a very wide maximum aperture). A lens for 35 mm press photography or surveillance work may only just cover its format, because all the design emphasis is directed towards widest possible aperture.

New lenses designed for digital backs outputting large files (page 57) give higher resolution than is needed for silver halide film. (Circles of confusion should not exceed in diameter the 'pitch' or distance between each of the millions of elements in a CCD matrix). And a lens designed for the curtailed resolution requirements of video cannot be expected to perform well taking silver halide photographs.

When choosing a lens decide too the handiest size and weight for your expected shooting conditions. This is especially important with long focal length lenses to be used on difficult locations. Do not go for maximum apertures wider than you will ever need – it only increases bulk and cost. Lens condition is especially important if you are buying second-hand. Elements with scratches (perhaps from excessive clean-ing?) will more seriously affect image quality than a speck of black or even a bubble in the glass. A lens which has been dropped may show no obvious external sign of damage yet have internal elements mis-centred, giving general deterioration of image quality. So if you are

buying an expensive second-hand lens always try it out first under your own typical working conditions or invest in a professional test (available from most major camera repairers).

Special lens types

Zoom lenses

New optical glasses with novel combinations of refractive index and dispersive properties, plus better lens design, mean that the best modern zoom lenses give really good image quality. To understand how a zoom lens works, remember that the focal length of a complete lens depends on the focal lengths of its component elements and the distances by which they are separated (affecting their 'throw'). In a zoom lens groups of elements move within the lens barrel when you alter the focal length control. This zooming action therefore 'restructures' the lens – for example, from inverted telephoto through to telephoto (shown schematically in Figure 2.21).

Zooming should alter focal length and therefore image magnification, without disturbing focus. At the same time, the designer has to arrange that aberration corrections also adjust to keep pace with your focal length changes as well as your focusing. It is particularly difficult to hold corrections for curvilinear distortion (Figure 2.8). The tendency in a poor-quality zoom is for square-shaped subjects to be imaged pincushion-shaped at one end of the zoom range and barrel-shaped at the other (see Figure 2.22).

Ideally, a zoom should also maintain the *f*-number you set throughout its zooming range. In practice, to reduce cost and size, many zooms

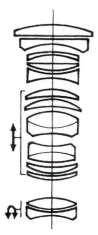

Fig. 2.20 A zoom lens design showing groups of 'floating elements' which are repositioned during zooming to alter focal length and maintain best correction of aberrations

Fig. 2.21 One basic form of zoom lens construction in which two sets of components are movable. Top: movement backwards to give inverted telephoto setting. Bottom: movement forwards for the telephoto setting. Rear nodal point (N) becomes progressively further from the focal plane, giving longer focal length and larger image detail. Converging components (+) remain static. See also Figure 2.31

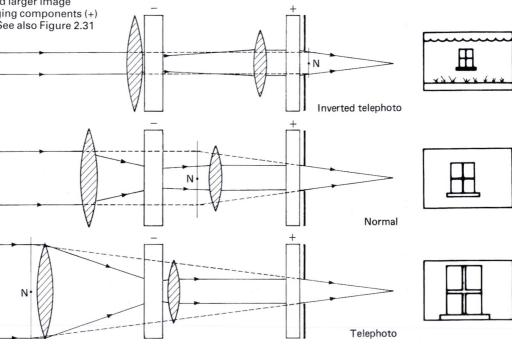

Inverted telephoto

Normal

Telephoto

Barrel

Pincushion

Fig. 2.22 Barrel and pincushion image distortion, shown here in exaggerated form

slightly alter how much light they pass at widest aperture (see Figure 2.30). The widest setting when used at longest focal length becomes up to one stop wider when you change to shortest focal length setting. Automatic through-the-lens camera exposure metering takes care of any changes as you zoom. However, if you use manual TTL metering, a non-dedicated flashgun or a separate exposure meter, be prepared to re-adjust for the new widest aperture at different zoom settings.

Because of their complexity, and a very competitive market, zoom lenses vary more in image quality than any other lens type. Some zooms fully match the standards of fixed focal length lenses. Others are much worse. It is true to say that the greater the zoom range (ratio of shortest to longest focal length), the less likely image quality generally will match that of a fixed focal length lens. A zoom with a ×5 or ×6 range, for example, is unlikely to be as good as one of ×3 or ×4. Similar reservations apply to the quality of zooms when set to macro mode. Unlike a good fixed macro lens, sharpness often deteriorates towards the corners of the picture. The answer is to tread warily, read the technical specifications and, when possible, make practical tests to check whether a particular zoom gives you good enough results.

Mirror lens designs

A photographic lens can be combinations of glass elements and curved mirrors. Figure 2.23 shows a typical mirror lens layout; it has a characteristic squat drum shape and an opaque circular patch in the centre of the front lens (the back of the inward-facing second mirror). The advantage of mirrors is that a long focal length lens becomes physically much shorter – its optics are 'folded up'. Mirrors do not suffer from chromatic aberration because they *reflect* instead of refract light. So the designer needs fewer correcting elements and this, plus the lightweight mirrors, makes the complete lens far less heavy than the same focal length in conventional optics.

However, a mirror lens has three disadvantages:

1. It cannot be stopped down – having a diaphragm would vignette corners of the picture. So you cannot alter depth of field, and exposure has to be controlled by fitting grey neutral density filters or by relying on the shutter alone. Mirror lenses do not therefore suit auto-exposure cameras using shutter priority or programme modes – only aperture priority or manual modes will work.
2. Any bright out-of-focus highlights spread into doughnut-ring shapes instead of the usual discs of light we accept as similar to eyesight. The dark central shape is due to the front mirror.

Fig. 2.23 Typical 500 mm mirror lens and internal structure. C: corrector plate. M: primary converging mirror. S: secondary mirror. L: weak secondary correctors for aberration control. N: neutral density filter (changeable) for exposure control

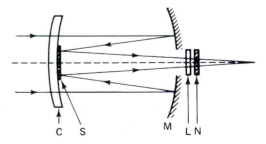

Fig. 2.24 Extreme fisheye lenses produce circular pictures but, together with the distortion of shapes they give, this can suit some subjects. Chris Harris set up a remote camera to shoot the basket of this hot air balloon, using an 8 mm Nikon fisheye. It was triggered by an IR release in the pilot's left hand

Fig. 2.25 Wide-angles, unlike fisheyes, are formally corrected for distortion. But extreme wide angles still 'pull' shapes furthest from the picture centre. This is especially obvious with shots of human figures, least with plain areas such as floor or sky. (By Ilkay Mehmet)

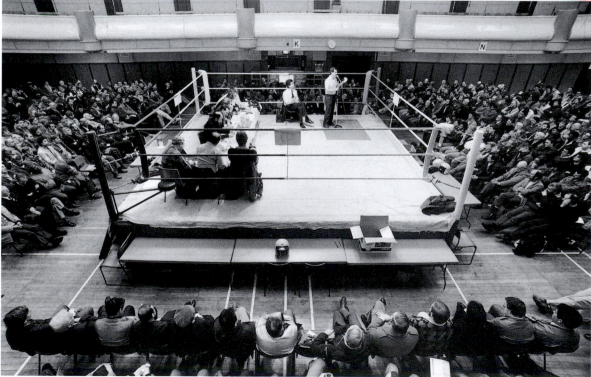

3. Aberrations increase to unacceptable levels away from the lens axis, so mirror designs are limited to narrow angle, long focal lengths. Typically, they come as 500 mm, or 1000 mm lenses for 35 mm format, with a fixed aperture of about $f/8$ or $f/11$.

Relatively few mirror lenses are available (they are described as 'catadioptric' or 'reflex' types in some brochures). Nevertheless, their light weight and handy shape make them convenient to use, especially for natural history or sports photography on location.

Fisheye lens designs

Fisheyes are special wide-angle lenses in which correction of curvilinear (barrel) distortion is sacrificed in order to give extreme angle of view. Angles of 180° or 220° are quite common, but to achieve this, image magnification varies greatly across the picture, producing strange fishbowl results (see Figure 2.24). In all other respects a good fisheye gives excellent image quality.

The lens has wide-diameter, bulbous front elements, which diverge light – similar in principle to a normal type lens looking through a concave window. You cannot add a lens hood or external filters because they cut into the angle of view, so light-shading tabs and 'dial-in' filters are built into the barrel itself.

Depth of field is phenomenal, typically stretching from 30 cm to infinity at $f/8$. Maximum aperture is often about $f/5.6$. A few wider-aperture ($f/2.8$) fisheye lenses have also been marketed, using front elements 20 cm or more in diameter, which makes them extremely heavy and expensive. Another unusual variation is the fisheye zoom, such as the Pentax 17–28mm. Most fisheyes are designed for 35 mm format cameras, and one or two for rollfilm types. You can also fit a 'fisheye converter' over the front of a regular lens. The best of these give excellent quality results, provided your camera lens is stopped down.

Development of modern extreme wide-angle lenses such as the 47 mm Super Angulon (covering formats up to 4×5in) put fisheyes into second place for record photography of confined interiors, etc. Fisheyes should always be used sparingly, perhaps to make spectacular industrial, advertising or editorial shots. They give novel geometry but you soon find that this dominates each and every subject you shoot, giving repetitive results. Some fisheyes are intended for special purposes such as surveillance work, photographs inside architectural models or all-sky photography for meteorology.

Soft-focus lens designs

When you focus a soft-focus lens it images any point of light from the subject as a sharp core overlaid with a 'halo' of spread illumination. The resulting softness of outline works well for atmospheric landscapes, portraits (weddings, children, etc.), especially in colour. The effect is most noticeable with contrasty subject lighting. Large tonal areas appear less softened than fine detail. In portraits, for example, skin blemish detail is suppressed and yet facial features in general remain much clearer than an image that is out of focus. See also Figure 2.27.

Fig. 2.26 A 16 mm *f*/3.5 fisheye lens

Fig. 2.27 Left to right: normal lens in focus; soft focus lens; normal lens out of focus. Soft focus gives a combination of sharp and unsharp detail, and lowered contrast. See also Figure 4.7

Soft-focus lenses differ in detail, but all tend to be highly corrected for optical errors with the exception of spherical aberration. As Figure 2.5 showed, retaining this error gives the mixture of sharp and unsharp characteristics of a soft-focus image.

You must be able to control the degree of 'softness', to suit your subject. With some lenses this is crudely achieved by stopping down – the aperture ring shows symbols for softest focus at widest setting, down to sharpest focus fully stopped down. Better designs have floating elements which shift to increase or decrease spherical aberration when you turn an extra control ring. You can then control softness independently of depth of field.

A few soft-focus lenses, undercorrected for spherical aberration, accept interchangeable multi-perforated aperture discs (Figure 2.28). Each disc increases dispersion and also makes image points consist of a hard core (central aperture) surrounded by overlapping smaller patches of light which form a halo effect. For different effects you

Fig. 2.28 Near right: (a) regular lens, image out of focus; (b) soft-focus lens image – each point on the subject records as a nebulous halo with a hard core. Far right: soft-focus lens for a large-format camera, using interchangeable perforated discs to give different amounts of dispersion and light patches

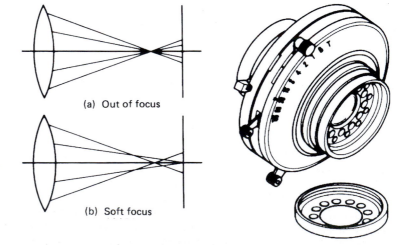

(a) Out of focus

(b) Soft focus

change discs. One disadvantage of this system is that, like a mirror lens, every bright unsharp subject highlight takes on the frontal appearance of the lens – a central patch surrounded by smaller patches. Each disc is marked with an 'equivalent *f*-number' for exposure purposes.

It is advisable to focus a soft-focus lens at the actual aperture to be used for shooting. If possible, use a plain matt focusing screen so you can then judge precise effects. Split-screen SLR manual focus aids and autofocus may not function. Where possible, measure exposure through the lens using the camera in manual or aperture priority mode.

You can produce superficially similar soft-focus results using a diffusing attachment over a regular lens. (A finely etched 'anti-Newton's rings' transparency cover glass is cheapest.) However, close comparison of results from an attachment against a good soft-focus lens will soon convince you of the subtleties of the latter. As an alternative technique, you can shoot on reversal film with a normal lens and enlarge this onto reversal printing material (such as Ilfochrome) using a soft-focus lens or attachment on the enlarger. Do not try this when printing from negatives, because the lens will then spread shadows rather than highlights, giving a very different atmospheric effect.

Macro lenses

The aberration corrections in a macro lens are balanced to give optimum image quality when the subject is relatively close. Focal length is usually normal or slightly long for the format it covers, for example, 50 mm or 100 mm for 35 mm cameras. The lens is designed to have a relatively modest maximum aperture such as *f*/3.5 or *f*/4, but often stops down as far as *f*/32. A working range of *f*/5.6 to *f*/64 is common with macros for larger formats. Macro lenses are corrected for these smaller apertures, which are helpful to improve the shallow depth of field when working close and/or using a large format outfit.

Most macros for 35 mm and rollfilm cameras have extended focusing barrels so that you can continuously focus out from infinity setting to image close subjects ×0.5 (half-size). As Figure 2.29 shows, the focusing ring has an extra scale of 'macro' numbers, typically from 10 down to 2. These are handy for precise record photography – by noting the number you are using for a particular shot the subject size and magnification can be accurately calculated later for captioning your picture. You can also use the scale to set a predetermined ratio, then move the camera nearer or further until the image is sharp.

Of course, any macro lens will focus still closer subjects if you add on extension tubes or bellows between lens and camera body. However, at magnifications greater than about ×2.0 you may find image quality gradually deteriorating, because you are outside the design limits of aberration corrections. For finest quality you can then change to a more expensive 'true' macro (or 'macro bellows') lens, each one corrected for optimum results at a particular magnification (for example, ×5, ×10, etc.). Such lenses come without a focusing mount, because they are intended for use with adjustable bellows. Scientific photographers often work with sets of these true macros, changing them in the same way as microscope objectives.

Always remember that through-the-lens metering is the most accurate way of measuring exposure when shooting close up, using extended lens-to-film distances. Image brightness dims considerably,

Macro numbers

Focusing distance (m)

Fig. 2.29 Macro lens, showing extra macro numbers on focusing scale relating to magnification. To find your subject magnification on film, divide the macro number into 1 (e.g. 10 means magnification of ×0.1)

and is not automatically taken into account if you are using a separate meter or a non-dedicated flashgun. It is easy to overlook this when working with studio flash and a separate flash meter (see page 154).

Converter lens attachments

You can buy attachments containing multi-lens elements to add to your main lens and convert its focal length. The most common types are teleconverters, containing predominantly diverging lens elements and designed to fit behind one or more specified, moderately long focal length lenses – usually by the same manufacturer. Typically, a ×2 teleconverter doubles the prime lens's focal length, recorrecting aberrations so that the same image performance is maintained. Such a convertor reduces aperture by two stops, and if used with a zoom lens in macro mode it doubles previous magnification. Similarly, a ×1.4 converter multiplies focal length, macro magnification and *f*-number by 1.4 (in other words, aperture is reduced one stop). Teleconverters are most often made for particular 35 mm format camera lenses of between

Fig. 2.30 Specifications for a range of 35 mm format lenses. Notice the greater complexity of construction in wide-angle and zoom lens types. Also maximum apertures quoted for zooms often alter according to whether shortest or longest focal length setting is used. Long focal lengths are less able to focus close subjects (macro lenses excepted). The table also shows how telephoto lens size increases greatly with focal length, and many are heavy and costly

Focal length and max. aperture		Construction: groups–elements	Angle of view	Min. f-stop	Closest marked distance (m)	Size: diameter × length (mm)
Wide-angle						
13 mm	*f*/5.6	12–16	118°	22	0.3	115 × 99
18 mm	*f*/3.5	10–11	100°	22	0.25	75 × 72
20 mm	*f*/2.8	9–12	94°	22	0.25	65 × 54
24 mm	*f*/2.8	9–9	84°	22	0.3	63 × 57
Normal						
50 mm	*f*/1.2	6–7	46°	16	0.5	68 × 59
50 mm	*f*/1.8	5–6	46°	22	0.6	63 × 36
Telephoto						
105 mm	*f*/1.8	5–5	23°	22	1	78 × 88
200 mm	*f*/2	8–10	12°	22	2.5	138 × 222
300 mm	*f*/2.8	7–10	8°	32	2	123 × 247
600 mm	*f*/4	7–9	4°	32	5	176 × 256
1000 mm	*f*/11	8–9	2°	32	14	134 × 577
Reflex						
500 mm	*f*/11	6–6	5°	–	1.5	89 × 116
1000 mm	*f*/11	5–5	2°	–	8	119 × 241
Zoom						
17–35 mm	*f*/3.5	12–15	103–62°	22	0.3	82 × 90
28–85 mm	*f*/3.5/4.5	11–15	74–28°	22	0.8	67 × 97
35–135 mm	*f*/3.5/4.5	14–15	62–18°	22	0.4	68 × 112
80–400 mm	*f*/4.5/5.6	10–16	30–6°	32	2.5	76 × 200
Fisheye						
6 mm	*f*/2.8	9–12	220°	22	0.25	236 × 171
16 mm	*f*/2.8	5–8	180°	22	0.3	63 × 66
Macro						
105 mm	*f*/2.8	9–10	23°	32	0.11	66 × 91

100 and 300 mm or zoom equivalents, and effectively give you two lenses from one. However, do not mix brands or try to use them on a main lens of the wrong focal length. Beware of converters claimed to be 'universal'.

A few converters are designed to fit over the *front* of a normal focal length lens. They form shorter focal length inverted telephoto lenses, giving a wide angle of view yet keeping the lens-to-film distance unchanged. A typical wide-angle converter changes a 50 mm lens to 30 mm, or a 35 mm lens to 21 mm. Often image quality deteriorates and in no way matches a fully corrected wide-angle lens of this focal length. An exception is some front-fitting converters designed to transform normal angle lenses into fisheyes (page 31).

A completely different type of converter, which fits between lens and camera body, adapts a manually focused lens to autofocus, provided that the body contains autofocus drive. You leave the regular lens set for infinity. The camera's autofocus mechanism engages with the converter and then moves focusing elements within it until a sharp image is sensed. The result is a fully autofocused system, although not as fast acting as one designed for AF.

Influences on image sharpness

Good lens quality is of vital importance, but for the best possible sharpness in your final print you have to take care at every key stage on the way. The following checklist contains all the main influences on image detail:

1. *Lens quality.* Use the highest-quality modern lens you can afford. Its covering power must match or exceed your camera's picture format. The correction of aberrations must suit your typical subject distance. The lens should be multicoated to minimize scattered light.
2. *Lens condition.* Do not use a lens with scratches, grease, dust, condensation or misalignment of elements (for example, due to physical mishandling). Avoid inferior filters, converters or close-up lenses.
3. *Camera.* Focusing must be completely accurate on the film – beware of non-registration of focusing screen, and also autofocus errors. Do not overuse movements (especially viewcamera shift movements which can position the picture format excessively off-axis). Sometimes the focus or zoom control slips when the camera is pointed vertically. Mechanical faults include SLR mirror movement vibration, shutter bounce or film starting to wind-on before the shutter has fully reclosed, etc.
4. *Shooting conditions.* The atmosphere may contain dust, ripples of warm air, pollution, moisture particles. Avoid shooting through glass windows, however clear looking, especially with a long focal length lens. Prevent vibration or movement of camera or subject during exposure.
5. *The light-recording material.* Its ability to resolve fine detail. With silver halide material this means film speed, grain and emulsion thickness; degree of exposure and development; also the type of developer. With digital capture it means the number and pitch of elements in the CCD; also whether it is a static one- or three-shot matrix or scanning array. (See page 57.)

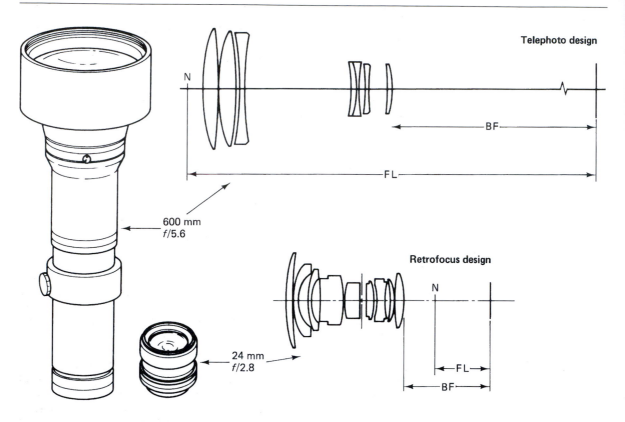

Fig. 2.31 Bulk and weight increase with focal length. However, differences are made less by telephoto and retrofocus (inverted telephoto) designs. Rear diverging elements give a telephoto a greater focal length than its back focus. Front diverging elements give retrofocus designs shorter focal length than back focus. Without this the larger lens here would be 25 times longer than the wide-angle

6. *Enlarging.* With film image magnification, type of light source, quality and condition of enlarging lens; the flatness of the film in the carrier and accuracy of focusing; movement during exposure; the contrast and surface texture of your printing paper.
7. Finally, there are the conditions under which you view your result, especially the brightness of the lighting and your viewing distance.

No one can control all these factors all the time, of course, but at least try to use equipment and routines which minimize the pitfalls if optimum sharpness is important in your work.

Summary: Choosing lenses

● Lenses begin with optical glasses, manufactured with precise refractive index and dispersive qualities (Abbe number). Glass should be colourless, offer the right machining qualities, yet be tough and stable.
● The designer works to satisfy a given lens specification (focal length, coverage, maximum aperture, focusing range, etc). The challenge is to avoid optical aberrations by combining elements of different glasses, deciding their shapes and spacing. Developments such as new glasses with extreme combinations of RI and dispersion, aspheric shaping and 'floating elements' extend design possibilities, but a balance always has to be found between optimum performance and economic price.
● Lens image quality is difficult to express, depending on contrast as well as detail. Do your own test of performance using fine print or a

pinhole light source as subjects, comparing their appearance on-axis and in outer-zone parts of the image. Manufacturers publish modulation transfer graphs, plotting percentage modulation against position in lens field (millimetres from axis) for a particular spatial frequency (fineness of detail) in lp/mm.

● MTF curves show you how far acceptable coverage extends – therefore size of format covered. They show the changes in perform-ance to expect when you stop down; come closer; use movements or a larger film; or accept lower standards. Plots are often made for 40 lp/mm (relevant for 35 mm format), 20 lp/mm (for large format) and 10 lp/mm. In practice, much also depends on the film used and your final viewing distance.

● A different form of MTF graph plots percentage modulation against a wide range of frequencies for one given point in the format (for example, on-axis). This is helpful when comparing lenses against each other and the known frequency range limits of your recording medium.

● When buying a lens read the manufacturer's technical information and comparative reviews in the photographic press. Focal length and maximum aperture are important, but ensure that corrections are designed for your kind of work, the lens gives sufficient coverage, and weight and size are acceptable. Carefully check the physical condition and optical performance of used lenses before purchase.

● Zoom lenses use floating elements to change focal length and adjust aberration corrections without disturbing focus. Zooms with variable maximum apertures can give inaccurate exposure when you alter focal length, if you use a separate meter or flashgun. Image standards vary – the best lenses (often having more limited zoom range) are excellent.

● Mirror (catadioptric) type long focal length lenses are compact and lightweight, and very easy to handle. However, fixed aperture limits your auto-exposure modes, and off-focus highlights have assertive shapes.

● Fisheyes – extreme wide-angle lenses with curvilinear distortion – give results very unlike human vision. Use them with restraint for dramatic effects, recording wide expanses of surroundings, and for their extreme depth of field. Filters and lens hood are built in.

● 'Soft focus' gives a more subtle suppression of fine detail than out of focus or general diffusion. Soft-focus lenses allow fine control of the effect by internal movement of floating elements, changing perforated discs or just stopping down. Focus, and view, at your working aperture. Soft focus spreads highlights of positive images, spreads shadows when used in enlarging negatives.

● Macro lenses are corrected to perform best at close subject distances. Most have an extended focusing movement and scale of (reciprocal) magnification numbers. For still closer technical work, use bellows and 'true' macros, each designed for a narrow band of distances. Remember to recalculate exposure, unless you measure light through the lens.

● A good teleconverter – designed to fit specific, same-brand, moderately long focal length lenses – gives you a still longer focal length option without loss of quality. Aperture, however is reduced. Other kinds of lens converter change normal lenses to wide-angle or fisheye, or adapt manual lenses to autofocus.

● Main factors affecting image sharpness are lens quality and condition; the camera's mechanical accuracy; movement, subject and lighting; characteristics of your light-sensitive material and its exposure and processing; enlarging and final viewing conditions.

3
Camera equipment

This chapter is mostly concerned with the hard practical considerations you must take into account when buying and using equipment. Principles of how cameras work were covered in *Basic Photography*, and your camera's instruction book will explain which particular buttons control what. Here we take an overview, comparing the good and bad features of various format cameras, and look at ways to avoid technical failures with them on what might be unrepeatable assignments. The chapter introduces camera equipment for digital imaging – mainly digital backs fitting existing professional camera types. It also describes special-purpose cameras such as aerial; underwater; panoramic and stereo, plus some of the most useful accessories for advanced photography.

General considerations

As a serious photographer remember that you do not so much buy a camera as buy into *a system*. It is an important and personal decision – after all, choice of format, and even type of design, can condition the way that you work.

35 mm format

35 mm cameras probably represent best value for money because prices are highly competitive. Using equipment this size means that you can carry around a comprehensive outfit in a small case. There is an unrivalled range of lenses and accessories available, and the whole system will incorporate the very latest developments in technology. However, because 35 mm cameras sell to a huge market of amateurs you are buying into a volatile, fashionable world in which models are updated quite rapidly and bristle with every conceivable feature. This 'bells and whistles' aspect is sometimes more to upstage rival brands than to improve your photography.

Excessive control buttons or, alternatively, total automation can be counterproductive for serious work. The many mode options and

viewfinder signals get in the way, even lead you into errors – perhaps through mis-selection or distraction by data displays at the key moment of some fleeting shot. Any camera for advanced amateur or professional work *must* also offer complete manual control. You need to have the assurance that you can take over and make use of your personal experience to get exactly the result required, including chosen effects.

A fully automated camera is well worth considering for fast, candid photography (including situations where you must shoot over your head in a crowd) but these cameras are only superficially intelligent. For example, they program greatest depth of field in bright light, and they can easily be focusing on, or exposing for, the wrong part of the subject. Worse still, you may start composing your pictures in ways which ensure that the auto mechanisms work perfectly (key element centre frame, for example). So make sure that there are convenient read-then-lock facilities for autofocus and for TTL exposure measurement. If the camera autosets film speed by DX cassette code sensing (page 77) it must also have a + or – exposure compensation control. Thus you can effectively set a different speed to suit up or down rating and changes to processing. Other features you may well rate as essential for any SLR camera include a stop-down button to preview your actual depth of field with all preset aperture lenses.

Using 35 mm format means that you work with lenses having apertures wider and focal lengths shorter than equivalents for larger formats. Fast lenses are helpful for hand-held existing light work. Short focal lengths give you generous depth of field, especially useful when subjects are close. However, then you have to remember that prints enlarged much beyond about 8 × 10 inches from 35 mm silver halide films increasingly show coarser resolution and cruder tone gradation than those from larger film. You must also take that much more care in the darkroom to avoid image blemishes.

Medium format

Camera equipment using 6.2 cm wide rollfilm (giving 6 × 6, 6 × 7, 4.5 × 6 cm, etc.) is a good compromise between the slowness and immobility of large formats and the poorer final image qualities of 35 mm cameras. Equipment this size is sold mostly to experienced amateurs and to professionals – a much more restricted market. Features tend to be more conservative, and because of the small numbers manufactured you can expect to pay over twice the price of an equivalent 35 mm kit.

Medium-format cameras are small enough to use hand-held and cope with action subjects. You can use most types at waist or eye level – there is a range of direct viewfinder wide-angle models as well as reflexes. At the same time, shift cameras (Figure 3.3) and monorail view cameras are now made for medium formats. Since rollfilm picture size is between three and five times the area of 35 mm, you can crop after shooting if you wish and print (or reproduce) from just part of the image without too much lost quality. An SLR this size also has a screen large enough to usefully attach a drawn overlay for critical jobs where your composition must fit a tightly designed layout.

Most importantly the majority of rollfilm SLRs have detachable, interchangeable backs, so you can be shooting using one film back

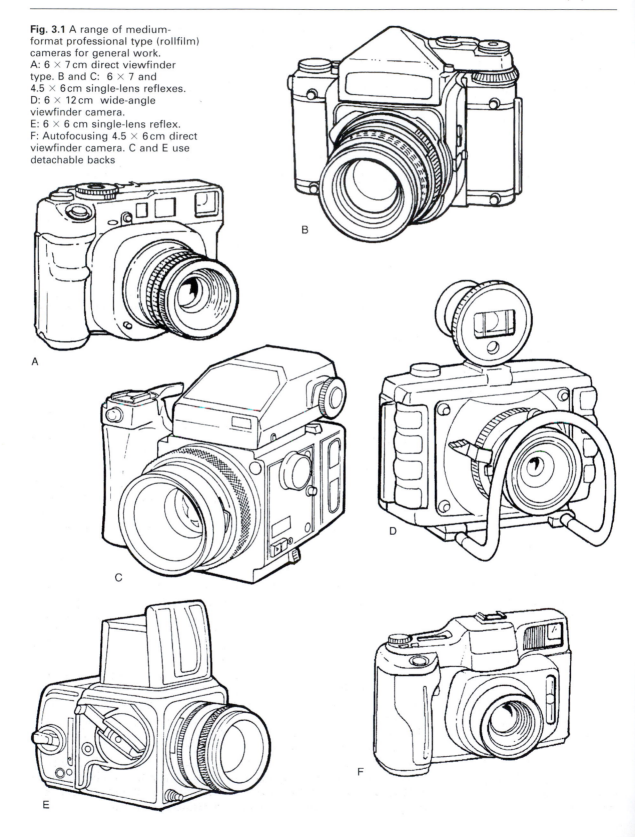

Fig. 3.1 A range of medium-format professional type (rollfilm) cameras for general work.
A: 6 × 7 cm direct viewfinder type. B and C: 6 × 7 and 4.5 × 6 cm single-lens reflexes.
D: 6 × 12 cm wide-angle viewfinder camera.
E: 6 × 6 cm single-lens reflex.
F: Autofocusing 4.5 × 6 cm direct viewfinder camera. C and E use detachable backs

Fig. 3.2 An instant-picture back, accepting packs of peel-apart material, attached to a rollfilm SLR camera in place of the film magazine. See also Figure 3.30

while an assistant is quickly emptying and reloading another, allowing fast, continuous photography. You can also shoot one scene on several different kinds of film stock by juggling backs. It's a facility which permits you to swap to an instant picture (peel-apart) back at any time during a shoot to visually check on lighting or exposure. See Figure 3.2. Many professional type rollfilm cameras will accept digital backs too, page 57.

On the debit side, if you are used to working with 35 mm the shallower depth of field given by the longer focal length lenses normal for medium formats can be an unwelcome surprise – especially when shooting close-up. Lenses also have maximum apertures one or two stops smaller than their 35 mm camera equivalents (typically, $f/2.8$ or $f/4$ for a standard focal length lens). The range of film stocks made in 120 rollfilm is also more limited, with the emphasis on professional rather than amateur emulsions.

There has been a recent downward trend in format sizes brought about by factors such as (a) silver halide emulsions with very greatly improved image resolution; and (b) the introduction of digital backs in which the complexity and cost of the (CCD) matrix light sensor increases enormously with area. Consequently scaled-down monorail view cameras, as well as shift cameras, are now made for medium format work, and accept all the appropriate backs and lenses. See Figure 3.3.

Large-format viewcamera systems

In many ways cameras 4 × 5 inch and upwards are a world apart. Photography with this type of equipment is more craft orientated, demands more elaborate preparation and encourages a more considered approach to your subject. There are fewer camera designs to choose from, and both cameras and lenses are expensive – especially the 8 × 10 inch size. Cameras often lack electronic aids completely, unless you add costly accessories. Therefore you must expect to use a separate hand-held exposure meter and calculate the exposure increase needed for bellows extension, etc. which is taken care of in other cameras by through-the-lens light measurement.

To get the most out of large-format photography you should understand and make full use of camera movements, which are offered in abundance (see *Basic Photography*, Chapter 6). Some will help you to improve depth of field, which is even shallower than with medium-format camera lenses. In any case, you must expect to stop down more and consequently require more light or longer exposures. Even maximum lens apertures average around $f/4.5$–$f/5.6$, some three to four stops slower than most 35 mm format lenses.

On the other hand, you can expect viewcamera lenses to have a much wider image circle than lenses intended always to be dead-centred on the film. For example, a good normal-angle 180 mm lens designed for 4 × 5 inches will give a circle of acceptable quality about 300 mm in diameter when focused for infinity and stopped down to $f/22$. This means that you can shift or pivot the lens until its axis is more than 70 mm off-centre if necessary for rising, cross or swing front effects before you see loss of image quality at any corner. It is a false economy to buy, say, a monorail viewcamera offering extensive movements and use it with an economy lens barely covering the format.

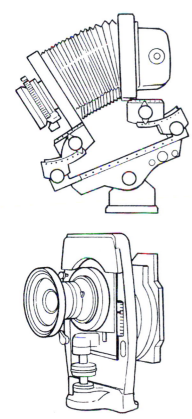

Fig. 3.3 Medium format cameras providing camera movements. Top: scaled-down monorail design accepts rollfilm magazines, instant picture or digital backs. Bottom: bellowsless wide-angle shift camera for architectural work offers rising and drop front, accepts rollfilm backs such as Figure 3.6

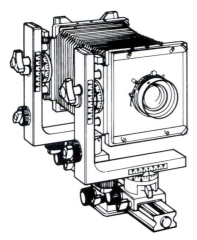

Fig. 3.4 Typical 4 × 5 inch unit-constructed monorail camera

A large-format camera is essentially a shot-by-shot instrument. You can insert a rollfilm holder instead and accept a smaller picture (Figure 3.6), but most of the time you bring to the camera single sheets of film which are later individually processed. Image resolution and tone qualities are better again than medium-format results when you make big enlargements. There is a restricted range of general-purpose films in sheet form, but this is boosted by some interesting special materials (line, lith and non-colour-sensitive emulsions, for example) not available as rollfilms. Digital backs capable of image-recording formats of this size are still extremely expensive.

To work with the relatively large focusing screen of a viewcamera is like having upside-down colour television. The equipment brings you much closer to the optical craft aspects of photography than any smaller camera, but you must understand what you are doing. Remember, too, that a 4 × 5 inch camera with a couple of good lenses can cost you over three times the price of a professional quality 35 mm three lens outfit.

Which one is best?

Clearly, no one camera will serve you well for every kind of assignment. Some give you a choice of at least two formats – a 120 rollfilm camera with a 35 mm back, for example; a 4 × 5 inch plus rollfilm back; or an 8 × 10 inch camera adapted down to 4 × 5 inches. However, the result is often an unsatisfactory compromise, with the lens too long focus and the camera unnecessarily bulky for the smaller format. Most photographers therefore opt for two camera outfits – for example, small and medium format or medium and large. Having two complementary kits means that you can exploit their advantages and minimize their individual shortcomings for the widest range of subjects. When you have made this decision go on to choose whether reflex, direct viewfinder or monorail designs (as available) will suit you best, and pick appropriate lenses.

On price, you will find that within any one category of camera the difference between cheapest and most expensive models can easily be a factor of 2 or 3 (six to eight times with 35 mm gear). Sometimes this extra cost is because the body has features utilizing the latest technology, or it is built with greater precision and finish, using much tougher components. Like hand-built cars, this lasting precision and reliability cannot really be seen unless you open up the inside.

Fig. 3.5 Catalogue data for four viewcamera wide-angle lenses. The L shape diagrams show how many millimetres you can shift the axis off-centre (for short and long sides of the film) in any direction, yet still have good coverage. Figures apply to focusing for infinity subjects. The f/4.5 90 mm lens here is far more highly corrected than the f/6.8 design, and costs over twice as much

Lens	90 mm, f/4.5		90 mm, f/6.8		155 mm, f/6.8		200 mm, f/6.8	
At aperture Diameter of image circle (mm)	f/11	f/22	f/11	f/22	f/11	f/22	f/11	f/22
	232	236	213	221	369	382	475	495
Negative: 4 × 5 in	51 → 46	54 → 48	40 → 35	45 → 40	126 → 118	133 → 125		
5 × 7 in	18 → 14	21 → 16	4 → 3	10 → 7	103 → 89	111 → 96		
8 × 10 in					41 → 34	50 → 42	106 → 94	118 → 105

Fig. **3.6** A rollfilm back fitted to a baseboard type 4 × 5 inch camera

Avoiding camera failures

Even the finest cameras are basically just machines and their users only human, so mistakes do occur from time to time. Every photographer must have occasionally lost pictures at the camera stage. The important thing is to minimize risks by setting up safety routines you follow as second nature, especially checks before and during shooting. It should be impossible for you to completely ruin any assignment through some failure of camera handling. Here are some typical hazards and suggested precautions.

Misuse of unfamiliar equipment: this is most easily done with hire cameras and lenses. Check anything complex and strange by exposing and processing a test film before using it on an important shoot.

The pre-set aperture fails to stop down within the lens of your SLR camera when you take the picture, usually due to sticky blades or a broken spring. The result is various degrees of overexposure (unless you set widest aperture). Do a quick pre-check before loading film. Set a small aperture and slow shutter speed, then notice if the diaphragm stops down by looking through the back of the open camera and pressing the release.

Your shutter fails to open, or close, or fully close. The result is no picture, or fogging and vast overexposure. Often the camera mechanism sounds abnormal, but check by looking through the back of the empty camera or make a trial exposure on instant-picture film.

Using flash, you get no image (perhaps just faint results from existing light) or, with a focal plane shutter camera, your correctly exposed flash picture only extends over about one half or one quarter of the frame. These failures are due to mis-synchronization (for example, part frames result from using fast-peaking electronic flash with a focal plane shutter at too short a shutter speed). Be wary of any camera which has an old X/M (or X/FP) switch for change of synchronization. Electronic flash fired on these M or FP flashbulb settings goes off before the shutter opens – no matter what speed is selected or whether it is a lens or focal plane shutter type. This error happens easily on a camera with a hot shoe and a sync selection switch tucked away somewhere else on the body. Pre-check by pointing the flash and empty wide-aperture camera towards a white surface in a dimly lit area. Through the open back of the camera you should briefly see the full picture area as a white shape when the shutter fires.

A run-down battery, making the camera meter erratic or non-active: this may also cause failure of the camera's electronically timed shutter and other circuitry. Always check with the battery state button when preparing for a session. Carry a spare set of batteries too, and as further back-up include a separate hand-held exposure meter. There are clearly advantages in having a camera body which, in the event of battery failure, still allows you use of at least one (*mechanically* powered) shutter speed.

Mechanical jam-up of an SLR camera: the whole unit locks solid, often with the mirror up. Some cameras offer you a reset lever or (medium formats) have some accessible screw you can turn with a small screwdriver to release the mechanism. The best precaution is to carry a spare body.

Shooting on already exposed film: this is most likely on 35 mm, 70 mm and sheet film, as regular rollfilm winds up onto a new spool, its

Fig. **3.7** Testing flash synchronization. See text

Fig. 3.8 Pre-shooting technical checks. Instant pictures give you the most information

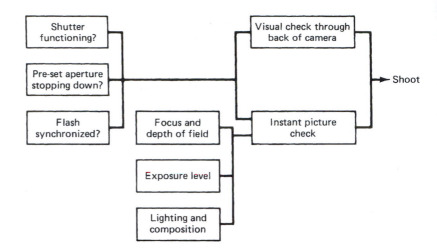

backing paper marked 'exposed'. Adopt a rigorous safety routine. Exposed 35 mm film can always be bent over at the end or rewound completely into its cassette. Each sheet film holder darkslide must be reinserted with the black top facing outwards after exposure. Seal 70 mm cassettes and all cans of bulk film with labelled tape.

35 mm film not properly taken up when loading: consequently, unknown to you, the film fails to wind on by one frame between exposures. Get into the habit of noticing, after shooting two or three frames, whether some rotation of the camera's rewind knob (or equivalent tell-tales) proves that film is actually transported inside the camera. Cameras with autoload mechanisms rarely suffer from this problem.

Out of focus due to coming too close with an autofocus camera: practise, and get used to recognizing nearest focusing distance from the way, say, a head reaches a particular size in the viewfinder.

Soft focus, and sometimes upset of the camera's whole electronic system, due to condensation on the lens and internal mechanism: if this happens on the internal glass surfaces of a direct viewfinder camera lens its effects are hidden until you see the results. Avoid bringing very cold equipment into a warm, moist atmosphere unless it is wrapped up and allowed to reach ambient temperature slowly.

Obstruction of part of the picture: the cause is usually in front of the lens (your finger, strap, lens hood or a filter holder too narrow for the lens's angle of view, etc.), especially with a direct viewfinder camera. Alternatively, it might be between lens and film (part of a rollfilm sealing tab fallen into the camera, crumpled bellows in a viewcamera used with shift movements or an SLR with its mirror not fully raised). Always glance into the camera space behind the lens as you are loading film. Fitting a hood of correct diameter will reduce the risk of something getting in front of the lens.

Remember the value of having an instant-picture back, to allow you to confirm visually that lens and body are working correctly – plus checking lighting, exposure and composition – at any time during a shoot. Some professional photographers habitually expose one instant picture at the beginning and another at the end of every assignment, as

Fig. 3.9 A negative shot with a wide-angle lens fitted with a lens hood designed for normal focal length. The more you stop down the more distinctly this 'cut-off' appears at corners

insurance. It is also a good idea to carry another complete camera (a 35 mm SLR, for example) as emergency back-up.

Special-purpose cameras

The advantage of any specialized camera is that the designer can optimize everything – lens, body, controls – to suit limited known conditions of use. However, specialization also reduces the market, so expect to find this equipment more expensive and less versatile than a regular camera.

Aerial cameras

Most small- and medium-format cameras can be successfully used from aircraft. However, for serious photography from helicopters and fixed-wing machines you will find it far easier to work with a camera specially designed for hand-held aerial use. Pictures may be needed for general environmental protection, city planning and construction reports, archaeological records, traffic studies, pictorial shots of property, etc.

Typically, an aerial camera of this kind takes medium- rather than small-format pictures because of the importance of fine detail. The camera might use double perforated 70 mm film (giving pictures 6 cm wide) spooled in 100 foot (30 metre) lengths and preloaded into interchangeable magazines. It can be supported by a wire sling from the aircraft frame – over a doorway or window frame – in an easy position for you to aim and control it with gloved hands. Simple manually set controls are large and rugged, and there is a direct vision finder (see Figure 3.10).

The camera is often electrically powered from aircraft circuits for shutter, film wind-on, camera-ready signals in the viewfinder, plus frame number data LED exposed onto the film alongside each frame. Some cameras signal their functions through an audio circuit you hear in helmet earphones. Shutter speeds may be fast only (1/500 to 1/1500 second, for example) because of the vibration and movement inherent in this work. Aerial lenses are most highly corrected for subject matter

Fig. 3.10 Front and back views of a wire-slung, electrically powered hand camera for general air-to-air or air-to-ground photography. Pictures 58 × 85 mm are shot on perforated 70 mm film, 100 ft (30 m) per magazine loading. Coloured diodes within the direct viewfinder eyepiece signal camera status

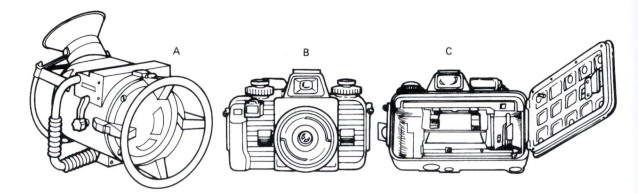

Fig. 3.11 Underwater equipment. A: heavy-duty housing for a 6 × 6 cm SLR. The domed glass port is protected by a handling ring. B and C: 35 mm camera with waterproof seals to its controls and camera back. The film plane is backed by the separate internal pressure plate

at or near infinity, and typically have a maximum aperture of about f/5.6. Quite different, larger-format aerial survey cameras are designed for map making. They use special wide-width aero rollfilm. Survey cameras are usually housed on special mounts within the belly of larger aircraft and are operated remotely.

Underwater cameras

There are two approaches to underwater equipment. First, there is a bulky underwater housing for a conventional land camera, such as a 35 mm or rollfilm SLR. Here rods attached to the main camera controls pass through the metal casing to oversize knobs on the outside. A heavy-duty housing like this is expensive but safe down to depths of around 100 metres, ample for practically all professional sub-aqua assignments. The best housings allow the lens to look through a *domed* port. Otherwise, with a flat port, you introduce curvilinear distortion as well as chromatic aberration and other refractive problems.

Alternatively, you can use a compact, direct viewfinder 35 mm camera specially designed with a waterproof metal body and lens. The camera has (watersealed) enlarged controls and viewfinder. Its lens is compounded to give best performance when it is separated from the subject by water and from the film by air. Camera seals withstand pressures down to about 50 metres, which easily covers most requirements such as natural history photography in coastal waters. (Do not confuse these underwater cameras with cheaper plastic 'fun' cameras for swimming pools and safe only to 5–8 metres.)

The lens considered normal for a small-format underwater camera has a focal length of 35 mm, which in effect gives you an angle of view of 43°. (All lenses narrow their angle of view by 30% when used in water instead of air.) Other lenses all tend to be of shorter rather than longer focal length, because you need to minimize your distance from the subject due to lack of clarity under water (see page 195). Typical maximum aperture is f/2.8 with shutter speeds between 1/30 and 1/1000 second. Most underwater camera lenses do not give satisfactory quality on land (the scale of focusing distances also alters). However, if the camera accepts a range of interchangeable lenses one of these is likely to be designed for use in non-underwater situations such as surfing and other marine sports.

Fig. 3.12 When a flat glass port is used on an underwater housing (top and centre) oblique image light is distorted. Domed port (bottom) presents the glass at right angles to all rays

Panoramic cameras

A true panoramic camera (not one just masked down to a long narrow format) scans a scene from one position by pivoting the lens or rotating the whole body during exposure. Meanwhile the film, located in a curved plane, is exposed through a slit sweeping across it just in front of the emulsion (see Figure 3.13). The effect is like viewing a scene slowly turning your head fully from side to side.

Most panoramic cameras use 35 mm film but give you a 2.5:1 image ratio, 6 cm long by a standard 24 mm high, which you can then print through a masked-down rollfilm enlarger. Typically, the camera has a 28 mm lens giving an expected 10° angle of view vertically but, because of its scanning action, 180° horizontally. Shutter speeds may range from 1/15 to 1/125 second. The lens moves more slowly at slower settings (a feature you can use to compress or expand images of very fast-moving subjects).

Image perspective is unique. Horizontal subject lines near the top and bottom of the picture reproduce curved – humped and dished, respectively (see Figure 3.14). Consequently in a scene containing a building in the background seen flat-on, the building photographs as diminishing away towards the left and right ends of the panorama. On the other hand, a curved subject – such a long group of people sitting on a concave row of chairs – reproduces as a straight line. (If you wish to counteract this distortion the final print should be curved into a concave shape and viewed from the centre of this radius. For example, correct viewing distance might be 35 cm for a print 30 cm high, being the magnification of 12.5 times the 28 mm camera lens focal length.)

Panoramic cameras can give new life to large groups, open landscapes and cityscapes. The picture proportions are interesting and dramatic, and results helpfully exaggerate depth and distance for property interiors and exteriors. Avoid including detail in the immediate foreground which will reveal distortion, unless you want this as a special effect. Miscellaneous foliage, grass or sky is acceptable, not cars or buildings. Panoramic cameras offering up to 180° generally have a direct viewfinder giving a 'wide-screen' view of what you will

Film

Fig. 3.13 Panoramic cameras for (near right) rollfilm, and (far right) 35 mm film. As shown in plan view, the lens and slit of the 35mm camera form a drum which rotates about a 150–180° horizontal field of view

Fig. 3.14 Subject shot (above) with a regular 35 mm camera and 28 mm lens, and (right) with a 35 mm panoramic camera and 28 mm lens. If you tilt a panoramic camera up or down, shapes are wildly distorted. Even when you keep it horizontal (bottom right), parallel horizontal lines in the subject reproduce curving together at each end of the picture. To see accurately, curve the page and view close

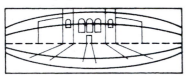

include. A few types give 360°. Here there is no viewfinder and the whole camera makes one complete rotation on a tripod while you duck below its vertical angle of view. You have to print the resulting negatives in sections, in a conventional masked-down large-format enlarger. Alternatively you can use a special scanning type enlarger which slowly tracks the long negative through the carrier while paper in a roll holder (Figure 10.32) on the baseboard moves in the opposite direction below an exposing slit. Seamless panoramic prints 10 metres long can be made in this way.

Stereo imaging equipment

Stereo cameras are really *pairs* of cameras with matched lenses and linked shutters and diaphragms. They exploit the fact that when you view a three-dimensional scene through a pair of eyes (binocular vision) parallax difference between the two viewpoints makes foreground objects appear in front of different parts of the background. To some extent you 'see around' close objects. For example, hold your thumb up about 30 cm away. Then, without moving your head, notice where the thumb coincides with some distant wall detail, just using left then right eye. This parallax difference (so much a problem with twin-lens reflex cameras) is one of the main ways in which we sense three-dimensional depth and distance. (The other clues tend to be differences in scale, tone, focus and in the greater image shift of near objects relative to distant ones when you move your head.)

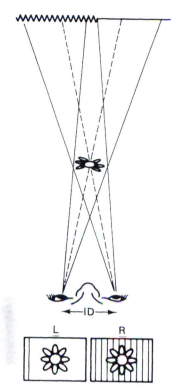

Fig. 3.15 Binocular vision. Because of the interocular distance (ID) between your two eyes, a close subject is seen in front of a different part of the far background by each eye. This gives you a visual sense of depth and distance

The two halves of a stereo camera have their lens centres about 65 mm apart, matching the average separation or *interocular distance* between a pair of human eyes. This also leaves room for a direct viewfinder between the two. Pictures are exposed in pairs onto 35 mm film, each one being half-frame or 24 mm square format. Frames are often interleaved (see Figure 3.17) and so must be sorted and paired up after processing. Alternatively just pair up two regular cameras (35 mm SLRs, for example). Paired cameras are best used with electric releases, wired in parallel to synchronize shutters and so work with flash or shoot moving subjects. Motorwind is also a helpful feature.

Another approach is to use a *stereo attachment*, a mirror box which fits over a regular camera's standard lens, like a lens hood. It splits the usual horizontal format picture into a stereo pair of upright half-format pictures. Inside, four front-silvered mirrors redirect the light (Figure 3.16C) so that your pictures are taken with viewpoints 65 mm apart. The attachment is best used on a single-lens reflex camera, where you can see the effect on the focusing screen. Results (usually on 35 mm slide film) can be seen in three dimensions, using a hand-viewer of similar design or by projection methods discussed overleaf. A quite different stereo attachment takes the form of a sliding bracket fitted between tripod and regular camera. It is designed for making stereo pairs of relatively static subjects – you take one full-frame picture then slide the whole camera quickly 65 mm to one side before taking another.

Viewing results

To view each pair of photographs (*stereograms*) and make them appear as a single three-dimensional picture it is essential that left- and right-

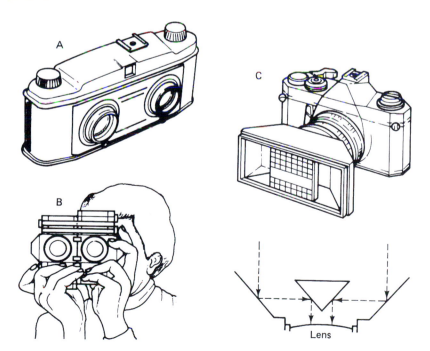

Fig. 3.16 Methods of shooting stereo pairs. A: 35 mm direct viewfinder stereocamera, having 65 mm lens separation. Few cameras like this are now made. B: lash-up using two regular SLR cameras. Both shutters are released together. C: mirror box stereo attachment. This gives two half-frames side-by-side within each normal 35 mm format; see Figure 3.17

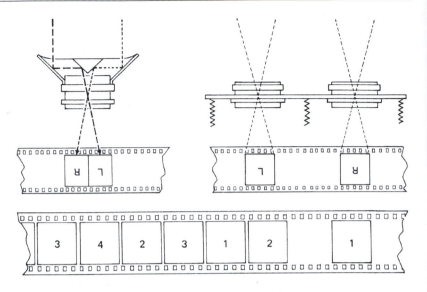

Fig. 3.17 How stereo pairs record on 35 mm film. A beamsplitter attachment exposes half-frame pictures within the regular format. Left- and right-hand versions are correctly located when you turn pictures correct way up. But (far right) when you use a stereocamera, half-frame images record with two spaces between them. This is filled in with parts of other pairs, to save film. Your film winds on by two half-frames each time, interlinking pairs as shown below

Fig. 3.18 Hand-viewers for stereo images. Top: viewer for 35 mm half-frame slide pairs, using a mirror box system similar to the type for shooting (Figure 3.16). Bottom: simple type for viewing medium-format contact prints or transparencies

hand versions are seen by your left and right eyes, respectively. You can do this with a hand viewer for slides (Figure 3.18) or for prints. Alternatively, you can project slides using two projectors to give offset images in the same screen, then give your audience spectacles which permit each eye to see one image only. As Figure 3.19 shows, you can achieve this by fitting left or right projectors with colour filters, picking any two hues well separated in the spectrum such as deep green and red. Spectacles matching these colours allow the correct image to be seen by each eye, although the result, even from colour slides, is a kind of monochrome. Alternatively, use pairs of linear polarizing filters orientated orthogonally to each other for the projectors and have matching glasses. This arrangement allows you to show stereo colour slides in full colours, but your screen must have a metallized (silver) surface so that polarization is unaltered when image light reaches the audience.

Yet another way of showing three-dimensional results is by a special parallax stereogram print (Figure 3.20). This works without needing spectacles at all but is more suited to mass production. A lenticular screen made of clear moulded plastic must form the print's top surface. It works on the principle that beneath the screen left- and right-hand images are split into alternative strips, best achieved by photo-mechanical printing methods. The results are more crude than by other viewing methods.

Stereophotography is useful wherever three-dimensional information is needed – for measurement, training and education or simply for pictorial effect. It is an important aspect of aerial survey photography, where it allows you to observe the relative heights of buildings and the general terrain. Subject matter below a flying aircraft is almost always too far away for a pair of eyes only 65 mm apart to give you stereoscopic vision direct (the limit is about 60 metres), so stereo pictures are taken using much greater separation. This is easy to do, by using a single camera and taking two shots one after the other, allowing time for the aircraft to fly a predetermined level distance between the exposures. Typically, separation equal to one fiftieth of the height above ground level gives a three-dimensional effect equivalent to something

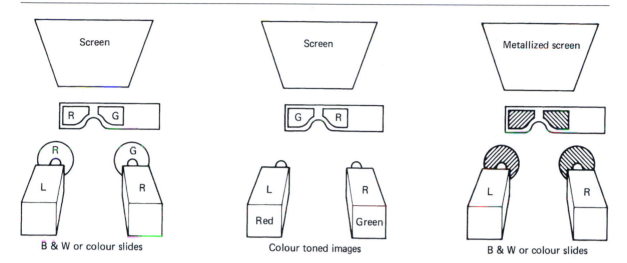

Fig. 3.19 Ways of projecting pairs of stereo images, with results encoded so that (looking through spectacles) each eye only sees its correct left- or right-hand taken picture. Left: deep colour filters over projectors; results look monochrome, even if slides are colour. Centre: black and white images colour toned; results are monochrome. Right: the best arrangement, using correctly orientated polarizing filters and metallized screen; images can appear in full colour

just over 3 metres away viewed direct with two eyes. This expanded separation technique is known as *hyperstereoscopy*.

The opposite technique – reduced separation or *hypostereoscopy* – is used with very close subjects. This time, normal 65 mm separation gives such extreme parallax difference that your eyes cannot fuse results into one three-dimensional image. For larger than life size images you work instead using a separation of 65 mm divided by magnification. If you are shooting still lifes you can use one camera and side-shift either subject or camera the required distance between pictures. (*Note*: Shifting the subject alone results in background detail appearing two dimensional, so it is best to use a plain ground.)

Specialized accessories

You can choose from a very large range of camera accessories. Many are unnecessary and gimmicky, but some of the more specialized add-ons allow you to interface cameras with completely different kinds of technology.

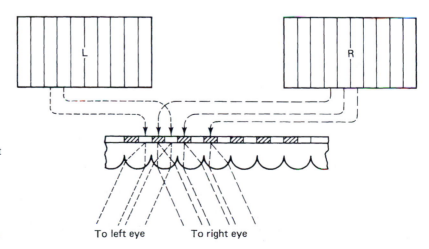

Fig. 3.20 Parallax stereogram print made up from narrow alternate strips of left- and right-hand images. The embossed plastic lenticular screen over the front ensures that (at average viewing distance) each eye only sees strips making up its correct image

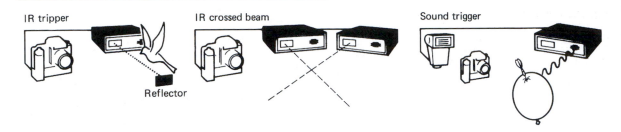

IR tripper IR crossed beam Sound trigger

Reflector

Fig. 3.21 Remote triggers. Left: breaking an invisible infra-red beam projected and reflected across the path of some event. Centre: two IR beams angled to correspond to one point in space. Only an object breaking the beams here triggers the camera. Right: ultra-high speed flash triggered by sound detection

Optical adaptors

Most 35 mm SLR camera systems include different adaptor rings which allow the camera body to fit over the eyepiece end of a microscope, telescope, medical endoscope, etc. Due to reflex design you can still accurately frame-up, focus and measure exposure whatever optical device is fitted. In fact the camera becomes a film-containing back for the other device. Similarly, you can use a cowl type adaptor to centre camera plus macro lens over a flat-faced cathode ray tube and so record computer graphics or television image displays. Camera, cowl and tube may be part of a copying unit which electronically synchronizes one or more slow high-resolution frame scans with a suitable shutter hold-open period. This can be a low cost alternative to a fully-fledged digital film recorder (page 257).

Camera triggers

You can buy electronic sensor units which trigger your camera in response to light, sound, radio or infra-red radiation. Normally, you wire one of these devices to a small- or medium-format camera having electric release sockets plus motor-drive so that any number of pictures can be taken remotely. The camera might be set up in some inaccessible position, such as under a jump on a racecourse, and then fired when you transmit an infra-red or radio pulse from the safety of the track-side. For natural history photography you can mount the camera in some hidden location, its shutter triggered automatically when your subject breaks the path of an infra-red beam projected out of the trigger box itself (see Figure 3.21). This works equally well day or night.

With high-speed analytical work, a sudden happening – a spark or one object striking another, for instance – can trigger events via a light or sound sensor or by breaking a strategically placed beam. Here you can set up the camera in a darkened studio with the shutter locked open and using the trigger to fire an ultra-short duration flash. Most trigger units allow you to tune their level of sensitivity to suit ambient conditions, sound or light. You can also dial in a chosen delay (milliseconds or microseconds) between sensing and firing to capture the event a little after trigger activation.

Fig. 3.22 Instant-picture back for a 35 mm SLR camera. A physical gap has to be bridged between the focal plane inside the camera and the more distant light-sensitive surface in the pack. A 35 mm format fibre-optic block in the regular film position receives the lens image at the front, and directs light through to its back surface in contact with the emulsion. See also Figure 3.2

Instant-picture adaptors

Instant-picture adaptors for 'self-developing' film are made to fit most professional type small-, medium- and large-format cameras, provided they have detachable backs. Peel-apart instant-picture material (page 100) is necessary, otherwise your result is laterally reversed. Small- and medium-format cameras only use film in pack form – two

Fig. 3.23 Programming/data-imprinting back for 35 mm SLR. B: additional battery compartment. D: LCD panel displays your keyed-in exposure programme, number of frames, what data will be printed on film etc. K: data-setting keys

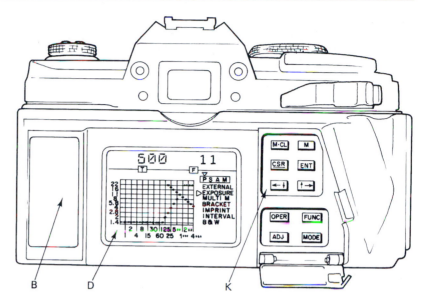

35 mm pictures can be exposed side by side on one sheet if the back adaptor incorporates a slide-over device. Large-format cameras can use either packs or individual pull-apart sheets in envelopes which push into a back inserted into the camera like a darkside. Backs for instant-picture sheets also accept some regular sheet films in envelopes. This is useful if you do not want to keep changing from an instant-picture adaptor to film holders. Instant pictures are not only invaluable for previewing results and checking equipment, but your instant colour print will probably be good enough to scan direct into a digital system via a flat-bed scanner. See also Figure 4.24.

Programming and data backs

Most advanced 35 mm (and some medium-format) camera systems allow you to replace the regular camera back with a dedicated program or data back. The substitute back is considerably thicker and carries electronic keys and a battery compartment. It extends the camera's electronic facilities in various ways. For instance, some backs for motor-driven cameras allow you to program autobracketing – a quick series of frames each shot at a different level of exposure such as half, one or two stops' progression. The same back may also act as an 'intervalometer', so that you can trigger pictures at intervals of seconds, minutes or hours, and preset the total number of frames to be shot.

Usually the inside face of the back carries a printing panel of low intensity LEDs to expose characters and figures through the base of your film, alongside or just within each frame. (The diode brightens or dims by varying its pulse rate to suit the slow or fast ISO speed set for the film.) This feature allows you to program in date, time, frame number, etc., or the camera can automatically imprint the aperture and shutter settings it made for each picture. A good programming/data back is expensive but invaluable for various kinds of record photography, especially time-lapse and surveillance work. It frees you from tedious logging of notes.

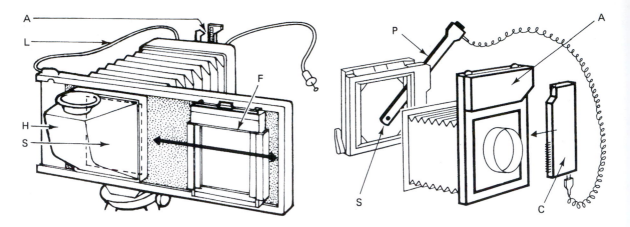

Fig. 3.24 Special viewcamera
accessories. Left: time-saving
sliding back arrangement. A:
aperture setting indicator. L: link
holds bladed shutter open when
focusing screen (S) and reflex
hood (H) are aligned with lens. F:
film holder, with darkslide facing
camera already removed. See
text.

Right: TTL exposure-metering
equipment. Probe (P) has a spot
reading tip (S) you can move to
measure any chosen area on the
lens side of the focusing screen.
C: control unit for setting film
speed, etc. A: electronic bladed
shutter which operates with all
lenses

Special viewcamera backs

One or two specialist back accessories are made for viewcameras
principally 4 × 5 inches. They are mostly designed to make the camera
quicker and more convenient to use. For example, a sliding back
reduces the delay between composing and exposing. Simple rails allow
you to rapidly exchange focusing screen for film holder (Figure 3.24)
or digital back. Meanwhile, the shutter is closed and set en route by an
electrical or mechanical link between the front and back of the camera.
Working in reverse, the shutter locks open when you return the focusing
screen.

Other replacement viewcamera backs accept a spot meter probe. This
measures image light reaching the focusing screen from the lens and
can program an electronic bladed shutter to give you aperture-priority
exposure control. Other forms of exposure program are unsuitable for
viewcamera photography because the subject itself and movements
mostly determine what aperture you should set. Elaborate 'add-on'
items for viewcameras are manufactured in quite small numbers, which
makes them expensive. Some more than double the cost of an outfit. So
although extras make your camera quicker and more convenient to use
they may not be justified unless you use large-format equipment most
of the time.

Digital imaging cameras and backs

Photography is steadily changing to include electronic as well as chem-
ical methods of recording the image in the camera. Instead of exposing
onto silver halide coated film, digital cameras (or digital backs attachable
to conventional cameras) contain a light-sensitive charge coupled device
known as a CCD sensor. CCDs are composed of thousands or millions of
minute electronic elements, usually grouped as a matrix – a rectangular
or square block, like a frame of film. After the camera lens has delivered
an exposure in the normal way the CCD downloads the image to create a
stream of related digits forming a 'file' (see Figures 5.19 and 5.20).

Image files can be recorded electronically in a number of ways: for
example, within a flat storage 'card' you insert into the camera; onto a
hard disk drive cabled to the camera and which may be located within
a computer; or held in an internal memory device permanently housed

in the camera. Files will play out as visual images on a computer monitor screen; also on a liquid crystal display (LCD) panel at the back of the camera, see Figure 3.26. They can be fed to a printer (page 285) which is able to produce an ink or dye print on ordinary paper, or expose your image by light onto silver halide film or colour paper.

Digital image quality and resolution are primarily determined by your equipment – the number of pixels or PIcture ELementS in its matrix CCD, although further influenced by the use of 'interpolation' software and 'bit depth', see page 105. Appearance also depends on the equipment and size you choose to output your final image, and you should plan for this from the start. The most advanced and expensive CCDs can give colour prints 16 × 20 inches in size indistinguishable from the silver halide route. But using a coarser CCD matrix the consequently smaller image file it delivers is easily over-enlarged, forming 'Legoland' pictures which reveal their square pixel structures. On the other hand, the larger the digital image file (file size is measured in megabytes or Mb) the longer it takes to transfer complete images from one terminal to another – for example, from camera memory device to computer, or computer to printer.

Digital imaging camera equipment falls into three main types:

1. Specially designed compact type cameras for point-and-shoot snapshots, or use as a computer peripheral.
2. Professional small-format SLR cameras of existing pattern, retaining their same 'front-end' features, but permanently housing a CCD in place of film.
3. High resolution digital backs which you simply attach and detach from your present medium- or large-format camera in the same way as a conventional rollfilm magazine or sheet film holder.

Fig 3.25 CCD sensor (as seen from the lens position) permanently housed in the focal plane of a 35 mm camera in place of film. CCD Matrix used here is smaller than full 35 mm format to reduce cost. This calls for a change of focal length, see Figure 3.28

Compacts and computer peripheral cameras

These are lowest cost consumer market cameras, often housing a tiny 0.3 inch matrix CCD with between about 300 000 (640 × 480) and 800 000 pixels resolution. A small LCD panel on the camera back displays your recorded result immediately after shooting, so you can erase unsuccessful images and reuse the released 'film' space. The display panel may also show a grid of miniatures, nine at a time, of the pictures you have already taken. Cameras accumulate up to 80 pictures on a SmartMedia, or Compact Flash card, and still more on a standard PCMCIA (PC Memory Card International Association) card. Being non-light sensitive, you can remove your card at any time and transfer it into the card slot of your office or laptop computer or printer. Alternatively the camera is cabled direct into the computer, or 'docks' into a cradle connected to the computer, to download pictures. See Figure 3.27. Beyond amateur snaps these cameras are useful for capturing record pictures to incorporate in PC generated documents (reports, for example). Image resolution is acceptable in prints up to about 4 × 6 inches.

Small-format, hybrid SLRs

It makes good sense to build a CCD into an existing professional 35 mm SLR body (for example, Nikon) as this can then utilize the host

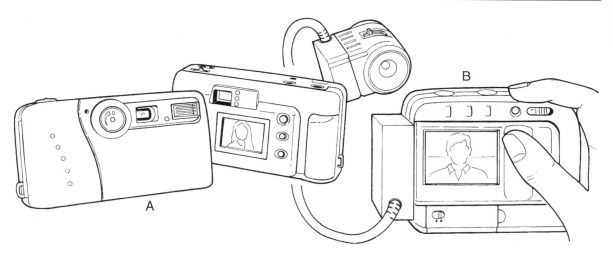

Fig 3.26 Digital compact cameras (1997). A: front and rear of camera type using 1.8 inch LCD on back to display exposed pictures. B: camera with detachable unit containing lens plus CCD sensor unit wired to the body or mounted on it. Here the LCD playback panel also acts as viewfinder

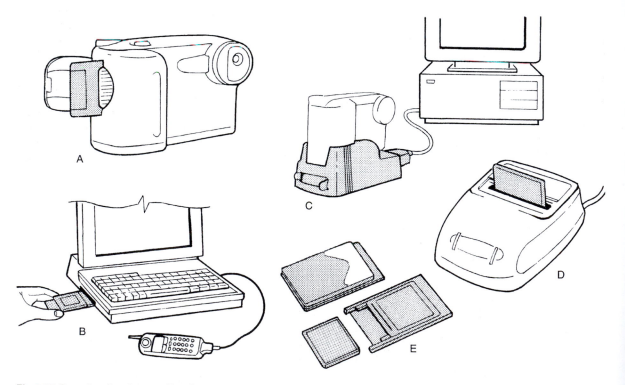

Fig 3.27 Downloading image files from digital compacts. A: Fuji-originated 'SmartMedia' 4 Mb miniature memory card storing 80 pictures is removed from camera. B: when inserted via PC card adaptor, images appear on lap-top computer, also transmitted elsewhere by digital radiophone. Alternatively camera reads out direct to computer through docking cradle (C) or plug-in cable. D: Compact Flash card reader, wired to computer. E: PC card containing 260 Mb hard disk, and Compact Flash card with PC adaptor

Fig 3.28 If the fitted light-sensitive chip is smaller than the camera's film format it replaces, then a shorter focal length lens will be needed to maintain the same angle of view. Top: 70 mm lens used on full 35 mm format gives 35°. Bottom: a 28 mm lens is required for this smaller size chip to give matching picture content. Wide angle shots demand exceptionally short focal length lenses

Fig 3.29 Higher resolution digital cameras, utilising versions of existing 35 SLR film camera systems. A: contains a single multifiltered CCD matrix. (see Figure 5.19) housed in previous film plane. B: in this extended body beam-splitters behind the lens (C) record on three matrixes separately filtered R, G and B. Both cameras take each picture with a 'one-shot' exposure

camera's sophisticated systems of exposure metering, etc., and most of its range of lenses and accessories. The CCD chip is larger than for point-and-shoot compacts (although still often smaller than full 35 mm format, see Figure 3.25) and may offer 6 million or more pixels. Cameras with this performance are costly and mostly intended for professional press and journalistic work such as sports photography, where it is vital to supply images to meet newspaper edition deadlines. Most often the camera uses a slip-in PCMCIA card as its storage medium, which can download through a laptop PC, modem and radiophone direct back to the picture editor's desk, just a few minutes after the action.

Camera-attachable digital backs

For highest quality digital images intended for big prints you need larger file sizes. This is made possible by fitting a digital back to a rollfilm SLR or viewcamera, see Figure 3.30. A 6 × 6 cm size matrix CCD back provides 16 million (4000 × 4000) pixels. Attached to a Hasselblad in place of its clip-on film magazine, the back delivers each picture as a 48 megabyte file – through cable to either a computer in the studio or a battery powered hard disk drive mounted on your belt when working on location.

All the digital devices described so far work 'one-shot', using a single exposure (and so allowing use of flash). But for still higher resolution at slightly less cost some backs use a 'three-shot' principle. You make a sequence of three separate exposures, one through each of red, green and blue filters changed on the front of the camera lens. The three digital files then combine to form one high resolution image.

Other digital backs use a *scanning* approach, by which a narrow bar or 'linear array' of sensors physically tracks across the camera image plane throughout an exposure which may run into minutes. See Figure 5.25. In this way a full colour image of many millions of pixels is built up line by line to give image files of 140 Mb and over. A linear array back is cheaper to purchase than a matrix version, but in common with most three-shot systems your camera and subject must remain absolutely still throughout exposures lasting up to several minutes. You

A B C

Fig 3.30 Attachable digital backs for medium and large format film cameras. Near right: scanning back fits 4 × 5 in cameras like a sheet film holder. Bottom right: scan back for rollfilm SLR, showing triple linear array tracking across focal plane (see also Figure 5.25). Top right: one-shot back interchangeable with regular 6 × 6 cm SLR film magazine. (A) flash socket. (B) socket for cable to computer/image store. (C) Power supply

cannot shoot with flash, and using tungsten illumination you must avoid any lighting intensity variations (such as minor flickering) because this will show up as a band across the picture.

Comparing digital and silver halide camera equipment

Advantages of digital:

● You get an immediate visual check on results (for example, displayed on a large studio monitor screen).
● No film or lab costs, or liquid processing in darkrooms.
● You can erase images, and reuse file storage, on the spot.
● Colour sensitivity is adjustable to suit the colour temperature of your lighting.
● Camera images can be transmitted elsewhere rapidly by wire or by radio.
● Digital image files can feed direct into a designer's layout computer – ideal for high volume work for catalogues, etc.
● Extensive ability to alter/improve images post-shooting. See pages 170 and 284.
● Silent operation.

Disadvantages of digital:

● Much higher cost of equipment; this includes powerful computing back-up with extensive file capacity (RAM) necessary for high resolution work. Unless you have a powerful computer high resolution image readout and manipulation is slow.
● Silver halide film still offers excellent image resolution at low cost – roughly equivalent to 3 billion pixels for every square centimetre of emulsion. Also colour prints, particularly in runs, work out much cheaper by traditional neg/pos chemical methods. See Chapter 10.
● The limits to final acceptable image size are highly influenced by the number of pixels per inch the camera CCD codes within a file. So when planning a large final print you must start with a camera delivering sufficient pixels.

● High resolution systems based on scanning or taking three separate exposures are limited to still-life subjects. (And for this reason will eventually become redundant.)
● Cameras with CCD sensors, like computers, are adversely affected by heat (i.e. from tungsten lamps).

Digital cameras and digital technology generally are still developing. Several of the above factors are bound to change as new advances are made. See also page 258.

Summary: Camera equipment

● Using 35 mm camera equipment you gain the benefit of latest technology at competitive prices. However, equipment may be either too automated or offer excessive options which get in the way. Consider manual override to be essential.
● Medium-format cameras offer a sensible compromise between equipment mobility and final image quality. As well as SLR and direct viewfinder types, shift cameras and monorail designs are made for rollfilm format. Often they allow use of interchangeable film magazines, instant picture and digital backs. However, equipment is expensive, and has a smaller range of lenses than 35 mm. Using this format also means less depth of field and narrower choice of film stock.
● Large-format viewcameras demand a slower, more craft-knowledge-able approach. They tend to be expensive, yet basic. The range of lenses is limited, with relatively small maximum apertures, but most often give excellent coverage to allow you to utilize comprehensive movements for architectural, still-life and technical subject matter. You can shoot and process pictures individually, and their size means that large prints show unique detail and tonal qualities.
● It is vital to have reliable camera technique – get into the habit of routine precautionary checks before and during shooting. Look through the back of the empty camera to see that the shutter, aperture and flash work and that there are no obstructions. Take an instant-picture shot before and after a session. Carry a spare body or some back-up camera; an exposure meter; spare batteries – plus a screwdriver.
● Aerial cameras for hand-held use are rugged, have a direct-vision finder and mostly use 70 mm magazines. Lenses are corrected for distant subjects. The shutter offers no slow speeds.
● For underwater photography fit an underwater housing around a regular camera or, for shallower depths, use a waterproof 35 mm compact. The latter needs lenses designed for underwater work, shorter in focal length than lenses for land cameras.
● Panoramic cameras scan a wide area of scene, using a pivoting lens and a moving slit in front of the film. Resulting dramatic perspective is unique – straight lines in the subject matter may record curved; concave shapes appear straight. Some cameras rotate 360°, giving a total horizontal record of surroundings. Uses include large groups, real estate and land-survey applications.
● Stereo cameras take pictures in pairs, with viewpoints normally 65 mm apart. However, by using a regular camera and shifting the camera or subject between exposures you can give greater (hyper)

Fig 3.31 Digital backs using the 'three shot' principle need a (motorized) tri-colour filter turret fitted to camera lens, or use one liquid crystal filter which alters colour. Changes are triggered by digital back circuitry

separation for aerial surveys or less (hypo) separation for very close subjects. Stereo attachments for normal lens cameras split each shot into half-frame stereo pairs.

● Pairs of pictures are combined by your two eyes as one three-dimensional image, using a hand viewer or twin projectors with appropriate viewing glasses. Stereo images can be mass produced as parallax stereograms, faced with a lenticular screen. Stereo photography is used for measurement, heightened realism, or pictorial effect.

● Specialized accessories include adaptors to join your (35 mm) camera body to a microscope, telescope, CRT copying unit, medical endoscope, etc. Camera triggers work by responding to light, sound, infra-red or radio signal, with built-in control over time delay. Instant-picture backs allow most advanced cameras to use pack or single-sheet materials.

● Program/data backs extend 35 mm camera electronics. Use them to imprint identification, exposure and time data alongside record photographs; also take pictures at programmed intervals, shoot bracketed sequences.

● Specialist backs for viewcameras allow fast focusing screen/filmholder exchange; and contain TTL metering linked to the shutter for aperture priority exposure control.

● Digital cameras and backs house CCDs in place of film. Most often matrices formed of hundreds of thousands of pixels, they download the camera image as a digital file to an internal memory, storage card, or hard disk usually computer-housed. The picture may display on a camera panel or computer monitor, and print out by inkjet, silver halide and other means.

● More pixels mean better resolution and colour, and larger final prints without pixels growing visible, although each image takes up a larger file. Large files (10 megabytes or more per picture) need larger memory files, take longer to transfer images, for example to build up a full monitor image or transmit by telephone.

● Digital cameras include computer peripheral snapshot types with image display panel, and rejigged 35 mm professional SLRs. Image files are stored internally or on a slot-in SmartMedia or similar card, or cabled direct to computer. Digital backs attach to medium-format SLR and viewcameras.

● Most digital back systems use a matrix type CCD allowing 'one-shot' exposures, but three-shot and scanning backs offer advantages of higher resolution at less cost. Most restrict you to still-life work, however.

● Top-end digital cameras can deliver results fully the equal of equipment using silver halide materials; capital cost is far higher, although reducing every year.

4
Films – types and technical data

It makes good sense to work with a limited range of well-chosen films. You get to know their performance intimately – what each can contribute to your particular style of picture, its response to different subject situations and, when necessary, just how far you can abuse the film before results become unacceptable. However, you must still pick your materials in the first place and keep an eye on interesting new products as they come onto the market. It would also be a pity not to explore some of the lesser-known films worth experimenting with for their special qualities and effects.

This chapter discusses, in an unbiased way, the practical points you should consider when choosing film. A section on reading manufacturers' data explains how products are described and compared by the graphs and tables which appear in technical information sheets. Finally, there is a review of some special-purpose films, selected for their unusual results or usefulness for solving special tasks.

Designing today's films

Early photographers were more chemists than artists. In the 1850s they had to take darkroom tents everywhere, primitively coating sheet glass with light-sensitive silver compounds just before exposure and development. However, these 'wet plates' were followed by gelatin + silver halide emulsions which could be prepared in advance, and so opened up photographic material manufacturing from about 1876. One by one, other barriers were overcome through emulsion research by chemists and manufacturers – glass was replaced by roll-up film; speed was increased over a thousandfold; response to only blue wavelengths was extended to the full spectrum. The last opened the way to practical films for colour photography (slides 1935 and negative/positive around 1942).

Throughout this evolution there was always something of a 'knack' to emulsion making – skills not unlike cooking, passed down from one generation to the next. In more recent times the very large investment in research and development applied to light-sensitive systems plus

advances in technology generally have brought much greater mastery of production. A kind of creative chemistry has evolved (typified by Dr Edwin Land's introduction of instant-picture colour materials in 1963). Emulsion chemists today are able to 'fine-tune' film performance, due to a better fundamental understanding of how an emulsion behaves when an image is focused on it in the camera. Manufacturers now have unprecedented control over crystal structuring and complex multilayer coating of film.

At this, the end of the twentieth century, *electronic* image recording is gaining ground as a viable alternative to *chemical* photography. Film manufacturers, however, remain extremely active, targeting and upgrading every practical aspect of silver halide materials. Their main aims are to further improve light sensitivity, definition, colour rendition, convenience and stability, and minimize increases in cost. Several of these requirements are traditionally conflicting. For example, it is difficult to increase ISO speed without, at the same time, reducing ability to resolve detail and record subtleties of tone and colour. Sheer film speed has always been an attraction, and gives definitive figures which everyone understands. They also read well in sales material. However, today, unless you must have ultimate speed for some specialist application, very fast films create problems in general photography. For example, it becomes awkward to shoot pictures with shallow depth of field and/or blurred movement. Also the larger grains and thicker emulsion coating, traditionally needed for extra light-sensitivity, deprive you of fine detail.

Manufacturers now give equal, or greater, importance to improving image qualities within their existing speed range of films. One way to

Fig. 4.1 Requirements for film to offer good image resolution, light-sensitivity, and freedom from grain all pull in different directions. Triangles here represent four films of differing speeds. Gains in one direction inevitably result in losses in another

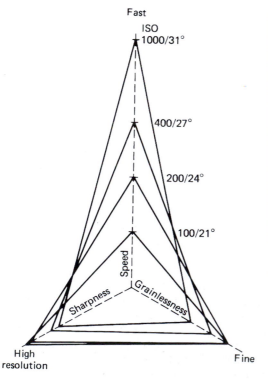

Fig. 4.2. Above: thin, tabular-shaped film emulsion silver halide grains, magnified about × 10 000. Unlike traditional flat-sided crystals these are thinner and have ruffled surfaces to increase area. The result is a better trade-off between speed and resolution. Courtesy Kodak Ltd

do this is by advanced chemical engineering, i.e. preventing silver halide crystals from growing into their normal smooth symmetrical shapes so that they form flat 'tabular' crystals with a ruffled surface texture instead. Both changes greatly increase the total surface area presented to the image light (ruffling alone more than doubles the area of a smooth crystal). Since the new crystal shapes lie flatter in the coated film, emulsions can be thinner, giving less image diffusion, improving sharpness and using less silver without loss of film speed. In other words, emulsion efficiency is improved all round.

Colour films now have better colour rendering and visual sharpness achieved by incorporating chemical 'inhibitors' (see DIR, page 98) which increase the contrast and the saturation of dominant colours without making neutral grey tones unacceptably harsh. The result is rich colour but without the sacrifice of shadow and/or highlight detail you would expect if just contrast was boosted. Changes of this kind aim to increase the main advantages of chemical recording over electronic recording – namely its excellent image detail, colour and tone range, especially when these are related to cost.

General points in choosing films

There is considerable competition between the four or five main manufacturers to capture larger shares of the world's photographic film market. At any one point in time some new (patented) development in chemistry or manufacturing technique pulls one brand ahead of another, only to be overtaken in turn by another competitor a year or so later. Whether you are choosing from existing films or assessing a newcomer, bear in mind each of the following aspects:

Accuracy; speed; exposure and colour latitude; suitability for slides and transparencies or prints; image dye stability; grain and resolution.

Accuracy

Slides (for projection) and transparencies (larger-format reversal film) on slow material remain unbeatable for resolution of detail and luminosity of colour. A projected slide in a properly blacked-out room (with no extraneous light to grey-up shadow detail) can give highlights four hundred times brighter than shadows. This is about four times the range of a print, which is severely limited by the percentage reflectance of its paper base and maximum absorption of light by its darkest dyes. The result is that often colour prints from colour negatives tend to lack the sparkle of a colour slide. For example, specular highlights merge with diffuse ones – a water droplet on a white flower petal becomes more difficult to pick out.

Publishers still prefer you to present colour work in slide or transparency form because the image has only been through a lens once. Results are closer to the original scene. However, you must also be that much more accurate with lighting, composition and exposure at the camera stage. Monochrome reproduction procedures, on the other hand, favour prints from black and white negatives, and this also gives you plenty of scope for control through cropping, choice of paper grades, shading and printing-in.

No good modern colour film can really be said to be more 'accurate' than another. The different dyes used are patented by manufacturers and used in slightly varied mixtures to reproduce image colours according to the colour response of each emulsion layer (pages 95 and 98). Beyond a certain point the feeling for accuracy is subjective. Some Asian manufacturers and users put a premium on brilliance of greens, while in North America consumers accept a 'cooler' bias, with greater richness of blues preferred. These differences are not easy to see in isolation, but show up clearly if you are unwise enough to shoot an assignment using a mixture of film brands. In order to avoid professional photographers opting for a rival brand just to obtain subtle colour variations, some manufacturers now offer two or three different versions of a film such as Ektachrome. They may all match in speed but one gives slightly warmer, more flattering skin tones, another more neutral hues well suited to fashion garments, and so on.

Speed

In general, grain pattern and loss of colour saturation grow worse with increase in ISO speed. The deterioration shows up more in fast colour slide materials than when colour negatives on film of an equivalent speed are printed. Overexposure of negatives and push-processing of all films both tend to increase graininess. However, fast slide and fast black and white negative films can be push-processed most successfully for extra speed because they have lower inherent contrast. Slower films tend to respond with excessively contrasty images, and (with certain exceptions) colour negative films should not be pushed at all. See *crossed curves*, Figure 9.3. Remember that manufacturers' speed figures are not sacrosanct. Use them as recommendations – they assume average subjects and lighting, standard processing and results which show maximum accuracy of tone and colour. Your own conditions and needs will sometimes be different. You must then decide from your own experience whether particular materials will perform better for you up- or down-rated.

Exposure and colour-temperature latitude

Exposure latitude depends greatly on subject brightness range, being least with contrasty scenes and greatest with soft, flat lighting. Having said this, slides and transparencies are least tolerant of wrong exposure, and black and white negatives offer greatest exposure latitude. Reversal colour films for slides and transparencies tolerate up to about half a stop overexposure or one stop underexposure. Colour negative films expand this latitude to one stop underexposure and two stops overexposure. However, most experienced photographers deliberately overexpose colour negatives by one stop, maintaining that they get optimum results. Latitude is considered two stops in each direction.

Colour negatives are also much more tolerant of wrong or mixed colour temperature subject lighting than reversal materials, but do not overdo it – underexposure or overexposure of one colour recording layer inevitably narrows the subject brightness range that your film can accurately reproduce (Figure 4.4). Nevertheless, colour negative films are a better choice if you are shooting under varying or mixed lighting,

and they give you an extra safety margin taking available-light pictures in situations where the illumination is unknown.

With black and white material one and a half stops underexposure and two stops overexposure are about the outside limits for fast and medium speed film. Exposure latitude is slightly less with slow films because they are more contrasty. Even this amount of overexposure is undesirable with 35 mm or smaller images because you start losing resolution through light spread, and 'solid' highlight detail in the negative demands contrasty printing paper which exaggerates grain.

Films for slides and display transparencies

When final results have to be projectable slides the obvious and best choice is 35 mm reversal film – if possible running off additional original exposures if more than one copy is needed. For extra copies later you can print off an original slide onto 35 mm low contrast duplicating stock (page 83). As an alternative you could shoot on colour negative stock and print onto print film. Both routes allow some adjustments of colour filtration and lightening of density through exposure, either overall or locally by shading. Best-quality mono-chrome slides result from 35 mm instant-picture film or black and white reversal film (alternatively slow general-purpose film given reversal processing, see *Basic Photography*). Results almost as good are possible by shooting on regular monochrome film and printing negatives (1:1 through the enlarger) onto 35 mm film with a bromide paper type emulsion such as Kodak fine-grain release positive. You can

Fig. 4.3 The more contrasty your subject the less your exposure latitude. Of the three softly lit pictures, directly below, the top one was overexposed 2 stops and the bottom one underexposed 2 stops. When harshly lit (far right column) just one stop overexposure (top) and one stop underexposure (bottom) starts to lose highlight and shadow detail respectively. Centre picture has normal contrast lighting, correct exposure

also print on lith film developed in dilute D76 to get medium contrast results. Large display colour transparencies for rear-illuminated advertisements, etc. are most often enlarged on special print film from colour negatives, using the same processing chemistry as for neg/pos colour paper. They can also be produced from original slides or transparencies using reversal print film (see Chapter 10).

Films for prints

Prints have obvious advantages for jobs where the photograph itself is the finished product (for example, sales albums, framed display prints, etc.). Prints also accept retouching and artwork far more easily than images on film. Often the best route to a colour print is to shoot on colour negative stock and then use neg/pos paper by the same maker. In practice, you may also get good results starting with a slide instead. From this you make a colour negative on internegative film (page 253) for colour printing as above, or print the slide direct on any of a choice of reversal papers. If you choose the latter it is important that your slide is not too contrasty or overexposed in any way. Results naturally differ from one another. Prints direct from slides, for example, have a richness of colour which may suit the graphic needs of a product advertising shot but not a family portrait.

The best monochrome print quality undoubtedly comes from good monochrome negatives. Bromide prints from colour negatives (preferably on panchromatic paper) give a handy method of proofing results for facial expression, etc. but do not make finished enlargements this way, because they will lack the subtle tonal values possible from black and white film.

Image dye stability

All colour images change in the course of time. Dye stability varies with particular hue and from one brand to another. Materials which contain ready-formed rather than chemically generated dyes, such as dye-bleach paper (page 210) give inherently long-lasting images. However, a given dye can have good stability in dark storage but fades fairly rapidly when

Fig. 4.4 Characteristic curves for an ISO 100/21° colour negative film (below left) exposed to a scene under correct colour temperature lighting, and (below right) exposed in lighting deficient in red. Only the parts between the broken lines are usable if you want to avoid colour-distorted shadows. So for the same subject brightness range (SBR) wrong colour temperature means less exposure latitude. Latitude shrinks even further with contrasty subjects

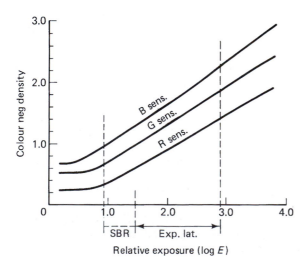

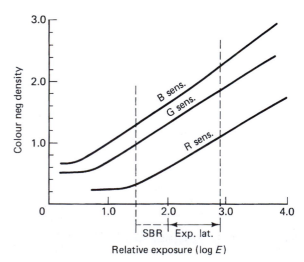

displayed in the light, and vice versa. Trials show, for example, that the magenta dye in most regular chromogenic colour films and papers has good dark but poorer light stability. Cyan dyes often have the opposite characteristics. So when pictures are hidden away image colours gradually become warmer, but framed on the wall (or projected) they shift towards cold hues. A colour slide left showing continuously in a typical projector starts to bleach noticeably and colour change after about 5 minutes. In general, slides shot on fast film stock deteriorate more rapidly than slow films and black and white silver images. Much depends on how you store your final images, of course. Always file colour photographs in cool and dry conditions (below 70°F and less than 50% humidity) and avoid exposure to volatile chemicals. This includes contamination from unsuitable paper or plastic sleeves and envelopes. With properly processed and stored film you can anticipate a life of at least 20 years without perceptible colour change.

Understanding technical descriptions

The technical information departments of film manufacturers, and most technical photographic magazines, publish comparative data on products in the form of graphs, tables, etc. Some parts of this material are more useful than others, but provided you can read and understand it there is more information to be found here about practical film performance than in purely advertising literature. Topics covered include granularity; acutance; MTF performance; characteristic curves; spectral sensitivity; reciprocity failure; and DX coding.

Grain

The grain pattern seen in a processed photographic film is like 'noise' in an audio or electronic signal – an overlaid mealy pattern breaking up image tones and fine detail. You are always most conscious of grain in midtone parts of the image, especially flat, even areas such as the sky or a plain grey studio background.

Grain is coarser in fast films than in slow materials, partly because larger silver halides are more sensitive to light and partly because fast films tend to have thicker emulsion layers. Thinner coatings of tabular-shaped silver halide crystals (page 63) help to minimize this relationship, but it is still inherent. In most colour films each colour-developed silver halide produces a slightly larger, roughly spherical patch of dye. Only these dye clouds remain after all silver is removed towards the end of processing, so although the dye coupling has effectively enlarged original grain size its *character* is softer, more globular and diffuse.

The grain qualities of a film are sometimes expressed by the terms 'granularity' and sometimes 'graininess'. They are not quite the same thing. *Granularity* is an objective figure. It is measured under laboratory conditions by a micro-densitometer which tracks across the processed image of an even mid-grey tone. The instrument's readout (Figure 4.5) can be converted into a number based on the average fluctuations of density above and below the mean density level. Manufacturers therefore publish figures called 'diffuse RMS granularity × 1000' for their regular film range, usually measured from an area with a density of 1.0. (RMS means root mean square – an average you

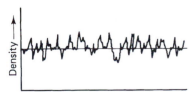

Fig. 4.5 Granularity measurement. A micro-densitometer tracking 0.1 mm across an apparently 'uniform' density gives this kind of analogue record of grain traces

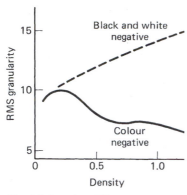

Fig. 4.6 A major difference between colour negatives and black and white negatives is that as density increases image granularity pattern becomes less (colour), and greater (black and white). On this basis colour negative film survives overexposure better than black and white film

Fig. 4.7 Left: normal photography on grainy reversal colour film. Centre: shot with a diffuser over the camera lens. Grain is still apparent, being inherent in the film. Right: reversal print from the left-hand transparency, with the enlarger lens diffused. Grain is lost along with image detail

get by adding up the squares of the variations from mean density and taking the square root of this total.)

A very fine-grained, ISO 25/15° thin-grained emulsion might rate 4 or 5 on this scale, whereas a black and white film of ISO 400/27° typically has a granularity figure of about 12. When you look at granularity figures for increasing densities black and white film continues to rise but colour tends to decrease slightly (Figure 4.6). One reason for this is that dye clouds tend to merge together more readily than silver grains. You should over- rather than underexpose colour negative film. Granularity figures are useful in comparing one film stock against another (they help to explain differences in film MTF graphs, for example, page 70). However, in practice many other factors influence the way grain looks in your final image.

Unlike granularity, *graininess* is a subjective, generalized term, taking into account the overall visual impression of your enlarged result under practical viewing conditions. It has to be based on 'average' observers reporting on just acceptable levels of grain pattern. The main factors influencing graininess are:

1. The granularity of the film you use.
2. Type of image and sharpness, proportion of even midtones, whether your subject has a lot of fine detail, and the optical sharpness of its image. A soft-focus or movement-blurred camera image is more likely to display its grainy structure, as this emulsion pattern may be the only sharp detail you can see. However, a sharp negative printed through a diffused or mis-focused enlarging lens will lose its grain pattern along with image detail (Figure 4.7).
3. Exposure and contrast. A black and white negative wholly under- or overexposed shows lower contrast and needs more contrasty printing, which emphasizes its grain pattern. Overexposure additionally scatters light, further reducing contrast so the prints made on high contrast paper end up with more graininess. Low contrast subject and lighting conditions result in flat images which again need contrasty paper, emphasizing graininess.
4. Degree of development – normal, held-back or pushed. Also (with monochrome silver emulsions) your choice of developer type. Overdevelopment and the use of speed-enhancing developers both increase graininess.

5. Chemical aftertreatment of the film image. Most solutions which reduce or intensify image density also increase graininess.
6. Enlarging. Obviously, degree of enlargement is important, but so is type of enlarger (diffuser or condenser light source). Printing paper contrast and surface texture – glossy or textured – is a major factor, but not paper emulsion structure because this is very slow and fine grained and not itself enlarged.
7. Your viewing distance and the brightness of lighting on the final result. Also the conditions of viewing – a transparency surrounded by strong light on a viewing box shows less graininess than when masked off with dark surround.

Graininess is not always a thing to avoid, of course. As long as it can be controlled you can use it creatively. Grain simplifies images by destroying unimportant small detail, evokes atmosphere and breaks up large monotonous areas of tone and colour. To maximize grain, shoot with a small-format camera and high resolution lens on fast film. Keep the image small (for extra enlargement later) and use flat subject lighting so that you can step up development to increase graininess without creating excessive image contrast. For black and white work push-process fast film in a speed-enhancing developer, or use E-6 first developer giving about 5 mins at 25°C. Silver image negatives can be slightly overexposed, then overdeveloped and reduced in Farmer's Reducer (page 163). You next enlarge with a condenser type enlarger, preferably a point source, onto contrasty glossy paper. As a less subtle but easier-to-handle alternative, print through a grained screen sandwiched with your film in the enlarger. Screens can be bought or made yourself by underexposing coarse-grain film to an image of an evenly lit plain surface.

Acutance

Boundaries between contrasting areas of the image – light and dark – tend to be exaggerated when silver halides are developed. Figure 4.9

Fig. 4.8 Grain can usefully contribute to the atmosphere of a picture. This promotional advertising shot for a brewery works through what it suggests in terms of a Sunday morning at the 'local'. (By Dick Swayne)

Fig. 4.9 Adjacency effect. When a subject boundary between dark and light (top left) is imaged onto film the density change in the processed negative does not show the expected profile (solid line). Instead, chemical changes across the boundary give an exaggerated edge effect. This improves visual sharpness. Right: the effect as recorded by micro-density trace across an actual film image

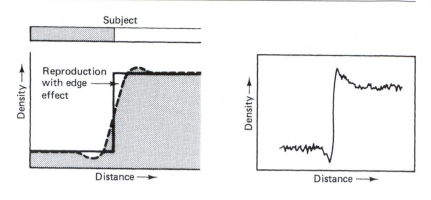

shows how the higher density becomes greater and the lower one less along the edge of light and dark. This so-called adjacency or 'edge effect' is due to chemical changes during development. Active developer diffuses from the low density area where it is underused, boosting development along the adjacent high density one. Meanwhile the oxidation by-products – bromide and iodide – released in largest quantities from the high density side slow development on the low density edge of the boundary.

All this is of practical importance, since exaggerated edges give a stronger impression of image sharpness. A graph like Figure 4.9 can be mathematically expressed as a number which gives an *acutance* value to the particular film. All emulsions are designed to give highest possible acutance (maximum edge effect). The same applies to high acutance black and white developers formulated to exaggerate these results. However, do not confuse acutance with fineness of grain. Acutance developers may even increase graininess by sharpening up edge contrast.

Film MTF curves

In Chapter 2 we saw how the quality of lens performance can be shown by a graph which plots accuracy of response (in percentage modulation or contrast) to images ranging from coarse to fine detail (low to high frequency). This kind of modulation transfer function is also published for films (see Figure 4.11). Notice how the graph runs to over 100% modulation with coarse to medium detail because edge effects have greatest influence here and boost contrast. At the finest detail, highest frequency end of the scale grain size and light-scatter within the emulsion take their toll, so that response dips. The point on the frequency axis where the graph line drops to 10% response is sometimes quoted as the maximum resolving power of the film. Typical limits are about 200 lp/mm for slow black and white film and 100 lp/mm for a medium-speed colour negative material.

Most manufacturers' technical data sheets on films, Figure 4.21 for example, include an MTF graph for comparative purposes. These prove (see facing page) that a fine-grain thinly coated, slow film gives a generally higher plot than a fast one. You can also add to the graph the MTF curve for the lens you are using, 'cascading' the two together by multiplying their percentage values at each frequency. The result shows

Film	Resolving power (lp/mm)
Very slow pan (ISO 32/16°)	200
High contrast process film	160
Slow pan (ISO 125/22°)	125
Fast pan (ISO 400/27°)	100
B & W infra-red	80
Ultra-fast pan (ISO 1250/32°)	63

Fig. 4.10 Maximum resolving power figures for a range of films, each given its recommended form of processing. Response steadily improves as new types of silver halide crystal are introduced. However, these figures offer very limited information on their own

Fig. 4.11 MTF curves. Top: slow, medium and fast black and white films. Centre: another ISO 125/22° film, and the combined effect of this film and the MTF of a camera lens. Bottom: two slide films. When judged down to 40 lp/mm Kodachrome gives better modulation than Ektachrome of equivalent speed. See also Figure 2.19

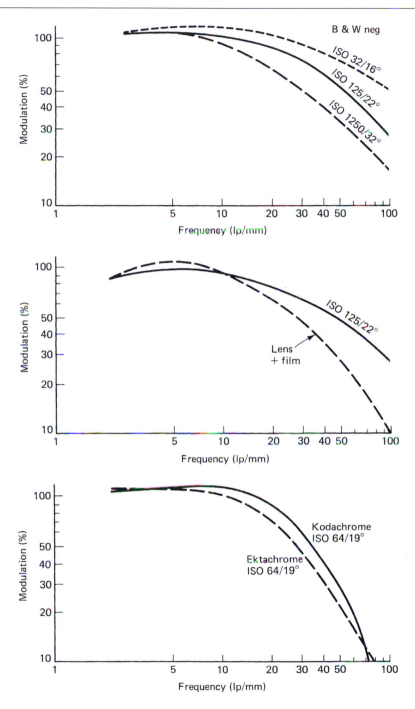

the combined performance of your lens + film. Clearly, a low resolution film can demolish the effective practical performance of an expensive lens, just as a poor lens nullifies a high resolution film. MTF can be taken even further by adding the performance of enlarging lens and printing paper. As discussed on pages 24 and 25, you can also apply a cut-off frequency beyond which performance is unimportant (say

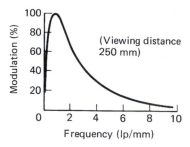

Fig. 4.12 Typical modulation transfer function of the human eye, viewing a print from normal reading distance. (Multiply figures on the frequency scale by seven to relate them to a 35 mm film which will be enlarged to 8 × 10 in)

40 lp/mm). The exact figure will depend on camera format, degree of enlargement and the distance expected for viewing final pictures.

Characteristic curves

Curves like Figure 4.13 are the oldest type performance graphs for light-sensitive emulsions, pioneered by scientists Hurter and Driffield working in Britain in 1890. Traditionally known as 'characteristic curves', they are also called H & D curves, density curves, or $D \log E$ curves. The drawing plots a wide range of 'light dosages' (log exposure) given to the film and scaled on the base of the graph against the resulting image densities measured after processing and scaled on the upright axis. Both axes are scaled in logarithmic units.

As shown in *Basic Photography*, a quick comparison of characteristic curves for different films shows you many of their vital differences. Relative contrast can be seen from the general slope of the curve; speeds can be compared broadly from how far to the left the curve rises from horizontal. Exposure latitude can also be gauged. This is done by seeing how far the range of exposure units representing your subject from the shadows to highlights (1:100 brightness range = 2.0 log E) can be moved in either direction along the log E axis before they fall on the unacceptably tone-flattening toe or shoulder of the curve. Characteristic curves published in sets like Figure 4.14 also show the effect of different degrees of development on density and contrast.

Reversal materials have characteristic curves which slope *downwards* as light dosage increases. See Figure 4.15. After reversal processing, parts of the image that contained most light reproduce as having least density – a directly positive result. The slide or transparency must be more contrasty to be acceptable as your final picture, unlike a negative, which is an intermediate for contrast-boosting printing later. It also needs good clear highlights. These features are shown by (1) a steeply angled curve and (2) low density at the bottom of the curve (0.2 is mainly the density of the plastic film base itself).

Characteristic curves of colour film images are most often prepared by exposing the material to a transparent scale of grey tones, the light, of course, matching the colour temperature for which the film is balanced. The great majority of colour materials recreate all the colours of the picture through superimposed images in yellow, magenta and cyan dyes. So after film processing every tone on the grey-scale image is checked out three times with a densitometer, reading through a blue filter to measure yellow dye density, then a green filter for magenta and

Fig. 4.13 Characteristic curves for (near right) normal-contrast films differing in speed. Far right: two much slower and higher contrast films. Lith film in particular can reach a maximum density level above 5 before 'shouldering off'

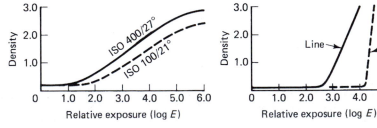

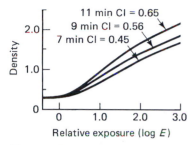

Fig. 4.14 Sets of characteristic curves show you the effects of development time. This is Tri-X developed in D76 at 20°C (68°F). Highlights build up most, therefore contrast rises. CI means contrast index; see page 304

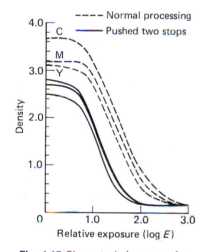

Fig. 4.15 Characteristic curves for 800/1600 colour transparency film, given normal and (two stops) pushed processing. Unlike negatives, extra development lessens the final density of shadows

a red one for the cyan layer density. All three plots must coincide in shape along most of their length, as in Figure 4.4.

It is vital that the same filters and densitometer colour response be adopted worldwide when making comparative measurements of this kind. Certified conditions known as *Status A* are used for positive colour film images. Three slightly different filter values are needed for evaluating colour negatives because the dye images here are geared to best suit the colour sensitivity of colour printing paper, not your eyes. Conditions are then called *Status M*.

Looking at Figure 4.4, you can see that characteristic curves for a typical colour negative film, read through correct blue, green and red filters, are similar in contrast to regular monochrome negatives. They are also offset vertically. This displacement is due to masking built into the dye layers, designed to compensate deficiencies in negative and print dyes (see page 95). Provided there is no displacement horizontally, and all curves match in shape, colour printing will cancel out this apparent discrepancy. Programs for quality control of colour processing make similar readings of test strips which are put through the system at regular intervals to check any variations in solution chemical content, temperature, etc. (see page 222).

Spectral sensitivity

A film's response to different colours of the spectrum is shown by a graph in which wavelength is shown against sensitivity (usually 'log sensitivity', being one divided by the exposure needed to give a density of 1.0 above fog and film base). The main points to look for in spectral sensitivity curves for black and white films are:

1. The highest wavelength cut-off point (Figure 4.16), showing whether a film is panchromatic, orthochromatic or only blue-sensitive. Ortho films finally reproduce red lips, red lettering, etc. as black or very dark, but films can be handled under deep-red safelighting. Blue-sensitive materials extend dark reproduction to greens but they are safe under bright amber bromide paper lights.
2. The uniformity of response of panchromatic film. Most films are panchromatic, but some fast materials have extended red light response which helps to boost speed and records more detail in deep-red subjects but also tends to bleach lips and other pale reds.

Fig. 4.16 Colour sensitivity curves for four types of black and white material. Extending panchromatic sensitivity to 720 nm boosts speed, especially in tungsten lighting. But for general work the final, positive, reproduction of reds from negative material of this kind may be too bleached to be acceptable

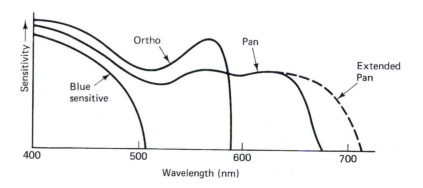

Fig. 4.17 Colour-sensitivity curves for (right) daylight balanced, and (far right) tungsten light balanced slide film. Only response above the broken line is significant. Notice the extra blue sensitivity of tungsten light film. If exposed in daylight it needs an orange filter to avoid excessive blue

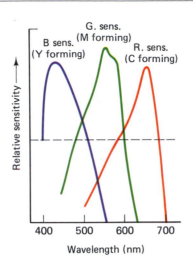
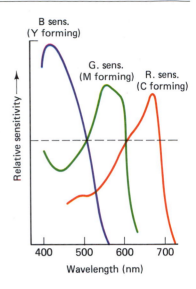

Colour film sensitivity curves are in sets of three for the blue-, green- and red-sensitive layers. Each curve should just overlap so that every colour in the spectrum is recorded by some response in one or more layers.

Colour balance

Colour films balanced for tungsten-lit subjects have blue-sensitive layers slightly faster in speed than red ones (Figure 4.17). This compensates for the fact that tungsten lamp illumination is deficient in blue wavelengths relative to daylight. It has a lower 'colour temperature' (page 113). Therefore by adjusting emulsion sensitivities the manufacturers can make different films balanced for practically any light source which gives out a continuous spectrum, i.e. contains a mixture of all visible wavelengths. In practice, only a few colour balances are on offer because, apart from daylight type, the market is quite small.

You may often have to pick the nearest film type and then make good any mismatch with a suitable colour-compensating filter over the lens. See Appendix E. Even with colour negative film it is still best to match up lighting and colour balance as closely as possible at the camera stage rather than rely too much on filtering back during colour printing.

Reciprocity failure

The reduction in film speed which occurs when you give a very long exposure to a very dim image is usually presented as some form of table

Fig. 4.18 The three main colour film types and their (unfiltered) compatibility with various white light sources

Film type	Colour temperature	Light source
'Tungsten' or type B	3200 K	Studio tungsten lamps
Tungsten movie stock or type A	3400 K	Photolamps
'Daylight'	5500 K	Sunlight + skylight and most studio flash

Fig. 4.19 Reciprocity failure varies with brand and film type. With colour reversal film the CC filter shown is needed to compensate for colour balance shift too

Indicated exposure time ▶	1	10	1000 seconds
Most B & W neg films	+ 1 stop − 10% dev	+ 2 stops − 25% dev	+ 3 stops − 35% dev*
Ektacolor 100T	None	None	+ 1 stop
Ektachrome 64	+$\frac{1}{2}$ stop	+ 1$\frac{1}{2}$ stops CC10C	+ 2$\frac{1}{2}$ stops CC10C
Fujichrome 400	None	+ $\frac{1}{2}$ stop	+ 1 stop CC5Y
Agfachrome 200	+ $\frac{1}{2}$ stop	+ 1 stop CC5G	

* Reduced development retains normal contrast.

(Figure 4.19). Short-duration reciprocity failure is less important. Modern films are designed to respond normally for very brief (1/10 000 second) bright images because this is needed for some forms of flash. However, long-duration reciprocity failure means that you may have to extend exposures of 1 second or beyond. Remember this when using an AE camera in aperture-preferred mode which rarely takes reciprocity failure into account. Make corrections with the camera's exposure compensation dial.

With colour materials some form of pale correction filter may also be specified. Filter colour varies with different brands and types of film. Reciprocity correction is most critical on professional colour films, where sometimes separate types are made for different exposure times (see Figure 4.20). Try to work strictly to manufacturers' recommendations for critical record work, studio portraits, etc. Fortunately, in a great deal of existing light photography – taken at dusk or night, for example – slight colour variations are accepted as natural. Provided that you remember to bracket your exposures towards longer times, complicated filtration and multiplication calculations (leading to still more reciprocity failure) can usually be avoided.

Product coding

Manufacturers mark up their products in various ways to identify type and batch. Most sheet films have coded notches (Figure 4.22) to show type, and may have a batch number impressed into the rebate of each sheet as well as printed on the outside of the box. Notches have the advantage that in the dark you can 'feel' the type of film you are loading. Rollfilm type information appears on the start and end of the

Fig. 4.20 Type L professional colour films are formulated to be exposed at 1/30 second or longer. Use Type S films for exposures of 1/15 second or shorter. Type L films are also balanced for tungsten light 3200 K colour temperature, and Type S for daylight

		Type S films										
Exposure	1	$\frac{1}{2}$	$\frac{1}{4}$	$\frac{1}{8}$	$\frac{1}{15}$	$\frac{1}{30}$	$\frac{1}{60}$	$\frac{1}{125}$	$\frac{1}{250}$	$\frac{1}{500}$	$\frac{1}{1000}$	second
					Type L films							

AGFAPAN 25 PROFESSIONAL

Speed

ISO 25/15°

Density curve

Exposure: daylight 1/100 s
Development: REFINAL, 4 min at 20 °C
Densitometry: Status M

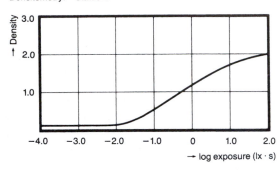

Sharpness

Modulation transfer function (MTF)

Densitometry: visual filter
Exposure: daylight

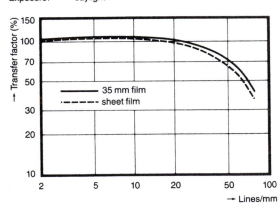

Resolving power

185 lines/mm (contrast 1:1000)

Granularity

Diffuse RMS granularity (x1000) = 8

Measured at diffuse density of 1.0 and with visual filter (Vλ) with a 48 μm aperture. This value is equivalent to a 12-fold enlargement.

Spectral sensitivity
(related to equal-energy spectrum)

Panchromatic.
The curve shown is of a density of 1.0 above fog level. The sensitivity is the reciprocal of exposure (in mWs/m^2) necessary to produce the density given.

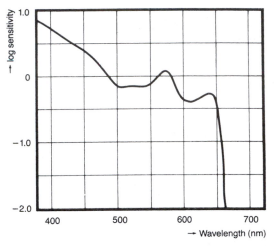

Emulsion structure

Single layer with supercoat.
Thickness: 7 μm.

Base

Safety film (acetyl cellulose) to DIN 15551.

Thickness: 35 mm film 130 μm
 rollfilm 95 μm
 sheet film (on polyester) 175 μm

Anti-halation layer

35 mm film:
Grey tinted base with AHU layer which turns transparent in the developer.

Roll and sheet film:
Dark green gelatine backing which turns transparent in the developer.

Reciprocity effect

Measured exposure time (s)	$\frac{1}{10000}$ – ½	1	10	100
Exposure correction (stops)	–	+1	+2	+3
Development correction (%)	–	–10	–25	–35

To obtain the same contrast range the developing time must be shortened.

Fig. 4.21 Facing page: part of the
manufacturer's data sheet for a
slow black and white film. It
quantifies practical performance
and allows comparisons with
other film types, provided you
know how to read the
information. Courtesy Agfa Ltd

Fig. 4.22 Some notch codings
from the top right corner of sheet
films

Fig. 4.23 DX coding. The
cassette's chequerboard pattern
(numbered here) completes
circuits through probes in the
camera's film compartment.
Centre: basic cameras use only
three or four contacts. Right:
advanced types have six more
contacts, four covering squares
7–10 (film length, latitude, etc.)

backing paper and is printed by light along the film rebate for you to
read after processing. Most 35 mm cassette-loaded film is DX coded to
program the camera automatically for the film's characteristics.

DX information is communicated through a panel of 12 squares on
the outside of the cassette, making up a chequerboard mixture of bright
metal and insulated (painted) patches. As shown in Figure 4.23, shiny
patches 1 and 7 are always unpainted electrical contacts. Probes in the
camera film chamber use this common area as an earth. Battery power
applied through probes in other positions 'read' information according
to whether they touch bare metal and complete the circuit or are
insulated by paint. Five patches communicate the film's ISO speed.
Three more tell the camera film length – to program its LCD 'frames
left' counter and film rewind, for example. A further two patches
encode whether the film has narrow exposure latitude (colour slide
material) or wider latitude (colour negative), information used to
modify camera auto-exposure programs. These data are also useful if
the camera's light-reading system works by comparing several
highlight and shadow 'spot' measurements (see page 152).

Advanced 35 mm cameras have 10 probes in two rows to fully utilize
all the DX-coded information. Cameras with less than six probes
default ISO 3200 film to 1600, while the simplest two-probe models
default all films ISO 800 and faster to ISO 400. What happens when
you load the camera with an uncoded cassette depends upon the camera
design. Most cameras set ISO 100/21° in default; some memorize and
reset for the last film you loaded, then flash a warning in the viewfinder
and top display panel. Take care if you refill old cassettes from bulk
film of a different kind. Self-adhesive printed foil 'recoder' labels are
available for specific ISO ratings.

35 mm cassettes also carry an external bar code which equipment at
the processing laboratory reads immediately on arrival to sort films into
batches for different processes. Finally, a code pattern, light-printed
along the entire film rebate, can be read after processing by an
automatic printing machine, which then adjusts its filtration and
exposure to suit the parameters of your particular type of film. The
machine's database will already be programmed to recall the colour
balance and typical image density range of your film (along with the
characteristics of dozens of other film types). Lab recognition is taken
further with APS (Advanced Photographic System) 24 mm wide film in
cartridges, designed for the amateur market. See *Basic Photography*.

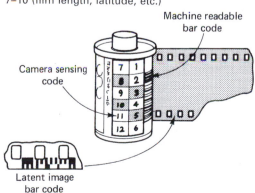

Machine readable
bar code

Camera sensing
code

Latent image
bar code

Special materials

Instant pictures

A good range of instant-picture materials are made for different kinds of applied photography as well as for the general professional photographer and the amateur snapshotter. In black and white these include high contrast peel-apart types for line copying, and ISO 3200/36° material for instrument recording under difficult conditions. Most peel-apart and integral-type materials are in packs which either fit instant-picture cameras or special backs which attach to regular large-, medium- or small-format cameras. Some 4 × 5 inch sheets come in packs as well as in individual envelopes, and a few rollfilms are still available for the older Polaroid rollfilm cameras and backs. Peel-apart 8 × 10 inch colour material, in special envelopes, fits large-format viewcameras. This material is 'processed' by feeding through a separate pod-crushing unit with 8 inch wide motorized rollers. Peel-apart type 35 mm films for colour and black and white instant slides are discussed on page 101.

Both integral and peel-apart instant pictures are important aids for the photographer or scientist needing to confirm results immediately. However, unless you repeat shots of the original subject or use a reclaimable black and white negative type it is difficult to run off duplicates or make enlargements without loss of quality. The complex chemistry in instant pictures is also temperature-sensitive. It is difficult to get results at all when photographing outdoors in near-freezing conditions unless you can warm the material while it processes. Instant pictures are more expensive than regular films, even including savings on processing costs. The colour materials are balanced for daylight and flash illumination. You can fit camera lens correction filters for other light sources, but these filters may differ slightly in density and hue from types needed for conventional colour films.

Reversal black and white slide film

As an alternative to instant picture material, you can make excellent black and white slides using 35 mm film specially designed for lab reversal processing. Agfa Scala 200 is one such example. Reversal monochrome film gives grainless, rich tone range results, but like all reversal materials there is less exposure latitude than when working neg/pos. This is a good way to copy exhibition prints for lectures, archives, etc., with minimal loss of image quality.

Lith film

This black and white film gets its name from lithographic photomechanical reproduction, and is still used in the printing industry for line origi-

Fig. 4.24 Using 8 × 10 inch peel-apart instant-picture material. 1: a special holder hinges open to receive one sheet of material in a flat envelope. You reclose it, then remove envelope alone through bottom of holder. 2: film holder is used as normal for camera exposure. 3: holder, plus receiving paper and chemical pod, is faced up to processor unit. 4: motor draws exposed material out of holder, passes it with the paper through pod-breaking rollers. Later you pull the two sheets apart

nals, lettering, etc. The material comes in 35 mm (bulk cans), sheet and wide-width roll forms. When processed as recommended it gives extreme contrast and very high maximum density (see Figure 4.13). Lith film is very slow, and most types have ortho sensitivity so you can handle and process them working conveniently under deep-red safelighting. It is designed to be developed in lith developer which works in an unusual way. By-products of development increase the activity of the solution, so development starts slowly and accelerates as the image forms. This so-called 'infectious' development gives lith film its extremely rich blacks combined with clear white and no midtones in between. It also creates edge effects (page 70) which help to improve sharpness.

Accurate exposure and processing times are very critical if you want repeatable results – both overexposure and overdevelopment begin to veil and spread the image, losing fine detail. The high contrast also exaggerates any uneven subject lighting. As with most materials of this kind processed to extreme contrast, you get a rash of clear 'pinholes' in the image from time to time, and these have to be spotted with opaque. The hydroquinone developing agent used in lith developer loses much of its activity below 10°C, so maintaining the correct temperature is important.

Lith film is good for any subject consisting only of pure black and pure white. It turns diagrams, charts and lettering into bold (negative) slides. It can also be used to make highlight masks (see page 168). You can make monochrome slides by exposing 35 mm lith film to regular continuous-tone negatives, under the enlarger or through a copy camera set-up. Three kinds of result are then possible: by processing in a D76 type developer the film gives normal-contrast continuous-tone monochrome slides. If you overexpose and then process by inspection in lith developer diluted to about one quarter correct strength, results are normal in contrast but extremely warm in tone. (This is like lith paper treated the same way, see *Basic Photography*.) Alternatively, by careful exposure and standard lith development you can turn your continuous-tone pictures into stark black and white.

Process/line films

These come in sheet film sizes and are also high contrast, although they cannot reach the intensely opaque black of lith film. However, you can process them in any high contrast developer (D11 type or even print developer) which has better keeping properties than lith developer and needs less critical timing because infectious development is not involved. Resolution is about 160 lp/mm, higher than lith. Process materials are a convenient way of turning general line originals into line negatives you intend to print on bromide paper as pure black and white.

Black and white infra-red film

Two or three brands of normal-contrast negative 35 mm, roll or sheet film are available having specially extended sensitivity to near infra-red wavelengths (see Figure 4.25). This means it will react to the infra-red in sunlight which is reflected off living green vegetation. For example, it gives a strange 'snow-covered' interpretation of a leafy sunlit landscape, particularly if this includes young spring growth. However, the film is also sensitive to much of the visible spectrum, especially blue. To maximize the infra-red effect you should use a filter which

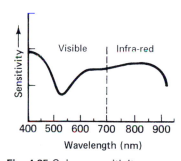

Fig. 4.25 Colour sensitivity curve for a black and white infra-red film. Although sensitivity extends well beyond the (700 nm) limits of visible light the film is also sensitive to red, blue and ultra-violet. This can be controlled by using a deep-red or IR-only passing filter

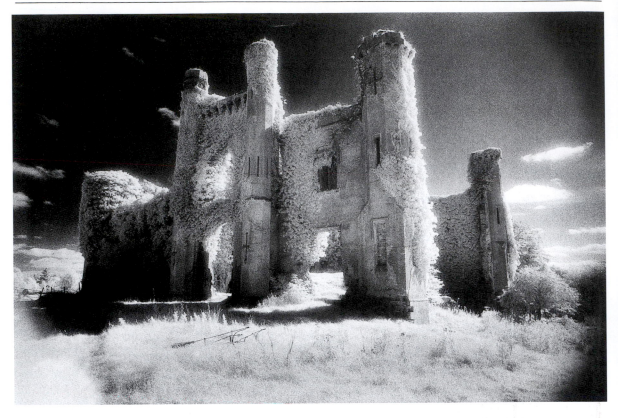

Fig. 4.26 Simon Marsden took this shot of Moydrum Castle, Ireland, on infra-red black and white film, using a deep-red filter. IR film helps to give a romantic, ghostly effect. Chlorophyll in living green vegetation strongly reflects infra-red from sunlight, and appears luminescent. The filter darkens the blue sky, making clouds stand out starkly

Fig. 4.27 A portrait taken using the same IR film and filter, by Jon Barnes. Dark eyes stare out at you from bleached facial tones. The material also picks out features just below the skin surface, such as veins across the man's chest

Filter (Kodak no.)	ISO setting* Daylight	Tungsten
25 (or 29, 70 or 89B) Deep-red, allow visual focusing	50	125
88A (or 87) Visually opaque	25	64
No filter	80	200

*Assumes you are not reading through filter.

Fig. 4.28 The effective speed setting for Kodak infra-red black and white film varies according to the filter you use. Visually opaque filters are not very practical, and may result in excessively slow film speed

Fig. 4.29 Red spot denotes focus setting for infra-red. If visible light from your subject is sharply focused when this lens is set for 10 metres (top), then re-set 10 metres against the spot (bottom)

Fig. 4.30 Colour sensitivity curves for emulsion layers in infra-red Ektachrome film. Response is mostly to green (yellow dye forming), red (magenta forming), and infra-red 700–900 nm (cyan forming). The sensitivity of red and infra-red emulsions to blue is subdued by exposing pictures through a yellow filter

only transmits infra-red. Unfortunately, this makes it opaque black to human eyes, so that you can no longer see to compose and focus on an SLR or viewcamera. A deep-red filter is therefore most often used instead. See Figure 4.28.

Infra-red films, together with a filter, range in speed between ISO 50 and 200 according to brand. You can process them in most regular type film developers such as D76. Final prints tend to look grainy, with blue sky and green paint dark, and reds very pale grey. There is also slight diffusion of detail wherever infra-red is reflected strongly, due to the way it penetrates the surfaces of some subjects. All these characteristics give a strange ethereal atmosphere to scenes, and turn portraits into starey, dead-looking faces with bleached lips. Infra-red also has the ability to penetrate haze (but not water vapour, fog or smoke), so that distant landscapes have exceptional clarity. This makes it valuable for aerial photography, as well as for medical and police purposes such as forgery detection, where it may pick out details the unaided eye cannot see.

Light sources such as tungsten lamps and flash emit infra-red plentifully for subject lighting (see page 128). Some films also record reflected, transmitted or radiated heat from hot objects provided they are above 250°C up to incandescent temperature. (If you wish, you could light a scene with powerful electric fires.) Bear in mind that most camera lenses do not bring infra-red to quite the same point of focus as visible light. If they have a red line one side of the lens-setting mark, you should focus visually, note the subject distance reading at the regular mark, then reset this distance against the red line instead. Alternatively, stopping well down should cover any errors. The accuracy of your exposure metering system may also prove suspect, depending on its infra-red response. When using a hand meter set it to ISO 50 for Kodak film and don't read through the filter. This will then read out correct exposure settings for the camera with a deep-red filter over the lens. It is always safest to shoot a bracketed series for each picture.

Colour infra-red film

This is a 'false colour' reversal 35 mm and aero rollfilm which differs in many ways from black and white infra-red material. It has three emulsion layers, but instead of these being sensitive to blue, green

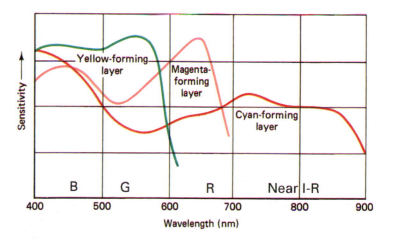

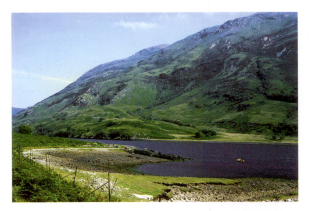

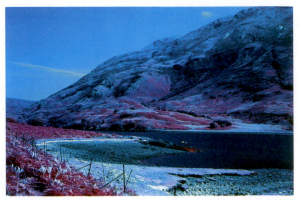

Fig. 4.31 A landscape photographed (left) on regular Ektachrome film and (right) on infra-red Ektachrome through a No. 12 yellow filter. Living vegetation reproduces magenta

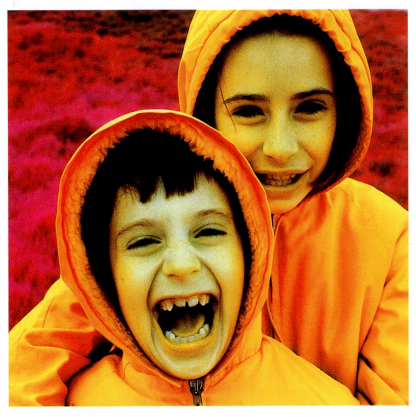

Fig. 4.32 The children here wore bright red anoraks. They were photographed on IR Ektachrome through its standard yellow filter. Their blue eyes reproduce almost black, while skin has a wax-like look. The background is grass and heather

Filter colour	Shifts image colour from	to
As well as deep Y filter:		
Cyan	Green	More magenta
Blue	Cyan	More red
Magenta	Blue	More yellow
Cyan (CC50C)	Gives daylight result in tungsten light	
Instead of deep Y filter:		
Deep red	All-over yellow	
Deep blue	All-over blue	
Deep green	Colder colours	

Fig. 4.33 The effect of strong colour filters on infra-red Ektachrome (deep yellow is normal). Read exposure through whatever filters are fitted, rating the film ISO 200/24°

and red (page 94) they respond mostly to green, red and near infra-red. (The film is normally exposed through a deep-yellow filter to reduce the sensitivities of green and red emulsions to blue.) The three layers form yellow, magenta and cyan dyes, respectively. The practical effect of all this is that green foliage reflecting infra-red records in the green and infra-red layers and so produces magenta (see Figure 4.34). Red paint, flowers and lips appear yellow, but blue sky becomes dark blue or turns cyan.

Infra-red colour film was designed for aerial photography, detecting camouflage from its living foliage surroundings and healthy forestry from diseased species. It is used also for medical applications. In

Fig. 4.34 The false colour response of infra-red Ektachrome varies according to the IR content of the lighting. In direct sunlight the chlorophyll in living vegetation reflects IR along with green wavelengths from its surface pigment. The leaf image therefore reproduces as magenta (see text). Red paint reflects red and infra-red, which this film reproduces as yellow. On an overcast day, or when in shadow, little IR radiation reaches the leaf. It then reflects green only, which reproduces as blue. Relate to Figure 4.30

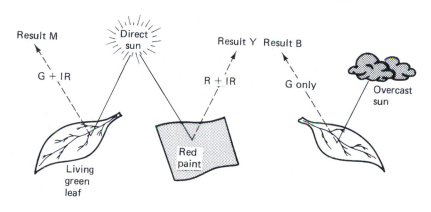

general editorial and fashion illustration this bizarre film is best used like a fisheye lens – with great restraint.

You will produce most striking results by shooting landscapes in direct sunlight during spring (fresh growth contains most abundant chlorophyll, which reflects infra-red). For different false colour effects try changing the deep-yellow filter for other strong filters; see Figure 4.33. Focus the camera lens normally, because despite its infra-red response the film still uses predominantly visible wavelengths. Infrared Ektachrome is processed in standard E-6 chemicals.

Colour duplicating film

There are several kinds of duplicating colour film made in bulk 35 mm and sheet film sizes, both reversal and colour negative types. All of them are slightly low contrast and have characteristic curves (Figure 4.35) which are predominantly long and straight with very little 'toe'. The reason for this is that when you are copying a colour photograph, duplicating a slide or turning either into a colour negative for subsequent colour printing you have to avoid two hazards. One is building up excessive contrast. The other is having correct midtone values but compressed tone and colour values in shadows or highlights, so that your result *looks* like a copy from its degraded darker tones or veiled highlights. You will meet both problems if you try duplicating on regular camera films.

Colour materials for duplicating purposes are normally balanced for tungsten light. Films are designed for either normal E-6 (reversal) or C-41 (negative) processing.

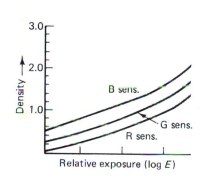

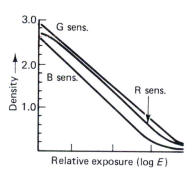

Fig. 4.35 Characteristic curves of colour films designed for duplicating existing photographic images. Top: internegative neg/pos colour film. Bottom: Ektachrome Slide Duplicating film

Photomicrography reversal colour film

Film designed for photography through microscopes has to overcome the low contrast many specimens give when imaged by this kind of optical system. So photomicrography slide films have characteristics of slightly higher-than-normal contrast and strong colour saturation. These same features make the film useful for turning coloured or black and white drawings, line artwork, etc. into bold slides for projection. Exposure is very critical, and it is best to bracket exposures at no more than half-stop differences.

Summary: Films – types and technical data

● Early silver halide emulsions were blue-sensitive only, and crudely hand-coated onto glass. Today the industry has unprecedented control over crystal formation, thin multi-layer coatings and the use of additives. The result is new standards of light-sensitivity, colour-fidelity, sharpness and freedom from graininess – but in growing competition from electronic methods of still-image recording.

● For resolution, tone range and richness of colour, slides and transparencies are hard to beat. They are still preferred for printed reproduction. However, colour bias differs between brands.

● Speed ratings are subjective in many ways. With most materials much depends on the degree of processing you choose to give (least flexibility with colour negatives). Processing, in turn, depends on subject and lighting contrast.

● Slides and transparencies are least tolerant of errors in exposure and lighting colour. When shooting under the most difficult conditions try to shoot colour (or black and white) negatives – then you can make improvements at the printing stage.

● Other things being equal, the most direct route from camera to final result is usually best. Repeat exposures of the subject when runs of slides are required (colour or black and white); shoot colour negatives for colour prints or large display transparencies and monochrome negatives for monochrome prints.

● All colour dyes change with time. 'Dark' and 'light' storage stability varies with different dye types and colours. Avoid humidity, heat, fumes and prolonged bright light (including slide projection).

● Grain ('noise') linked to fast, thick emulsions shows most in image midtones and can be measured objectively in terms of *granularity*. More subjective *graininess* combines visual effects of grain size, image detail and contrast, exposure and processing, aftertreatment, enlarging and final display conditions.

● Chemical effects at tone boundaries improve the visual appearance of detail. Edge effect is encouraged in emulsions and developers formulated to give high *acutance*.

● MTF graphs plot an emulsion's modulation against cycles per millimetre frequency. This can be combined ('cascaded') with the MTF performance of the camera lens.

● Characteristic curves plot image densities against exposure to light. They help you to compare contrast, speed, palest and deepest tones, and the effect of processing. Densities of colour film materials are measured through appropriate A or M 'status' tricolour filters.

● Spectral sensitivity curves plot emulsion response (log sensitivity) against wavelength. Plots show you uniformity of response and cut-off frequency. The relative spectral response of the three primary emulsion layers in colour film are designed to be balanced to record subject colours accurately under lighting of a particular colour temperature.

● Reciprocity-failure loss of film speed differs in severity according to film type and brand. Published data show how to correct it through additional exposure, preferably by widening the aperture. Black and white materials can be given altered development to compensate for reciprocity-failure changes to contrast. Colour films may need a correction filter. Type S and L professional colour films are designed

for shutter speeds and lighting colour balance appropriate to short or long exposure times respectively.

● Codings on packaging and on the film itself (notches, numbers and code light-printed on rebate) give identifying information. 35 mm DX cassette code communicates film speed, length and exposure latitude to the camera, given sufficient sensing probes in the film compartment. Lack of DX information may set ISO 100/21° automatically.

● Instant-picture materials come as peel-apart types (fit backs for regular cameras) and integral types for cameras having a mirror in the optical path. 35mm types yield instant colour or monochrome slides, given use of the necessary Polaroid hand processing unit. Advantages of almost immediate results must be balanced against cost; only camera-size pictures (unless reclaimable negatives are enlarged); and failure to work at low temperatures.

● Lith film gives extreme black and white density and contrast in lith developer (infectious development). Exposure is critical; pinholes common; remember to maintain developer temperature. Uses include line subjects, highlight masking, etc. Processed in low activity developer, lith film will give continuous-tone projection positives from normal-contrast negatives.

● Black and white reversal 35 mm film is the most direct, high quality route to monochrome slides for lectures, etc.

● Infra-red monochrome films have sensitivity extended to about 900 nm. Used with a deep-red or infra-red-only passing filter it records sunlit living foliage, lips, etc. as white and blue sky as black. Highlights have a diffused appearance. Landscapes and portraits take on a strange, grainy, 'other-world' look. Reset your focusing scale or stop down well.

● Infra-red colour reversal film (yellow filter) gives a mixture of false colours. Infra-red reflecting vegetation records as magenta, lips and red paint yellow, giving bizarre results. The material is important too for aerial surveys of vegetation and some medical applications.

● Colour negative (or reversal) duplicating films are intermediate materials – they offer low contrast and long straight-line characteristic curves needed for turning existing prints or slides into copy colour negatives or duplicate slides.

● Photomicrography reversal films have higher-than-normal contrast, useful for making slides from low-contrast microscope images (also for colour diagram copying).

5

How camera materials work

This chapter discusses how our light-sensitive materials work, especially colour films. It traces the way that ingenious principles have been put into practice and compares how camera materials *record* relative to the way our eyes *see* subjects directly. So the chapter begins by describing how eyes and brain receive and interpret the sensation of colours and comparing this with the far more fixed chemical response of colour films. Differences between seeing and photographing are important to grasp in order to control results.

The basic principle of chemical photography – the changes which happen when a silver halide crystal is struck by photons of light – was outlined in *Basic Photography*. Briefly, there are several billion silver halide crystals in every square centimetre of fine grain film emulsion. Silver atoms accumulate at specially structured faults or 'sensitivity specks' in every crystal, according to the light received and the crystal's sensitivity (for example, surface area). Later these specks form catalysts for liquid developer chemicals to darken exposed crystals, turning the invisible or 'latent' image into a black silver negative.

You will see how exploiting this principle over the years has allowed today's different kinds of colour films and instant-picture materials to evolve. The end of the chapter inevitably brings us to the electronic recording of still images. Here it discusses how light-sensitive CCD sensors work, and looks ahead to increasing replacement of silver halides and liquid processing solutions by digital storage systems.

Colour as seen and photographed

Many ingenious inventions are based on 'observations of nature'. The way colour films work owes much to scientists' basic study of just what colour is, and how human eyes and brains respond to coloured surroundings. In the seventeenth century Sir Isaac Newton showed that white light is really made up of all the spectral colours. In 1801 Thomas Young suggested that the retina of the human eye does not contain receptors for each discernible hue. Instead it has a mixture of three different kinds of receptor – sensitive to blue, green and red, which

Young called the *primary colours* of light (not the same as pigment primary colours, familiar to the artist as blue, yellow and red). This 'three-colour vision' gives your brain the sensation of any spectral colour from the combination of signals it receives. James Clerk Maxwell proved this in the 1850s by demonstrating with light from blue-, green- and red-filtered lanterns overlapped on one screen. Dimming or brightening individual lanterns re-created all the colours of the spectrum, while an equal mixture of the three primary colours formed a patch of white.

Today it is well established that our retinas contain many millions of rod- and cone-shaped cells. The rods are more sensitive to light but have no colour discrimination. The less-sensitive cones react to colour with their three types of reception determined by chemical content. Some aspects of colour vision are not fully explained by the tricolour theory, but the discoveries of these nineteenth-century scientists remain highly relevant for understanding colour photography. At the same time, remember that your eyes are virtually an extension of your brain, connected to it by over 750 000 fibres in each optic nerve. In dealing with colour *vision* the brain's ability to interpret is as relevant as the actual stimuli received from eye response.

The aim of colour photography seems to be to recreate accurately subject colours as they looked at the time. However, here problems begin, because of three factors which do not quite match up:

1. Colours are measurable and can be objectively defined, using terms such as hue, saturation, etc. However,
2. Colours as seen by the eye and experienced by the human brain are not fixed at all and are subjective. Colour appearance changes under different surroundings and viewing conditions, and is influenced by psychological reactions such as colour experience and association.
3. Only three dyes are used in colour films to make up all the final image colours. Since these dyes are far from perfect it is impossible to always match (1). At the same time, a film's response is relatively consistent and determined by its chemical structure – it can never be as flexible and accommodating as human colour vision (2).

1. Colour in factual terms

Instead of vaguely describing colours met in life as 'pink', 'yellowish', etc., physicists use the terms *hue, saturation* and *luminance*. Hue is the name of the colour itself, the dominant wavelength expressed as a colour title such as green, yellow and so on. Saturation (or chroma) means the purity of a colour. The more white, grey or black mixed in with a colour, the less its saturation. Pastel colours are desaturated and strong vivid colours are highly saturated. Luminance (or value) is a measure of the brightness or brilliance – how much incident light it reflects.

There are two main systems which can pinpoint a colour and label it with a numerical code. One devised by the American artist A. M. Munsell classifies colours through a collection of over 40 charts of patches. (The charts themselves make up a three-dimensional sphere, see Figure 5.2.) The Munsell system gives every colour a reference number which identifies its chart (Hue), and then its vertical (Value) and horizontal (Chroma) location, like a street atlas. Munsell numbers

Fig. 5.1 Right: a wide range of colours can be formed by adding different amounts of blue, green and red light. Yellow is formed when green light is added to red. White forms where equal amounts of all three primary coloured lights overlap

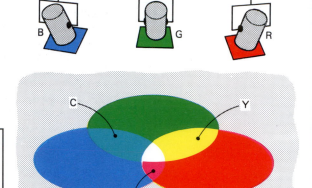

Fig. 5.2 Munsell system of colour classification (below). The Munsell 'solid' represents the three dimensions of the system. The central axis (neutral) runs from white at the top to black at the bottom. Saturation increases away from this central axis. In practice this sphere takes the form of dozens of charts, hinged along the vertical axis and each one dealing with a different hue. (The lopsided shape here is because printing inks have to be used rather than theoretical colours. Inks still have severe colour limitations.) Shown below are just two strips out of one chart for a blue hue, saturation increasing to the right and luminescence increasing vertically. Any colour patch can be referenced by quoting hue, value, and chroma coordinates. The table gives four examples

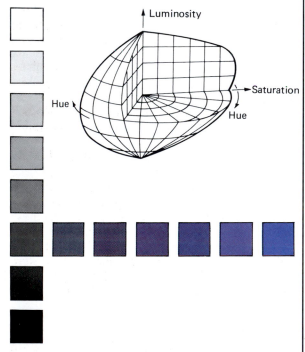

	Hue	Value (luminance)	Chroma (saturation)
Titanium white	White	9.6	0.1
Cadmium red	6.6R	4.3	13
Emerald green	4.6G	4.0	8.8
Ivory black	Black	1.5	0.9

Fig. 5.3 CIE colour classification (below). In basic terms imagine this as a white screen with lights – red, green and blue – shining inwards from three positions (see broken lettering). The middle of the triangle formed by the lights is neutral white. Light from any one corner is at zero in the centre of the opposite side. Spectrum colours from blue through to red are located along the dome-shaped locus (bold line). Quoting x and y coordinates pinpoints any colour for matching purposes. The table gives examples for some subjects shown on the chart above it

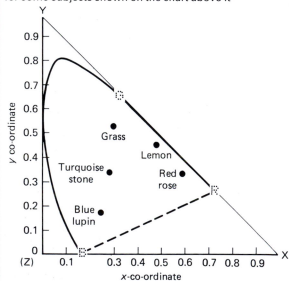

Subject	Chromaticity co-ordinates		Reflection factor
	x	y	
Red rose	0.586	0.330	12.2%
Lemon	0.473	0.467	51.3%
Grass	0.290	0.518	29.7%
Polished turquoise	0.253	0.325	22.4%
Blue lupin	0.228	0.182	8.3%

are used as matching standards for artists' paints, printing inks and any pigmented colour products. It is limited by the actual pigments available for printing the charts.

The other system is the chromaticity diagram, introduced in the 1930s by the Commission Internationale d'Eclairage. The CIE system identifies colours by matching them to mixed quantities of blue, green and red light. The exact mixture can be given a position on a graph which maps the relative strengths of the three sources (see Figure 5.3). Most colours – whether in the form of pigment or light have a matching position somewhere within the CIE diagram, so you can describe any one by quoting graph coordinates.

Colours, of course, originate from all kinds of sources. This is what makes them difficult to reproduce exactly with any dyes or pigments, let alone mixtures of the three dyes in colour film, or three phosphors within a computer or video CRT screen. Any or all of the following forms of colour may be in front of your camera:

(a) Pigments and dyes which selectively reflect, transmit or absorb incident light. Colours here are greatly influenced by the colour of the light and the subject surface. (At certain angles a smooth surface will reflect a high proportion of incident light unchanged off its top surface, mixing with and desaturating the colour selectively reflected from underneath.)
(b) Colours derived from white light by diffusion and scatter. For example, the blueness of clear sky caused by scatter of the shorter wavelengths in sunlight by water and dust molecules in the atmosphere.
(c) Colours formed by interference – as seen on soap bubbles or reflected from oil on a wet road. These changing hues are caused by two reflections from inner and outer surfaces of a thin transparent film. Displacement by half a wavelength interferes and cancels out this wavelength colour, forming other colours from remaining white light.
(d) Colours produced by diffraction – for example, reflected from a compact disc or the sheen of a rayon type fabric. Such effects are caused by the change in direction of some wavelengths in white light when reflected from a surface covered in a fine pattern of lines.
(e) Fluorescent colours. Special inks or coatings, as on 'dayglow' poster papers, etc. which generate visible coloured light under sunlight or any other source containing ultra-violet radiation.
(f) Phosphorescent colours. The 'glow' from substances able to store energy from light and release it in a coloured form later (for example, the luminous coating on the hands of a clock).

2. Colour as seen

Normal human eyesight is quite good at comparing two coloured objects and judging if they match, provided they are seen together under identical illumination. However, colour seen in isolation is another matter. Judgement here varies from person to person and from one set of circumstances to another. Colours become personalized and you cannot even trust your own eyes. Look at the way people adjust the television to get 'realistic' colour – some have it bright and garish, others muted and restrained.

There are all kinds of eyesight inconsistencies and differences that exist between individuals:

(a) *Colour adaptation*. The dimmer the light, the wider the iris of your eye becomes (its range is about five stops). After this the retina itself slowly adapts to increase sensitivity, relying less on the cones and more on highly responsive but colour-insensitive rods. Eye peak sensitivity shifts (the *Purkinje shift*) further towards the blue–green, then even this colour response fades to zero. After about 20 minutes' adaptation in extremely dim light you may just make out things in monochrome, with very poor resolution and a degree of visual 'noise' which destroys almost all detail. In a garden in dim moonlight you can only see the dark-grey shapes of flowers – but flash a lamp and their sudden colour brilliance emphasizes what our eyes have lost. To a lesser extent, the same thing occurs in a scene with contrasty lighting – your eyes see fewer colours in shaded areas than in midtones and highlights. (A point to remember in colour printing – colour inaccuracies are least noticeable if restricted to dark areas of the print.)

Adaptation also makes visual judgement of 'white' light suspect. Walk from one area lit by daylight type fluorescent tubes into another lit with incandescent tungsten lamps and you are at first conscious of the 'yellowness' of the lighting, but within a minute or so you accept this as neutral white. When you return to the tube-lit area it first strikes you as 'blue'.

Eye adaptation is useful in life but a handicap in colour photography. Colour films cannot respond in the same way. Long exposure in dim light (despite reciprocity effects) will record a range of subject colours which just could not be seen by eye. Film is also balanced for white-light illumination containing a known mixture of colour wavelengths (quoted as 'colour temperature', see page 113). Under lighting of a different colour temperature, which your eyes soon ignore, film will not reproduce colours or neutral tones accurately. You will have to use correction filters.

(b) *Colour fatigue*. You eye's assessment of a coloured object is greatly influenced by the colour surrounding it as well as what you looked at previously. Use Figure 5.4 as a simple test of the latter. If this works for you it will be because blue receptors in your retina

Fig. 5.4 Stare steadily at this coloured shape from a close reading distance for about 15 seconds. Then switch your gaze directly to the adjacent blank white space. Briefly the shape is re-seen on the sheet in pale yellow

become 'fatigued'. But green and red receptors in the same area remain unchanged and so temporarily respond more actively and produce the yellow afterimage. Similarly, a pastel colour seems to change hue when taken away from one brightly coloured backdrop and set in front of another totally different in colour. Changes in eye sensitivity also sometimes make it difficult to judge colour prints – the longer you compare any two test prints with different colour casts, the more you think correct colour is midway in between.

(c) *Individual colour vision.* Everyone differs slightly in their response to colour. Can you be sure you see what someone else sees? Around 10% of the male population and 0.5% of women have some form of defective colour vision. Their trichromate response may simply be uneven or, more severely, they cannot distinguish between red and green. Add to this the fact that the optics of your eyes grow yellower with age and it seems that we must all see colour differently. In jobs involving critical assessments – such as colour printing – good colour vision is essential. You can test yourself using charts in S. Ishihara's book, *Tests for Colour Blindness* (H. K. Lewis, London).

(d) *Psychological influences.* We are also all influenced in our judgement of 'correct' colours by experience and memory. 1 may not see quite the same green as you but to me the grass in that photograph is the same colour it appeared on the lawn. Similarly, you *know* that certain favourite flowers are yellow, city buses are another familiar colour and so on. Familiarity can even make you accept and overlook a colour which is somewhat distorted – you unconsciously 'read into' it what the colour should be. On the other hand, certain subject colours such as flesh tones and common foods are read quite critically. Your eyes tend to detect small deviations. Colour photographs of totally unfamiliar things are almost impossible to judge unless some reference (such as a grey scale) has been included alongside.

It is an interesting point that colour can really only be remembered by comparison. Can you imagine a colour you have never actually seen? Colours have broad emotional connotations too, also based on experience. Red suggests warmth; blue cold. These are old clichés but they are still used effectively in advertising. Therefore you have an orange bias in a sales picture of hot soup and an emphasis on green–blue for 'tingling fresh' toothpaste.

3. Colour as photographed

As you will soon see in more detail, manufacturers have to work within the limitations of having only three dyes present in colour films. From different mixtures of these dyes all image colours from all kinds of subjects have to be reformed. Some, such as fluorescent and phosphorescent colours, are therefore impossible to reproduce accurately. Even subjects with regular colours will only reproduce acceptably if illuminated by light for which the tri-colour-sensitive halide emulsions have been balanced. 'Adaptation' by using filters is only possible to a limited extent. In choosing their three image-forming dyes film manufacturers have to compromise between high accuracy in only

a few colours and the acceptable reproduction of many. Different brands solve the problem in different ways, so final colour images vary slightly in appearance according to the film you choose, even though each film was used correctly.

Similar problems exist in digital photography, where the image displayed on your computer screen, formed by R, G and B phosphors, has to reproduce all subject colours. Even if you get this to look acceptable it differs again from what is later output onto paper in C, M, Y, K inks. See Chapter 11.

With all these variables and provisos it is incredible that colour photography is so realistic. 'Correct' rendering of colours seems so unlikely it is barely worth striving for. On the contrary, you must tightly control all the technical aspects of colour reproduction so that results are consistent and reliable, leaving human vision as the *only* variable. Fortunately you rarely examine final results right alongside the original subject – so here, at least, the way that your brain interprets what your eyes see is a plus factor.

How colour films work

The principles on which most of today's colour films are based were established long before anyone could actually put them into practice. The French scientist Louis Ducos du Hauron published a book *Les Couleurs en Photographie*, in 1868, forecasting several of the colour reproduction systems we now use. However, it was not until the 1880s that Dr Hermann Vogel's research in Germany into sensitizing additives made possible orthochromatic and panchromatic emulsions to add to the blue-sensitive materials used exclusively up until this time. Panchromatic response to all colours, and ability to control colour sensitivity unlocked the door to practical colour photography.

'Subtractive' methods

To see how today's materials have evolved, imagine that you were working in the 1930s, photographing something to get colour prints. You would have to take every picture as a series of three black and white negatives on panchromatic material – through deep blue, green and red filters. Subjects were therefore mostly still lifes, although a few expensive one-shot colour cameras (Figure 5.5) exposed 'separation negatives' simultaneously.

When developed, the blue filter negative recorded subject whites and blues as dark silver, blacks and the colours from the remainder of the spectrum (predominantly greens and reds) as pale density. The negative taken through the green filter showed whites and greens as dark and blacks and colours such as blues or reds as pale. On the red filter negative whites and reds were dark, blues and greens pale. Other colours and neutral grey recorded as midtone values on either two or all three negatives.

The next step was to print these colour separation negatives, each one in a different coloured dye. Then by sandwiching the three positive images together in exact register you formed one multicoloured print. Follow this through more closely. The blue filter negative naturally printed subject whites and blues as white but blacks and all colours

Fig. 5.5 A 'one-shot' colour camera as used in the 1930s to expose three colour separation negatives simultaneously. Inside it had semi-reflective mirrors and blue, green or red filters just in front of three plate holders. The long-focus lens used a bladed shutter. Compare with Figure 3.29

Fig. 5.6 Primary and complementary colours of light. The white light spectrum can be broadly divided into three primary bands: red, green and blue. If any one of these bands is removed the remaining two form a combined colour which is said to be complementary (or secondary) to the missing band. So when red is missing the remaining light appears cyan – its complementary colour. Similarly yellow is complementary to blue. and magenta to green

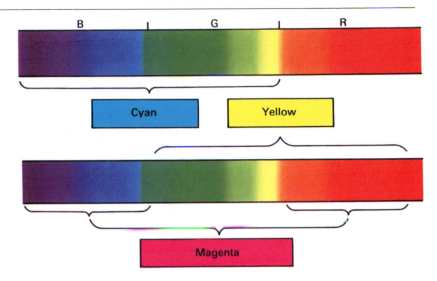

complementary to blue as dark. This black and white image had to be printed in *yellow* dye which is complementary to blue (Figure 5.6), logical when you remember that all the dark parts here are 'non-blue' areas. The print from the green filter separation negative was printed in magenta (whites and greens appear white, all non-greens are magenta),

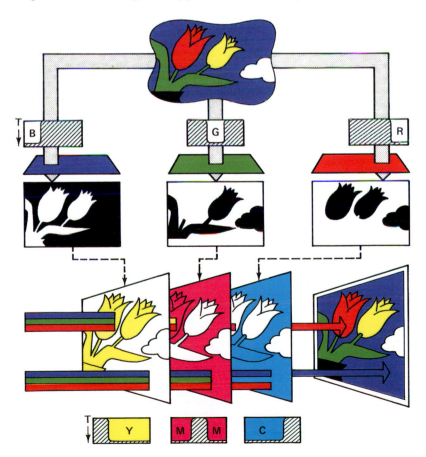

Fig. 5.7 Principles of subtractive colour reproduction. Top: subject exposed on panchromatic film through blue, green and red filters (or more commonly on three stacked layers of emulsion sensitive to blue, green and red). Each image records one third of the spectrum. Bottom: the final transparency or print consists of three positive images, each in a dye complementary to the colour response of its 'taking' layer. Each of these complementary colours transmits (T) two thirds of the spectrum, subtracts one third from white viewing light. Most colour films work on this basis

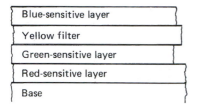

Fig. 5.8 Layout (simplified) of a multilayer emulsion colour film

and the red separation was printed in cyan dye. When all three prints were transferred onto one sheet of white paper (or clear film for a transparency) the stacked dyes made up all the original subject colours.

As Figure 5.7 shows, a *red* flower appears colourless on the cyan print from the red filter negative but is represented by dye in the yellow and magenta prints. In the red flower area white light illuminating the final result has blue subtracted from it by the yellow (leaving its green and red content intact), then green is subtracted by the magenta. All that is left (red) is reflected back to you from the white paper base as a red flower. Other subject colours reform the same way – trace them through on the diagram. Paler and other colours not shown here are made up by mixtures of lesser amounts of the three-colour image, but always just using three dyes. Think of each dye as 'subtracting' the colour of its taking filter from different areas, so that what finally remains from white light forms the colour picture. It is important to see why each dye layer cannot *match* the original filter colour as you might at first expect but must be complementary (negative) to it.

The actual mechanics for doing all this some 70 years ago were diabolically labour-intensive. Negatives had to exactly match in image dimensions and contrast, and so had the three enlargements. Earlier image-colouring processes such as carbon, bromoil or wash-off relief were used for the printing stage, the results being transferred in exact register onto a final support. Today we still use the same subtractive principle but this kind of *physically assembled* result only remains in regular use for systems like photomechanical printing, as used for the colour pictures in this book. Here original colour artwork or photographs are basically copied into three red–green–blue separations and printed in turn onto the page in cyan, magenta and yellow inks. (A fourth unfiltered separation printed in black ink is added to improve tone range and contrast: see Chapter 11.)

As a photographer today you do not have to handle mechanical aspects of subtractive colour reproduction any longer. Emulsion chemists have built all these stages into modern multilayered colour films. In most colour reversal (slide and transparency) films the stack of emulsions has at the top a blue-only sensitive layer. Below this comes green- and then red-sensitive emulsions. (Usually these emulsions have some sensitivity to blue as well, nullified by a yellow filter located directly below the blue-sensitive emulsion which lets

Fig. 5.9 In practice a colour film contains additional emulsion layers to improve image tone range. Antihalation dye absorbs back-scatter of light, and a top coating helps to protect from abrasion damage. Collectively these layers may only be 0.005 mm thick in the dry state

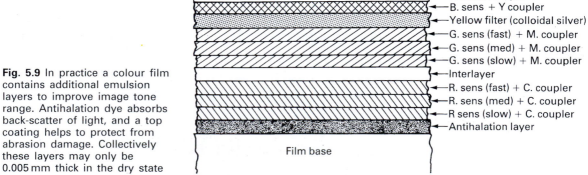

green and red pass freely. The filter becomes colourless later during processing.) So today one exposure effectively records three colour separations, in any camera.

With the exception of a few materials (one such being Kodachrome), all reversal films use silver halides with 'colour couplers' attached – in the blue-sensitive emulsion these chemicals will later form yellow dye when triggered during processing. Similarly, there are other couplers to form magenta dye in the green-sensitive layers and cyan-forming couplers in the red-sensitive ones. After exposure in the camera the first stage of reversal processing is black and white development, which forms monochrome separation negatives in the emulsion layers. Then remaining halides are fogged (chemically) and the film goes into a colour developer. This developer acts on the fogged halides, which in fact form a positive image in each layer. However, as halides are turned into black silver, particular developer by-products are produced which turn the couplers in each layer into their designated dyes. Note that dye only forms where fogged halides are developed, so cyan, magenta and yellow dye-positive images are created in their layers.

At this stage you cannot yet see image colours because of the presence of so much black silver – the negative images from first development, plus the positive black image formed in colour development as a means of 'colour coupling' the dyes. However, the last stages of processing bleach and remove all black metallic silver, leaving dye images only. So your result is just like the old hard-to-work assembly routine, but done for you internally by multilayer film and 'chromogenic' (dye-forming) development.

Colour negative films use the same principle of having red-, green- and blue-sensitive layers with cyan-, magenta- and yellow-forming couplers, respectively. Processing here is similar to the latter half of reversal processing. The film goes first into colour developer which turns image-exposed areas into black silver and, via by-products, coupled dyes. Then all remaining silver halides and black silver are bleached away. As Figure 5.10 shows, the result is an image which has negative tones and complementary colours – red flowers are cyan, blue sky yellow. The density and contrast given by negative films and their processing, together with the spectral characteristics of dyes formed, are all geared to suit the same maker's colour printing paper. Neg/pos colour paper works on the same general principle as colour negative film, forming a colour negative of a colour negative – in other words, an image which is positive and correct colour.

Masking

Negatives are not judged as ends in themselves but are intermediaries. This fact allows manufacturers to do some tinkering with the negative production stage to improve final prints. For example, chemically formed dyes do not perform as well as they should in practice. Magenta dyes tend to subtract (absorb) some blue light as well as the intended green light. Cyan is worse and absorbs a little blue and green, as well as red. By the time colours have been generated twice – once in the negative, once in the print – these deficiencies accumulate. The practical effect tends to be that blues and greens look too dark relative to yellows and reds. Reds also appear orangey, while greens shift towards blue.

Fig. 5.10 Colour negative film. Below: exploded view of the basic layers before processing (left); after colour development (centre); and after processing is completed (right). Layer 1 has blue-sensitive emulsion plus colourless yellow-forming couplers. Layer 2 is a yellow filter which becomes colourless during processing. Layer 3 has green-sensitive emulsion plus pale yellow magenta-forming couplers. Layer 4 has red-sensitive emulsion plus pinkish cyan-forming couplers. The negative's warm cast is due to the yellow-plus-pink mask remaining in layers 3 and 4 in places where magenta or cyan dye is not formed. Colour printing paper is balanced to suit this colour-masked image

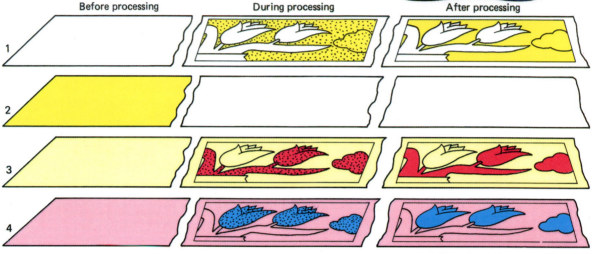

Before processing During processing After processing

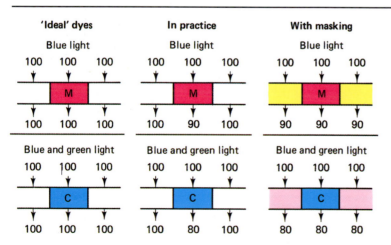

'Ideal' dyes	In practice	With masking
Blue light	Blue light	Blue light
100 100 100	100 100 100	100 100 100
M	M	M
100 100 100	100 90 100	90 90 90
Blue and green light	Blue and green light	Blue and green light
100 100 100	100 100 100	100 100 100
C	C	C
100 100 100	100 80 100	80 80 80

Fig. 5.11 Why dye-deficiency colour negative masking is needed. An ideal magenta (top left) should transmit as much blue light as clear film, but in practice (centre) it absorbs 10%. But if dye absorbing 10% blue is incorporated into clear areas of the magenta image layer (right) the whole layer acts as even density to blue light and no longer influences image blues. Similarly deficient cyan dye which absorbs 20% blue and green light is improved if unused cyan couplers remain pink

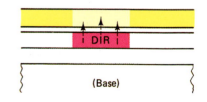

DIR

(Base)

Fig. 5.12 Development inhibitor-releasing (DIR) couplers. The amount of dye formed during colour development in the magenta coupled layer here is designed to retard the formation of yellow in the layer directly above. This way unwanted blue absorption of magenta dye is offset by having less yellow dye formed. Colours are richer and edge sharpness visually improves

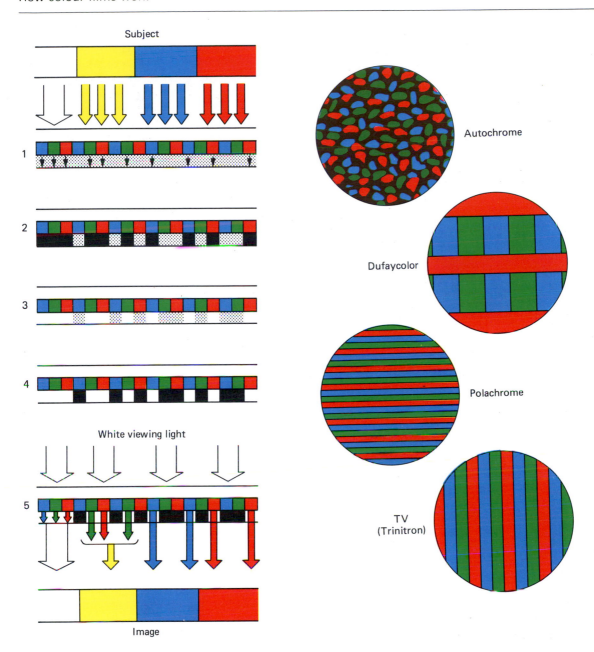

Fig. 5.13 Additive colour reproduction, using a filter mosaic. 1: cross-section of film. The pattern of tiny filters faces the image in the camera, backed by panchromatic emulsion. Image colours pass through the filters that do not absorb their particular colour. Film is then given reversal black and white processing. 2: appearance after first development. 3: negative image removed by bleaching (Polachrome by later physical stripping). 4: remaining halides blackened to form positive image. 5: viewed or projected by white light, each area of the film transmits light matching the original image colours. Provided the filters in the mosaic are small enough, the coloured areas appear continuous. Right: detail of various methods for producing the filter mosaic. Earliest Autochrome used dyed starch grains, randomly distributed and with the spaces in between filled with carbon black. Dufaycolor used a grid, printed in dyes (greatly enlarged here). Present Polachrome has colour bands 0.02 mm wide. Colour mosaics or bands are similarly used on video and computer monitor CRT screens to reproduce colour images

To overcome these dye deficiencies, negatives are 'colour masked'. Take, for example, the magenta coupler in a green-sensitive layer which goes to form a dye wrongly absorbing 10% of blue light. Manufacturers make all the original coupler here not colourless but *yellowish* (absorbing 10% blue). So although during processing this coupler changes from yellowish to magenta where colour development takes place, everywhere else it remains as a faint yellow (positive) mask. As far as blue light is concerned, then the whole layer – yellowish mask or magenta dye – subtracts an even 10%. Image-wise it now controls only green light as intended, and has no more effect on blue light than a grey filter. See Figure 5.11.

In the same way, cyan couplers are made pale pink to absorb the same amount of blue and green as the deficient cyan dye. The presence of these built-in masks is the reason colour negatives appear with an apparently overall warm tint, a feature which makes it difficult to judge images by eye for correct colour and density.

Recent chemistry takes improvements beyond this integral colour masking by adding small quantities of DIR (development inhibitor releasing) couplers. They use the amount of dye formed in any one layer of film to affect the amount of colours produced adjacent to it in other layers. This is done by releasing a colour developer inhibitor which splits off from its own couplers and diffuses upwards and downwards without also affecting the 'host' layer. The result is improved richness of dominant colours in an image and more colour contrast, without unduly altering neutral tones which would otherwise give a harsh, contrasty result. Also, with inhibitors at work the centre parts of coloured areas get slightly less colour development than the edges. This gives extra boost to density difference around the edges of detail and improves the appearance of sharpness (see edge effect, page 70). Inhibitors are used for reversal films as well as colour negative types.

'Additive' methods

A quite different approach to reproducing colours was also pioneered at the turn of the century and is used in a few modern forms today. It relates back even more directly to Clark Maxwell's demonstrations using light from primary filtered lanterns and nineteenth-century recognition of the human eye's blue, green and red receptors. Remember too, that during the 1870s and 1880s French Impressionist painters such as Monet, Pissaro and Seurat were making use of *pointillism* – the technique of juxtapositioning tiny brush strokes in paints of strong luminous colours and subtle tones. It is a significant fact that the very first colour photography materials to go on sale were manufactured in France (Lumière's 'Autochrome', 1907) and worked on what is known as the additive principle.

Additive type colour film has a mixture of thousands of primary coloured blue, green and red filters permanently built into the film base, like a microscopic patchwork or mosaic. There has to be equal numbers of the different colours (Figure 5.13) so that from normal viewing distance the eye just sees the film as neutral pale grey. Panchromatic emulsion is coated on one side of this base and the film is exposed in the camera with the base facing towards the lens. Light from red parts of the subject can therefore only reach the emulsion through the tiny red

filters. It is absorbed by green and blue filters, just as red light would be if shining through green and blue parts of a stained-glass window. Light from green parts only affects the emulsion behind green filters, yellow light (which is a mixture of two primaries) passes through both green and red filters, and so on.

To see results, you give the film black and white reversal processing (see *Basic Photography*). During this processing a tiny patch of black silver develops behind each filter which has let through light. Then this silver is removed and the remaining silver halides blackened to give a positive result. So when you finally hold the film up to white light, wherever there are red parts of the image only red filters are 'unlocked', in green parts you see green light and in yellow areas a mixture of red and green specks of filtered light add up to appear yellow. The whole system relies on the human eye's inability to resolve individual filters but to fuse together different *additions* of red, green and blue light to reform a complete range of subject colours.

An additive colour photography system of this kind is relatively simple to process because no colour development is needed. However, results are limited to slides and transparencies, and these cannot be much enlarged because you then start to see the mosaic pattern. Images also look much dimmer than on subtractive materials. Even in white areas only one third of possible illumination is really being transmitted, two thirds being absorbed by each filter. The same loss of light makes additive materials very slow in speed, typically about ISO 50/18°. However, as a system it has been revived for instant-picture slides. The additive principle is also exploited for colour CRT computer monitors and TV receiver screens. You can see the filter pattern by closely checking white parts of the lit screen.

Instant-picture materials

Instant-picture materials date from 1948 when the American scientist Dr Edwin Land's Polaroid Corporation (originally set up in the 1930s to produce polarizing filter material) launched the first 'Polaroid Land' one-minute camera and (roll) film. Land's process was based on diffusion transfer chemistry – the fact that while an exposed monochrome image is developing a *negative* on one material coated with suitable silver halide emulsion, by-products from its unexposed areas can be made to migrate (diffuse) over to a receiving material and appear there as a *positive* image.

Film packs and single-shot 4 × 5 inch film (in envelopes) largely replaced rollfilm from the 1960s onward. These materials were all 'pull-apart', meaning that you remove a sandwich of exposed and receiving material from the camera, wait long enough for transfer to take place, then pull negative and positive apart. By 1972 original research into chemical engineering added packs of 'integral' type instant material – the kind that are ejected from the camera as a single white sheet that you can watch as the colour image forms.

Evolution of instant-picture materials has always been closely aligned with the design of suitable cameras. This is because, with the exception of reclaimable negatives (page 101), the picture formed in the camera is the same size as the final print. Manufacturers have to trade-off camera bulk against a usefully large picture. Also, with

Fig. 5.14 How peel-apart black and white instant-print material works. Top: the light-sensitive material exposed in the camera, and (far right) print material afterwards sandwiched face to face with it. Rollers break the reagent pod and spread its contents between the two

1: The first, negative-forming phase of processing. 2: by-products transfer and form positive image. 3: peeling the two materials apart. (Moisture-proof paper mask M prevents silver transfer, giving your print white borders, instead of black.) 4: retained final print

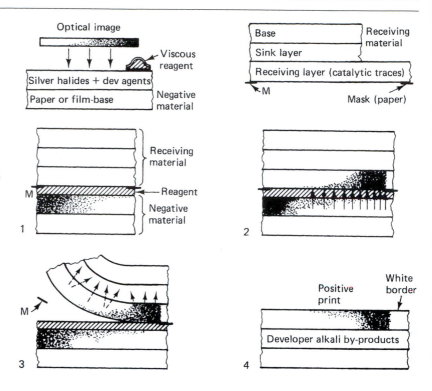

integral materials you only get a right-way-round result if your camera system reflects the image off a fixed mirror, usually built in behind the lens. For this reason, instant-picture backs for conventional cameras (Figures 3.2 and 3.26) still use peel-apart materials.

How peel-apart materials work

The basic reactions within typical peel-apart black and white instant-picture material are shown in Figure 5.14. There are three units:

1. Light-sensitive emulsion containing silver halides and inert developing agents, coated on a film or (more often) a paper base.
2. Receiving material, usually paper or permeable plastic or, in some instances, film. This is non-light-sensitive but contains invisible trace elements, i.e. a few atoms of silver to form *catalytic* sites, as explained later.
3. A pod of reagent, containing a powerful alkali plus silver halide solvent, in jellified 'viscous' form.

In practice, (1) is exposed to the camera lens image, then brought into face contact with (2) with the reagent from the pod spread evenly between them. The actual mechanics of doing this, using a pack back, is shown in Figure 5.16. Inside the sandwich alkali rapidly activates developing agents in the emulsion which develop up a negative black metallic silver image within seconds. The solvent contents of the reagent, overcoming an induction period, next act on the remaining silver halides. These change to soluble silver ions which, if they were in a conventional fixing bath, would diffuse out into solution as by-

Fig. 5.15 Internal reactions during black and white peel-apart processing. Activated developing agent, plus solvent from the reagent, first work on the exposed negative material. Then they encourage formation of a black silver positive in the receiving material. See text

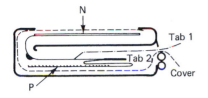

Fig. 5.16 Instant-picture peel-apart film pack. (Only arrangement for one picture shown here.) Rollers are a permanent part of the camera or pack-holding back. Above left: after fitting pack, cover sheet is removed. Light-sensitive negative material (N) now faces lens. Positive sheet (P) is held in rear compartment of pack.

1: after exposure you pull tab 1, bringing the end of tab 2 out between the rollers.
2: pulling tab 2 allows you to remove the whole sandwich from the camera, breaking the pod and spreading reagent at the same time. Negative and positive bases are opaque to light, allowing processing outside the camera without fogging until it is time to peel them apart

products. Here, however, they diffuse out from the emulsion directly into the receiving layer of the print material in contact with it. See Figure 5.15.

Meanwhile, the viscous alkali has also penetrated into the positive material, followed by active developing agents, mostly from shadow areas of the exposed emulsion where there has been little to blacken. The developing agents donate electrons to the catalytic sites they meet in the receiving layer, making them negatively charged. So when soluble silver ions diffuse over from the other material a few seconds later they are attracted to the charged atoms – combining with them to form black silver. Most silver diffuses over from image shadows and least from highlights, so a positive black and white picture forms in the receiving material.

After a suitable period for all this to happen (10–90 seconds, according to the product), you peel the two apart. Your print needs no fixing – the underlying sink layer on the receiving material accumulates and neutralizes the alkali and other chemicals. The negative is thrown away unless it is a reclaimable type (on a film base) which is then soaked in 15% sodium carbonate solution, swabbed clean and dried. From reclaimable negatives you can make enlargements on regular printing paper. Results are excellent, provided your original camera exposure is chosen to give best quality in the negative rather than the instant print.

The physical arrangements for peel-apart prints (i.e. transfer of the picture from paper negative to a receiving sheet) also allow you the possibility of transferring the image by squeegeeing the otherwise discarded negative onto alternative surfaces, such as textured drawing paper. This is called 'Image Transfer', shown on page 270. Another interesting manipulation is to float the emulsion off its regular receiving base – either 'straight' or in a wrinkled or edge torn state – onto a range of new materials. See 'emulsion lift' page 269.

Peel-apart slides

Polachrome instant colour slide films combine an ingenious variation of peel-apart black and white chemistry with an additive system for recording colours. The 35 mm film base with its mosaic of filters (Figure 5.13) has three main layers – a transparent final image-receiving layer next to the base, then a 'release' layer and a top layer of silver halides. You expose the film through the base, then place it inside a small processing unit with a processing pack. Here alkaline processing fluid feeds onto a 35 mm wide plastic applicator band which is wound up in tight contact with the film on a drum. Exposed silver halides are immediately turned into a weak negative while unexposed ones migrate down to the receiving underlayer, where a much denser positive image is formed.

Fig 5.17 Hand operated processing unit for instant 35 mm slide film. Having inserted the film and its liquid chemical pack all stages are carried out in normal light. Total processing time is about 2 min

You leave film and band rolled up together for a set period (typically, 60 seconds) then rewind them back into cassette and processing pack, respectively. As they separate, the applicator band cleanly strips off the film's top negative-carrying layer along with any remaining liquid, and these end up inside the processing pack which you throw away. The film itself is left with an effectively dry positive silver image, blacking out some of the colour filters in different coloured areas, so when the slides are held up to white light you see all the original subject colours.

Other instant-slide materials work on the same basis and give high contrast colour (for line artwork) or have no filter mosaic and give normal or high contrast black and white slides. Since each film comes with its own processing pack the type of developer is always correctly matched to film type.

How electronic (CCD) image sensors work

Silicon CCD image sensors work in the camera in a very different way to film – more approximating the human eye with its retina containing millions of rods and cones to convert light into electronic signals. As described on page 54, most CCD (charge coupled device) sensors consist of a solid grid or 'matrix' of vast numbers of microscopic electrical elements. Looked at in more detail, Figure 5.19, a typical matrix for colour work has each element overlaid with either a red, green or blue filter, each forming what is known as a light-sensitive photosite. (The tri-colour filters are needed to make use of additive colour reproduction similar to the mosaic structure of additive type colour film, see Figure 5.13.) Image light reaching a photosite provides energy which releases negatively charged electrons from silicon atoms. Another layer of silicon directly below the photosites is receptive to these freed electrons, and acts like a container or 'well'. The negative charge built up during exposure and afterwards contained in each well is therefore proportional to the amount of light received by its photosite. In the brightest part of the image a well might hold 100 000 electrons.

Immediately following exposure all charges simultaneously transfer into adjacent 'shift registers' and, as shown in Figure 5.20, are systematically read out of the matrix as a fast stream of signals. The

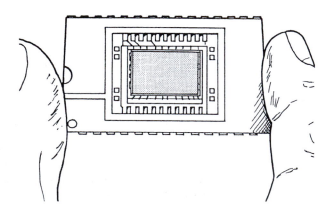

Fig 5.18 A CCD matrix, centre rectangle here, may carry several million microscopic elements (photosites) held in thousands of rows. Each element converts image light intensity into electrical signals

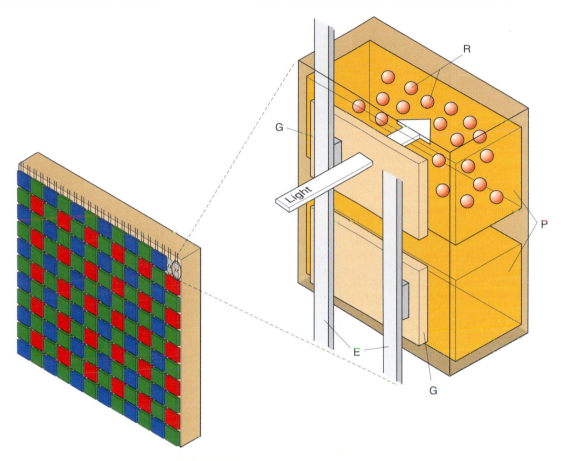

Fig 5.19 Tri-colour filtered CCD matrix detail. Excess of green filters biases light response closer to eye sensitivity. Infra-red absorbing filter (not shown) covers matrix face to counter CCD over-sensitivity to IR. Right: light reaching each tiny photosite releases electrons from the silicon. Every element has a transparent electronic gate (G) attached. A voltage applied via electrode (E) causes silicon area (P) behind exposed element to become a pocket or 'well', retaining these light-freed electrons (R). Charge level present in each well after exposure therefore represents light received. See also Figure 5.20. (Based on Agfa-Gevaert original)

sequence of widely varying image signals next passes through an analogue to digital (A/D) converter, usually built into the camera or back. The converter has a vital role, translating the CCD's continuous range of film-like analogue signals into a stepped series in which each tone value has a numerical value (becomes digital data). Its action is rather like turning readings from a film's continuous characteristic curve into steps on a microscopic staircase. In this way the image becomes a grid of points, each one coded with a number of binary digits ('bits') representing the volume of light it has received.

Bits and bytes

Pictures captured and stored ('filed') in this digital rather than analogue form are immediately available for computer-based applications, Chapter 11. Also being purely numerical, they can be duplicated free from any of the image quality deterioration you have to accept when duping with analogue silver halide materials.

The range of bit values which can be recorded per pixel depends upon the design of the converter. If it offers a bit depth of 3 bits, Figure 5.22, data from one of only 8 separate grey levels can be recorded for each pixel. In practice this is too crude and results in continuous tone images having a 'posterized'-like appearance. So information is chopped into at least 8 bits (256 grey levels) which is the maximum

Fig 5.20 Reading out an image from a matrix CCD uses 'conveyor belt' principle. Post-exposure contents of photosite wells can be shifted, steered sideways or down, by applying different voltage patterns to all the CCD electrodes (Fig 5.19). A: exposure charges are moved together into adjacent and non-light-sensitive vertical shift registers (white circles). B: next each charge is stepped downwards, the bottom charges entering a horizontal shift register. C: charges then step-shift to the end of the register where they are systematically read out before B and C steering procedures repeat for the next horizontal row of photosites. The stream of electronic signals created represents one complete image. Once empty, photosites are reset to receive a new image

A B C

range of grey tones displayed by most computer monitor screens. High resolution camera backs may even output 12 bits (4096 levels) per R, G and B colour – an initial 'super-sampling' even though it may have to be reduced during later digital processing to give manageable size image files.

Eight bits are known as a 'byte' in digital technology, a byte being the standard unit universally adopted to define computer memory storage. The trouble is that huge numbers of bytes accumulate when you have millions of pixel readings to record, particularly in high resolution digital camera back systems. Byte figures become even more overwhelming when you are concerned with storage systems accepting many image files. See page 282. Consequently it is normal to use the term megabyte (Mb), each being 1.05 million bytes; also gigabyte (Gb), representing 1024 megabytes of digital data.

CCD 'speed'

A CCD matrix camera or back has a fixed response – you can't swap it to a faster or slower light-sensitive type like a choice of film. Amateur compacts and computer peripheral cameras most often have CCDs with an equivalent speed rating of ISO 100, although some medium-format 'scan backs' (Figure 5.25) work at ISO 1600. Like pushing film, simplifying small signals from each element in a given CCD increases speed rating but degrades image tonal range (resolution is not lost through 'graininess' because the number of CCD elements remains the same).

Maximum ISO rating depends upon the lowest acceptable signal-to-noise ratio – meaning how weak a light-induced signal from subject shadows can be, yet still significantly overcome the noise or slight background 'dark current' charge which always builds up in CCD elements in the absence of light. Bear in mind too that noise level increases with temperature (it may double with a rise of 10°C) so you must avoid overheating from studio lighting. Overexposure on the other hand overcharges the CCD elements with electrons in the subject highlight zones. The result is a 'burnout' to white, rather like transparency film response. In extreme cases charges 'bloom', meaning that they leak electrons into adjacent elements so that image highlights flare generally or form long white or coloured light trails.

Tonal range and resolution

Exposed accurately, CCDs can capture a much wider image tone range than reversal slide film. A typical matrix is able to record a high contrast scene of around 250:1 (eight *f*-stops). Some trilinear scanning

Units used to denote volume of digital data

1 byte = 8 bits = 256 tones (e.g. black, white, plus 254 possible grey tones in between)*
1 kilobyte (K) = 1024 bytes
1 megabyte (Mb) = 1024 kilobytes
1 gigabyte (Gb) = 1024 megabytes
1 terabyte (Tb) = 1024 gigabytes

* As a comparison 1 byte provides sufficient codes for all the upper and lower case characters and other symbols found on a standard keyboard. 3 bytes (24 bits) provide enough codes for 16.7 million different instructions. 4 bytes can handle 4294.9 million (2^{32}), and so on

Fig 5.21

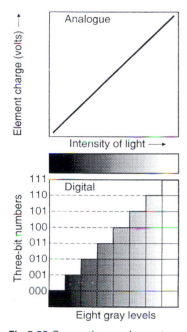

Fig 5.22 Converting analogue to digital. Top: CCD response to increasing light intensity is a continuously rising (analogue) charge. Bottom: a digital converter chops signal into stepped density levels each encoded with a sequence using zeros and ones only. Crude '3 bit' conversion shown here translates response into 8 grey levels only. A 12-bit A/D converter uses 12 zeros or ones per code, designates 4092 different grey levels. For high resolution colour 12 bits for each R, G, B channel may be captured – a 36 Mb file per picture

Fig 5.23 Some removable storage devices for digital image files. Bottom left: 15 Mb PC card. Bottom right: 4 Mb Smart Media card. Top: 270 Mb Syquest hard disk cartridge

arrays may even handle a tone range approaching 1000:1 (or, given a lower subject brightness range than this, provide wide exposure latitude before reaching over- or underexposure). Remember, however, that your final printed-out image on paper is only likely to reproduce about 32:1 or five stops.

Final digital image resolution depends on:

1. The size of your CCD matrix and number of pixels per inch (ppi) it contains or the effective number given by scanning with a CCD linear system. Too few pixels will reproduce curved or diagonal subject lines with jagged edges ('aliasing').
2. Physical arrangements for image sensing. A full colour, single CCD matrix, Figure 5.19, has its elements alternately coated with red, green and blue filters, in order to provide tri-colour readings (like early colour photography, page 98). Gaps in readings between elements filtered the same colour have to be filled in by averaging – using 'interpolating' computer software which reads from adjacent elements. The effect inevitably diminishes resolution, so you need particularly tightly packed pixels in the first place. This is where three separate colour separation exposures onto an unfiltered matrix through R, G and B lens filters (Figure 5.25, right) maximizes the CCD resolution by not needing interpolation. A scanning CCD tri-linear array stepped across the image plane also makes a set of R, G and B readings from every point in your picture. A viewcamera back containing, for example, a scanning array with three rows of 6000 elements that take 7500 line readings gives data for over 40 million pixels during one 4 minute pass across the camera image. So although multi-shot and scan systems seem archaic and are limited to still lifes, they offer advantages for high resolution, large size prints.
3. How have you chosen to save the image on file? Often with a digital camera you have the option of compressing image data in order to reduce each image file size and so, for example, squeeze twice as many pictures on to a given Mb capacity memory card, or shorten transmission time across networks. The most common forms of compression software use 'lossy compression' which inevitably loses some information from each image.
4. The physical size of your final picture. Assuming that 300 ppi in a print appears patternless and sharp to your unaided eye then the number of pixels per inch along each side of the camera's CCD matrix divided by this resolution figure (300) tells you the maximum acceptable size print, in inches. For example, a 4096 × 4096 ppi image could go up to 13.6 × 13.6 inches before becoming less than 300 ppi or, adopting a coarser 150 ppi level acceptable for newspaper reproduction, up to 27 inches square. See also page 258.

Digital file size

In practice there is a big difference between low- and high-end digital imaging systems. A compact or computer peripheral camera (page 56) might use a small one-shot matrix CCD with 500 000 pixels, able to write out a 24-bit depth colour image (or 8-bit black and white). It could record up to 38 images in compressed form, each as a 0.1

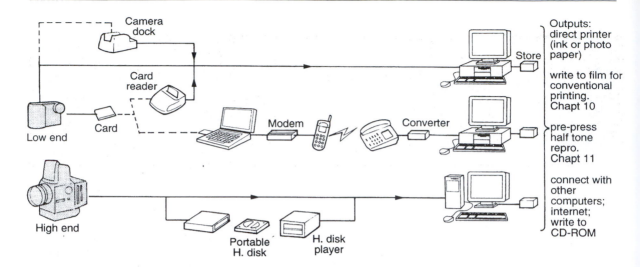

Fig 5.24 So called 'low end' digital cameras are relatively inexpensive, low resolution compacts which record on to removable cards or are linked direct to computer. High end cameras and backs, costly and mostly used in the studio, create huge high-resolution image files. These either read out direct to computer or on to a high capacity hard disk cartridge which may be in a portable recorder. See also Fig 11.22

megabyte file onto a tiny 4 Mb SmartMedia card slipped into the camera's card slot. Files of this small size would write out 6.8 × 5.1 inch prints at the fairly coarse resolution of 150 ppi or make finer 300 ppi prints only 3.4 × 2.5 inches.

At the 'high' end, a tri-colour linear CCD forming a scanning back for a 6 cm square SLR camera may effectively read from 147 million pixels per three-colour scan. This writes out 36-bit depth images each as a 140 megabyte file – seven pictures would fill a 1 gigabyte computer hard disk. Given that your computer equipment can accept and process files of this massive size without becoming very slow (page 284) it will write out prints of 300 ppi resolution 18 inches square. However, the scanning back is likely to cost about 30 times the price of the compact and, being a scanner, remains limited to still-life subjects.

Fig 5.25 Left: scanning system used for some large and medium format digital backs has trilinear strip – three rows of CCDs, filtered R, G and B. This linear array slowly tracks across the camera's focal plane, reading the image over a period of several minutes. Principle is similar to a flat-bed scanner, see Figure 11.20. Right: three-shot system uses an (unfiltered) CCD matrix. Camera gives three exposures in sequence through coloured lens filters. Both arrangements give higher resolution than a multi-filtered matrix, see Figure 5.19, but are limited to still-life subjects

Fig. 5.26 Aliasing. Image photo-graphed off computer monitor and shown on this page resolved at (left) 170 pixels per inch, (centre) 55ppi and (right) 40ppi. The coarser resolutions give diagonal and curved lines a jagged, 'aliased' staircase appearance, the electronic equivalence of grain. Resolution chosen for inputting must be related to the final image size and quality requirements of your output (printing) device. Divide required final image resolution into the number of pixels input across base and height to find max print dimensions. Too few pixels permanently limit you to small prints if the image is to remain aliase-free; too many pixels may overwhelm your data storage capacity and delay every stage of digital data processing time

Summary: How camera materials work

● Colours can be identified in terms of their hue, saturation and luminance. Hue is the basic colour title; saturation (or Chroma) its purity; and luminance (Value) describes its brightness. The Munsell system uses numbered patches on charts against which you can match pigments. The CIE system uses primary coloured lights and quotes any colour of pigment or light through coordinates plotted on a chromaticity diagram.

● Subject colours are the result of selective reflection or transmission by pigments, dyes, etc.; also scatter, interference, diffraction, even fluorescence or phosphorescence.

● Your eye's reception of colour 'adapts' with the intensity and colour of the viewing illumination; fatigue (previous and adjacent colours); eyesight colour defects; and judgement influenced by experience and association. Colour film, however, has a fixed, specified response to subject colours and illumination. Its final image colours are mixtures of just three dyes.

● Most current colour film photography systems use the principle of 'subtractive' reproduction – emulsions sensitive to blue, green and red which go on to form dye images in yellow (subtracts blue from white light), magenta (subtracts green) and cyan (subtracts red), respectively. Dyes are mostly formed by different dye couplers attached to the halides in each emulsion. These react to by-products wherever colour developer forms black silver.

● In colour negatives it is practical to incorporate integral masking to help to overcome image dye colour deficiencies. Magenta dye-forming couplers and cyan couplers are made yellowish and pink, respectively. They stay that way in areas where their dyes are not actually formed to compensate for unwanted absorption of blue and greeny-blue. Negative and slide films also contain developer inhibitors to step up the brilliance of colours without making neutrals harsh.

● Additive colour reproduction – used for the earliest colour materials, present-day instant slides and video/computer monitor displays – works on the principle of a permanent mosaic of primary coloured filters. On films, panchromatic black and white emulsion is exposed through the filters and then reversal processed to 'block up' unwanted colours. The colour dots which are left add together to reproduce all subject hues when viewed against white light. Additive type film materials are slow, results are denser than subtractive types and resolution is limited by fineness of filter pattern.

● Instant-picture materials are founded on diffusion transfer chemistry. They use migration from unexposed parts of the light-sensitive surface to form a positive image in a receiving layer.

● Peel-apart materials comprise a surface coated with light-sensitive emulsion and developing agents, receiving material and a pod of reagent containing jellied alkali plus solvent. Sandwiched together with the reagent spread in between, a black silver negative develops in the emulsion, then the solvent releases salts which transfer and blacken to give a positive print.

● Peel-apart colour slides are exposed through an additive filter mosaic in the film base. Reagent forms a top surface negative and underlying silver positive. Negative (and chemical remnants) are physically stripped off, leaving semi-dry colour transparencies.

● Unlike film, electronic image sensors use CCD chips offering large numbers of pixel photosites. Electrons released by individual sites during exposure pass to a 'well', then read out through an A/D converter as a stream of digital data storable on a disk or card as an image file.

● In digitizing, the number of grey levels which can be recorded from each pixel is indicated by bit depth. 8 bits (= 1 byte) represent 256 grey levels. Since the CCD may contain millions of pixels a complete image file is described in megabyte or gigabyte figures.

● ISO equivalent speed for a CCD depends on chip design. Excessively high rating results in image shadow detail corrupted by 'noise'; overexposure burns out or 'blooms' highlights. Matrix type CCDs can typically record 250:1 subject brightness range.

● Final digital image resolution factors: effective dimensions of CCD sensor and pixels per inch, how the camera image is read (matrix, single- or tri-exposure, or scan); influences of any image compression software; your printout size and equipment. According to the effective number of pixels and bit depth the size of each image file may range from about 0.1 Mb (small compact cameras) to 140 Mb and beyond (large-format scan back). Largest files are slowest to handle, require higher capacity (gigabyte) storage, call for the most expensive camera back CCD system, and will prove unnecessary if you know final images will be reproduced small and/or printed on coarse paper.

6
Lighting control

This chapter gathers together technical aspects of lighting, from principles and aims in illuminating the subject to setting up a studio and choosing tungsten or flash equipment. It looks at practical ways of controlling contrast and colour balance, and out of this shows the roles played by lighting ratios, colour temperature and mired filter values. You also need to control *mixtures* of lighting – natural and artificial or existing light augmented by a photographic source such as flash. In fact, flash has become perhaps the most useful of all light sources for still photography, in or out of the studio. Being able to confidently handle lighting is one important way of controlling the tone values of your final picture. This is discussed further in all its aspects in Chapter 7.

Principles and aims

Lighting challenges you in two ways at once. First, you need to illuminate the subject in such a way that its own important qualities are stressed and it has the right mood to suit your style and purpose. In other words, it must *look* right. Second – equally important and often more difficult – you need the technique to make it appear this way in the final picture. Here the challenge is to understand how the appearances of scenes alter when they are imaged and reproduced on film or paper or the computer screen. Often you have to marginally alter the way the subject looks at the shooting stage, anticipating and allowing for this *photographic translation*, so that the finished result appears just as originally planned.

Lighting control is easier to practise in the studio or at least where subjects and light sources are fairly close to hand. If you are shooting great landscapes or architectural vistas on location, control of lighting is more a question of picking the best time of day, weather and viewpoint.

Aim to avoid these four most common lighting problems:

1. *Excessive contrast*. It is very easy to light something so that it looks bold and dramatic, only to find that it photographs with ugly

Fig. 6.1 Soft, directional light has a simplicity and naturalness which suits a subject of this kind. But despite the soft quality you must still take care over contrast. This picture is on the edge of losing important shadow and highlight detail. Accurate exposure (based on midtones) is important. (By Susie Weeks)

Fig. 6.2 A 'studio-look' top lighting arrangement with plenty of frontal fill-in. Taken by Cecil Beaton, this style spelt glamour in the 1930s influenced by the movies where lighting was mostly hung well above the set. Rim lighting strongly picks out shapes from their backgrounds

burnt-out highlights, impenetrable shadows, and not much in between. Keep contrast down, unless harshness is part of the mood of your picture or shadow shapes are an important element in its composition. Remember, a soft directional light often gives more successful results with a contrast-boosting process like photography than a hard directional light. When a scene looks about right to your eye try to make it marginally less contrasty – perhaps by softening the light source or adding a little more illumination to shadow areas.

2. *Overlighting*. If one light source will illuminate your subject well (often with the help of reflectors) do not use two, three or more sources instead. Adding lights from all sorts of directions makes the scene look unnatural, although you might choose top lighting used this way in the style of old Hollywood movies. Every additional light is really only justified if it has a specific job to do – perhaps illuminate background or foreground, or bounce off a reflector to reduce contrast generally. Without this self-discipline you build up increasing problems such as confused criss-cross shadows. Simplicity is best (see page 122).

3. *Unexpected colour casts*. Beware how readily your eyes adapt to various forms of 'white' light, hardly noticing their different colour content, unless you see them together. Always bear in mind the colour balance of the film you have loaded and how it will reproduce what you see. Be careful when mixing flash with other lighting – its duration is too brief to let you check visually how they match up for colour. Bouncing light off a not-quite neutral wall or ceiling or using incandescent lamps where there are voltage variations can also easily tint results. Unless you are after some well-calculated mood or effect, match the colour balance of film and the lighting as closely as you can. Always carry some light-balancing and correction filters, and, if possible, use a colour-temperature meter (page 116).

4. *Wrong atmosphere*. This is more subjective. It has to do with the feeling that the lighting has worked *against* rather than *for* the character and atmosphere you wanted in your picture. There is always a danger that in striving for technical accuracy – manageable contrast, correct colour lighting, accurate exposure, etc. you throw away naturalness and general ambience. It might be more important that a lighting colour cast helps to convey a sense of warmth or coolness; that contrast strengthens drama or gentleness; and variations in intensity within the picture are used to create emphasis.

Be warned by the sort of pictures some photographic materials manufacturers choose to show off the full colour and tone range of their products, or the lighting approach of television soap type dramas. Here the lighting often gives results with a bland 'photographic' look, purged of the kind of minor idiosyncrasies you experience in real life. Working on location and using existing light as much as possible helps to avoid this pitfall. The greatest risk is in the studio, where so much lighting is on hand and the whole situation is artificial anyway. Never adopt routines slavishly, like following a book of rules. Your technical skills in lighting allow you choices – make them with due concern for eye and heart.

Fig. 6.3 Changes in lighting ratio. By increasing the amount of fill-light from the camera, lighting ratios were (A) 1:64, (B) 1:20, (C) 1:8, (D) 1:4, and (F) 1:1.5. Reproduction here on the printed page has altered some tone values – they only approximate results on photographic bromide paper

(A) (B)

	Maximum subject brightness range	No. of stops
Film:		
Continuous tone		
B & W neg only	1:200	7.5
Through to print	1:128	7
Reversal colour		
slide	1:32	5
Through to colour		
print	1:16	4
Colour neg only	1:128	7–8
Through to print	1:32	5
CCD (colour):		
Matrix	1:250	7–8
Tri-linear array	1:712	9–10*
Final print	1:32	5

* Reduced to 8 stops for computer applications and output to printer.

Fig. 6.4 The subject brightness range (subject reflectance range × lighting range) within which detail can just be recorded at one exposure setting. Often film records more than printing paper will accommodate; you must then select your range of tones on the print through choice of exposure, and improve local areas by shading or burning-in. Similarly the dynamic range captured by CCD is electronically adjusted to meet the requirements of the printing-out device

Practical control of contrast

The brightness range or contrast in a scene is mostly made up from (1) the inherent reflectance range of the subject itself, multiplied by (2) the lighting ratio (lighting contrast). Subject reflectance range means the difference between light readings from the palest and darkest areas of significant detail when your scene is flatly lit. With a subject like Figure 6.3, for example, the difference between the plaster shapes and the background might be 1:4. Lighting contrast means the difference between readings of one element in the picture, where it is in deepest shadow and where most strongly lit. In the case of Figure 6.3C, lighting contrast might be 1:8. Put the two together and the total contrast here is 1:32 (the difference between extremes of the background in shadow and the plaster where it receives most light).

As a general guide (Figure 6.4), reversal films will record a maximum brightness range of about 1:32 with full detail throughout. Monochrome negatives, however, can handle about 1:128, or more if you hold back development (page 157). For the record, harsh direct sunlight on a subject in the open under clear blue sky gives lighting contrast of about 1:10. Related to this, a so-called average subject with a reflectance range of 1:13 gives 1:130 or seven stops total brightness range. Kodak suggest that very few situations give a range greater than nine stops (1:500).

Colour negative film can record a 1:128 range in terms of *detail*, but colour begins to distort towards the extremes of this range. When you include the still more limited range colour paper will accept off the negative it is safer to work within a brightness range of four stops (1:16) or even three (1:8) for critical subjects where both final colours and tone values must reproduce as accurately as possible. Most pictures do not need recording with this degree of colour precision, and you can usually regard five stops (1:32) range as acceptable when shooting general subjects. CCD sensors in digital cameras and backs capture a greater dynamic range than most colour films.

When controlling your lighting contrast:

1. Remember broadly the capabilities of the light-sensitive material you are using. Reduce your lighting ratio for colour films, especially reversal types.

(C) (D) (E)

Ratio

1:200

1:19

Fill-in adds 10

1:5

Fill-in adds 50

Fig. 6.5 How 'filling-in' shadows reduces lighting contrast. Top: no fill-in. Shadow part of subject receives only one two-hundredth of the illumination in lit part. Centre: adding reflector which redirects 10 units to both lit and shadowed parts drops ratio to 1:19. Bottom: boosting light from the reflector directs 50 units towards subject. Ratio is now down to approximately 1:5

2. Look at the subject reflectance range. A black cat in front of a white wall, for example, cannot take as much lighting contrast as a grey cat against a green hedge.
3. Think whether the shot really *needs* detail from brightest highlights right through to deepest shadows. If you can accept darkest parts as featureless black then increase lighting contrast and expose mostly for highlights and midtones.

To reduce lighting contrast, position a white reflector surface to add general diffused illumination into the shadow side of the subject. Outdoors, you can wait until parts of the sky away from the sun contain more cloud, change viewpoint or move your subject so that a nearby white surface acts as reflector. For more contrast reduction, illuminate this reflector with flash or some other suitable form of artificial light. Alternatively, change to a main light source which is physically larger and which gives softer quality illumination.

In the studio this may mean fitting a 'soft box' (Figure 6.16) or tracing paper over your light source or bouncing its illumination off an umbrella, reflector board or white wall. When working outside, wait until the sun is diffused, or shoot totally in an area shaded from the sun and illuminated only by light from the sky (but beware of colour-temperature changes, see below). Remember, however, that, unlike shadow-filling, anything you do to soften the quality of your main light also makes shadow edges less clear-cut throughout the subject.

With experience you can judge the combined effects of subject and lighting contrast by eye with reasonable accuracy, but it is far better to play safe and actually measure ratios. Here you appreciate the value of a camera or hand meter which gives spot readings, or at least allows close-up brightness range readings from highlight and shadow areas. See also page 151.

Colour temperature

For accurate colour photography it is essential to relate the colour of your lighting to the colour balance of your recording medium. When shooting digitally, CCDs can be electronically matched in sensitivity to most kinds of light source by means of white balance setting. Adjustment may be fully automatic, or you can pick any neutral

surface, such as a standard grey card within the scene, as reference point. Silver halide films, however, lack this flexibility. They need to be chosen either colour balanced to the same colour temperature as your light source (for example, daylight or tungsten photo lamps) or if this is not possible adjusted by a filter over the camera lens or lighting unit. This means having a working knowledge of colour temperature and its measurement.

What it means

Colour temperature is the handiest way of expressing the colour content of a light source. When a solid metal body is heated it becomes incandescent (glows with heat). Sources like this, which include the sun, tungsten lamps, etc., give out light of all wavelengths and are said to have a continuous spectrum. However, the relative proportion of short and long wavelengths produced varies quite widely, and depends on the temperature of the source. For example, if you have two 100 W household lamps, one run at correct voltage and the other underrun at a fraction of correct voltage, the underrun lamp is not only less bright but gives a more orangey illumination. Similarly, if you compare correctly run 500 W and 100 W lamps, the weaker source gives out a higher proportion of red wavelengths and a lower proportion of blue ones. It looks more orangey-red.

You could express the relative proportions of wavelengths for different continuous spectrum sources by a graph like Figure 6.6, but it is much quicker to quote a single 'colour temperature' figure, which is formally defined as follows:

The colour temperature of a white light source is the temperature in kelvins (K) of a perfectly radiating black body when emitting light matching the source under test.

The term 'black body' here means a piece of material dark enough not to reflect incident light and radiating continuously and evenly

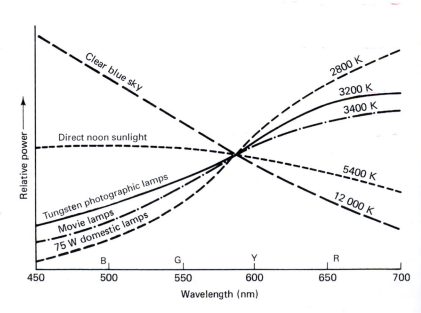

Fig. 6.6 Spectral energy distribution curves for some white light sources. Each contains a 'cocktail' of all the visible wavelengths – some rich in blue and depleted in red, others the reverse. They can also be described by their colour temperatures, in kelvins

Fig. 6.7 Natural daylight is by no means consistent in colour temperature, as these figures show

Daylight conditions	Co... Lowest	
In shade (light only from blue sky)	12 000	
In shade (light only from hazy sky)	7 500	8 4...
Sunlight + light from clear sky, midday	6 000	6 500
Sunlight + light from clear sky, morning or evening	5 700	6 200
Sunlight + light from hazy sky	5 700	5 900
Direct sun alone, midday	(Average = 5 400)	
Direct sun alone, morning or evening	4 900	5 600
Sunlight at sunset	1 900	2 400

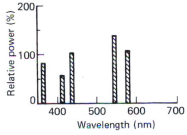

Fig. 6.8 Spectral energy distribution graph of a mercury vapour lamp. Only bands of wavelengths are produced. This lamp gives out no red wavelengths at all

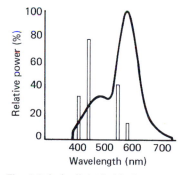

Fig. 6.9 A daylight 'white' fluorescent tube produces a mixture of band and continuous spectra. This is suitable for colour photography, but will probably need a magenta camera filter to reduce green

throughout the spectrum when heated. As it is heated it first glows a cherry red, then orange, and slowly the predominant wavelengths tend to move towards blue or 'white hot'. At any point, therefore, the colour proportions of the light can be described by the 'colour' temperature of the body, expressed on the Absolute scale, in which the unit is named after the scientist Lord Kelvin. 273 K equals 0°C.

Remember that a light source rich in red and yellow and deficient in blue wavelengths has a low colour temperature. For example, a typical candle flame has a colour temperature of 1900 K. A source producing more blue, fewer red wavelengths has a higher colour temperature – the filament of a 500 W tungsten photographic lamp reaches about 3200 K. The 'direct noon sunlight' colour temperature (an average, measured at ground level throughout the year in Washington, DC) is 5400 K. However, as Figure 6.7 shows, daylight can change considerably, according to time of day and atmospheric conditions.

Limitations to colour temperature

As the whole concept of colour temperature is based on the colour of a material heated to incandescence, non-incandescent sources (fluorescent tubes, sodium lamps, etc.) which create light by other means cannot strictly be given a colour temperature figure. In fact, spectral power distribution curves like those in Figure 6.8 show you that some give a 'discontinuous' spectrum. The energy is given out in lines or bands with great gaps where no wavelengths are produced at all. (This is why mercury vapour street lights make most red-painted objects appear black, no matter how bright or close the lamp may be.)

Fortunately, most fluorescent tubes now used in retail shops, light boxes, etc. are of the 'colour-matching' kind. The tube gives a continuous spectrum overlaid with a fluorescent band spectrum from the tube coating (see Figure 6.9). It can therefore be given an equivalent or 'correlated' colour temperature. The same applies to photographic flash tubes. These have line spectra due to their gas filling but, because of pressure and the high density electrical discharge, the lines broaden into bands which overlap to become continuous. Typical and equivalent colour temperatures are shown in Figure 6.10. Another problem is that you may have the correct colour light *source* for your film but the colour temperature of illumination

Fig. 6.10 Colour temperatures for some typical light sources. CRI stands for Colour Rendering Index, quoted by fluorescent tube manufacturers. HMI lamps use a metal halide arc and provide flicker-free illumination for the duration of the long exposures needed by digital scan backs. See Figure 6.29

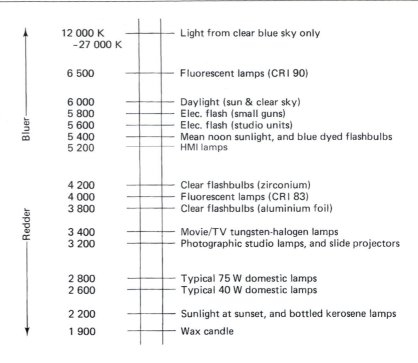

12 000 K –27 000 K	Light from clear blue sky only
6 500	Fluorescent lamps (CRI 90)
6 000	Daylight (sun & clear sky)
5 800	Elec. flash (small guns)
5 600	Elec. flash (studio units)
5 400	Mean noon sunlight, and blue dyed flashbulbs
5 200	HMI lamps
4 200	Clear flashbulbs (zirconium)
4 000	Fluorescent lamps (CRI 83)
3 800	Clear flashbulbs (aluminium foil)
3 400	Movie/TV tungsten-halogen lamps
3 200	Photographic studio lamps, and slide projectors
2 800	Typical 75 W domestic lamps
2 600	Typical 40 W domestic lamps
2 200	Sunlight at sunset, and bottled kerosene lamps
1 900	Wax candle

Bluer — *Redder*

Fig. 6.11 Colour-temperature meter. Light is measured through the flat white diffusing disc near the top. Meter is presently programmed for daylight type film, and reads out reference for the colour compensation filter needed over camera lens or light source. Programming buttons allow you to select readout in kelvins, and to make settings for other types of film

reaching the subject is not right because of one or more of the following reasons:

1. A lamp is used at a voltage lower or higher than the correct rating (see Figure 6.31). (This does not apply in the same way with flash tubes, which are fed from storage capacitors. So variations in the supply alter the *time* these capacitors take to recharge.)
2. The light is bounced off a reflector or passed through a diffuser (or lamp optics) which are not quite colourless. Similarly, close-coloured surroundings just outside the picture area tint the subject.
3. Atmospheric conditions filter sunlight (see Figure 6.7).
4. Other types of light source with different colour temperatures are present, strong enough to influence results.

Colour-temperature meters

If you always shoot colour in your own studio, with your own lighting and other known conditions, most of the difficulties above can be avoided. However, where the lighting is uncertain – especially with indoor assignments on location – it is very helpful to check out colour temperature with a special meter. A typical colour temperature meter has three silicon photocells filtered to detect blue, green and red under an integrating diffuser (see Figure 6.11). The meter circuits compare the *relative* responses of the three colours to obtain a profile of the spectral content of your lighting. For example, tungsten lamps make the red cell give a stronger response than the blue one, whereas daylight produces an opposite effect.

Colour-temperature meters are always designed to make incident light readings from your subject position because, if pointed directly,

'Warm up' filters (positive mired values)		'Cool down' filters (negative mired values)	
85B	+127	80A	−125
85	+112	80B	−110
85C	+86	80C	−81
81EF	+53	80D	−55
81C	+35	82C	−45
81B	+27	82B	−32
81A	+18	82A	−18
81	+10	82	−10
CC20M	+8	CC30G	-10
CC10M	+4	CC10G	-4

Fig. 6.12 The mired shift values of some Kodak filters

they would measure the colour of the subject instead of the colour of light reaching it. Note, too, that within the meter's operating limits the *intensity* of your lighting is unimportant. The instrument's cells can still make their comparisons whether the illumination is a 60 W lamp or brilliant sunlight. Good professional meters can also read the colour of brief-duration sources such as flash. You point the meter with its white diffuser facing towards the camera, preferably from the subject position or at least where it receives the same lighting. Pressing a button gives a direct readout in kelvins. Alternatively, you pre-program some meters with the colour balance of the film you are using, whereupon the readout gives the value of any correction filter needed.

Colour-temperature meters are expensive but, together with a good range of filters, they offer insurance to any photographer aiming for lighting colour accuracy on location. They are also helpful to check for faults and changes in the studio. Remember that the meter is designed to read continuous spectrum light sources. It will give rogue readings of sources such as lasers or most sodium or mercury vapour lamps because they all emit lines or bands of wavelengths with gaps in between (Figure 6.8). This confuses the meter's sensors.

Mireds

Colour temperature meters may read out any correction filter you need in terms of a 'mired value' instead of a manufacturer's reference number. For example, instead of Kodak 81 the meter may display +10M. In fact, all filters for colour-correction work, whatever the brand, tend to have a mired rating as well as a number (see Figure 6.12). You would think it would be more straightforward to simply have filters marked as having, say, 50 K or 100 K colour-temperature effect upwards or downwards. The trouble is that the actual colour content of light sources does not change pro rata with colour temperature. So a filter which raises colour temperature by 100 K at 2800 K has a 130 K effect at 3200 K and a 300 K effect at 5000 K (see Figure 6.13). (This is because the colour-temperature scale is based on physical temperature rather than proportional colour content.)

To solve the filter calibration problem you convert kelvins into MIcro REciprocal Degrees by dividing the colour temperature into one million.

Mired value = 1 000 000 divided by colour temperature in K.

For example, the mired value of 2800 K household lamps is 357M, whereas type B colour film is designed for 3200 K (312M). A filter to

Fig. 6.13 Why mireds are used. Below left: the relative blue content of an (incandescent) light source does not increase proportionally with colour temperature. Therefore a bluish filter, which has a fixed upward influence on blue content, causes more change of kelvins when illumination is 5000 K than when 2800 K. It cannot be given a 'kelvin shift value'. Below right: by converting kelvins into mireds you have a regular scale directly relating to blue content. A filter has the same 'mired shift value' at high and low positions on the scale

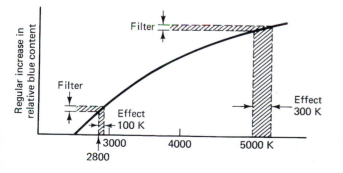

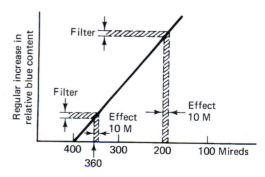

Colour temperature (K)	Mired value
6500	154
6300	159
6000	167
5800	172
5600	179
5400	185
4200	238
4000	250
3800	263
3400	294
3200	312
3000	333
2800	357
2600	385
2400	417
2200	454
1900	526

Fig. 6.14 Kelvin/mired conversion table

balance the film to the lamp needs a mired shift value of –45, or as near this as possible. Used with photo-lamp lighting of 3400 K (294M) the same filter would change the colour content to 249M, which is 4000 K. Notice how the first change of 400 K has become a change of 600 K, in terms of the colour-temperature scale. A filter can therefore be given a mired shift value (+ or –) which holds good, irrespective of the colour temperature of the light source. Notice also that the higher the mired value, the lower the colour temperature. So 'warm-up' yellowish-orange filters have positive mired values and 'cool-down' bluish filters have negative ones.

Another useful feature is that the effect of filters can easily be added together. If your meter, or simple calculation, shows that a +127M filter is needed to colour balance the light source to your film you can either use a Kodak 85B (+127M) or combine an 85 (+112) with an 81A (+18). If mireds are not already shown on your filter containers, calculate and mark them up. If you have a colour-temperature meter you can finally check any proposed filter by holding it over the sensing head and remeasuring your light source. The meter should show correct colour. Sometimes filters and colour-temperature meters quote 'decamireds' instead of mireds. One decamired equals 10 mireds.

Practical control of colour

Using filtration

Even if you do not have a colour-temperature meter, keep a selection of colour-balancing and (paler) colour-correcting filters in the camera case to cope with lighting or environments you know will give colour-cast results on your film. Have straight conversion filters like an 85B and 80A, plus some weak yellow or red colour correctors such as CC05Y, 10Y, 20Y, etc. Stronger values can be made up by combining two of these gelatin filters.

You will also want CC filters to improve results when a job allows test shots to be exposed and processed first. Remember, when you are viewing reversal film test results with a cast you should look through colour-correcting filters of the complementary colour until image *midtones* look accurate. Then reshoot using a filter half this strength over the lens. For example, if a bluish slide appears corrected seen through a 10Y filter, use a 05Y over the lens. Make your assessment over a lightbox containing colour-matching tubes. Do not use this technique on instant pictures when you intend to shoot finally on regular colour film. Instant-picture materials differ slightly in their response to filtration.

Another useful filter is an 81A or 81B to warm up the somewhat cold light delivered by some flashtubes, and for outdoors a pale-pink or CC 05R helps to compensate the bluish result that some films give under sun-plus-blue-sky conditions. When shooting film from which prints will be made do not assume that negatives (or slides) can be fully colour corrected by filtration at the enlarging stage. Optimum quality comes from having correctly colour-balanced film originals in the first place.

The amount by which colour temperature can be in error before results show a noticeable colour cast varies with film type and subject. Latitude is about 10 mireds either way on tungsten type slide film when

the picture contains mostly pastel tints and the subject is easy to assess (for example, Caucasian skin tones). Daylight film and bold colours tend to be less noticeably affected by a slight cast. Greater errors of colour temperature in kelvins can be tolerated at the high (daylight) end of the scale than at lower (studio lamp) levels.

Take care if your film's ISO rating is given for when used with a conversion filter. For example, 'ISO 200 in daylight; ISO 80 in tungsten using an 81 filter'. It is easy to set your in-camera meter for the filtered speed and then read exposure through the filtered lens – accidentally doubling the compensation.

Mixed lighting

Avoid mixed lighting (light sources of two or more different colour temperatures illuminating the same scene) whenever you want accurate subject colours. This is where filtering the camera lens is of little help. Instead, you can:

1. Filter one of the light sources to match the other. Some acetate sheeting is made for this purpose, so if, for example, you are shooting interiors mostly lit by tungsten lamps you can cover the outside of windows with orange 85B acetate to make the sunlit view match internal details. (Acetate is tougher and cheaper than gelatin filter, although optically too poor for lens use.) Alternatively, place blue 80A acetate filters over the tungsten lamps only, and then shoot on daylight film.
2. If no subject movement is involved and you are using a tripod, split the exposure into two halves. In the example above you can put black material outside the windows and shoot on tungsten light type film. Then remove the blackout, switch off the interior lights and give the second half of the exposure with an 85B orange filter over the lens.

Even on colour negative film it is extremely difficult, if not impossible, to correct a mixed lighting colour shot during colour printing. You may end up having to have an important job expensively airbrush-retouched or computer manipulated.

Do not become obsessive about colour temperature/film balance matching. The whole point is to have *control* so that you can make *choices*. What exactly is it you are trying to show in your picture? The classic case here is the photographer who ruined a romantic evening landscape by shooting it through a blue filter because the setting sun

Fig. 6.15 Mixed colour temperature lighting. White plasterwork within this room is lit by a 3200 K tungsten lamp, while details beyond the bars are in daylight. It was shot on daylight type slide film (left), and on tungsten light film (right)

was a lower colour temperature than regular daylight. A portrait with an orange cast may look a disaster in close-up or against a plain background giving no indication of environment. However, the same orangey face becomes acceptably natural when the picture also shows a fire in the hearth, a red shaded lamp and generally warm surroundings. Do not destroy the very atmosphere which attracted you in the first place.

Mixed lighting also allows one or two attention-grabbing special effects. For example, you might photograph a figure out of doors in daylight surroundings but in shadow, lit up locally by 3200 K tungsten lamps. When exposed onto tungsten light film this figure detail records correct colour but miles of surrounding landscape has a dreamlike, strongly blue-biased appearance.

Working environment

It is essential that unwanted tinted light should not find its way to your subjects in the studio. Any windows should have shutters or blinds so that when you are using unfiltered tungsten lighting there is no risk of mixing in any daylight. Internal finishes must be colourless – preferably neutral-grey floor and matt-white walls and ceiling. Even white paint yellows with age, and since you will often bounce light from these interior surfaces they will need regular redecoration. Beware of coloured background papers left hanging on the wall which easily create a cast on a nearby set through reflected spill light.

Other factors which upset the colour balance of your lighting are discoloured diffusing materials used over the front of soft boxes and window lights (Figure 6.16) as well as lamp reflectors and bounce boards. If necessary, hire a colour-temperature meter for the day to check out your environment and equipment from time to time. Remember, even your own clothes can create a local colour-cast (for example, if you wear a highly coloured shirt when working with the camera close to your subject). Do not mix flash units from different manufacturers and avoid shooting with studio flash on low power but with its tungsten modelling lamp at full power (it may just add an orange cast). Where you have to work in an improvised studio, use barndoors, snoots and honeycombs to restrict your lighting to where it is really needed, instead of spread over possibly coloured surroundings.

When outdoors, remember the influence of surrounding greenery, coloured walls, posters, etc. on the colour balance of your lighting. This is where folding white reflectors are so useful to 'clean up' the light as much as to reduce contrast. Electronic flash and daylight have the same colour temperature in theory, but in practice most self-quenching built-in or hand flash units do increase their CT to 100–200K higher than their full power performance when reduced to 1/16 or 1/32 output, because this increasingly clips the warm 'tail' of flash output. More significantly daylight varies according to time and weather conditions. So although using fill-in flash may produce matched colour around noon in direct sunlight, at other times the flash may look colder than the ambient lighting. A warm-up filter over the flash head is the answer. Some photographers position a small square of orange filter over the centre part of the flash head just to warm the colour slightly. It is always best to use a colour-temperature meter to forecast what filtration to use when your subject matter is critical.

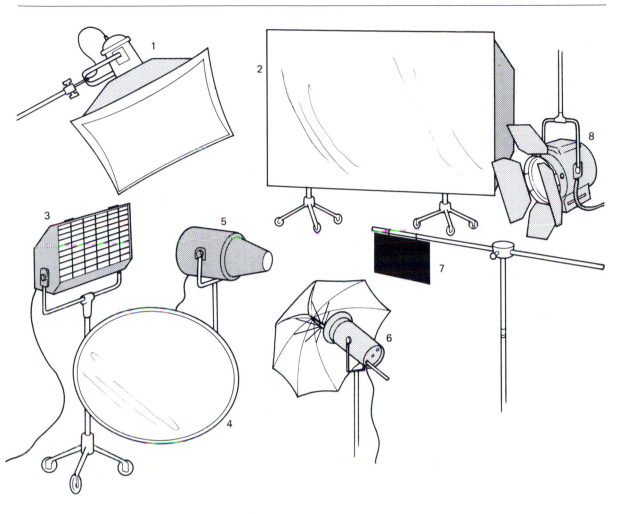

Fig. 6.16 Some lighting equipment and accessories. 1: studio flash head with a soft box fabric diffuser. 2: window light – fabric or opalized plastic over several flash tubes. 3: tungsten floodlight (internal bounce reflector). 4: portable diffuser hoop filled with white fabric, twists into figure of eight for packing into camera bag. 5: flash head or tungsten head fitted with metal snoot to limit light spread. 6: flash head bounced from white-lined umbrella to soften light. 7: 'flag' useful to shade backlighting from lens, or to shadow a part of subject. 8: ceiling-track slung tungsten spotlight, fitted with light-restricting barndoors

Guidelines for lighting

Aim to be able to create any chosen lighting effect, no matter whether the light source be tungsten studio lighting, flash, daylight or some form of existing artificial light. With *all* these sources the following six guidelines apply:

1. *Lighting quality* (hard or soft) is controlled by the size of the light source relative to its distance from your subject. A large, relatively close, diffused source always gives softest shadow shapes; a compact, distant direct source gives the most hard-edged shadows.
2. *Direction of shadows* and position of highlights in the picture are controlled by the height and direction of your light source relative to the subject and the viewpoint chosen for the camera.
3. *Contrast* or brightness range of the picture you present to the lens is the combined result of your highlights-to-shadows lighting ratio and the subject's own reflectance range, discussed on page 112. Brightness range is best controlled by the amount of 'fill' light you can introduce into the shadows.

4. *Evenness* depends on the relative distances of the nearest and the furthest parts of your subject from the light source. Evenness improves with a more distant and softer light.

5. *Colour content* is controlled by your type of light source and any colouring influences (filters, reflector surfaces, etc.) it meets on its path to the subject. With incandescent lights colour also alters with change of voltage.

6. *Intensity* depends on the light output and distance of your source, plus any light-absorbing material it may pass through or be reflected from before reaching your subject.

Unless you are after theatrical effects, the aim of most artificial lighting is to create a general sense of naturalness. After this, it should emphasize the form, shape and texture of your subject, wherever you decide these features are important and relevant. Third, it may contribute to the 'atmosphere' of the shot through colour, softness/harshness, etc. When aiming for naturalness in the studio, remember the features of typical daylight conditions – light coming predominantly from one light source, directed from above rather than below your line of sight. There is always *some* light present in shadows.

All this means that if you switch on a spotlight in a darkened studio you will not simulate direct sunlight. Your lighting is more like the sunlighting astronauts experience in space, because nothing reaches your subject from the rest of the 'sky'. Any subject under a single hard light will need some shadow fill from reflectors (large and distant or smaller but close) to begin to look like natural sunlight. You can help the situation by simulating hazy daylight, enlarging the source itself perhaps by changing from spotlight to a soft box or window light, or just bouncing your spotlights off a large area of white wall or ceiling. Softened light has many advantages. It gives more gentle, subtle modelling of shapes; it avoids conflicting shadows in pictures containing a complex mixture of objects; and it reduces contrast and unevenness.

Of course, there are many situations where one light (even a soft source) cannot adequately model subjects with complex multi-plane forms or illuminate and separate foreground, mid-distance and background. For example, your subject, as lit by one source, may seem to disappear into a black abyss. Here your second light source can be put to work to brighten or accent the background from a position to one side or below. Another separation technique is to backlight the main subject from above and behind, to give some mild rim-lighting. Here you need a barndoor or flag between light and camera (Figure 6.16) to shade the lens from flare. Try to avoid this effect looking unnaturally like a second sun.

Complex subjects such as furniture or machinery, with many planes or facets to be shown, often need a second light. Do not have both sources at equal heights, equal angles to the camera or equally bright. Symmetry in lighting is seldom a virtue unless you are copying. Try to make one (or both) of the units a soft source. Pick height and direction to make every subject surface and plane in the picture a different intensity, and remember that it often helps to create depth and distance if front surfaces are darker than top or sides. You may need your second light source simply to fill shadows to a level not possible with reflectors just bouncing back some main light. In this case, the extra light needs

Fig. 6.17 A multilayer studio subject (the key and ribbon are on glass) which needs several light sources. Tim Imrie used three tungsten spotlights. One was tightly directed on the top key from the top right. Another side lit the keys below, and the third was diffused and amber filtered to fill in the shadow side from bottom left

to be soft and shadowless, perhaps diffused or wholly bounced. The skill is in deciding just how much fill is appropriate to the subject and the mood you want to create as well as fulfilling the recording medium's technical requirements.

Third or fourth lights may be necessary to tackle some of these functions in difficult situations, but, all the time, try to make *one* source predominate (the one which gives the main shadows). Every additional source must have a clear role or it will only complicate matters. Good professional lighting often has an incredibly simple look.

Combining flash and continuous light

Various kinds of interesting lighting possibilities occur when you combine flash with existing light. Be sure that the flash and the other light source match in colour temperature unless you want special effects. For example, you can orange filter the flash to match tungsten. It is best to work with a camera which has a shutter offering a wide range of speeds

Fig. 6.18 Never overdo fill-in flash. For natural effects it pays to underexpose the flash by at least two stops, diffusing it or bouncing it to give soft light directed mostly from the camera. The camera settings here remained 1/30 second at *f*/16. In the far right version flash diffused with tracing paper was added, used at one quarter correct power for this aperture

for use with flash. Some cameras with dedicated flashguns have automatic facilities you can select for techniques such as fill-in flash. However, there is more scope if you have your flashgun set to manual, and, when using a camera offering a range of exposure modes, set this to manual as well. Then experiment with the following routines.

Fill-in flash

The function of fill-in flash is to reduce the lighting ratio by adding illumination to the shadows formed by existing light, so you need the flashgun mounted on the camera, and preferably diffused. Work as follows:

1. Measure exposure from midtone parts of the subject lit directly by existing light (use a grey card if possible). Take the reading for a shutter speed at or longer than the flash-synchronization speed. This might, for example, work out at 1/60 second at *f*/11.
2. On the flashgun set an ISO number (arithmetic) four times your film's true ISO rating. Read off the flash-to-subject distance for *f*/11 or calculate it from the gun's Guide Number.
3. Shoot at this distance to get a flash: existing light ratio of 1:4.

 If the distance is too great for your subject matter to fill up the frame, turn down the flash to half power or fit a flash neutral-density filter or diffuser which halves the illumination. Then come about one third closer to your subject. If, on the other hand, the distance is impractically close, change to 1/125 second at *f*/8 (provided 1/125 is within synchronization range). Then you can move back until about one and a half times as far from the subject, keeping the flash at its original power.
 Use similar manoeuvres to work at a smaller or larger aperture when depth of field is important. A powerful flashgun with a full range of controlled manual outputs – full power, 1/2, 1/4 and so on down to 1/32

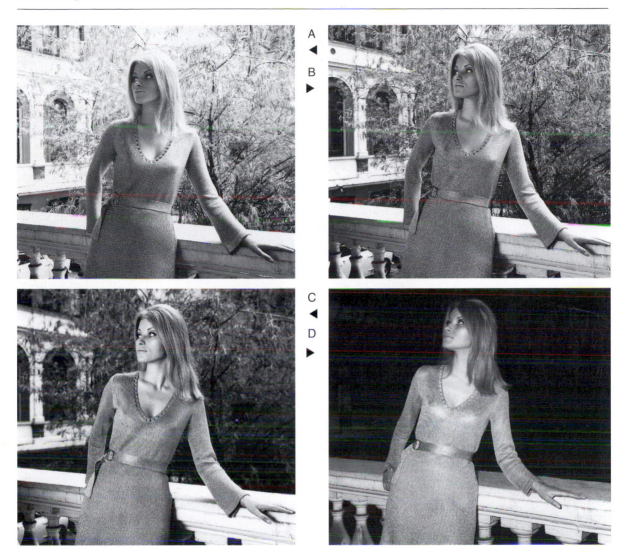

Fig. 6.19 In this series different intensities of fill-in flash were combined with different camera settings to maintain the same flash exposure. Unlike Figure 6.18, this makes a sunlit environment change appearance from natural daylight through to a night scene. A: one eighth full flash output, 1/60 second f/8. B: half full output, 1/125 second f/11. C: full flash output, 1/250 second f/11. D: flash distance halved, 1/500 second, f/16. (Camera had a bladed front shutter suitable for flash at all speed settings)

power is ideal for fill-in flash technique. Just bear in mind that colour temperature rises slightly with lower-powered (shortened) settings, page 120. Whenever possible, bracket your results with variations of flash power, and if in doubt always *under-* rather than *over*fill.

Overlaid mixture of sharpness and blur

This is a combination of a relatively long exposure time, while you move the camera, and movement-freezing flash. Results (Figure 6.20, for example) show near parts of the scene sharpest, with background highlights streaked, giving an impression of action. The existing light should not be too bright, especially on the foreground. If necessary, work in an area of shade. Have your flashgun on the camera.

1. Load slow film.
2. Set a slow shutter speed, somewhere between 1/15 and 1/2 second.

3. Take a general existing light reading and set the aperture indicated for your shutter setting.
4. Set your flash power so that it gives correct exposure at this aperture for the distance between flashgun and the nearest part of the main subject.
5. When you shoot, purposely pan, rotate or jog the camera. Sometimes you have to fit a neutral-density lens filter to avoid overexposing in daylight, and change to a more powerful flashgun to keep flash exposure correct.

Most cameras fire the flash when the shutter first opens, so if you are panning the scene blur lines may extend into the 'leading edge' of the flash-frozen detail. In some instances your subject seems to be hurtling backwards. If your camera shutter offers 'second blind sync', opt for this mode, and the flash will fire just before the *end* of exposure, which avoids the problem.

Do not overlook the value of flash just to help 'sharpen up' a fairly long exposure you are forced to hand-hold. For example, in dim lighting conditions you may have to set a 1/15 or 1/8 second shutter speed to record surroundings by ambient light and preserve a naturalistic effect. This makes sharpness a gamble, however steady your hands may be, but by the addition of some (underexposed) flash from the camera you ensure that nearest objects at least are exposed at 1/1000 second or less. At worst, they will record as a mixture of sharpness and blur which is often visually acceptable.

Fig. 6.20 A mixture of (camera) movement blur and sharp foreground detail frozen by flash adds an unreal element to this picture by Andrew Heaps. For results like this use about 1/2 second shutter speed. See page 125

Foreground objects 'shadow' scene detail behind

This surreal effect images all detail sharply, but moving objects in the foreground seem to cast a shadow on the background (landscape, for example). The result is like a three-dimensional object in front of a two-dimensional billboard or stage scenery. Pick a scene in which the general level of illumination is again low – preferably with the ambient light making the background area brighter than the main (foreground) subject, even to the extent of semi-silhouette.

1. Load slow film.
2. Set the shutter for around 1/8, 1/15 or 1/30 second, depending on subject speed. The more the subject's image shifts during exposure, the larger (but less dark) the shadow formed.
3. Take a general existing light-reading of the background area only and set an aperture which will underexpose this by one stop.
4. Set your flash output, or filter or diffuse the head, to give correct flash exposure for your main subject distance at this aperture.
5. Shoot with the camera static while the subject moves. The 'shadow' forms where the underlit moving subject blocks out background detail while the shutter remains open. As before, the shadow tends to appear *ahead* of the subject's direction unless you use second blind sync (or arrange for the action to take place backwards).

Flash as 'sunlight'

Flash here is used to add the appearance of hard, directional sunlight when your actual ambient subject lighting is excessively flat and dull. You need a powerful flashgun connected to the camera by a long lead.

1. Set the shutter to a speed suitable for flash.
2. Take a general exposure reading of the subject, then stop down two settings beyond the *f*-number shown for your shutter speed.
3. Position your undiffused flashgun high and about 45° to your subject, at the correct distance from it for the *f*-number in use. Think carefully about where to place the flashgun (have it held by an assistant or set up on a tripod), because having it too low gives an impression of light at sunset. Do not attempt to 'sunlight' large areas either – this technique suits portraits, architectural detail, carvings, etc. Also, avoid having the flash so close to your subject that its light is uneven and no longer looks natural. If necessary increase the distance and turn up the power.

Fig. 6.21 Near right: shot in existing, overcast daylight, 1/60 second at *f*/8. Far right: same daylight but shot with a flashgun held two metres to the right of urn; 1/60 second at *f*/16, the correct aperture for this flash outdoors

With all these flash-plus-other-lighting routines remember that when your flashgun is used outdoors its effective Guide Number (subject distance × *f*-number) becomes less than the figure printed on the gun. This is because published guide numbers assume that you are working in an average domestic interior surrounded by 'average' reflective ceiling, walls, etc. Outdoors, the light that these surfaces would return to the subject is lost. Try working with a Guide Number about two thirds normal as a basis for your own tests.

Invisible (infra-red) flash

If you filter your light source so that only infra-red wavelengths reach the subject you can record the image on infra-red-sensitive film, but no one around at the time will see any illumination or imagine that pictures are being taken. Electronic flash units, like tungsten lamps, deliver a good proportion of infra-red radiation along with visible light. The easiest way to work is with flash on the camera. Tape a visually opaque, infra-red-passing filter such as a Kodak 87 tightly over the window of the flashgun so that no visible light can escape. Use black and white infra-red film (see page 79). As for exposure, try using a Guide Number *half* what it would be if you had no filter and used regular ISO 100/21° film.

If you want to work in complete darkness, position and clamp the camera and pre-focus the lens in normal lighting first. Alternatively, use an autofocus camera and flashgun which sends out a weak pulse of infra-red from a separate window just prior to the flash, allowing the autofocus mechanism to focus whatever is currently centre frame. In practice, you can often shoot under dim half-light which is sufficient to focus and frame up (but too dark for people to realize that you are actually taking pictures). If there is much ambient light around you could also fit an 87 filter over the lens. This will then absorb most of the ambient lighting but pass the flash (already filtered and invisible). However, since you can no longer see through the lens of an SLR camera it is easier to work with a direct viewfinder camera instead. Infra-red flash results have the same 'unearthly' appearance – pallid face, dark eyes – of infra-red portraits in daylight (see page 80).

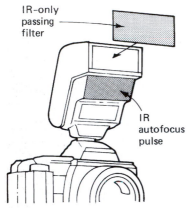

IR-only passing filter

IR autofocus pulse

Fig. 6.22 Fitting a black-looking, IR-passing filter over the flash window allows you to take pictures without the flash seeming to fire. The flash unit may also have an IR pre-pulse unit for autofocusing

Fluorescent (ultra-violet) photography

Certain materials fluoresce and 'glow' in the dark with white or coloured visible light when they are radiated with (invisible) ultra-violet wavelengths. Plastic jewellery, dayglow inks or poster paper, shirts of manmade fabrics, even washing-up liquid and teeth all glow to a greater or lesser extent. Most blue-rich light sources emit ultra-violet, including sunlight, mercury vapour ultra-violet health lamps and purple-dyed display spotlamps or strip tubes. As Figure 6.24 shows, the light source should include a filter which allows ultra-violet but very little visible light to reach your subject. All films are sensitive to nearest ultra-violet wavelengths, so you must stop the ultra-violet itself reaching the film while letting through the visible light from the fluorescing subject. This means filtering your lens with a (clear-looking) ultra-violet absorbing filter such as a Kodak 1A.

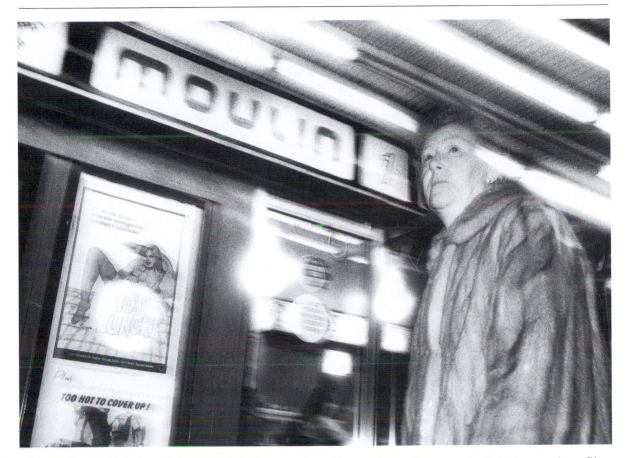

Fig. 6.23 Camera shot from the hip, using infra-red filtered flash on IR film. The flash could not be seen going off, and the subject had no idea she had been photographed. An exposure time of 1/15 second also picked up brightest ambient lighting in the background

It is best to shoot fluorescing colours on daylight type colour film, working in a blacked-out studio with your subject lit by one or more ultra-violet health lamps or spots. These units are so heavily filtered that they only give out a dim blue glow plus a great deal of ultra-violet you cannot see. Fluorescent parts of your subject now glow brightly, and, provided that there is an ultra-violet absorber over the lens, the film will record exactly what you see. (Without the filter the subject records as if doused with blue light, blotting out most colours.) Often you need to add a little general visible light, or the fluorescent parts float in a sea of black. So introduce a low level of daylight from the side or rear, perhaps by partly opening a window blind and diffusing incoming light. Judge correct balance by eye. Measure exposure from the fluorescing parts using regular reading techniques with your camera or hand meter. Avoid staring directly at any UV lamp unless your eyes are protected with UV-absorbing goggles.

Planning a studio

The studio itself

You may not need your own studio if you work in a large town or city. The chances are that you can hire a fully equipped photographic studio by the hour or day as required for jobs, passing on the cost to the client. Again, your kind of photography may be so location based – travel,

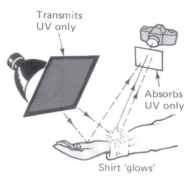

Fig. 6.24 Some materials glow with visible light when illuminated by (invisible) ultra-violet radiation. To record what you see filter out the reflected UV which would otherwise record too. See Figure 6.35

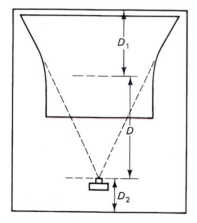

Fig. 6.25 Planning a studio space. For useful workspace D_1, plus D_2 should equal D, which is lens-to-subject distance. This plan as drawn is for a 46° angle of view lens

Fig. 6.26 An office divided from the studio by large folding doors (below) allows you to use the whole area for large sets (right)

architecture, documentary, sport, etc. – that you can just work out of a darkroom and office. For most photographers, however, a studio forms a base in which to experiment, accumulate props, have time to build sets you can photograph and check before dismantling, and generally work on into the night if necessary. Your studio represents privacy and technical convenience, and although at other times it might have to revert to barn, garage or even sleeping quarters, no professional photographer should really be without one.

Studios are hardly ever too big, and it is probably true that sets expand to fill, or exceed, whatever space is available. Shape and height are as important as size, and a simple squarish/rectangular floor plan is much more flexible than a room with additional corners and alcoves (see Figure 6.25). To decide size, think of the largest subject you are likely to tackle and the longest camera lens focal length you would want to use on it. Then the distance you will need between subject and lens will be the height of the subject divided by the negative height, multiplied by focal length. For example, a full-length figure with ample space top and bottom might be 2.5 metres high. Shooting with a 6 × 7 cm camera and 90 mm lens you need to be 3.2 metres away, or with a 165 mm lens the distance is 5.9 metres. On top of this, you must add space to work behind the camera, plus sufficient room behind the subject for a separately lit backdrop, backlighting, etc.

The area you can light from different distances can be worked out from polar curves published for lamps or lighting units fitted with a reflector. A polar diagram such as Figure 6.28 plots the spread of light from the source, so you can relate this to a plan or scale model of your proposed studio.

Most still-photography lighting units are supported and moved around on rolling floor stands, but if the ceiling is high enough (over 3 metres) you have the option of fitting ceiling track to carry tungsten or flash units, see Figure 6.27. Rigging some of the lighting overhead gives you more floor space and fewer cables to walk over, but make sure that units track easily between a wide range of positions, or your lighting may start to become stereotyped.

A good studio should have at least one window of generous height and width to allow you to work in daylight. Organize shutters or a blind to reduce window size and so produce harder lighting quality at will. You must also be able to black out the studio completely to avoid mixed lighting. Consider access carefully, especially if you expect to move large objects, lighting booms, backgrounds, etc. in and out of the studio. Floor-to-ceiling double or folding doors are best here, ideally leading

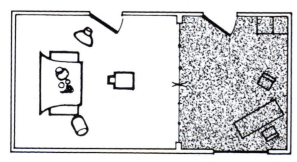

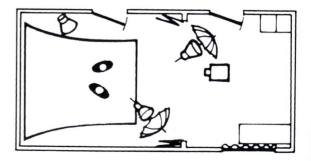

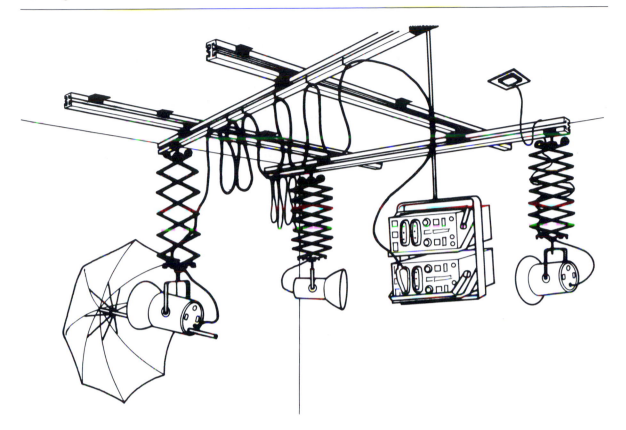

Fig. 6.27 In a studio with a tall ceiling some flash-heads and powerpacks can be suspended from track. The lower beams here supporting lamps can be pulled along the cross-beams above. Suspension gear is spring counterbalanced, making lamp-heads effectively weightless. Packs and monoheads are triggered by IR pulse from camera directly outside or into an elevator or corridor free of awkward corners or stairs.

Make sure that studio electricity supplies are ample to power all the lighting you can plug in at one time. Have plenty of sockets distributed around the studio, mostly in corners and alcoves, where they are out of the way of sets and backgrounds. Surface finishes must be matt-white or black, with the floor perhaps neutral grey. Floors should be flat, even and solid enough not to vibrate if someone is moving about during a time exposure.

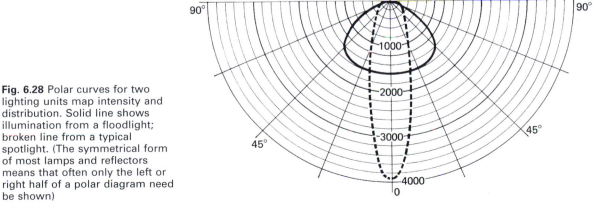

Fig. 6.28 Polar curves for two lighting units map intensity and distribution. Solid line shows illumination from a floodlight; broken line from a typical spotlight. (The symmetrical form of most lamps and reflectors means that often only the left or right half of a polar diagram need be shown)

Fig 6.29 Continuous flicker-free light sources suitable for digital scan-back cameras. Left: units containing HF fluorescent tubes. Right: HMI discharge lamp with ballast unit. Both types work at a colour temperature matching daylight and flash

Fig. 6.30 Tungsten lighting units. A: boom with fabric soft-light head. B: tungsten halogen hard light (lamp can be wide or narrow beam focused in reflector). C: tungsten flood using folding umbrella. D: fold-open twin lamp unit with own reflector board. E: small flood clips onto other units, tops of doors, etc. All fabrics suitably heat-resistant. See also Figure 6.16

Continuous studio lighting

Most lighting units used in the studio contain tungsten halogen lamps, which are more efficient, compact and consistent than conventional filament types. Where the unit is designed to give soft-quality lighting the illumination is spread into a larger area source by being directed into a reflector or through a diffuser (Figure 6.30). Lamps vary in size and shape, cap type, working voltage, wattage and the colour temperature they give out at correct voltage. You can buy most photographic types in a choice of either 3200 K or 3400 K (the latter colour temperature is standard for movie film). Avoid mixing up these two. The visual difference is slight, but 3400 K gives a cold cast on tungsten-light colour films. Photographic lamps are quite expensive, and for black and white work you can greatly extend tungsten lamp life by reducing voltage by, say, 10% through a resistor or transformer. However, do not try doing this for colour photography – underrun lamps also drop in colour temperature (Figure 6.31).

Remember that for digital photography with a linear scanning camera back, page 58, any continuous light source you use must be flicker-free. An HMI (Hydrargyium, Medium-arc Iodide) lamp is one solution – this is a daylight balanced compact discharge light source giving a high level of illumination. Unfortunately HMI units are very expensive. Lower cost lighting units are made containing four or six high frequency fluorescent tubes either in grid form or bunched together to give harder illumination. See Figure 6.29. Neither give out as much light as an HMI source.

The main advantage of a continuous light source over flash is that it is easy to see exactly what effects you are going to get. The precise position and quality of a shadow or highlight and the balance of

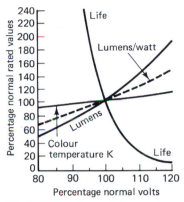

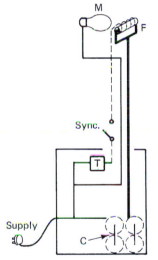

Fig. 6.31 The effects of decreasing or increasing the voltage applied to a tungsten lamp. Reducing the supply greatly extends life but reduces colour temperature; also fewer lumens of light are produced per watt consumed, and illumination dims

Fig. 6.32 Basic schematic layout of an electronic flash fitted with modelling lamp. Electricity from normal household supply builds up a charge in capacitors (C). A second circuit powers modelling light M close to the flash tube. A third circuit runs through step-down transformer (T) and contacts in your camera shutter or other triggering device to a wire passed around the outside of the flash tube (F). When this 10–12 V circuit is closed it lowers the resistance of gas in the tube, allowing the capacitors to discharge through it with a brilliant flash. At no time does high voltage pass through the triggering circuit

brightness between one source and another are easily checked by eye. Having continuous light makes it easier to take subject-brightness range exposure readings, and you may have the option to show movement through a controlled degree of blur. You can even move a light unit during exposure to spread and soften its lighting effect (see light-hose, page 137).

Studio flash

Flash illumination, on the other hand, creates little heat or continuous glare (big advantages for portraiture). The light output is consistent, even when there are minor supply voltage fluctuations. This is because the tube is powered by a pulse from storage capacitors and only indirectly from the supply. Flash, of course, freezes camera shake or subject movement, giving you much greater freedom to move around the studio. Also, provided that each flash head has a tungsten modelling lamp matching the flash tube in size and position you can preview the direction and evenness of your lighting. Accuracy is greatest with soft light heads.

Most popular studio units give a flash of 5500 K or 5600 K colour temperature. This is less blue than small hand-flash units, but tests may show that it is still advisable to use a very weak warm-up filter for some brands of daylight slide film. Turned down to fractional power the flash from a good studio unit should not alter appreciably in colour temperature. Like any other lighting unit, however, colour temperature may also differ according to the reflector, diffuser or other accessories you may use with the head. A colour-temperature meter (page 116) will check this out for you. Do not mix different brands of flash in the same studio.

The duration of studio flash is typically 1/500–1/1000 second, but this changes according to the proportion of power you select to be discharged and whether this is split up between a number of heads. The same studio unit may deliver a 1/400 second flash at full power using one head or 1/1000 second at fractional power with three heads plugged in. Remember this when shooting fast-moving subjects (pouring liquids, dance, moving mechanisms, etc.). The more your flash unit is turned down, the more 'frozen' the subject will record. Self-quenching portable flashguns give you an even wider range of flash durations, as short as 1/40 000 second at close range.

In general, studio flash is designed in two forms – an all-in-one monobloc unit, or a powerpack ('generator') with separate plug-in heads. See Figure 6.33. Monoblocs are cheaper and lighter but less powerful. By combining powerpack and flash head you have a compact single unit you can mount onto a floor stand or track, and plug into the electricity supply just like a tungsten lamp. Separate powerpack units accept a variety of heads which can include ring flash, strip tubes or even a front-projection unit (Figure 6.34). These give a wider range of lighting than is possible by simply adapting a monobloc via clip-on reflectors and diffuser units. The generator rests on the floor forming a weighty base to one of the flash heads or it hangs from track for you to adjust controls, the heads being located freely on the track like the tentacles of an octopus.

The power of a flash unit is usually quoted in joules (or the equivalent 'watt seconds'), but this refers to the maximum energy the

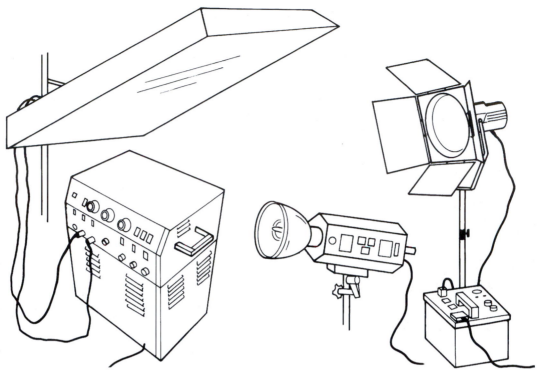

Fig. 6.33 Electronic flash heads with separate or integral powerpacks. Left: large window light powered by 5000 Ws powerpack. Several other types of heads can be plugged into same unit. Centre: 500 Ws monobloc unit. The powerpack is directly behind the reflector. Right: 2000 Ws separate powerpack flash accepting up to three heads. All flash heads contain modelling lamps

tube receives from the power unit, ignoring what type of head and reflector are fitted. So it is more practical to know exactly what exposure Guide Number the equipment provides. International practice here is for the Guide Number quoted in sales literature to mean use of ISO 100/21° film and the head fitted with a reflector giving about 65° spread (light measured at 2 metres). Modelling lights are often quite high intensity – helpful to see the effect when lighting is bounced or heavily diffused. This means that you often have a blower built into the

Fig. 6.34 Front-projection flash unit. Flash unit (F) illuminates transparency (T) which is imaged by a projector lens and reflected off 45° one-way mirror (M) towards special 3M Scotchlite screen (S). Beaded screen material is highly directional, reflects light back along same path through mirror to camera lens. The less reflective figure appears in silhouette in front of a brilliant image of background detail. You illuminate the figure separately, from any angle beyond 25° to the lens axis. Any light reaching the screen from this flash is reflected back to source, so does not wash out the background. Have a dark studio wall behind the camera to eliminate stray light too

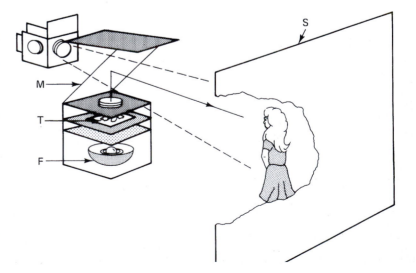

head to prevent overheating. Powerful modelling lamps can be dimmed (manually or automatically) pro rata to flash output. You can also photograph just using the modelling lamps alone as continuous light sources. However, if you shoot colour in this way ensure that all lamps are running at the same colour temperature, matching the colour balance of your film.

If you do not have a flash meter a studio flash with modelling light can be read with an ordinary (non-flash) exposure meter or camera TTL system. First, discover the illumination relationship between lamp and flash, as follows:

1. Light a subject in the normal way using, say, two flash heads set to equal power and having matching modelling lights.
2. Take a meter reading, and note down the shutter speed/aperture combination it gives.
3. Take a series of flash exposures bracketed at different-guessed *f*-numbers and check results to see which one was correct. Now check back to see what shutter speed your meter gave for this *f*-number. Forget that it refers to the shutter – just remember it as your 'datum mark' for flash readings. Next time you shoot with this flash equipment, repeat stage (2) but read off your aperture for flash as the *f*-number shown opposite the (shutter speed) datum mark.

Fig. 6.35 Fluorescent product label lit up by a UV lamp from front left. Weak tungsten light from the rear picks out shapes, gives a warm cast on daylight film. See page 128

Even with a fairly low power unit, remember that you can shoot still lifes, room interiors and other non-moving subjects with a *series* of flashes, provided the camera is on a stand. A second flash (after pausing for recharge) doubles the light, and so allows an extra stop depth of field. A total of four flashes allows you to close the aperture two stops, and so on. Another reason for repeat flashing is to give the effect of several light sources by moving the unit between flashes. This way you can light a long room from various hidden flash positions. However, if you are now illuminating different areas with each flash the exposure must be based on the average distance between flash unit and subject for any *one* flash.

Microflash

Occasionally you need to produce 'frozen' pictures of very fast-moving images. Flying insects in close-up, sprays of water droplets, breakages, collisions, even small explosions are all likely to be beyond the capabilities of normal flash. You can then hire or buy a microsecond flash unit, as used for scientific recording work. A microflash will give a flash lasting one millionth of a second. At this duration its photographic effect is much weaker than normal studio flash, especially when you add the influence of (short-duration) reciprocity failure on the film. So expect to have the flash quite close, and use fast film if you must also stop well down. For critically timed action such as breakages, work in a darkened studio with the shutter open – then use a sound or infra-red beam-breaking trigger (page 52) to make your subject fire the flash. Unfortunately, microflash shots of some rapid actions give you all the detail but results look too unnatural. So you can add in longer-duration regular studio flash to contribute some blur. Synchronize both units together either by subject trigger or shutter.

Fig. 6.36 Microflash shot of rifle bullet passing through a balloon at about Mach 1.4 (450 m/s). Taken in a darkened studio with the camera shutter locked open and flash triggered by microphone and delay system. (Dr Gary S. Settles and Stephen S. McIntyre/Science Photo Library)

Studio lighting accessories

Each manufacturer of tungsten or flash lighting units provides a supporting cast of interchangeable accessories. These include lighting supports (wheeled or folding stands, clamps, booms) and all kinds of beam shapers and diffusers which you attach over the front of the head. Beam shapers mean wide- or narrow-angled conical reflectors, snoots, honeycomb grids, barndoors and flags, all of which help you to restrict light to where it is needed. Clipover diffusers, soft boxes and umbrellas are all devices for turning compact, hard light sources into large soft ones, albeit with loss of intensity.

You can buy accessory spotlight optics to fit over the front of a flash head and its modelling light. This hardens up the light and gives a controlled beam like any tungsten-focusing spotlight. Another accessory, useful for still lifes, is a fibre-optic attachment (Figure 6.37) which 'pipes' light from a flash tube or suitable tungsten lamp into some difficult location (to pick out some key area, for example). This way you cán duct light into an architect's scale model building or introduce it as a light source into a tank of water. The flexible, stranded glass fibres duct the light without heat, very helpful for delicate subjects such as flowers and some foods. However, fibre optics must be designed for photographic lighting purposes. Some fibre systems green-tint the light they are ducting.

A further extension of this type of illumination is to use a long, flexible optic hose (for example, *Hosemaster* system) to 'paint' still lifes with light. This means working in a darkened studio with the camera shutter locked open, handling the end of the hose like an air brush or paint brush and continuously moving a patch of light systematically over the subject from different angles. According to the area you choose to illuminate, how fast or slowly you paint, and your 'brush' distance, the balance of tone between different objects or between objects and background can be uniquely controlled. Also you can slip a diffuser over the lens when lighting, say, the background and

Fig. 6.37 Fibre-optic attachment fits over front of studio flash head, piping heatless flash or tungsten light to any small delicate subject (at S), or adding local colour (above)

Fig 6.38 'Hosemaster' kit for painting with light. Main box contains a powerful xenon lamp which transmits its light via a long fibre optic hose to any of a choice of plug-on heads. Lighting can therefore range from a narrow beam to softer 'highlight shapers'. Each head carries a cut-off shutter button

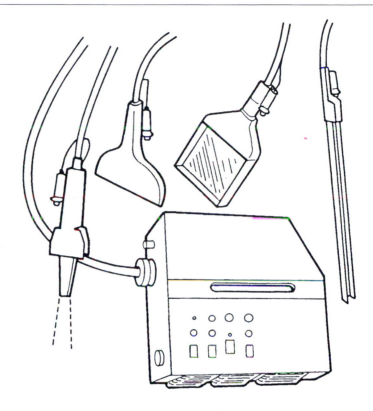

supplementary 'props' but remove it when painting your main subject. The resulting image then shows soft focus and spread highlights only in the areas you chose to place them – an effect impossible by any technique other than post-shooting digital manipulation.

Choosing lighting equipment

Really, you need both continuous and flash lighting equipment, for each of their particular advantages. Opinions vary, but still photographers equip their studios primarily with flash, keeping some modest power tungsten units for special situations – where movement must be shown, for example. (Flicker-free continuous light is also essential for scan-back electronic image work in the studio, whereas flash is a better choice when using a one-shot matrix CCD system because of reduced heat.) You should find lamps of 650–1000 W amply bright for still photography, unless you are lighting cars or huge room sets. Overpowered lights create problems of both heat and space. Remember, too, that it is easier to soften a compact, hard-quality light unit (by bouncing or fitting diffusing attachments) than to harden up a broad, soft-quality lighting source.

If you are equipping with flash make sure that the system you are buying into is sufficiently versatile to give a wide range of lighting. Check the range of accessories. Consider an infra-red or photocell slave triggering unit as essential, as well as an umbrella or soft box. Be certain that spares such as modelling lamps are easily available,

especially if equipment is foreign. Flash units of monobloc design are handiest to use on location as well as in the studio, but separate powerpack systems are more powerful and often more convenient when several heads are wanted. They also accept a wider range of flash head types and accessories.

As for power, a pair of 500 Ws monoblocs may be sufficient for 35 mm work at wide apertures, but if you are shooting large format the extra stopping-down needed may justify a system giving 5000 Ws or more, at about ten times the price. Flash output reduction in percentage steps is a worthwhile feature, especially for exposure bracketing and to allow some choice of flash duration. Carefully compare flash recycling time (the period power storage capacitors need to fully recharge for the next shot). Studio flash recycles faster than most battery flashguns, but a 5000 Ws unit can still take 5 seconds at maximum power. This is insignificant for a still life, but a long delay for action subjects. Some lower output units are designed to recycle in 0.3 second, which means you can work them with a motor-drive camera or create strobe type multi-image effects.

Think too about the general styling and visual design of your chosen system if it is to be used in public – after all, it *is* a part of your professional image. Studio electronic flash is an expensive investment and you need to thoroughly assess what you intend to buy. The best way to do this is to hire a set of the proposed equipment and try it out on typical subjects under your own working conditions.

Location lighting equipment

Here your choice naturally depends on whether a household type electricity supply is available. Even if it is not, you may be able to carry in the back of the car a small petrol engine electrical generator. This can deliver a steady 1 kW or so of power – not much use for tungsten lighting units but enough to power a pair of regular monobloc 500 W/second studio flashes with modelling lamps. Some flash units are specially designed as portable kits, and will operate through appropriate power converters from household/generator supply, your car battery (see Figure 6.39) or NiCad batteries. Using studio type flash on location in this way allows you to light subjects even in the middle of a field or on the beach.

There is a wide range of lightweight, open-fronted quartz-iodine tungsten lamp units. Typically, output ranges from 500 to 1500 W. Most are designed for video/movie work and produce hard light and much heat. They are best used bounced. By adding a heat-resistant blue filter you can convert colour temperature to 5500 K – useful when you are supplementing daylight.

Battery-powered units

One or two battery-powered tungsten lamp 'sun guns' are made primarily for video news gathering. They give hard light, which can be somewhat softened with a small clip-on diffuser. Each gun is powered from a battery belt or hip-slung accumulator and typically operates for

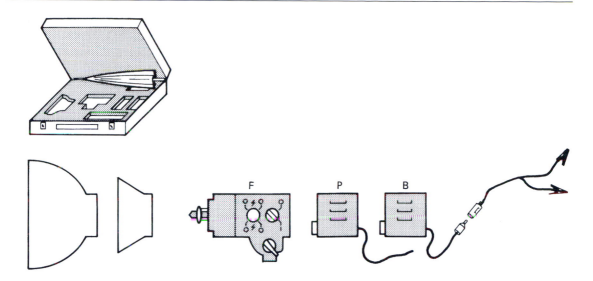

Fig. 6.39 Compact location flash kit. Main 250 Ws flash unit (F) contains circular flash tube, modelling lamp, and power level controls. Power converter (P) is used with regular household electricity supply. Alternatively unit B allows supply from car battery, via cigar lighter socket or through battery clips

Fig.6.40 The performance of an alkaline battery hand flash changes with temperature. At 20°C you can fire 300 flashes with this unit before its recharging time exceeds 10 seconds. At 0°C only 100 flashes are possible. (Tests based on flashing immediately unit has recharged)

about 20 minutes per charge. Recharging them takes 6–8 hours. Sun guns are not very practical for still photography when there is such a range of sophisticated flashguns available instead.

Battery-powered hand flash differs from studio flash in several important practical features – it is self-contained, cheaper, offers no modelling light and is less powerful. Flashguns tend to have maximum Guide Numbers ranging from about 15 to 60 (metres), depending on the unit's size and design. (This compares with a GN of 40, typical for a small 400 Ws studio unit, up to around GN300–400 for 5000 Ws equipment.) A flashgun of GN30 is barely powerful enough to act as a main light source if you intend to bounce the light or use it outdoors off-camera, unless you keep using fast film and wide apertures. It pays to have ample light output and not have to use *all* the power with *every* flash. A professional-size gun allows you to work at fractional power, for fill-in work or to gain a rapid recycle rate, but also switch to full power for when a diffuser, wide-angle beam-spreader or filters are attached.

Choose a flashgun which tilts for bouncing and accepts an extension trigger lead, as well as a slave cell for when it is used off-camera and fired remotely from another flash (for example, on camera). The gun might be a dedicated or own-sensor type (Figure 6.41) but it must also allow you manual operation. A good choice of output ratios will help you tackle techniques using flash with other light sources discussed on pages 123–127.

Some 'long-peak' electronic flash guns give out a prolonged, steady flash of about 1/25 second. This allows synchronization with the full range of 35 mm focal plane shutter speeds and consequently offers you more choices of *f*-number to use with fill-in flash and similar techniques. However, bear in mind that although you have this wide choice of shutter settings without having half the picture missing due to mis-sync, the faster shutter speeds progressively give you less light. The same thing also happens with bladed shutters. Using a long peak flash means that the Guide Number changes with shutter speed, and a gun with a Guide Number of 30 at 1/60 second or longer may only give GN12 at 1/2000 second.

Fig. 6.41 Near right: basic circuit of self-regulating flashgun (batteries not shown). C: light sensor behind pre-set neutral density filter. Some types use apertures of various sizes instead. A: analogue control chip. T: thyristor switching device. C: main capacitor, feeding flash tube. Far right: light reflected from subject to sensor causes a small charge to accumulate. When this reaches a set level the flash is terminated. So the closer or paler your subject the briefer the flash. (Blacked-out sensor setting is manual mode)

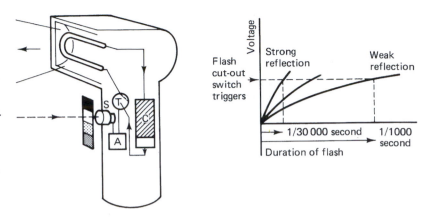

A range of accessories are made for flashguns. Many are unnecessary or can be improvised instead. Some reduce light output you can ill afford to lose. It is, however, useful to have several flashguns, each one either cord-linked to the camera or 'slaved', so that, where circumstances permit, you have almost the same scope for creative lighting as in the studio. However, do not mix flashguns of different brands – any differences in colour temperature (5500–5800 K) may show up in your results.

Lighting and safety

Mishaps with lighting are a common cause of accidents in photography. Here are some safety guidelines:

1. Lighting heads are potentially most unstable when their floor stands are extended to full height. Make sure the whole unit will not topple over if a cable is tugged – clip the cable to the stand at floor level. Weigh down the base if a sudden gust of air might bowl over a unit (a monobloc head with umbrella or softbox fitted and raised to the top of its stand is especially vulnerable).
2. Try to run cables where they will not be walked over or stood on. Do not overload cable with too many lights through the use of distributor boxes or adaptors. Avoid powering a lighting unit through cable tightly coiled on a drum. Electricity can heat a coiled-up cable until it smoulders.
3. Do not drape materials over incandescent lamp sources to diffuse or filter light. Use the proper fittings which space accessories away from hot surfaces. Fires can also start from litter (for example, background paper) trapped between electrical plugs and sockets.
4. Lights or powerpacks suspended from ceiling track *must* be fitted with safety chains. Always *raise* these overhead units after use; similarly *lower* floor standing units.
5. Electricity and water (including condensation) do not mix. Avoid storing or using lighting where it may come into contact with moisture unless specially protected first.
6. Never open up an electronic flash to attempt to repair it. Units are not intended for user servicing, and even a small flashgun may give

Fig. 6.42 Regular flash is so brief it can only be used with a focal plane shutter that opens fully at some point in time (near right sequence). This flash may be fired when the first blind is fully open, or just before the following blind starts closing for mixing sharpness and blur, see page 125. Long pulse flash, however, is slow enough to use with faster shutter speeds where only a slit moves across the focal plane. It fires when the first blind starts to open (far right sequence) and maintains even light until the shutter has completed its action

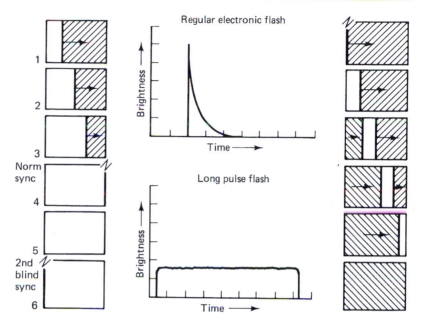

you a shock. Do not disconnect, or reconnect, a flash head to a fully charged powerpack because this may cause contacts to 'arc-over'.
7. Make sure all your lighting equipment is efficiently grounded ('earthed').

Summary: Lighting control

● Lighting must have the right visual effect on your subject, but at the same time anticipate changes that will occur when the picture is recorded onto film. Main points to avoid are: excess contrast; unwanted colour casts; lighting which is technically correct but atmospherically wrong for your theme.
● Subject contrast = subject reflectance range × lighting ratio. The less the reflectance range, the higher your lighting ratio can be. Guide total subject contrast limits for detail in both shadows and highlights is about 1:128 (black and white); 1:32 (reversal films); also 1:32 for colour negatives, but 1:8 where colour is critical throughout. CCD sensors ratio (matrix) 250:1. Also (tri-linear scanning array) 712:1, although thereafter reduced to suit computer needs. The best way to control lighting contrast is through different strengths of fill-light.
● The higher the colour temperature (degrees Absolute, in kelvins), the greater the blue wavelengths, the less red wavelengths. However, non-incandescent sources may not give out a continuous spectrum and, at best, have only a colour temperature *equivalent*. Films are mostly balanced for 3200 K or 5500 K. CCD systems can have colour sensitivity adjusted via 'white balance' setting. Lighting colour changes occur with wrong lamp supply voltage; non-neutral reflectors/diffusers, or coloured surroundings; atmospheric conditions/time of day; and when different colour temperature sources are mixed.

● A colour-temperature meter measures your light source for the *proportions* of red, green or blue wavelengths present, reads out in kelvins or mireds (micro reciprocal degrees). M = 1 million divided by K. Filter mired shift values (+ or −) remain constant whatever colour-temperature source they are used with. The effect of combining filters is shown by adding their mired values.

● Have conversion filters and colour-correction filters, and preferably a colour-temperature meter. When slide results show a cast, reshoot using a filter *half* the strength needed to correct slide midtones visually. Errors of 10 mireds can give noticeable casts. Aim to match lighting to film colour balance, even with neg/pos colour. If mixed lighting cannot be avoided filter one source to match the other, or split your exposure and use a lens filter for one part as necessary. Have neutral surroundings and matched light sources in the studio; on location, white reflectors help to 'clean up' coloured environments, but do not be obsessive and destroy atmosphere.

● Basic principles of quality, direction, contrast, evenness and colour apply to your lighting, no matter what the source. Most lighting schemes should be simple and naturalistic, but this should not prevent you from experimenting.

● For combined uses of flash plus existing light set your camera and flash to manual. Control fill-in flash by exposing for existing light, then adding flash (on camera) at quarter correct power. Using flash with slow shutter speeds produces mixtures of sharpness and blur, depending whether camera or subject moves. For synthetic sunshine use correctly exposed flash (positioned well off the camera) and underexposed soft existing light. Remember, flash GN is reduced when working outdoors.

● Flash filtered to give out only infra-red forms an 'invisible' source to use with black and white infra-red film. Fluorescent materials which glow under ultra-violet light record on daylight colour film as they appear to the eye, provided you use a UV-absorbing lens filter.

● In planning a studio, consider shape, size, removable blackout, decoration, ventilation, electrics (placing of sockets and total loading), access from outside. Hardware will include continuous light or flash units, either on floorstands or hung from track. Match up the colour temperature of all your tungsten sources – usually to 3200 K. In black and white work lamps can be underrun for economy. Digital photography using a scan system calls for flicker-free fluorescent tubes or HMI light sources.

● Studio flash, mostly monoblocs or power units with plug-in heads, works at 5500–5600 K. Typical flash duration is 1/500–1/1000 second at full power. Output is rated in watt-second (Ws), typically 500–6000. Unless otherwise stated, the Guide Number quoted is for ISO 100/21° film, using the flash head in a standard reflector. Each flash (and modelling lamp) can be stepped through a range of power output ratios. Exposure is best read by flash meter, but you can measure the modelling light with an ordinary meter and calculate flash exposure from this. For freezing ultra-fast subjects hire a microflash.

● Aim to have both tungsten and flash studio equipment, with a range of accessories for beam shaping, diffusing and bouncing light. Fibre optics allow flash or tungsten light to be ducted into difficult areas and pick out local detail. This can be taken further by selectively 'hose-piping' continuous light onto your subject in a darkened studio. Powerful flash outfits are more costly than most tungsten systems.

● Working on location, use lightweight QI lamps or portable studio units. If necessary, power them from a small petrol generator. When choosing a flashgun pick one having a Guide Number over 30, with manual mode and fractional power ratios and facility to slave at least one other head. For critical colour work with a self-regulating flash remember possible CT change when flash duration is chopped. Long-peak flash allows you free use of all focal plane shutter speeds but gives progressively less exposure at fast settings.

● Be safety-minded when handling lighting. Prevent tall units toppling, do not overload or damage cables or add items to lampheads which then overheat. Keep lighting and water apart, and resist the temptation to service your own studio flash – it may finish you off instead.

7
Tone control

This chapter brings together all the influences on the tonal quality of your final picture. Being able to produce results with a rich range of tones is vital in black and white and equally important in colour. The difference between 'good' and 'outstanding' final print quality depends on how much care you take at a number of stages, ranging from measuring subject brightness to the way you display finished results. The tone range of your film image (negative or slide) is of special importance here and the most common single cause of poor prints. This is paralleled in digital imaging by the ability of your CCD sensor and converter (page 104) to capture a suitably wide dynamic range.

Starting with a review of all the tone quality factors, the first section explains how the performance of films and paper and the influence of exposure and development dovetail together. The zone system is explained as one method of achieving tight control over monochrome results. Sometimes, sadly, important films turn out too dense, pale, contrasty or flat – but it may still be possible to make improvements, and these are described. Finally the chapter outlines how, with appropriate software, post-shooting tone control can be applied electronically to alter the brightness, contrast and colour of digital images.

Practical influences

Tone values, like sharpness, are one of the characteristic qualities of a photographic image. This is not to say that the full brightness range of your subject can or indeed must be reproduced accurately in your final picture. On the contrary, sometimes the shadow or highlight end of the tone scale should be allowed to distort, or all tones 'grey up', or results simplify into stark black and white if this furthers the aims of your shot. (In the same way, using shallow depth of field or soft focus and blur are all sharpness options.) What is important is that you have *control* over your picture's final tonal values. There should be no uncertainties and surprises which destroy images in a haphazard way.

You can influence final image tone values at some 11 stages. Most are relevant to colour as well as black and white photography.

Fig. 7.1 Subject brightness (or tone) range depends on both lighting and subject. In the picture above, harsh lighting makes an all-one-tone scene contrasty. See also Figure 6.3. In the flatly-lit picture, above right, contrast is due to the extreme reflectance range of flowers and foliage

1. *Subject-brightness range.* This is the combination of subject reflectance range and lighting ratio. By controlling one by viewpoint or arrangement and the other by additional or changed lighting you may be able to avoid excessively high or low contrast. Extreme reflectance range combined with high lighting ratio give the longest span of image tones to deal with – possibly well beyond the range of any film or CCD sensor. See Figure 6.4.

2. *Filters.* Coloured contrast filters in black and white photography influence the tones in which colours record. Polarizing filters increase the tonal and colour richness of some surfaces with a reflective sheen (see *Basic Photography*). Diffusers and similar effects filters spread light from highlights into shadows, making both colour and monochrome images less contrasty.

3. *Lens and imaging conditions.* Lens performance, flare and atmospheric conditions all influence the tone range of the image reaching your film. Combined ill-effects tend to be like mild diffusion, a tendency for shadows to become diluted and compressed. See Figure 7.2.

4. *Light-sensitive medium.* The inherent contrast of the film emulsion, and its graininess. If small-format images show coarse grain structure when blown up this will tend to break up areas of tone and destroy gradation. Film condition (age and storage) must be the best you can achieve, or expect degraded tone values. In digital work equivalent factors are the number of pixels sampled by the CCD

Fig. 7.2 The effect of light flare on image shadows. Graph shows (baseline) subject brightness range, converted to (vertical axis) lens image brightness range. If lens was 100% flare-free the graph would show line at 45°, and both ranges would match. In practice scattered light here dilutes shadows, reduces brightness range reaching film. Flare may be due to dust, grease, condensation on optics; back or side lighting spill into lens

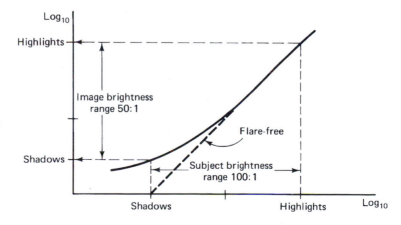

sensor, the bit depth of the A/D converter (page 105) plus any data compression – all related to the final size of printout.

5. *Exposure accuracy*. Light readings which give over- or under-exposure will produce tone-crushing in highlights or shadows, respectively. Remember that film manufacturers design most monochrome negative materials to be exposed on the lower part of the characteristic curve. If you can do this consistently the negative density range will 'fit' printing paper performance like two pieces of a jigsaw and give a full tone range print (see page 148). Overexposure of a CCD gives burn-out and flare around the brightest highlights; underexposure gives 'mealy' detail and incorrectly coloured pixels in deepest shadows.

6. *Film developer and development*. In black and white neg/pos work your choice of film developer and amount of development can often be geared to suit imaging conditions. Increasing the development expands the tonal separation (contrast) of the negative, useful for compensating for low-contrast images. Extending development serves the opposite function for contrasty situations (see The zone system, page 154). A disadvantage of 35 mm here is that with a film containing 36 exposures all having to be developed in the same way, compromise is inevitable. Colour film processing is less pliable. Pushing or holding back slide film is acceptable for some compensation of under- or overexposure (altering ISO speed) but not good practice purely for contrast control, because of side effects on image colour balance. Also make sure that your processing solutions are in good condition, at the correct temperature and are properly agitated. Any safelights you are using must really be safe, and there must be no light leaks in your darkroom to give the slightest tone-degrading fog.

7. *Image manipulations after processing*. This includes chemical reduction or intensification of your film to improve a poor tone range. Less drastically, you can 'mask' an image by sandwiching it with a weak negative or positive version which reduces or increases the tone range before printing or (slide) duplicating (see page 165). In digital work a range of post-camera options are possible using computer software programs such as PhotoShop.

8. *Enlarger and enlarging technique*. The film illumination system in your enlarger influences final print tone range – from a harsh point-source through condenser systems to a fully diffused lamphead for least contrasty results. Lens flare is an influence again here. When enlarging negatives it smudges shadows and spreads them into high-lights. Minimize flare by keeping your enlarger lens and the inside surfaces of the enlarger clean, and do not allow light to spill through the rebate of the negative you are printing. On the other hand, you can purposely reduce the tone range of prints from excessively contrasty negatives by 'flashing' the paper to light (see page 169).

9. *Electronic adjustment*. With digital files extra pixel files can be generated by a process of electronic 'interpolation', allowing a larger print without jagged edge (pixellation) becoming obvious. Tonal values for every new pixel are invented by averaging values of immediately surrounding pixels, but since they cannot add actual image details at this late stage definition suffers.

10. *Print material and processes*. Surface finish mostly determines your print material's maximum black – greyest with matt, richest with

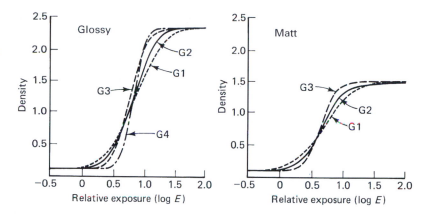

Fig 7.3 The effect of printing paper on final tone range. The glossy graded bromide paper curves, right, show that all grades give richer blacks and therefore a wider overall density range than matt surface types. If papers had tinted bases the bottom of these curves would flatten out at about 0.4 or greater, limiting range still further. Notice how contrast (slope of curve) varies. Grade 1 glossy is equivalent to between Grades 2 and 3 matt surface

glossy. Working with black and white silver halide materials, you have a choice of grade and also base tint (affects brightest attainable highlight). Variable contrast bromide paper allows you to 'split-grade' your print, dividing the overall print exposure between two different grade filtration settings to expand or contract tone ranges in chosen areas. Remember the importance of being consistent with print exposure and the developer timing and temperature. Using poor-quality or badly stored materials and chemicals gives prints with degraded tone values too, and there must be no sign of fogging from safelights or light leaks. In printing from digital files the actual file size, method used (inkjet, dye-sublimation, light-jet, etc.) plus choice of print-out resolution (pixels per inch) relative to picture size are important factors.

11. *Final viewing conditions.* Prints behind glass softly lit from the front will have blacks which look only grey and all dark tones degraded. For maximum richness of tones display a print free of glass on a wall lit obliquely by a spotlight, masked down tightly to illuminate the picture area only. Project slides in a 100% blacked-out room.

If your pictures lack tonal quality it will almost certainly be due to lack of care at one or more of these stages. A combination of slight neglect at several points – in silver halide work perhaps erratic temperatures and a dirty enlarger lens – will insidiously undermine the excellence of all your results. Sometimes it is only when you compare

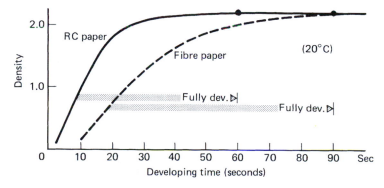

Fig. 7.4 The importance of fully developing printing paper. RC and fibre base materials react differently. RC papers develop quickly – most tones have built up after 20 seconds and maximum density is reached at about 60 seconds. Fibre paper images build up more slowly and progressively. Full density takes a further 30 seconds in this developer

your work against actual prints by masters in exhibitions that these deficiencies show up. Not every picture works best with a full, rich tone range, of course, but many do, and you must be able to achieve this when required.

Tone control theory

Fig. 7.5 Bar chart tracing typical black and white silver halide reproduction, from subject to final print. Brightness (luminescence range) is reduced by the lens, and compressed again by the negative reproduction. Enlargement and printing paper characteristics then modify and expand tone range. Given correct exposure throughout, midtone values (see X, denoting the tone of an 18% reflectance grey card) are least altered. Greatest compression is at highlight and shadow extremes, especially shadows. Bottom part of diagram allows direct comparison of the subject and print range shown above

Some of the links in the chain just discussed, as they apply to silver halide film and paper, are shown diagrammatically in Figure 7.5. This illustrates the contraction and expansion of tone values you can expect when a subject is imaged in the camera, turned into a black and white negative and then enlarged onto black and white bromide paper. Subject brightness range chosen here is 1:160 or just over seven stops – marginally in excess of the maximum recommended range for black and white when it is important to preserve all shadow-to-highlight detail. Dense blacks and tiny specular highlights are even further apart in value.

The light from the subject is put through a lens with a flare factor (subject range divided by brightness range of its image) of 2. This might be for a long focal length lens used outdoors, especially if fitted with a filter. A modern multilayer coated normal lens in low-flare studio conditions will have a factor of less than 1.5. Notice how flare compresses darker tones by spilling light (you can see this on a focusing screen – blacks turn to grey when you put something brightly

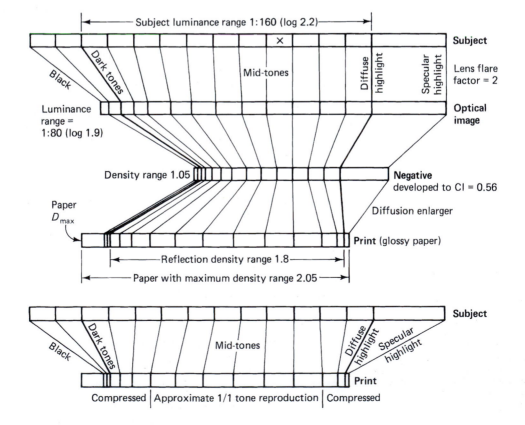

lit near the front edge of a lens). The tone range of the image actually reaching the film therefore comes down to 1:80 (or log 1.9).

Correct exposure places these light values on the toe and lower straight line section of a normal contrast film's characteristic curve (see Figure 4.13). The result, after standard processing to a Contrast Index of 0.56, shows all tones slightly compressed, darker subject tones being more compressed than others but still separable. The densities representing original important shadow and highlight detail now have a density range of only 1.05.

The bottom line of Figure 7.5 represents what happens when you print the negative through an enlarger fitted with a diffuser light source and takes the (low) enlarger lens flare factor into account. The result on grade 2 normal glossy paper is a print with a density range back to about 1.8. Notice how the darker end of subject midtones are relatively more expanded by the paper than other tones at the printing stage, compensating for their compression in the negative. Diffuse highlights reproduce just marginally darker than the paper base, allowing specular highlights to appear pure white. Tinted papers cannot give an equivalent maximum white, and so lose these delicate highlight tones. Darkest shadow detail tones have about 90% of the maximum density the paper can give, leaving this D_{max} for subject pure blacks. Matt surface paper, with its greyer maximum black than glossy paper, loses you your darker tones. Some of this film/paper relationship is shown by linking their characteristic curves in a 'quadrant diagram' (Figure 7.7).

Multistage diagrams like these show that manufacturers aim their materials to receive the image of a subject with a wide brightness range (for example, a sunlit scene), and take this through to just fill the density range offered by normal grade paper. On the way the negative is given the least possible exposure which will still record important shadow detail. So the film performs with maximum speed rating and resolution, and least grain and light spread within the emulsion.

Notice how the system is so designed that image midtones are least compressed and distorted – manufacturers assume that these are the most critically judged parts of the picture. If you want still more midtone separation you could process the negative to a higher contrast index (say, 0.65 or 0.7), which would then really need grade 1 paper. However, by printing on grades 2 or 3 and burning in highlight detail and shading shadow detail you still squeeze all the information onto the print while achieving the extra midtone contrast. Several practical points come out of this tone performance theory:

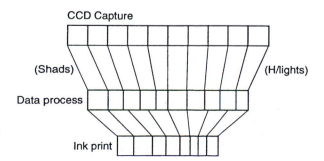

Fig 7.6 Digital imaging reproduction bar chart. Top row shows maximum image range captured by a CCD sensor. This is reduced to meet computer needs, centre. Selective use of tone curve software (see page 171) then flexibly adjusts the input further to create new output tones, suiting the particular picture. Here it expands shadow tones relative to highlights, before finally passing on the image file to an inkjet printer

Fig. 7.7 Quadrant diagram relates characteristic curves of negative and positive silver halide materials, shows the necessary 'correct' exposure and development to give acceptable tone reproduction. Quadrant 1: camera image luminance range is exposed onto film. Resulting relative density values for subject highlights and shadows are plotted off on left. (Rotate book anti-clockwise.) Quadrant 2: these negative density values exposed onto paper characteristic curve give print densities, left. Transfer quadrant 3 turns plots through 90°. Quadrant 4: here the original camera image values can be traced back and compared against final print tone reproduction. An ideal, distortion-free result would be a straight line at 45°

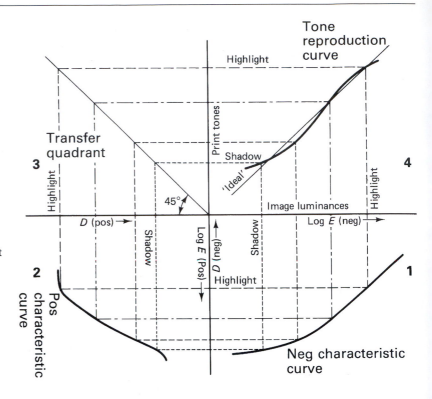

Stops difference	=	Ratio	=	Difference on \log_{10} scale
1		1:2		0.3
2		1:4		0.6
3		1:8		0.9
		1:10		1.0
4		1:16		1.2
5		1:32		1.5
6		1:64		1.8
		1:100		2.0
7		1:128		2.1
8		1:256		2.4
9		1:512		2.7

Fig. 7.8 Three alternative ways of expressing ranges (lighting, subject brightness, image density, etc.). The log scale is most often used when exposure and density, ranges are plotted as a characteristic curve performance graph

1. Wherever possible, it is best to get the right subject brightness range first (often by control of lighting) rather than have to tinker afterwards with exposure and development.
2. You may just be able to record an extreme brightness range subject on negative material with detail throughout, helped by reduced development and compensating slight extra exposure, but it is another matter to find suitable printing paper for such a flat negative. Even the best glossy papers can only produce a maximum black about 60 times as dark as the whitest highlight. So although your print may contain all the detail, the steps between different subject tones will be so compressed and slight that appearance is unnaturally grey and flat, even on hardest grade paper.
3. Gear your exposure and development technique to suit the characteristics of your enlarger and preferred surface printing paper. The penalty of having a negative with a density range way beyond what the paper will accept is bleached-out delicate highlight tones and lack of detail and tone separation in shadows. Both are bad news if your result is due to be reproduced on the printed page. It helps to have interchangeable heads for your enlarger, to allow both hard and soft forms of illumination. Using a condenser head, you can enlarge an 0.8 density range negative onto the same grade of paper as would be needed for a 1.05 range negative enlarged with diffuser head equipment. Remember that warm tone (chlorobromide) papers give better separated dark tones than regular bromide ones.
4. Over- and underexposed negatives will not fit any paper exactly. The distorted end of the tone scale will need a different (usually harder) contrast grade than the other tones in your picture. However,

according to the shape and size of these faulty tone areas it may be physically possible to use variable-contrast paper, shading and then printing them back with a higher contrast filter.

5. Under laboratory conditions, computer programs based on data such as Figure 7.5 can be used to control image reproduction. The optimum level of film exposure, development, print material exposure and processing may all be calculated in advance. This is useful for jobs such as bulk printing of aero films and movies, mass printing of copy negatives and so on. As a practising photographer, you can seldom work in such an analytical way, but it is important to remember these links in the chain as warnings of where you must always take care if final pictures are to have the right tonal qualities.

Precision measurement of exposure

Accurate subject exposure reading is vital for tone control. As shown in *Basic Photography*, one centre-weighted measurement through the camera or a general reading made with a hand meter are adequate for average situations. However, readings of carefully chosen parts of the subject give you far greater information, although they take more time and knowledge to do. The main point to remember is that any one light measurement will give you camera settings which record the area read by the meter as a *mid-grey tone*.

A general reading mixes the light from dark, medium and bright items in the picture, taking greater account of large areas than small ones. The whole lot is scrambled on the theory that this integrates all subject values to grey. A centre-weighted system does the same thing but takes less account of corners and edges of the picture because important elements are assumed not to be composed there. A similar single-reading approach is to measure a mid-grey card held where it received the same light intensity as the subject. Kodak make 18% reflectance cards for this purpose (on the basis that 18% of incident light is reflected from an 'average' scene). Again, you can fit an incident-light diffuser attachment over a hand meter and make a reading from the subject towards the camera. Results should work out the same as for the grey card technique, and both avoid overinfluence from large but unimportant areas of the scene which are darker or lighter than your key subject.

For selective area readings, bring your general-reading camera or hand meter close to chosen parts of the subject. If this is impossible measure nearer substitutes your eye judges an exact match. Best of all, use a spot hand meter or a camera offering spot reading mode – both allow you to measure quite small parts of the subject, even from a shooting position some way back. Some large-format cameras have add-on meters which also make spot readings from any small selected part of the subject imaged on the focusing screen (see Figure 7.10).

Selective area reading means that you can pick the part of a scene which you want mid-grey in the final picture and base exposure purely on this. Alternatively, you can discover your subject's brightness range by measuring a diffuse highlight area such as clouds in a landscape, then measure the darkest part where you want detail to just record. Read off the difference in stops (for the same shutter speed). If this

Fig 7.9 Sensitivity patterns of different through-the-lens metering modes. Centre-weighted concentrates about 60% of light-reading sensitivity over a large area, centre screen. Pattern is also designed to play down sky in landscapes. Partial, and spot: these give a smaller reading area that you must align with key element, then use exposure lock if this element is recomposed off-centre. Bottom: spot-reading a large-format image means using a probe that you can move to measure any part of the picture. Some 35 mm SLR systems 'matrix' multi-segments which read four or five parts of the screen at once, allowing contrast measurement with one reading

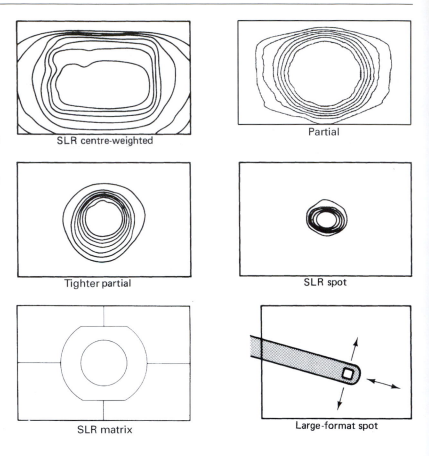

SLR centre-weighted

Partial

Tighter partial

SLR spot

SLR matrix

Large-format spot

warns you the scene is beyond the range of your film (page 112) you can either:

1. Add some fill-in illumination to reduce the range, if practical;
2. Increase exposure and curtail development to avoid a negative with excessive contrast; or
3. Decide to sacrifice one end of the tone range (top or bottom) for the sake of recording all the rest. In this case, it is usually best to expose reversal materials to preserve highlights, even though you lose shadow detail. With neg/pos materials expose to just preserve shadow detail.

Having identified the top and bottom of the subject range you want to record, average their two readings and set exposure accordingly. Some of the small-format cameras that provide spot metering automatically average readings for you. As soon as the second measurement is taken, camera settings for midway between the two appear in the viewfinder display. Some cameras have so-called 'Highlight' and 'Shadow' modes of spot reading. Lining up important pale detail and pressing 'Highlight' makes whatever the spot is reading set an exposure typically one and a half stops more than a normal reading, so that in the final picture this area is sure to be paler than midtone. The 'Shadow' button has the opposite effect. Using one or the other you can 'peg' elements in your picture to particular tone values

Fig. 7.10 Add-on spot-reading exposure reading system for a monorail viewcamera. You set ISO film rating and required aperture using dials on the control box. Then align the probe with the chosen part of image (sensor facing lens) and insert a darkslide behind it to prevent light entering through the back of the focusing screen. Pressing a button on the external end of the probe takes reading and sets shutter speed on bladed shutter at front end of camera. Exposure here is 1/30 second at *f*/22

Fig 7.11 Spot meter. Narrow angle reflex viewfinder system allows visual alignment of a small measuring circle on to any selected part of the subject. Pressing the trigger displays aperture/shutter settings on side panel and inside eyepiece

(although, with care, you can achieve the same result manually by using the exposure override control, for example). See Figure 7.12.

Just how much over- or underexposure Highlight and Shadow controls give really needs to depend on the exposure latitude and type of light-sensitive material you are using. This information may be programmed by the checkerboard pattern printed on the film cassette (see DX coding, page 77). Where it is not communicated in this way bear in mind that most 35 mm camera meter systems assume that you are shooting on negative material. (The great majority of films sold to amateurs are neg/pos colour.) This means that the circuit is 'tuned' to set sufficient exposure to preserve shadow detail. When you use reversal films such a setting can lose much-needed highlight detail, overexposing by perhaps half a stop. You may find that it helps to adjust for this on the camera's exposure override control every time you shoot slides.

Flash exposure can be measured with the same brightness range technique provided your equipment allows you to spot-read a trial flash. Flash is still often measured and controlled by an in-flashgun sensor which takes a general reading or, when you use a dedicated gun, by a centre-weighted TTL reading from inside the camera. Separate flash meters tend to give only incident light measurement, but you can use them to check lighting ratios. Take a reading from the subject pointing towards the main light, then towards any light illuminating shadows.

Fig. 7.12 Exposure override controls. Top: mechanical dial, presently set to make meter underexpose by half a stop. Bottom: electronic reset button and camera top display showing same half-stop underexposure, here for frame 10

Remember, when using a separate flash meter, to take into account any filter or extra lens-to-film extension which will call for additional exposure. It is easy to forget to increase exposure when using a close-focusing macro lens, extension tubes or bellows for close-ups. Working with small- or medium-format cameras, you become used to relying on an in-camera meter which takes all such influences into account *when measuring continuous lighting*. However, unless it also measures your studio flash, results may be underexposed. One practical way to check the correction needed is:

1. Place a white or grey card over your (focused-up) subject.
2. Take an exposure reading through the camera of the card, under modelling light illumination.
3. Take a hand meter reflected-light reading off the card, same illumination.

The difference between (2) and (3) in *f*-stops is the exposure increase needed when using and measuring flash with a separate meter.

The zone system

The famous American landscape photographer Ansel Adams devised what he called the 'zone system' to put tone theory into everyday practice. The system is helpful in two ways:

1. It shows you how to work out a personal routine to get the best quality out of silver halide film, paper and chemicals, under your own working conditions.
2. It allows you to accurately fine-tune your result up or down the available tone scale and to expand or contract how much scale it occupies (alter contrast) according to the needs of subject and interpretation.

In fact as an experienced zone-system user you should be able to look at any subject and 'previsualize' how it might be recorded in tone values on the final print, then steer the whole technical process to achieve these chosen qualities.

Adams intended the zone system for black and white photography using a large-format sheet-film camera. Ability to individually process negatives and the kind of performance you get from monochrome films and printing papers are in-built features. However, the zone system can also be used for roll or 35 mm film (page 161). For the moment, to learn how it works imagine that you are using individually exposed sheets of film and measuring exposure with a hand meter.

The zones

The essence of the system is that you look at each subject as being a series of brightnesses, from its deepest shadow to brightest highlight, and relate these to a set scale of tones. As shown in Figure 7.13, the zone system uses eight grey zones (I–VIII) plus total black (0) and total white (IX). Zone V is mid-grey – the tone you would normally pick for subject brightness about midway between darkest and lightest extremes

Fig. 7.13 The zone system. A full tone range black and white photograph can be rearranged as a scale of eight tones between maximum black and clearest white (approximated here in printer's ink). Each one-stop change of exposure shifts representation of all your subject tones up or down the scale by one tone zone. Top picture: exposure gauged by one reflected light reading off the top of the waterline rock. This was overexposed by one stop so that instead of zone V (which all meters normally give) the rock reproduces zone VI. Bottom picture: the same reading but underexposed by one stop makes the rock zone IV, shifts all tones to darker values

0 I II III IV V VI VII VIII IX

and equivalent to 18% reflectance card. Other parts of the scene only half as bright would fall into zone IV or, if twice as bright, zone VI, and so on. Changing exposure by one stop reallocates all the subject brightnesses one zone either up or down the scale.

The span of 10 different zones covers a subject brightness range of over 1:500, only rarely encountered in scenes backlit by some harsh light source. Eight zone-system zones (1:128), which is just seven stops difference, are taken to be more typical. This is just below the maximum subject range that normally processed film and paper will reproduce on a full tone range print, using a diffuser enlarger. See Figure 7.5. Your technique must be sufficiently under control for you to be sure that one chosen brightness really does reproduce as a chosen zone value on the final print. Then other brightnesses will also fall into predictable places along the tone scale. As a result you can decide at the shooting stage which parts of a scene you want to make a particular zone and then previsualize how the whole print will finally look.

To achieve this, however, you must start by standardizing key aspects of techniques – effective film speed, development, printing – as they apply to your own equipment or working conditions. This preliminary work takes some time, but is a once-and-for-always operation.

Personalized film speed

The manufacturer's recommended ISO speed ratings and development time assume 'average' subject and lighting, typical exposure measurement and the kind of negative which prints well in popular enlargers. Their assumptions may not apply to you exactly. The first step, therefore, is to assess the effective speed of each of the films you use. Do this by finding the exposure needed to record deep shadow detail as zone II (just perceptibly darker than the film's palest tone) on the negative in the following way:

1. Find or set up in the studio a contrasty scene with a span of eight zones. Check with your camera or hand meter – brightest parts should need seven stops less exposure than darkest shadow.
2. With the camera or meter set for the ISO speed printed on the film box, measure exposure for the darkest shadow where you still want detail to just record. Meters making a single subject measurement read out the exposure needed to reproduce this part of the subject as zone V. However, you want darkest shadow detail to be about zone II on the final print, so reduce the exposure by three stops (three zones) before exposing the picture.
3. Shoot four other exposures, rating the film twice, one-and-a-half and one quarter its box speed. Then give all your exposed film normal processing in whatever developer you have chosen.
4. When results are dry, judge carefully on a lightbox which negative carries just perceptible detail in the shadow area you measured. The speed setting used for this exposure is the effective speed setting for your film used under your working conditions.

Personalized development time

Next, review your film development time. Exposure does most to determine shadow tone, but highlight tones are the most influenced by

development. While you still aim to reproduce shadows just above the negative's palest tone you can decide to record highlight parts of your test subject as just below the film's darkest tone. The reasoning here is that you make maximum use of film tone range.

1. Make a series of seven identical exposures of your test subject, as measured with the film rated at your effective speed.
2. Give each exposure a different development time – one can have normal time, others 10%, 15% and 25% less and 15%, 25% and 40% longer. Be very accurate with temperature and agitation technique.
3. Carefully judge which test negative records brightest important subject details just short of being too dense to print with acceptable detail and contrast with your enlarger. Make trial prints as necessary to check quality. The development time which gave the best negative is correct under your conditions for an eight-zone subject. (If this differs much from the development used when you established film speed you may have to rejig your speed rating. Retest for speed if necessary.)

Now you can start to shoot pictures with a more controlled technique, adjusting development when necessary to expand or contract tone range. Always begin by separately reading the exposure for lightest and darkest important detail in any subject. Then compare them (in number of stops) to discover what zone range your picture spans. If the range is high (over eight zones) there are three alternatives:

1. Sacrifice either shadows or highlights to improve tonal reproduction at the opposite end of the scale. For example, underexposing by one stop shifts all tones down one zone. This sacrifices shadow details which move off-scale to zone 0 or beyond on your print but lets in highlight detail to now record as zone VIII. Overexposing one stop shifts all tones one zone in the opposite direction, moving highlights off-scale but improving shadow tones which now print as zone II. To take this decision, you must look at the scene, previsualizing it on the final print either with its palest detail indistinguishable from white paper or its darker shadow detail featureless black.
2. If you do not want to lose detail at *either* end of the tone scale then earmark the film for reduced ('held back') development. You already know from your tests the development time needed for an eight-zone range. Go back to your tests to discover how much reduction in this time will contract the zone range by one zone. Do not overdo development control, though. Avoid changes from the manufacturer's regular development time greater than 40–50% otherwise, as discussed on page 150, you get negatives too flat to print on any grade of paper. Also, since this amount of development reduction affects both shadow and highlight tones you have to start readjusting your effective film speed (downrating to allow for holding back).
3. Adjust subject lighting range by adding more fill-in or wait for a change in existing light conditions. Even adjust viewpoint so that your picture contains a lesser range of tones. As before, check out the effect by comparing separate light readings of darkest and lightest subject detail to discover the new zone range.

Fig. 7.14 Rejigging exposure and development to compensate subject contrast. Top centre and bottom centre: normally developed contrasty and flatly lit subjects, respectively. Top left: negative given more exposure and less development has less contrast. Bottom right: negative with less exposure and more development increases in contrast. Reproductions here can only approximate photographic film results

Your problem may be the other way around – an excessively flattened subject spanning perhaps fewer than six zones. Control this by either (2) or (3) but reversing the suggested technique. It will also help if you can change to a slightly more contrasty film such as one with a lower speed rating.

Including your printing conditions

It is true to say that, having got a really good negative with the right tone range and all the detail, your picture should almost 'print itself'. In any case, within the darkroom it is easy to work trial-and-error methods not possible when shooting. However, you can choose to adopt a similar zone system approach here as well, to establish personalized exposure and development times geared to your printing paper and enlarging equipment.

First, test for exposure with just a clear piece of film in the enlarger negative carrier. Set your most usual lens aperture (typically, two to three stops down). Expose a half sheet of normal graded or grade 2 filtered variable contrast paper with strips of six to eight test exposures, bracketed closely around the time you estimate will just produce a full black. Process the paper in your normal developer for its recommended time, then check your print to find the strip beyond which extra exposure does not give a deeper black. This is the paper's maximum black produced from clear (subject zone X) parts of the negative. (All other

tones should then follow on, up to something almost indistinguishable from the paper base from subject zone 0 areas of your negatives.)

Next, test for best print development time. Working with the clear film and giving the exposure time you have just established, expose a full sheet. However, before processing your paper cut it into nine equal pieces, each numbered on the back. You then develop each piece for a different period bracketed around the recommended time. For example, if the regular time for fibre-based paper is 2 minutes, range from 1 to 3 minutes at 15-second intervals. From the processed strips decide which time has just produced the paper's fullest black, and then make this your standard print development time for the zone system.

Putting the zone system to work

You have now standardized your technique, from film speed to print development. It forms a chain giving fullest tone reproduction from your silver halide materials (regard paper contrast grades and local printing-in or shading as extra adjustments for corrective or expressive use). Successful use of the zone system relies on your keeping this core technique very carefully under control. You should then be able to look at and measure a subject, decide and forecast the final print, and be reasonably certain of achieving it.

For example, you might be shooting a portrait in soft, diffused light. Delicate flesh tone detail is of utmost importance. For a Caucasian you might decide to make this zone VI (see the scale on page 155), in which case take a single meter reading of the face and increase exposure one stop. A dark-skin face would be better reproduced as zone V, achieved by giving the meter indicated exposure straight.

Perhaps the subject is a harshly lit building, mostly in shadow. You judge the shadowed parts as most important, but reckon it would look wrong to have them any lighter than zone IV. So read the shadow only and decrease exposure by one stop. Another treatment, if the building has an interesting shape, is to make it a silhouette. This means reallocating the shadowed walls as perhaps zone I by underexposing their reading four stops.

Suppose you now move around the building to a viewpoint from which there is a harsh mixture of important sunlit and shadowed areas. You want detail in both but start off reading the lit part. Consider making it zone VIII. Now measure the shadowed walls – perhaps this reads six stops more, a difference of six zones. Can you accept detail here as dark as zone II? (A print from the negative may be wanted for reproduction on the printed page, where good separation of tones in darker areas of the picture is always important.)

It might therefore be a better compromise to raise the whole picture by one zone, making sunlit walls zone IX and shadows zone II. Do this by reading sunlit parts and decreasing exposure three stops, or reading shadowed parts and increasing exposure two stops. Another option would be to avoid a contrasty negative by decreasing development by an amount which reduces picture zone range from six to five zones. (If you decide to do this, consider halving the ISO setting on your meter before taking final readings, or bracket at both settings.)

Finally, check out the blue sky behind the building. Will any building tone match the sky too closely so that in monochrome they run together,

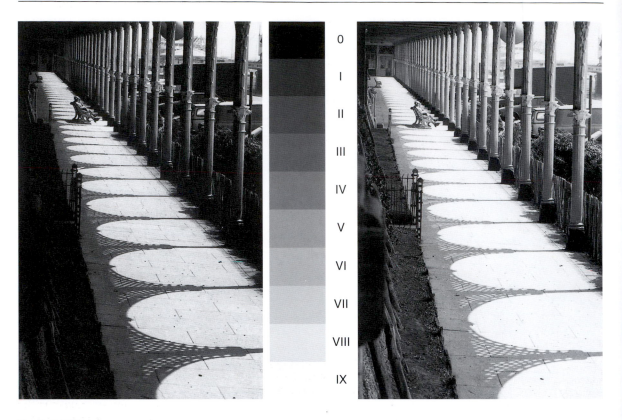

Fig. 7.15 With an extreme tone range subject like this, decide at which end of the scale you can best afford to sacrifice detail. For the left-hand picture, sunlit paving was exposed to record zone VIII although shadowed earth is lost into zones II and I. In the right-hand picture, giving more exposure holds this shadow detail at zone IV but the paving now reproduces zone IX and beyond.

losing subject outline? Decide this by eye, or compare readings from blue sky and sunlit parts of the building. If you forecast that tones are too similar (for example, the sky is less than one stop darker, one zone lower), you could separate them by using a filter. Try a polarizer or a yellow or green coloured filter on the camera. Do not forget the filter factor if you are not metering through the lens.

Metering for zoning

If you use the zone system you fully appreciate the value of accurately reading light from chosen parts of any subject. Generalized readings are not very helpful. A spot reading system is ideal, but short of this, be prepared to come close with the camera or hand meter or read off a handy visually matching substitute.

If you have a hand meter with a suitable large calculator dial you can make a simple 'zone scale' to attach to it. These small segments of tone, perhaps cut from your bromide paper tests, give direct visual readout of how different subject brightnesses will reproduce (see Figure 7.16).

Limitations to the zone system

The zone system offers a sound technical grasp of tone control, but you must also recognize its limitations. The system best suits black and white landscape and still-life large-format photography where time permits careful measurement of different elements in the picture.

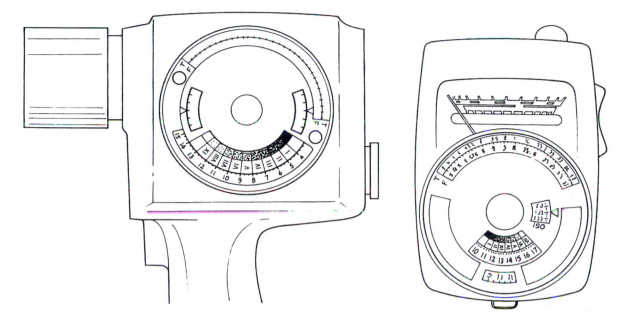

Fig. 7.16 Some hand meters have zone system settings built in. Other dial types (right) can be adapted by sticking on tiny pieces of a bromide paper grey scale to represent zones I–IX. Zone V should be pasted over the normal-setting arrow. Each paler tone corresponds to higher light readings, darker tones to lower readings. Now, by measuring any chosen part of the subject, you can align its light reading with the tone you want it to be in your final print. (Assumes normal development)

Many other picture-shooting situations are too fleeting to allow several local readings. Again, it is less easy to individualize degree of development when using a rollfilm camera or a 35 mm film containing up to 36 different shots. One solution is to pick development which suits the most important pictures on the film, then rely on adjusting the tone scale of prints from your other negatives through paper grades (see also page 169–170). Alternatively, fill a whole rollfilm with bracketed exposure versions of each picture. If your camera has interchangeable magazines, or you have several bodies, organize your shooting so that all pictures requiring the same amount of development accumulate on the same film.

35 mm format films are also more vulnerable to the side-effects of over- or underdevelopment as part of system control. For example, overdevelopment increases graininess, and although this may barely show in enlargements from 4 × 5 inch negatives, the same size prints from 35 mm quickly become unacceptable. You must remember that any change of film type, developer or use of an enlarger with a different light source means having to make new tests.

Colour films cannot be given adjusted processing to expand or contract tones as freely as black and white because of unacceptable distortion of colours. Zone system methods for colour negatives especially are limited to light measurement and exposure. (Here it can be argued that a trial shot taken on instant-picture material gives you an equally valid and faster tone value guide.)

However, even if you do not work the zone system in detail, understanding it will definitely help you previsualize the final monochrome print at the time of shooting. Remember the concept whenever you light-measure different parts of a scene. It makes you stop and think what will be the most suitable tones for each part you read, and, where necessary, to put aside exposed material for modified development. Also bear in mind that a full detail, full rich tone image does not always mean a great photograph. You must know when to make an

Fig. 7.17 Zones can leapfrog when you use colour filters on coloured subjects. Left-hand picture here was unfiltered, the other exposed through a deep-red filter. Notice how the bottoms of balconies are darker than the blue sky in left version, but a tone lighter than the sky on the right. Always previsualize zones looking through the filter

exception – break away from this 'look' if it is likely to work against the style and mood of a particular picture. The zone system is a technical control but not something that should ever control and limit you.

Tone changes after processing

You can alter tone values in a processed film by chemical or physical means to get better final image quality. Most chemical treatments are for emergencies when mistakes have been made or subject conditions were beyond the range of the film. Physical methods such as duping or masking (sandwiching the film with a weak positive or negative contact printed from it) are less drastic. They do not alter your original film image itself, which remains safe. Chemicals to reduce or intensify image tones often create permanent changes, so you should choose and use them with due care. There is always some risk of ruining the image through stains or some other chemical or handling mishap, so it is a sensible precaution to make the best possible print first, as a standby. Always start out with a film which is properly fixed and washed before treatment, and for safety test out one image alone first. If possible, preharden in liquid hardener. During reduction or intensification keep the film agitated gently all the time it is in solution, and afterwards thoroughly wash it before drying.

It is important to observe health and safety recommendations when mixing and using chemical solutions. Read over the points on page 294.

Correcting dense black and white silver negatives

Negatives which are too dense might have been overexposed, overdeveloped or slightly fogged overall. Perhaps the subject spanned too great a tone range and was exposed mostly for midtones and shadows. Dense flat negatives can be duplicated (easiest by rephotographing at 1:1) onto colour slide film. The resulting negative will be more contrasty, and by careful choice of exposure important subject brightnesses may reproduce as properly separated tones.

Alternatively, chemically change the flat original negative in a subtractive type reducer. This removes nearly equal quantities of silver from dark, medium and pale tones, and so has greatest effect on pale tones, making the negative more contrasty as well as less dense. Farmer's one-solution ferricyanide reducer R-4a is a good choice (see formula, page 293). Treat the negative in a white tray containing the solution near a light-box so you can closely observe the reduction effect. Do not allow it to go too far, and remember that heavily reduced negatives tend to show a coarser grain pattern.

Dense but contrasty negatives, perhaps due to overdevelopment, are best reduced in a *proportional* reducer such as Kodak's R8. If subject highlights are very dense (an overdeveloped contrasty scene, for example) use a *superproportional* reducer instead. Superproportional R-15 persulphate reducer removes more silver from dense areas than pale areas of your negative. Used carefully, it reduces the density and printed tone separation of subject highlights without much affecting shadow tones. (Formulae and method are in Appendix B.) If you are working on a negative 4 × 5 inches or larger it may be practical to reduce just chosen areas of the image by applying one of these reducers locally, by swab or brush. Another approach is to reduce contrast by masking (explained on page 165).

Correcting dense colour slides and transparencies

With the exception of Polachrome, colour films (and black and white negatives carrying a final dye image) do not contain silver. Therefore you cannot treat them in the chemical solutions used to reduce regular black and white negatives.

However, surprising improvements are sometimes possible by copying your dense transparency onto reversal dupe film (see page 255), giving an exposure which will produce lighter results. (As a guide, give one stop overexposure for every half stop the original was underexposed.) Once again, you reach the limit of this technique when shadow tones appear an unnatural, featureless grey. You must also accept a generation loss – the kind of optical and tonal deterioration which happens when any image designed for final viewing is copied.

Another, and equally non-destructive, approach is to adopt digital methods. For example, scanning-in the film image, and then using computer software to make improvements before printing out or recording back on to film. See page 170.

Fig. 7.18 When chemically reducing a film, check results visually by working near a light box or window (but avoid direct sunlight). Have a water supply nearby to rinse and halt the action when tone changes have progressed far enough

Fig. 7.19 A flat, underdeveloped negative intensified (left two-thirds) in chromium intensifier. Darkest tones strengthen most, increasing contrast

Correcting pale black and white negatives

The usual causes here are underexposure and/or underdevelopment or a very contrasty subject exposed mostly for midtones and highlights. Negatives which are severely underexposed with loss of shadow tones and detail are very difficult to salvage. You cannot put back information which has not recorded at all in the first place.

Various chemical intensifiers are designed to build up existing tone values in silver image negatives. They all increase graininess too. Flat, underexposed or underdeveloped negatives are best treated in a solution such as Chromium Intensifier IN-4. The intensifier bleaches the film, which you then wash and redarken in any fast-acting developer such as print developer (see page 293). Tones are strengthened in proportion to the amount of silver originally present, and you can repeat the treatment to increase the effect.

Negatives which are contrasty and thin will need the most density build-up in their palest tones. You therefore need a subproportional formula such as Kodak Intensifier IN-6 (see formulae). However, you can often get even better results by trying a contrast-reducing or a selective contrast-increasing mask used only on subject shadows (pages 165 and 168).

You may be able to press an extremely thin negative against white paper under glass and rephotograph it on reversal film. Another strictly emergency technique is to set up the film a short distance in front of black velvet (Figure 7.20). When you illuminate the negative obliquely from the rear with a hard light source even the slightest silver deposit scatters light and appears milky against clear parts you see through to the black velvet. The picture therefore appears *positive* and you can photograph it on reversal or negative film. Unfortunately, anything approaching normal tones (pale grey underexposed highlights, for example) may appear as detailless grey, or even negative, when lit this way.

Pale colour negatives

An underexposed or underdeveloped colour negative is unlikely to give a satisfactory colour print. Missing shadow tones reproduce darker parts of the subject as devoid of detail, and usually with a strong colour cast. Low contrast images 'mis-match' the quite critical relationships of negative and print material. For example, you will not be able to print with the same tone contrast or colour balance at shadow and highlight

Fig. 7.20 Emergency set-up for copying an extremely pale black and white negative. See text

ends of the subject's tone scale. Try printing with a condenser enlarger (rather than the usual diffuser lamphead type used for colour). You may achieve best results by abandoning colour altogether and printing onto hard-grade black and white bromide paper.

Pale slides and transparencies

There is almost no way to improve overexposed, overdeveloped or fogged reversal films because the subject's lightest detail is 'burnt out'. If results are also flat you can sometimes make improvements with a contrast-increasing mask (page 167). Even though you are only adding a weak black and white positive to the transparency to add weight to tones already there, results look much more acceptable. Otherwise, if the shot is important and unrepeatable you will need to have the best possible reversal print made – and then pay for this to be retouched.

Tone control by photographic masking

This is the technique of physically sandwiching your deficient negative or transparency with a weak monochrome film image contact printed from it, and known as a mask. The two images registered together change the tone range of your result. For example, a negative with a weak positive mask will have most tone added to subject shadows, none to highlights. Its contrast is therefore *reduced*. However, if the mask is a weak negative it will have the opposite effect – having the two negatives together gives greatest tone build-up in subject highlights, *increasing* contrast.

Having made your negative or positive mask as described below, you sandwich it with the original film image between two pieces of glass. Take great care to register them accurately. Avoid any dust or finger

Fig. 7.21 Near right: an excessively contrasty negative. Far right: a contrast-reducing mask, contact-printed from the negative on normal-contrast sheet film. Non-colour-sensitive film was used here but pan film will do as well, provided you avoid safelight fog. Negative and mask sandwiched together give a lower contrast print. See also Figure 7.22

marks and seal up the edges of the glass. Then set up the sandwich in the enlarger negative carrier for printing, or over a lightbox for 1:1 duplicating (see Figure 10.35).

Most contrast-controlling masks are pale, ghost-like images, far less dense than those they are masking. Anything stronger starts to give part-positive, part-negative 'special effects'. Masks are usually made on slow, low contrast continuous-tone sheet film. For improving black and white originals you can use any suitable non-colour sensitive material, which allows you to work in the darkroom under convenient bromide paper type safelighting. For colour film originals use a similar but panchromatic film such as Kodak's Pan Masking film. (Masks for colour originals are best made in monochrome as this alters tones without the complications of colour changes.)

Correcting excessive contrast (negatives)

Your colour or black and white negative may be too contrasty due to the extreme lighting range of the subject, overdevelopment or – worst of all – underexposure and overdevelopment. It gives harsh prints even with your most diffused, soft light head enlarger. In this instance you need to make a positive mask which ranges in tone from being transparent in subject highlights to pale grey in deepest shadows. See Figure 7.21. Judged by normal positive images, it needs to be underexposed and underdeveloped.

The controlled way to set about masking is to use a densitometer. Then you can measure the density range of your original, compare this with what suits the printing paper and make the mask with characteristics to fill the gap (see Figure 7.22). However, a trial-and-error approach is often equally successful and makes masking easier than you might think. Try several bracketed exposures, always stacking the negative and unexposed film as shown in Figure 7.23. If possible use a tilting head enlarger as your light source. Process in a tray of diluted general-purpose negative developer giving only about 50% of the normal time.

The only way to find out which of the masks you have made is best is to try printing with it in place. Register the mask against the back of your negative and place the sandwich between glasses in the negative carrier. Expect the new printing exposure time to be about one-and-

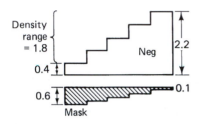
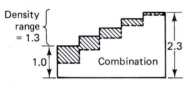

Fig. 7.22 Masking to reduce contrast. A contrasty negative with a density range of 1.8 (1:63) can be masked to a range of 1.3 (1:20) by sandwiching it with a pale, 0.5 density range, positive version. Mask adds 0.6 density to subject shadows but only 0.1 to highlights

Fig. 7.23 Two alternative ways of exposing an unsharp mask for a negative. Left: under glass the original negative (N) is emulsion down on clear spacer film, above unexposed masking film (M) emulsion up. Alternatively have the negative emulsion up, without a spacer. Make the exposing light source oblique to the sandwich, which you rotate during exposure. Right: exposing without movement directly below the enlarger as light source. Diffusion here is achieved by inserting a Kodak mask diffusion sheet, plus glass, between negative and unexposed masking film

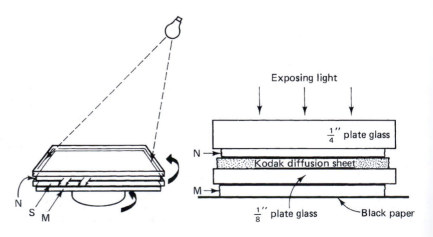

a-half times what was necessary for the negative alone. The colour filtration for a colour negative should remain unchanged. Try your thinnest mask first. It is surprising what an improvement is produced, even with just the smallest amount of extra density in the shadows.

Contrast-reducing masks are best made 'unsharp', meaning slightly diffused. Figure 7.23 shows the technique. Consequently, although each mask carries a positive image any areas of fine detail only record on it as averaged, even tone. When mask and negative are registered together contrast is reduced in all areas except this very fine detail. Since your assessment of visual sharpness depends greatly on the contrast of detail, a print from the combination actually looks sharper than from the original negative. A soft-edged mask is also easier to register.

Correcting excessive contrast (positives)

Your reversal slide or transparency may be too contrasty, for reasons similar to those giving contrasty negatives. As a result, it may print too harshly onto reversal paper. To reduce contrast, this time you need a weak black and white negative as a mask. This is exposed on pan masking film following the same unsharp procedure described above. However, slides and transparencies often have highlight tones of slightly lower contrast than that of midtones. You saw how paler tones fall on the toe of the characteristic curve in Figure 4.15. So contrast reduction masking may improve most of the tone range but give overmasked and artificially grey-looking highlights.

To overcome the problem, you first make a 'highlight' dropout mask from the transparency. This means underexposing onto lith film and processing in high-contrast developer to get a negative in which only highlight detail records, as dense black. Next, register the highlight mask and the original transparency and print your final contrast-reducing mask (unsharply) from their combination. This weak negative final mask therefore has clear areas corresponding to highlights. See Figure 7.25, overleaf. Now discard the highlight mask and combine original transparency and contrast-reducing mask. The resulting picture has a generally reduced contrast range but still retains its purity of highlights (see also 'flashing', page 170).

Correcting insufficient contrast

Occasionally, your negative or film positive is too low contrast to print with a full range of tones, even using a condenser enlarger. The cause might be a low contrast subject, atmospheric conditions or flat lighting, giving a low image brightness range; alternatively film which was slightly fogged; or overexposure plus underdevelopment. Here you need a mask to *increase* contrast, which must be negative for a negative or positive for a slide or transparency. Consequently, an extra stage is needed, making three in all:

1. Make an intermediate mask by sharply contact printing the original onto regular contrast film given normal development. The result should look like a normal monochrome positive (or negative) but slightly dense.
2. Contact print (1) onto another sheet of the same film. Have the intermediate mask pressed base side towards the film's unexposed

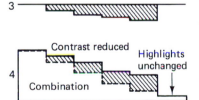

Fig. 7.24 Highlight masking when making the main contrast-reducing mask for a transparency or slide. 1: original contrasty image on film. 2: underexposed high contrast negative forms dropout mask. 3: pale negative image printed from 1 + 2. Highlights, covered by dropout mask, are just clear film. 4: when 1 is combined with 3 contrast is reduced throughout, except in highlight parts. (Mask densities here are greatly exaggerated relative to transparency)

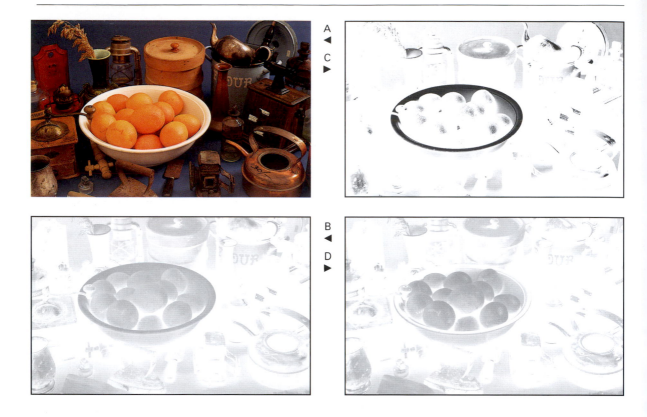

Fig. 7.25 A: original transparency for masking. B: contrast-reducing mask made 'straight' from transparency. C: dropout mask on contrasty film. D: mask made from combination of dropout mask and colour transparency. Notice difference between B and D along rim of bowl. Strongest highlights are now unmasked. Relate to Figure 7.24

emulsion. Give similar development to (1), aiming for a result which looks underexposed – clear film at one end of the tone scale and barely mid-grey at the other.

3. Tape (2) in register with your faulty original. You will see the improvement immediately. Sandwich the films between glass and print your final enlargements.

Selective masking

So far, most masks for tone control have affected the whole picture area, but sometimes you want to be much more selective and so mask (or omit from masking) certain chosen parts. For example, the contrasty negative of an interior may include one or two dense, flat window areas where you do not want a contrast-reducing mask to operate. Alternatively, you may want to boost the contrast of just one or two figures in a crowd, or give emphasis to one red-coloured object in a colour shot. To do this you must be able to decide freely where tone changes are to take place, then either use one of the following silver halide/chemical techniques, or scan-in your faulty image and mask it by digital means, see page 170.

Dropout intermediates

Following a similar procedure to highlight masking (on page 167) make a high contrast intermediate mask. This blocks out one or other end of

the original film's tone scale just while you are making your main contrast mask. The covered parts appear as clear film on the final mask, leaving the original unchanged. Images of all sizes can be selectively masked this way.

On the other hand, if your original picture is large format and the areas you want to leave unmasked are fairly simple in outline, you can paint a dropout intermediate by hand. Use fixed-out clear film taped over your original transparency or negative, and onto it paint liquid opaque to cover details not to be masked. You have total freedom of choice here – areas need not be the lightest or darkest parts of the picture, or all have the same range of tones. As before, have your 'hand-made' mask registered over the original when exposing your main contrast-controlling mask, then discard it and combine this main mask with the original.

Hand-bleaching the mask

You can make a whole picture contrast mask direct from the original tone-faulted image, but then bleach away parts of the mask image wherever you do not want masking to occur. Do this by applying silver bleach solution (such as iodine, see page 293) on a brush to any chosen part of the picture. Once again, this is only practical with large-format images and fairly simple outlines.

Selective colour masking

When you are masking a colour film image it is possible to alter the tone range of one colour only. You do this by exposing the mask through an appropriately coloured filter. For example, in a colour transparency of some blue flowers you may want to reduce the contrast of everything else in the picture. By comparison, the flowers will then stand out boldly in tone and colour. You therefore make a mask of the whole image (on pan masking film) but using a deep-yellow filter over the light source. As a result, blue parts of the picture record as clear areas on the mask. When mask and colour transparency are combined the flowers remain unaltered, while contrast elsewhere is reduced according to the strength of your mask.

Less extreme colour masking can also be used to compensate for inefficient dyes in the original colour film. For example, you might be printing from or duplicating a harsh colour picture in which greens and blues have reproduced too dark. It is then helpful to make a contrast-reducing mask through a pale red filter. Adding the mask then slightly darkens and subdues reds, effectively lightening greens and blues. Similar principles are used in the integral masking of colour negatives (see page 95).

Controls during enlarging

Sometimes quite simple changes in your darkroom equipment or techniques can give a significant improvement in the printing quality of an excessively contrasty or flat negative. For example, if you are trying to print a contrasty image in a condenser enlarger and do not have a diffuser head (such as a colour head) available, place tracing

Fig. 7.26 Preparing a 'handmade' dropout mask using a clear sheet of film over your original film. With liquid opaque you can freely work over areas you want to remain unaltered when the rest of the image is masked. See text

Fig. 7.27 Reducing the effective size of the lamp in a condenser enlarger lamphouse – gives harder illumination and a more contrasty print

Fig. 7.28 Strenthening tone contrast and density by digital means. Results are controlled via a displayed 'histogram' bar chart. Below, left: appearance on monitor of low contrast transparency after scanning-in. Histogram proves that only part of the available tone scale (shown below chart's baseline) is in use. Right: having used the mouse to 'stretch out' the same total number of brightness levels and drag them left, the image shows expanded contrast and greater proportion of dark tones

paper over the top of the condensers. This gives a dim but one-grade-softer light source. If this is not a sufficient improvement, try 'flashing' – evenly fogging the printing material to a small quantity of light.

A correctly flashed print changes only in subject highlights. Your normal exposure to the contrasty negative is too weak to give a developable image here. However, the extra photons of light the paper receives from flashing are sufficient boost for traces of subject detail previously 'sub-latent' to develop up. Overdone, flashing gives a print with flat grey highlight detail and a fogged appearance, so there are limits to the amount of contrast reduction possible. You can also use flashing when printing onto reversal materials (i.e. colour prints from slides) or when duplicating contrasty transparencies. This time, flashing helps to bring up better *shadow* detail but overdone shadows start to look flat grey.

The amount of light needed to flash the emulsion after image exposure has to be found by testing. With colour printing try removing the film from the enlarger carrier, placing a 2.0 neutral density filter (factor ×100) under the lens and giving your paper the same exposure time over again. For black and white you can simply leave the negative in place and hold thick tracing paper about 3 cm below the lens. This scrambles the light sufficiently for the paper in the enlarging easel to receive even illumination. Try giving about 10–20% of the previous exposure.

To increase the printing contrast of a flat tone range negative, make any change which will harden the enlarger light source. Change from a diffuser to a condenser head. Better still, change to a condenser enlarger with a point source lamp. Alternatively, you can harden up a regular opalized lamp with a hole in opaque foil (see Figure 7.27), but make sure your negative is still evenly illuminated – you may have to raise or lower the lamp. The much dimmer image will have to be compensated for by a wider lens aperture or longer exposure time.

Making changes digitally

By working on your picture as a digital image it is far easier to achieve fine control of tone and colour. You can start with your film image scanned onto a memory disk such as a CD-ROM, page 280, or direct to computer (unless you have already shot with a digital camera feeding a

card or connected direct into the computer memory system, page 279). The resulting file is then brought up on your monitor screen and displayed as an image with its histogram or tone curve alongside (explained below). Altering the shapes of the graphs creates simultaneous visual changes in the image which you can check at every stage. Your final corrected file is saved and may be recorded back onto photographic film or paper, or output direct to equipment such as an inkjet printer. See page 285.

Working digitally avoids use of chemicals, darkrooms, etc., avoids physical problems of dust, mis-registration, and time delays drying film. You may choose any localized area for change by shaping it out; also if a mistake is made you can instantly go back to the previous version. On the other hand, the image as carefully judged on the monitor can differ greatly in colour and tone from your final printed-out result, unless the two are properly calibrated one to another.

Brightness and contrast corrections

Both histogram and curve displays are useful to control practical results. As Figure 7.28 shows, a histogram is a bar chart in which the number of pixels present in your image for each grey level between full black and white is 'totted up' and shown by the relative height of each bar. In all there are 256 bars, each representing one particular grey level in a standard 8-bit monitor screen greyscale, even though the original image may have been digitalized to a greater bit depth than this, see page 103. As an example of histogram use, if one or both tone extremes of the

Fig. 7.29 Photoshop software includes tone curve for sophisticated digital image control. Below, left: with no correction graph displays 45° straight line, plotting input values (base line) against unchanged output values (vertical axis). Bottom right: graph here had top 'pinned' at max shadow, and bottom at max highlight tone positions. Then central was pulled and pushed until reshaped to increase contrast in shadows and highlights, although flattening mid-tones. Curve is normally displayed alongside image, which responds to each change

image are shown dropped to no pixels within the 256 tone range available you can operate your computer mouse to pull them to pure black or pure white limits of the scale. This action proportionately adjusts all the pixels in the other channels too. The effect of 'stretching out' the data to fill the histogram improves both contrast and visual sharpness.

Another, and photographically more familiar, way to redistribute tones digitally is to work through a tone curve. Calling this up, Figure 7.29, presents you with a graph which plots image tone range before changes ('input values') against the effect after changes ('output values'). Starting with a 45° straight line you can mouse click onto any point on the graph line and either pin it or move it like bowing a piece of string to a new shape. It can for instance be shaped more like a photographic characteristic curve to increase midtone contrast, or alternatively given a flattened central section so that shadows and highlights become more contrasty than midtones. Every redrawing of the curve shows the corresponding change in the displayed image. You may also restrict change to a premapped-out area of your picture to achieve the equivalent of shading or burning-in, or of 'split-grade' printing with variable contrast paper.

Colour image changes

Histograms and curves for colour images often (as shown here) combine all three R, G and B sets of readings so that your adjustment of tones and contrast takes place without affecting colour. However, when you need to make colour corrections – eliminating an overall cast, or perhaps making a local change to compensate for mixed lighting – data on each component colour can be displayed, forming a set of three separate graphs. Values can then be raised or dropped for each colour, in a broadly similar way to altering filtration in silver halide colour printing. Most photo-manipulation software programs also allow you to produce the digital equivalent of unsharp masking (page 167) over a wide range of precisely targeted levels, to produce image-sharpening effects (see page 285).

Summary: Tone control

● To control tone values, look after all the links in the chain – subject and lighting contrast; filtration; lens and imaging conditions; film contrast and grain; exposure accuracy; development; reduction, intensification or masking; enlarging conditions; print material and techniques like 'split-grade' exposing; also final viewing conditions.
● Working digitally, recognize the ill-effects of over/underexposure and excessive contrast range. Also plan final print size from the beginning – otherwise extra pixels may have to be 'interpolated', resulting in appropriate tone/colour but poorer definition.
● Typically, subject brightness range is compressed as recorded on the negative, especially shadow tones. It expands again to some extent (especially in darker tones) when printed. Quadrant diagrams prove the importance of correct exposure – partly on the toe of the film curve – to make proper use of the full tone range of the paper.

● Try to get your subject brightness range within reasonable limits in the first place by care over lighting. Compensate extreme contrast by reduced film development (but overdone, your negatives will be too flat to print well). Gear exposure and development to your own printing conditions. Over- or underexposed negatives will not 'fit' any paper.

● Any single light measurement reads out camera settings which reproduce this part of the subject as mid-grey. You get greatest exposure information from several local area readings. Separately reading highlights and shadows shows whether subject contrast is within the range of the film. It warns you to compensate by lighting fill-in or adjusted development, or to accept loss of top or bottom of the tone range.

● The zone system helps you to devise your own practical routine for tone control. Subject brightnesses are previsualized against a range of zones (I–VIII), with mid-grey zone V, black (0) and white (IX). Changing exposure one stop shifts all subject brightness one zone up or down.

● To work the zone system you must have your exposure/development/printing technique firmly under control. Then adjust one or more of these stages to get the best possible tone range reproduction for your particular shot. First establish the effective speed of your film. Find development times for high, medium and low subject brightness ranges to get negatives with the right tone range to print well through your equipment. Similarly, you can establish best paper development time.

● Use the zone system by picking a key subject brightness, deciding the tone it should reproduce and then exposing so you know you will achieve this precisely. You can also measure darkest and lightest important detail, and by picking the right exposure and development arrange that this just fills the full tone range offered by your printing paper.

● The zone system best suits sheet-film black and white pictures of inanimate subjects. It can be adapted to rollfilm and 35 mm sizes provided you can locate all pictures needing the same development together on the same roll. Even if you do not work every aspect of the system, remember the concept and train yourself to tonally previsualize your results.

● You can modify tone qualities at later stages to improve or salvage results. Use appropriate chemical reducers to lighten dense black silver negatives. Reducers also alter contrast – subtractive types increase it, proportional or superproportional reducers maintain or reduce contrast.

● Dense, flat colour transparencies may improve if duped. Treat pale black and white silver halide negatives in chromium intensifier or (contrasty negatives) use a subproportional intensifier. Remember health and safety advice.

● Masking to improve an overcontrasty film original means contact printing a very pale black and white film image of opposite tonality, then printing from both films sandwiched in register. Contrast-reducing masks are usually made unsharp to preserve contrast in details. Negative masks to be combined with contrasty colour slides and transparencies are best exposed to leave clear film in delicate highlight tone areas, where contrast is lowest. Make a very underexposed, contrasty 'highlight mask' first, fitting this over the original before you expose your main mask.

● Contrast-boosting masks are pale black and white versions of the film image they are masking. You therefore need to go through an intermediate stage when mask making.

● Selective masks alter contrast in chosen areas of the picture. Make an underexposed contrasty dropout intermediate to block out whichever end of the tone scale you do not need masked. Alternatively, make your intermediate by opaquing-out these parts on clear film. Then print the main mask from your original plus the intermediate. You can also make a full image mask and bleach out unwanted parts by hand.

● Printing off a mask by coloured light produces a mask which is paler (or clear) wherever the original image is complementary in colour.

● Reduce tonal contrast at the enlarging stage by diffusing the light source or 'flashing' the paper to light. To increase contrast, change to a condenser head and more point-source lamp.

● Both tone and colour contrast control can be greatly extended by digital means. Once the image is stored in computer memory software allows you to use histograms or tone curves to make visual adjustments – either overall or just within selected, mapped-out areas.

8
Subject problems

This chapter is subject orientated. It takes a cross-section of twelve kinds of subject matter from sports to simple astronomy, outlining some typical professional markets and the general organization and technical approach to the work, plus hazards to avoid. Of course, whole books could be written about each subject, but running them together here points up the different pressures and priorities they impose on you as a photographer. Perhaps you will never have to tackle all of them, but then you are unlikely to specialize in only one type of subject either, especially if you are just setting up as a professional.

It is dangerous to be too categorical about the technique used by different individual photographers. People have an idiosyncratic approach to equipment and working method. After all, it is *possible* to use a large-format camera for candid documentary photography and 35 mm for still lifes and architectural interiors. Similarly, some photographers heavily impress their own particular style on whatever they shoot, almost to the point of excluding the purposes for which the picture will be used. These, however, are the exception.

Generally, market forces, your own specialist subject experience and even equipment design determine why and how pictures are taken. Convenience and common-sense dictate your best technical approach. Most photographers tackle jobs in the way outlined here – just remember that no approach is set and immutable. New markets and new kinds of equipment (digital, for example) mean that subject problems and their solutions change over a period of time. In any case, newcomers to photography should always question the way things were done previously, for breaking away and finding new visual solutions is one way of beating your own path to success.

Most commissioned photographic jobs have to fulfil some form of commercial need or requirement of communication. They also challenge you with extra constraints. The final image may have to fill a long low format, it may have to be quite small (calling for a simple, bold approach) or it has to work when converted later into stark black and white only. Even when you have not been *assigned* to photograph a subject as a job it is important to set yourself tasks or projects. This gives you a structure to work within, while still allowing experiment.

In portraiture, for instance, you might discipline yourself to produce six pictures of *pairs* of people, and then consider all the ways subjects could relate – mother and son, husband and wife, old and young, etc. Equally, your series might all be people living in the same building, or all in uniform or travelling. Then when you have actually taken pictures along self-set lines and processed and contact-printed results you start to discover take-off points for further extending your project or progressing into new ones. For example, two of the people you photographed might appear in an interesting location which leads on to a series on environmental interiors, or accidentally blurred detail in one frame suggests a series on movement and abstraction.

In this chapter each subject area is discussed under three headings. *Purposes* means typical functions and markets, reasons why pictures are taken. *Approach and organization* discusses planning and your relationship with the subject, while *equipment and technique* suggests how to put it on light sensitive material, using appropriate gear.

Sport and action

Purposes

Strong, topical action pictures are always of interest to newspapers and the sporting press. Over a period of time a sports photographer accumulates a vast range of shots filed, for example, under the specific occasion; the personalities shown; and more generalized pictures of different activities. The best of these photographs will sell over years to publishers of magazines, books, posters and other advertising. They may be used for anything from editorial illustration to product packaging or textile designs. Freelance sports photographers therefore tend to contribute to or run their own comprehensive picture libraries. Others are on the staff of news agencies or specialist publications, or may work directly or indirectly for sport sponsors and sports goods manufacturers.

Approach and organization

First, you should fully understand the sports or activity you are covering. You also need patience, the ability to anticipate a high point in the action and to immediately respond to some vital moment, which can often be unexpected. The main aim is to capture participants' skill, anguish and tension, plus the dramatic excitement and atmosphere, preferably all summed up in one shot. Experience and preplanning are of great importance. Aim to pick out the best possible viewpoint in terms of perspective, background (atmospheric but not confusing) and where the action will be most intense. If you do your homework properly you should be in the correct position for a left- or right-hand golfer and know which end a particular vaulter gets his legs over the bar. Some sports like athletics or cricket consist of mostly repetitive actions, and the problem is to find a picture which is interestingly different. Other events take place all over the field, so you must keep all your options open, working with a kit of lenses from one or more key positions.

Go for the expressions and body language which visually communicate how it feels to be taking part. See Figure 8.1. Look at the tension

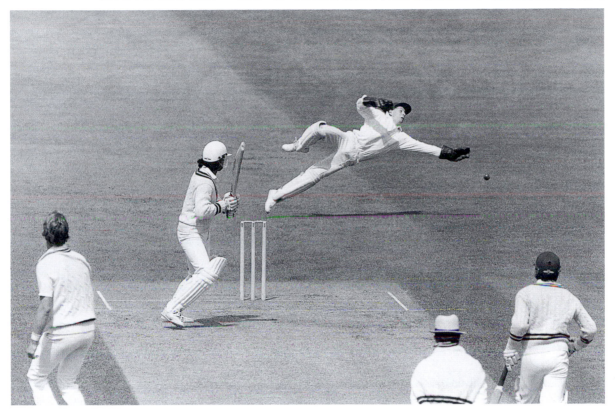

Fig. 8.1 A split second at a test match, after a long period of waiting and anticipation. Patrick Eagar shot this using an extreme telephoto lens, for *The Sunday Times*

competitors go through just prior to an event and the reaction of spectators, as well as the vital peak of action itself. At the same time, your photography must never interfere with the sport or activity – you must know and respect its requirements and rules. Wherever possible, get the cooperation and interest of people organizing the event. This will lead to viewpoint opportunities not otherwise open to you.

Equipment and techniques

You will need a good range of lenses, plus at least two 35 mm bodies. Wide angles are useful for crowd shots, general scenes and dramatic, steep perspective close-ups. However, for many sports your enforced distance means that you will rely on long focal lengths – 600 mm or more in the case of cricket. All these lenses need to be as wide aperture as you can possibly afford. You are likely to work at shutter speeds of 1/500 and upwards, and the shallow depth of field given at wide apertures is helpful in subduing distracting backgrounds.

On the other hand, it is a good idea to freeze only those elements in a picture which need to be seen in detail (facial expressions, for example). Rapidly moving extremities – arms, legs, wheels symbolize action much more effectively blurred, especially when shot in colour. This takes judgement and risk in choosing the shutter speed for any one occasion. There is always the possibility of excessive abstraction. Panning your camera to follow the action of track or field events is another way of making blur dramatize speed and isolating subjects from often distracting surroundings.

SPORTS

2 35 mm bodies with motordrive	
Wide-aperture	50 mm
lenses:	24 or 28 mm
	70–200 mm
	300 or 400 mm
	600 mm
Tripod	
Monopod	Remote release

Despite autofocus cameras, experienced sports photographers often prefer to prefocus on some key spot on the ground and shoot when the action reaches this point. Others pull focus by hand to keep the main element sharp – preferring the freedom this gives to the always centre-frame focusing of automation. Single-frame motordrive is an important aid because it becomes easier to keep your eye to the viewfinder between shots. Continuous-drive mode motordrive is mostly used in short bursts, unless you are going for a planned analytical sequence.

Never assume that by shooting a rapid series of frames you are *bound* to capture the vital moment of an event. Even at three frames per second, pauses between pictures are still around three hundred times longer than the moments being recorded. The mirror also locks up at fastest framing rates, making it difficult to work. There is really no substitute for foreseeing what will be the peak of action and learning to press the shutter just a millisecond or so ahead. Pictures covering an important event are often urgently needed back at a newspaper's sports desk, to catch an edition. This may well justify the cost of a digital hand camera able to download shots via modem and mobile phone direct to the editor's computer screen.

Photo-journalism/documentary

Purposes

In-depth journalistic picture series are like essays or published articles, as opposed to press pictures which singly cover deadline news. The whole concept of 'photo-journalism' was pioneered in the late 1930s by magazines such as *Life* and *Picture Post*. A good *visual* story, strong photography with a point of view, plus intelligent layout on the printed page together form a powerful kind of communication. In recent years markets for photo-journalistic essays in magazines and newspaper supplements have greatly declined. However, strong documentary pictures are still in demand for travelling exhibitions, books of photographs and new forms of publication such as CD-ROMs.

Most subject themes revolve around human events – after all, most people are interested in people. The relationship of people to their environment, society, work, violence or some catastrophe are constantly recurring story lines. Some of the best journalists – like the best documentary writers – have been obsessed by their subject matter to the extent that it becomes a crusade rather than a job. (See the work of Farm Security Administration photographers revealing the 1930s plight of destitute US farmers, and Eugene Smith's book *Minamata*, on industrial pollution.)

Approach and organization

You must decide the theme of your story and give plenty of time and thought to the best approach. As far as possible plan a mental list of vital pictures, so that your project is structured and shows various aspects of the subject and theme. At the same time keep open-minded and aim to take a lot of pictures which can be edited down later. Good selection then allows you (or, more often, the art editor) to lay out pictures which determine the order of viewing, make comparisons through being run side by side, and so on.

DOCUMENTARY

2–3 35 mm camera bodies
Motor drive
Flashgun (GN 30–60)
Wide-aperture 24 mm
lenses: 35 mm
 50 mm (2)
 70–200 mm

Tripod or clamp

Perhaps you will want to show differences between young and old, rich and poor, or contrast people's public and private lives. People at work could be photographed to show both social life and working activity. At public events turn your camera on spectators and events behind the scenes as much as the scenes everyone else sees and photographs.

Equipment and techniques

Mostly you will want to be inconspicuous, and merge in with the people around you. This means dressing appropriately and simplifying your camera kit which you carry in a bag not too obviously photographic. 35 mm is the ideal format because of its compactness. Autofocus is also helpful on occasions, especially if you must grab pictures without looking through the viewfinder (for example, over people's heads). Otherwise preset focus and also exposure settings by reading off substitute subjects such as your hand. Have two camera bodies fitted with different lenses and motordrives. Be prepared to wind on manually in situations where motor noise will attract attention. Use existing light as much as possible but pack a flashgun for times when conditions and depth of field requirements are beyond even the fastest film, or when you must fill in ambient light to reduce contrast (page 125).

Most work will probably be done with a wide-aperture standard lens, but have a wide angle for interiors and whenever foreground detail should look large and dominate the general environment. Pictures taken close with a wide-angle lens add to a sense of 'being there' when you are among a crowd, and during a threatening situation even increases the apparent aggression. Shooting from afar using a moderately long focal length 'puts together' elements in mid-distance and background. You can also use it for unobtrusive head shots some distance away (sometimes an easy option – you will get a less 'detached' perspective by shooting closer with a normal lens).

Portraiture

Purposes

Apart from mere physical identification, most deliberate portraits are shot either to flatter the sitter or to express individual character. Of course, these purposes are not mutually exclusive, but flattery portraiture is mostly commissioned by or taken for your actual sitter or his or her family or business organization. Sitters expect to be shown favourably, perhaps portrayed as they see themselves or hope others see them. However, with portraits commissioned by third parties such as magazine editors you can forget flattery and sum up a person as a character, even if this is cruelly revealing. It is helpful to know how a picture is to be used – perhaps framed in a commanding position on a boardroom wall, reproduced single column or full page in a magazine or even sent out in response to fanmail. Pose, lighting and size of detail within the frame can then be geared to this end form.

Approach and organization

It definitely helps to be extrovert and good with people. You may prefer to photograph in the studio, isolating your sitters from their normal

Fig. 8.2 Monique Cabral used existing light for this journalistic portrait shot for *New Society* magazine. 35 mm camera equipment offers lenses with wide aperture and adequate depth of field to record environment, even under poor light

surroundings. The studio is easier for you but often more intimidating for your sitter. Going instead to their own environment (home or work) means that you can make local features form a part of the portrait, adding information and allowing you scope for interesting composition. Unlike candid portraiture, the sitter must be *directed*. Uncertainty or over-management on your part is likely to result in either self-conscious or 'stagey'-looking portraits. Make up your mind what facial features you should emphasize or suppress. Observe the way your sitter uses hands, sits or stands. You need to establish a relationship, talking and putting the sitter at ease while you decide setting, pose, lighting and viewpoint.

If hands are important you might have the sitter at a desk or table, perhaps at work. He or she will take up a much more relaxed, expansive pose in an armchair than perched on the corner of a stool. Photographed from a low angle someone will look dominant, whereas shown from a high viewpoint they can appear dominated. A broad face or broad shoulders look narrower from a three quarter viewpoint instead of square-on. Organize everything for a natural and productive relationship between you and your subjects. Minimize the machinery. Do not have people trapped into straight-jacketed poses and critical lighting arrangements which are bound to make them look artificial and ill at ease.

Equipment and techniques

This type of subject lends itself well to medium-format cameras. The extra picture qualities outweigh equipment size and weight. It is a good

Fig. 8.3 A formal approach to portraiture in this near-symmetrical baby shot by Sue Packer. It was photographed on location with bounced studio flash, using a 6 × 6 cm camera. The simplicity of the lighting makes the throne-like chair shape all the stronger. From series 'Baby Sittings'

idea to use a tripod anyway. You can more easily fine-tune lighting, etc. without moving the camera and disturbing composition. If you stand to the left or right of the lens you naturally get the sitter to look to the right or left in your picture, without direct instructions. For half-length or head shots, pick a slightly longer than normal focal length lens (i.e. 150 mm for 6 × 6 cm or 85 mm for 35 mm). You can then work from a more distant viewpoint, giving a less steep, more flattering perspective and intimidating the sitter less with your camera equipment.

Of the three light sources – daylight, tungsten lamps or studio flash – daylight indoors often gives excellent natural qualities but it can be difficult to control. Flash scores over tungsten lighting in terms of heat and glare. Its power allows you to shoot on slower, finer-grain film. Be sure to have plenty of light reflectors and diffusers. Try to go for a simple lighting arrangement within which the sitter can freely change poses without instantly calling for light-source adjustments or altered exposure. One soft main light from a 'natural' angle plus reflectors to return light into the shadows and help to create catchlights in both eyes is a typical starting arrangement. As soon as possible, stop tinkering with the equipment and concentrate on your relationship with the sitter.

Weddings

Purposes

Photographing weddings is often regarded as a chore, but the fact is that within a family a wedding is a very special occasion. Consequently,

PORTRAITURE

6 × 6 cm camera
150 mm, 250 mm, 80 mm lenses
2 studio flashes
Flash meter
Tripod, cable release
Reflectors, diffusers

covering such an event is a serious responsibility. Indifferent or missed pictures will deprive participants of important memories. Your work must be good enough to be framed and put in albums, and looked at over the years by different generations. Wedding photographs are a kind of time-warp within which families measure themselves, so results are of increasing value and interest.

Approach and organization

Meet the bride, groom and parents before the event to talk over the scenario. Clear permission with the religious or official authorities so that you know where photographs can and cannot be taken during the ceremony. Find out if there are to be any unusual events – for example, the bride arriving in a horse-drawn trap or the appearance of some invited celebrity. If the proceedings are to follow an unfamiliar ethnic procedure it is vital to learn the order and significance of each stage.

On the day itself remember that you are a part of the proceedings. Dress neatly, in deference to other participants, and arrive early. This allows you to assess potential backgrounds, lighting and best camera positions. Avoid backgrounds which are cluttered, ugly or inappropriate (church gravestones, for example). You can also start photographing the arrival of guests, preferably posed in groups. Follow this through with the arrival of key figures such as groom and best man, bride and father. Where there are noticeable differences in height it is best to step back and take full-length shots rather than half-lengths and close-ups.

After the ceremony there will be formal groups. Start with husband and wife alone, then work outwards, adding the immediate family and increasing numbers of close relatives until the final group includes most guests, if there is sufficient space. With the smaller groups, especially, pay great attention to detail. Make sure that men have jackets buttoned and no flapping ties, long dresses are arranged neatly, hair and head-dresses tidy. Later, complement these somewhat cliché but popular pictures by taking informal shots at the wedding reception. See Figure 8.4. Similarly, look out for, and record, any unexpected event which people will enjoy recalling – the groom arriving by motorbike because of a car breakdown, the best man hunting for the ring, even just a pile of hats in a church porch, or puddles and umbrellas if it rains.

Equipment and techniques

A medium-format (preferably magazine-loaded) camera allows you to work fast yet give excellent detail. This is especially important for groups. Use mostly standard and moderately long focal length lenses, the latter mainly for head shots and half-lengths. Have a wide angle for interior general views, but do not use it for shots of people or groups unless space limitations are desperate. A tripod is important. It sets the camera position so you can go forward and adjust some detail or tactfully ask people to change places or move closer. You must also have a powerful variable-output flashgun to deal with daylight fill-in problems – for example, people arriving at a doorway photographed from within the building. A few effects filters such as 'misty' diffusers are useful, along with pins and clips to help arrange dresses. A 35 mm SLR outfit with zoom or wide-aperture normal lens is the best equipment for candid shots at the wedding feast. If you

Fig. 8.4 Formal groups are only one aspect of covering a wedding. You also need some candid pictures, plus romantic set-up shots like this one, by Bobby Collins, which stresses human relationships. Techniques such as a diffuser over the lens, and contrast-reducing light from a reflector or bounced flash, help you create the right atmosphere

WEDDINGS

6 × 6 cm camera with 80 mm, 150 mm, 65 mm lenses
35 mm camera with 35–100 mm lens
Flashgun, meter
Effects filters
Tripod

have an assistant he or she can use this equipment to cover incidentals at the ceremony.

Computers have made it practical to include post-shooting image manipulation as part of your service. This may range from suppression of unwanted background detail to changes of expression (by seamless substitution of someone's face from one version of a group shot into another).

Landscapes

Purposes

Landscapes are photographed for a wide variety of purposes. Detailed, representative shots are needed as picture library material for travel, ecology and educational publications of all kinds. Many of these photographs have timeless qualities which make them sell over a long period. However, landscape also lends itself to personal expression and interpretation. It can be majestic and dramatic, undulating and gentle, an abstract mixture of patterns or stark slabs of tone. From early times

creative photographers have recognized landscapes' visual possibilities. Pictures on exhibition walls, published as book portfolios or framed prints, prove how landscape photography can symbolize concepts like ageing, rejuvenation, a joyful sense of life . . . or mystery and gloom.

Yet again, the main point of a landscape photograph may be much more social documentary, with the significance in *what* it contains. Threatened coastlines, pollution from industrial plant, the carving up of countryside by new roads and other developments need to be brought to the attention of the public and those who make planning decisions.

Approach and organization

Landscape photography looks deceptively easy. After all, the subjects themselves are largely unchanging and always there. Yet your total experience of a landscape includes space, distance, air movement, sounds, smells – you look around you and notice the changing juxtapositions of elements near and far as you walk. These things are difficult to sum up within one still photograph, unless in some way you can isolate just a part which will encapsulate the character of the whole scene. Perhaps this means a low viewpoint, wide-angle shot which exaggerates jagged foreground rocks and, through differences of scale, emphasizes the depth and distance between them and distant, brooding mountains.

Sunlight and shadow changes transform landscapes too. Differences of weather, time of day and season of year all make startling differences to appearance. You need the care and organization to pick conditions which strongly convey the mood of the place. Direction and quality of light can emphasize textures, patterns, colour and linear and tonal perspective. So you have to be dedicated enough to get yourself and equipment to a particular chosen viewpoint at a calculated time.

Look at the way one form overlaps another. Think about the best proportion of land to sky, that all-important placing of the horizon

LANDSCAPE

Medium- or large-format camera
Normal, wide-angle, and
moderately wide-angle lenses
Filters, including polarizer
Tripod
Meter
Instant-picture back

Fig. 8.5 Sometimes the mood of a landscape is best summed up in sombre shapes and muted colours. Foreground detail can relate to distant features

Fig. 8.6 Panoramas. When shooting a series of pictures for a join-up panorama, avoid pointing the camera either downwards or upwards, however slightly. Results will have a dished or humped horizon. Instead use a spirit level to help set the camera exactly horizontal. A rising or drop front (e.g. shift lens) then allows you to reposition the horizon higher or lower in the frame if needed

which occurs with practically every shot. The picture may depend greatly on some feature such as a line of cast shadow, reflections in water, or some small, strongly placed shape.

Equipment and technique

Landscapes lend themselves to medium- or large-format photography provided that you are prepared to transport the equipment. Larger cameras offer finer tonal qualities and detail, plus possibilities of camera movements (swings to extend depth of field from foreground to horizon; shifts to adjust converging lines). Often there is plenty of time to set up a check of composition and exposure while you wait for the right lighting conditions. However, difficult locations may have to be handled with 35 mm equipment using slow, high resolution film. 35 mm or medium-format cameras fitted with motordrive are also handy for shooting negatives for mosaic panoramas. Consider too the possibilities of using a panoramic camera, see page 47.

A tripod will prove vital for serious work, as you may be shooting at dawn or dusk. Filters are also very important. When shooting in black and white, have orange or red contrast filters to darken the tone of blue skies and a green filter to lighten vegetation. For colour, have a polarizing filter and an ultra-violet absorbing or 'warm-up' (haze) filter to reduce blue casts when you are working at high altitudes or near the sea. Include colour-correcting and colour-balancing filter types. A graduated grey filter is handy to prevent sky and cloud 'burning out' when you are exposing for darker ground detail.

Fig. 8.7 Graduated grey filter, useful to avoid overexposure of sky detail in dark-toned landscape. The more you stop down the more abrupt the transition between filtered and unfiltered parts of the scene. Preview effects at your working aperture

Architecture

Purposes

Photographs of the exteriors and interiors of buildings are required by architects, real estate agents, conservationists, historians, local authority and community groups, etc. Architecture, like landscape, still-life and other 'non-people' subjects, is also chosen by some photographers concerned with expressing their own ideas in pictures which are ends in themselves. All these people use photography for different purposes. The architect of a new structure will want striking dramatic pictures for magazine articles and exhibitions. You need to show the spirit of the place, as well as its character and broad features (form and texture). For more technical publications important details must be stressed, and the architecture generally shown with less visual licence. Specialist readers need information on its structure and proportions.

Environmentalists may want photographs to show the relationship of a new building to its local community, perhaps stressing detrimental influences. Real estate agents want a highly complimentary portrayal, showing space and light, and all the best features, but with

no signs of the cement works and fertilizer factory next door. If the purpose of the pictures is freer and mainly to express yourself it can be argued that you are very much in the hands of the original architect. Like photographing sculpture, it is not easy to take someone else's creative work to form original images of your own. The challenge is often to express the impressions the architecture makes on you as an observer.

Approach and organization

Your two most important controls are lighting and camera viewpoint. Make up your mind about the important features to show and plan the best time and lighting conditions to bring these out in your pictures. Unlike landscape photography, your choice of camera position may be quite restricted – and this then determines the time of day you must shoot. A compass and watch are useful tools in planning where the sun will have to be to pick out different facets of the building. Better still, keep returning to observe throughout the day how lighting changes the appearance of volume, surface, colour and shadow pattern. See Figure 8.9.

List the shots to do at any one time. This might include close-ups of embellishments at one part of the building and, at the same time of day, general views of a totally different part, because light will then just be brushing across large wall surfaces. Do not overlook the possibilities of exteriors at dusk. Arrange to have all the lights on early enough for you to shoot a series while natural light fades and the dominant illumination changes from outside to inside the building.

The main problem with exteriors is the weather, as well as irrelevant surroundings such as parked cars and building plant. Listen to the weather forecasts. For many situations soft but directional hazy sunlight is best. Totally overcast conditions give a lifeless, tone-flattening effect (although this might better suit a social documentary shot of poor housing).

Avoiding unwanted elements is mostly a matter of devising the right camera location. Sometimes this is quite hazardous, but you may need to be above parked cars, traffic and people, or block them out by some foreground feature. All this is best worked out ahead, helped if you know how much you can include with each of your different focal length lenses. Architecture which is essentially low in structure with surrounding grounds usually looks more impressive from a high viewpoint outside the area. If necessary, turn to low level aerial photography (see page 197).

The main difficulty with architectural interiors is the unevenness and mixed colour balance of the light and the need to include as much as possible. Your eye tends to scan an interior, and it is not easy to match this with any wide-angle lens which does not also distort shapes. Like landscape, you may have to seek out some part which epitomizes important features of the whole. Be prepared to shoot rooms from outside windows or from corridors looking through doorways. The normal content of rooms often looks cluttered in photographs, so expect to spend time removing or rearranging items to avoid confusion and give a sense of space when seen from the camera's static viewpoint. As in still-life work, take out anything which will not be missed from your picture.

ARCHITECTURAL

Large-format monorail camera
Shift camera, or medium-format camera with shift lens
Normal and wide-angle lenses having good covering power
Filters, flashgun, compass, meter, lamp kit with clamps, spirit level, instant-picture back

Fig. 8.8 Some 'room' sets are incredibly basic, using three simple surfaces – the floor and two walls. This shot is geared to present a common decorative theme, and is 'propped' to maintain colour scheme rather than convey reality. (By Michel Tcherevkoff/The Image Bank)

Fig. 8.9 Chateau in the Loire valley. Having set up for this viewpoint with a 6 × 6 cm camera and 40 mm lens, Charlie Waite hung on for over an hour until the expected storm appeared. The shot was taken just before the first rain broke up the reflections and direct sunlight was blocked out

Equipment and techniques

A camera with movements is essential for serious architectural photography, although detail work can be carried out with any regular camera. Vertical lines shown strongly converging are acceptable for dramatic, linear compositions but they look wrong (or careless) when just off-true. In any case, you will need shift and probably swing movements to work from high or low viewpoints, extend depth of field over a chosen plane, etc. Your lenses – especially wide angles – must therefore offer really generous covering power (see pages 41–42).

Have a kit of lamps or portable studio flash to help fill in and reduce contrast and unevenness with interiors. For colour shots, have blue acetate so that, where necessary, you can match up lamps with daylight seen through windows. However, never overdo your extra lighting – often it is vital to preserve the existing lighting scheme as part of the character of the building itself. For this reason, soft, bounced illumination is often best. Take some blue-tinted domestic lamps to swap for lamp bulbs in any desk lamp, wall lights, etc. included in the picture if an orange cast here is objectionable on daylight film stock. You also need a powerful variable-output flashgun for situations where there is no suitable electricity supply. An instant-picture back helps you to preview whether fill-in is sufficient yet natural-looking. Remember that either tungsten light or flash can be used from several different positions during a time exposure (covering the lens in between) to fill in dark areas. Another way of working is to shoot at dusk and use tungsten light film – at one point your interior will be lit at the same intensity as the outside orangey daylight view.

Have filters which include a polarizer to help control unwanted reflective glare as well as darken sky tones. A strong neutral-density filter allows you to extend exposure (say, $\times 100$, a filter density of 2.0) so that in daylight shots moving people or traffic are so blurred that they do not record. Have light-balancing filters for daylight and for different forms of tungsten and fluorescent lighting, plus any colour-correcting filters needed for reciprocity failure compensation, and the usual contrast filters for black and white shots. A spirit level will let you check that the camera is truly upright, and a small hand torch helps to make camera settings in dim interiors or when shooting at night.

Built studio sets

Purpose

A set built in the studio to represent a room, patio, etc. has the advantage that it can be designed in every detail to suit a drawn layout. Sets range in complexity from a couple of simple wallpapered 'flats' to three sides of an elaborate room. Building time and cost involved is often much higher than working in a real location. However, this is justified for jobs such as product advertising in bulk (for example, for mail order catalogues), where you want to shoot a series of kitchen suites or fitted bedroom units one after another, just changing the curtains and decorations. A built set may also be the only practical way you can put together a historical scene, such as a Victorian kitchen for an editorial feature on nineteenth-century recipes. The accessories can come from television/film prop hire, or loaned or bought from dealers.

The main advantage of a well-planned set is that you have greatest possible freedom of camera viewpoint and lighting. The absence of a 'ceiling' and fourth 'wall' gives plenty of space for equipment outside the picture area, and complete control over every element shown.

In macro form there are similar advantages when you photograph scale models for architects, town planners, exhibition designers, etc. The usual purpose here is to give a realistic preview of something which has not yet been constructed. You must therefore match the technical accuracy of the model with properly worked-out lighting and a scaled-down 'human eye' viewpoint for the camera.

Approach and organization

Set building may take several days – far longer than the photography. Sets are best constructed from clamped-together 'flats', like theatre and television scenery (see Figure 8.10). Working from the angles of view of your lenses for normal or steepened perspective viewpoints, plan out the total size of the set on paper first. Remember to leave sufficient gap between the flats and studio walls and ceiling to get in lights, reflectors, etc. The main danger is that a constructed, propped set becomes too perfectionist, and lacks the idiosyncrasies and untidiness of an actual room. Results then look self-conscious and sterile, like a museum exhibit. Naturalness is also important in the lighting. Illumination should appear to come through windows (or imaginary windows in a wall unseen), not from a ceiling grid of top lights as in a television soap.

With scale models, take particular care over the height and direction of the 'day' light. This needs to comply realistically with any compass bearing marked on the model, not shine from one or more impossible quarters. If a model building has to be shown internally illuminated, as at night, use scaled-down sources which light limited areas just as they might be in reality. Fibre optics (page 136) are the easiest way to 'pipe-in' light to different areas within a small model.

Equipment and techniques

Apart from having a studio of sufficient size and with good access, you need basic carpentry and general do-it-yourself skills to construct flats. Whenever possible, incorporate standard builder's doors and window frames. Clamps and clips can take the place of nails and screws,

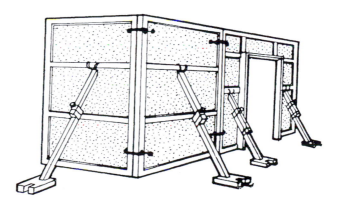

Fig 8.10 Simple corners of 'rooms' can be quickly constructed from wooden flats, G-clamped together and propped up from behind

provided they are unseen. If the budget is sufficient you may be able to have a stylist to decide and track down necessary props. There is little point in not using a large-format camera, together with an instant picture back (another possibility is a hired computer-linked digital back). You are certain to want camera movements to give the freedom to shoot from a higher or lower viewpoint without always showing vertical lines converging. Have plenty of studio lighting units – tungsten or flash to light various areas of the set. They can also give general soft light, bounced off the studio ceiling and perhaps walls behind window frames. Have a sufficiently high level of illumination so you can stop down for sufficient depth of field without reciprocity failure. Remember that with flash you can fire and recharge again several times during one exposure.

For scale models, it may be physically easier to work with a medium- or small-format camera, unless you need comprehensive movements. For realism, scale down your viewpoint to match the model. For a 'standing spectator' viewpoint (say, 1.6 metres above the ground in a 1:50 model) have the centre of the lens 3.2 cm (1.6 m divided by 50) above the base. A wide angle is the most useful lens. Stop down fully, because shallow depth of field is the biggest give-away that the subject is not full size.

Studio still lifes

Purpose

Still lifes (inanimate objects) cover everything from factual records of technical subjects through catalogue illustration to abstract images intended purely for mood and atmosphere. Your subject may be some form of merchandise for advertising, or perhaps the need is for a 'scene-setting' editorial illustration or cover shot to suit the theme of a magazine article or section of a book. It may be a collection of shapes and forms you put together for a picture which is complete in itself, as a piece of fine art or a social or political statement. Sometimes a plain background is necessary, for clarity of outline. However, more often you have to devise a background or setting which positively contributes to picture content, helping to put your subject in context without dominating it or confusing important features.

Approach and organization

By photographing a still-life subject in the studio you have a totally controlled situation. It is so open-ended that you can miss pictures by the sheer range of opportunities, skipping from one possibility to another. A disciplined approach is therefore essential. For example, decide the most important subject qualities (perhaps some aspect of form, shape, texture, colour) you need to show. Perhaps the subject itself will fill and bleed off the frame so there is no need for a setting, as in Figure 8.12, or the space around may be filled up with props or an area of appropriate background. Simplicity is often best – the more you can take *out* of your picture and still make it work, the better. Where you have to include many items on a background it is often best to work them into a group which has a satisfying overall outline and shape. Build up the lighting gradually, starting by deciding the position and

STUDIO STILL LIFE

Large- or medium-format camera
Normal and wide-angle lenses
Studio flash or tungsten lights
Meter, CC filters
Pola filter, camera stand
Instant-picture back
Fibre optics lighting

Fig. 8.11 An exploded view of components must show them in true relationship to one another. Align and support them carefully; avoid shadows from blocks, threads, etc. falling across the objects themselves. Later, supports are erased by digital retouching, or print bleaching or airbrushing to give a plain white background

Fig. 8.12 A still-life shot by Philip Fraser-Betts (for British Petroleum) making graphic use of simple shapes and colours. It is the sort of picture which can be used time and time again for brochure covers, exhibition displays and advertisements. Immaculate subject matter and tight control of lighting are vital. The tone range includes good shadow and highlight detail without flatness – which reproduces well on the printed page

quality of your main source. Keep returning to the camera (on a stand) every time you adjust lights or the position of objects, to check how these changes actually look within the frame.

When shooting promotional pictures of products, food, flowers, etc. it is essential that the particular specimen in front of your camera is in immaculate condition. Special preparation for photography is advisable, although you must not break laws protecting the consumer from false appearances. It is legitimate, for example, to undercook food to retain texture and colour, 'shine-up' sausages and meats with glycerine or treat cut fruit with lemon juice to prevent discoloration. Food shots usually mean calling in expert help from a home economist who can prepare your dishes in the studio. Whenever possible, have two examples of each item made – one to set up, compose and light, the other to be substituted fresh just before shooting.

Equipment and techniques

The gradual build-up of a still-life picture suits the considered approach of a large- or medium-format camera. They also offer shift, swing and tilting movements. Use a normal lens or a slightly longer focal length for objective work where steep perspective and distortion are undesirable, and keep close viewpoints with a wide-angle lens for rare dramatic effects. Seriously consider use of a digital back for bulk shooting sessions – to illustrate mail order catalogues, for example. It can pipe the images as you shoot them direct to a page-layout computer present in the studio – allowing you and a graphic designer to put together complete, finished spreads *on the spot*.

Studio flash is the best lighting equipment for any delicate subject matter which is easily heat damaged. Have a good range of light heads, especially softbox or large umbrella types. For subjects with highly reflective surfaces you will probably have to build a light-diffusing tent, while for exploded views items will have to be supported from behind or suspended from a gantry (Figure 8.11). Even quite small subjects often demand more studio space than you might expect. Remember, too, that still-life photography – with its progressive refining of ideas and approach – can often take longer than most other subjects.

Natural history

Purposes

Natural history pictures span a vast range of subjects, from plants to birds, tiny insects to herds of wild animals. Mostly they are needed for detailed factual information in educational publications (books, specialist magazines, exhibitions) as well as for general illustration. This is therefore another area where you can build up a specialist subject picture library. The secret of successful natural history photography is to show your subject and its environment accurately, but at the same time turn it into a creative picture which non-specialist viewers will also enjoy.

Approach and organization

This is an area where it is helpful to have special knowledge (as a biologist, ornithologist or zoologist) outside photography itself. You need to understand where and when to locate your chosen subject, best

Fig. 8.13 Laurie Campbell stalked this gannet using a 600 mm *f*/5.6 regular (non-mirror) telephoto lens

location and time of year, and (animals and birds, etc.) regular drinking or eating habits. Practise within an enclosed location such as a butterfly farm, plant sanctuary or safari park, where there will be a range of good specimens in a reasonably natural setting. Zoos are the easiest places for animal portraits, but these habitats are often ugly, and the inmates' behaviour usually quite different to that in the wild.

For animals and birds you need the ability to track down locations, perhaps with expert help. Then by stealth, anticipation and a great deal of patience you must photograph your subject from an effective angle and showing an identifiable activity. Sometimes it is more appropriate to work from a hide (see Figure 8.14) and watch and wait for your subject. Unless your hide is a permanent feature it may have to be assembled gradually over a period of time so that the animals and birds accept changes taking place. Then whenever you go to the hide take someone with you who soon leaves, making your prey think the hide remains empty.

With flowers and plants choose perfect specimens in their natural setting and photograph to emphasize their form, structure and colour. It is often helpful to include a scale for sizing – show this along one edge of the picture where it can be trimmed off later if necessary. With all natural history work there are two golden rules. Always log details of what, where and when you photographed; and do not damage or seriously disturb the plants or creatures which form your subjects.

Equipment and techniques

Most subjects are best photographed using 35 mm equipment, giving you the benefit of its range of lenses. Long focal length lenses are

NATURAL HISTORY

35 mm camera
Macro, normal, 80–200 mm zoom,
 500 mm mirror lenses
Spot meter, motordrive
Tripod and clamp
Flashgun, remote control
Notebook

Fig. 8.14 Portable photographer's hide must offer ample space for you and equipment over long periods. A long focal length zoom lens is helpful here

Fig. 8.15 An aquarium adapted for photography. Pick a suitable muted colour non-reflective backdrop. Black card around the camera prevents reflection of you and your equipment. Use main and fill-in flash from well to the sides for controlled illumination

UNDERWATER

35 mm auto-exposure camera with motordrive in underwater housing
21 mm lens
Action finder
Underwater flash on long extension

particularly important for wild life, giving a good-size image from a distance and picking out subject from background by shallow depth of field. Mirror-type designs are the lightest to carry and hold. Even so, a lightweight but firm tripod is essential. If your camera or hand meter takes spot readings this is especially helpful when birds and animals are moving against changing backgrounds. Autofocus also helps in these circumstances.

You need a macro lens for insects, flowers, etc. A flashgun (on an extension lead) is also important for close work, allowing you to shoot at a small aperture to improve the shallow depth of field and freeze movement. Make sure that lighting direction will enhance form. Flowers often need card outside the picture area to act as a wind break when you are shooting outdoors. However, try to avoid card backgrounds – the trick is to include some information on habitat in your background but without confusing detail.

With subjects such as birds frequently returning to a nesting or feeding place you can gradually build up a motor-driven camera system clamped in some nearby position. Include flash if necessary. Then trigger the camera by radio or infra-red pulse (page 52) from a remote hide where you observe the action through binoculars. Sometimes you can use an infra-red trigger beam across the path of the subject itself so that it keeps taking its own photograph. At night you can photograph light-shy creatures with the flash filtered down to emit infra-red radiation only and expose on infra-red film (see page 128).

Underwater subjects

Purposes

Most underwater photography is intended to show fish and plant life for general informational purposes in publications, like many other natural history subjects (see page 192). However, you may also have to take underwater pictures of products, ranging from industrial equipment to fashions, as well as special editorial feature illustrations. Yet another facet is record photography of wrecks, for archaeological or marine engineering interests.

Approach and organization

You can photograph small objects, fish and plants in a glass-sided aquarium. As Figure 8.15 shows, decide and place your background and keep moving fish within your depth of field by narrowing the tank's front-to-back depth with an extra sheet of glass. True underwater photography, however, means shooting with you and your equipment also submerged. Apart from having waterproof equipment the main problem is the optical changes created by imaging through water instead of air. Underwater, subjects appear closer and larger than they actually are. This upsets distance-guessing and focusing, but otherwise the camera is affected in the same way as your eyes – camera lens angle of view is reduced by about 25% (see page 46).

Second, daylight rapidly reduces in *intensity* and changes *colour content* (losing red) as depth increases. For greatest penetration, work at around noon, when sunlight is at right angles to the water and there is less reflection off the surface. Work out the depth at which you will

Fig. 8.16 A new angle on the butterfly stroke, showing how an Olympic swimmer expels air underwater. Chris Smith took this sports shot sitting at the bottom of the pool with an underwater 35 mm camera and 35 mm lens

Fig. 8.17 SLR camera in underwater housing, with flash on a long adjustable extension arm. Flash should not be directed from the camera, but from well to one side

be photographing. Down to about 30 feet the blue-cyan cast can be corrected by filtering, so prepare your camera with, say, a colour-correcting 30 or 40R filter. If you must shoot general views (for which only daylight gives broad enough coverage) try to keep to shallow waters. For close work, and at depths where only blue twilight remains, flash and battery lamps are the only satisfactory way to show subject colours. Never underestimate the potential dangers of diving and photographing underwater – always have at least one other person present.

Equipment and techniques

Underwater direct viewfinder cameras are small and handy but relatively primitive, especially for close work. An underwater housing for your 35 mm or rollfilm regular camera is expensive and cumbersome but you then have the imaging accuracy of an SLR and the ability to use your range of lenses. Remember that a housing with a domed port gives least optical distortion (page 46). Wear the smallest volume face mask so that you can get your eye as close as possible to the camera eyepiece. If possible, change the regular SLR pentaprism for a sports action optical finder – this lets you see the whole focusing screen from several inches away.

A wide-angle lens is by far the most useful choice underwater. It allows you to get everything in from a shorter lens-to-subject distance, so you suffer less light-loss and contrast-flattening scatter from all the particles of silt and plankton suspended in the water. An extreme focal

Fig. 8.18 Shallow-water diver working with a 35 mm camera in an underwater casing. Water quickly filters out longer wavelengths from daylight, giving this typical blue/cyan cast. Fit a compensating reddish filter, or use flash instead

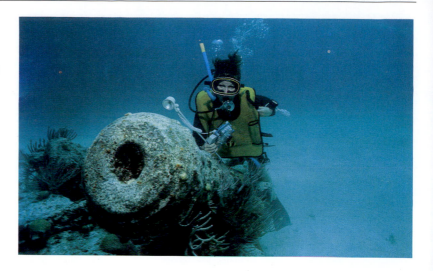

length type, such as a 21 mm on a 35 mm camera, reduces its angle of view underwater to that of a 30 mm lens in air. Lack of visibility underwater also means that flash on the camera gives results like looking into fog. So have a waterproof flashgun on a long-jointed arm which positions the light well to one side of the lens axis and closer to your subject. As a general guide underwater, do not try photographing subjects further away than about one quarter of the greatest distance your eyes can see.

Aerial subjects

Purposes

Air-to-ground photography at low altitude is used for pictorial shots of architecture and estates, records for traffic surveys, city planning and proposed new developments. It also forms a platform for press photography when covering large open-air events. In archaeology, aerial pictures (taken at dawn and dusk, when sunlight rakes the ground contours) often show up evidence of early structures invisible at ground level. Similarly, colour-filtered black and white shots or infra-red colour pictures in flatter light (during the middle of the day) reveal patterns in crops denoting earthworks and geological changes beneath the soil, as well as crop diseases. All these pictures are valuable for research, information and education. At higher altitudes, specialist aerial survey photography forms a vital reference for preparing accurate maps for resource planning and military purposes. (This merges into remote electronic imaging from satellites.) Air-to-air pictures of aircraft, ballooning, etc. are used for technical record, sales and general press pictures.

Approach and organization

The camera can be flown at low levels (up to 300 feet or so) in a model aircraft, balloon or kite and operated remotely from the ground. However, for more accurate, sustained work you need to be up there aiming the camera from a helicopter, fixed-wing aircraft or balloon.

Helicopters are ideal for controlling your position in space but are expensive to hire and suffer from vibration. Air balloons make expensive, much less manoeuvrable but smoother camera platforms. You are most likely to do general low-level aerial photography from a light aircraft – preferably a high-wing type because this allows you maximum visibility. Have a window removed for oblique shots, and use an aperture in the cabin floor for vertical pictures.

To make best use of your hire costs, pick weather conditions which give the lighting you need. For example, air is clearest after a cold front has passed. Work out the time of day for the best direction and height of sunlight for your subject. Plan with the pilot the best flying height (links with focal length), provided that this complies with regulations such as a minimum 500 feet (150 metres) over country, 1500 feet (450 metres) over towns. The lower the height, the less light-scattering haze between you and your subject, so you get greater tone contrast and purer colours. Fix up a clear means of communication between you and the pilot. His cooperation and understanding of your needs are vital.

Equipment and techniques

Model aircraft, balloons and kites are able to lift a 35 mm motordrive camera, triggered by radio or controlled through the tethering wire. You operate the camera when it is seen to be pointing in the correct general direction. However, if your balloon or kite is powerful enough it will be practical to fit a miniature closed-circuit television camera to the still-camera eyepiece and so check what you are shooting from a monitor at ground level (see Figure 8.20).

The best equipment for working from a full-size aircraft for general oblique photography is either a hand-held rollfilm aerial camera (see page 45) or a 35 mm SLR with normal and moderately wide-angle and long focal length lenses. Small-format cameras have the advantage of wider maximum apertures. Depth of field is not a problem, and this means that the best automatic exposure programme to use is shutter

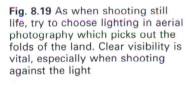

Fig. 8.19 As when shooting still life, try to choose lighting in aerial photography which picks out the folds of the land. Clear visibility is vital, especially when shooting against the light

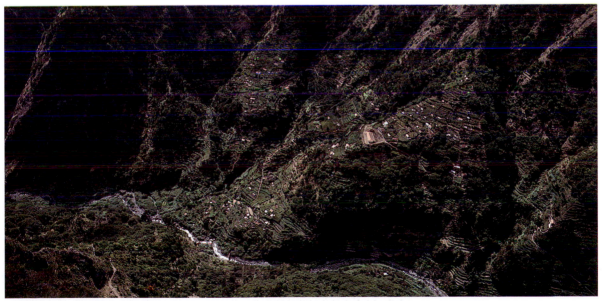

Fig. 8.20 Camera-raising stands and platforms. Where you cannot be alongside the camera yourself, use video to monitor viewpoint (on mast and balloon here)

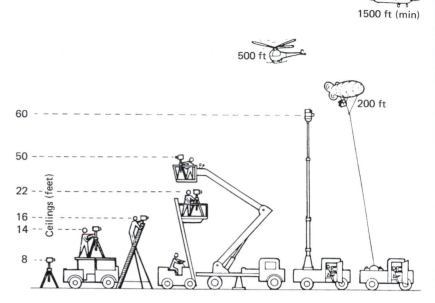

priority. Keep to 1/1000 or 1/500 second minimum, and let the camera's light reading control *f*-number.

Cushion the camera with your body or support it in a special hanging cradle – do not rest it on any part of the vibrating aircraft body. Filters are important to emphasize tone contrasts in black and white photography, and correct colour balance for colour work. An ultra-violet absorbing filter is best fitted as standard along with an efficient lens hood.

Vertical survey cameras are most often clamped on shock-absorbing supports looking downwards from within the aircraft fuselage. Typically, they shoot pictures 23 cm square on wide rollfilm, through a glass plate pressed hard over the emulsion and engraved with crosses at 1 cm intervals. By recording lens focal length aircraft height and ground speed as data alongside each frame you can make accurate measurements of ground distances from the processed film. It is vital that the aircraft flies at a steady height and speed over carefully planned flight lines so that by triggering cameras at timed intervals you get each shot overlapping in subject content by at least 30°. You can view prints or transparencies from such a series through a stereo viewer (page 50) or lay them out in an overlapping mosaic, from which maps are prepared.

Fig. 8.21 Video camera being fitted to a 35 mm SLR in place of removable pentaprism. Exact frame content can then be observed on a distant monitor

Night skies

Purposes

Serious astronomical photography is mostly for experts, scientists with access to specialist equipment. However, as a non-expert you may want to photograph night skies as dramatic backgrounds for advertising products, fashion, etc. or as part of landscape or architectural pictures. (Remember though that when star pictures are reproduced in print any specks of light smaller than the dots of the halftone screen will disappear.)

Approach and organization

For best detail pick a clear atmosphere and shoot in a rural area well away from towns or highways, which will spill light upwards. If there is a product to be shown against the sky this can be lit independently by flash. Where you want some suggestion of detail in the landscape, take a series of pictures in clearest atmosphere at twilight (dawn or dusk). Stars appear at a constant intensity as the sky lightens or darkens, so the scene goes through a whole range of different lighting balances. The moon, like the sun, appears less bright when near the horizon. With careful planning you can record the moon with its surface detail at dawn or dusk, and still show most of the landscape detail (most realistically shot with the land one-and-a-half to two stops underexposed.)

Equipment and techniques

Long focal length lenses enlarge moon detail but, curiously, have little effect on the image *size* of individual stars because of their vast distance away. Shooting with a telephoto simply limits your field of view. For starry skies it is often best to use a medium- or small-format camera with a wide aperture, normal or wide-angle focal length high-resolution lens. Then you can enlarge from this picture later. Remember that the colour of starlight, and also the moon when high in the sky, is effectively the same as sunlight. Use daylight colour film.

Length of exposure may have to be found by trial and error, although most TTL meter systems will measure exposures of several minutes. Test exposure with the camera programmed for aperture priority, then time the exposure it gives and bracket around this with further shots. The longer the exposure, the more faint stars will record and bright stars flare. However, in practice, choice of exposure is also influenced by four factors:

1. Blur caused by rotation of the Earth;
2. The light-gathering power of the lens (not *f*-number in this instance);
3. The reciprocity failure of your film (see Figure 4.19);
4. Light pollution – the general background brightness of the sky, particularly near cities. This gradually accumulates as light on the film, swamping detail.

The amount that the images of stars move during any given exposure depends on the part of the sky and your lens focal length. The pole star appears to remain stationary while all other stars rotate about it, 360° in 23 hours 56 minutes. As a guide, stars are likely to record as streaks instead of dots in a 1 second or longer exposure with a firmly clamped 500 mm lens. To keep all star images still, borrow an equatorial telescope mount which has motors and gears to gradually pan the camera against the Earth's rotation.

Another special feature of astronomical work is that a lens's starlight-gathering power depends on the *area* of its effective aperture, not its relative aperture (*f*-number). The wider the 'hole', the more photons of starlight the film will accumulate in a given time, irrespective of focal length. So a 500 mm lens at *f*/11 (effective aperture diameter 45 mm) becomes faster than an 80 mm *f*/2 (effective aperture

Fig. 8.22 The tracks of satellites, planets and stars recorded by a static camera during an exposure of several hours. Photographed from a high altitude in the mountains, the clear air and freedom from light pollution allowed hundreds of tracks to record without light-scatter destroying contrast. Most of the colours here are normally unnoticed when you see objects only as specks of light (Marion Patterson/Science Photo Library)

diameter only 40 mm). This applies for point sources such as stars; for extended sources such as comets or nebulae the relative aperture is important.

Summary: Subject problems

● In sports photography you need subject know-how and anticipation, patience and fast reaction. Pick moments of human tension and reactions. A good viewpoint is vital, plus a good range of lenses – mostly telephotos. A digital hand camera plus radiophone transmission may be justified to meet publication deadlines. Go for movement and dynamic action, often through controlled blur, dramatic angles, correct choice of moment. Do not rely on autofocus and motordrive to create good pictures.

● A good documentary picture story needs research, ample shooting time to express a point of view and sympathetic final layout. Often the best work is people based. Adopt a positive, determined approach yet remain sensitive to significant events. A small-format inconspicuous camera kit and use of existing light will least influence your subject matter. Close viewpoint and wide-angle lens give a sense of dramatic involvement and overcome lack of distance in tight situations. Standing back with a telephoto closely relates near and far components.

● Portraits (for flattery or character) might be shot in the studio or in the sitter's own environment to add to content. Decide what features and postures to emphasize. Camera viewpoint, your personal direction of the sitter, lighting and surroundings are all important but never so fixed that they prevent freedom to relax and relate as person to person. Work with a longer than normal focal length lens; using studio flash or existing light.

● Weddings are undervalued but responsible occasions for a photographer. Contact the people concerned, go over the details, plan your key shots. Dress appropriately. Pick the best possible backgrounds. Work calmly but authoritatively, covering formal and informal elements. Have a medium-format camera and tripod for groups, hand-held 35 mm for incidentals. Consider use of digital means for any necessary post-camera image adjustments.

● Landscape photography ranges from a personal art form through pictorial travel illustration to objective geographic records. Pictures can symbolize abstract feelings, concepts, or document social ecology. Plan the work, picking weather and time of day (lighting), distance and viewpoint. Medium- or even large-format cameras offer best tone qualities and detail. Do not overlook filters.

● Architectural photography ranges from the needs of real estate, architects or environmentalists, to being a subject of form and texture for self-expression. Time the best lighting for chosen viewpoints – avoid flat, overcast conditions. Check the external appearance of lighted buildings at dusk. Expect to simplify internal furnishings, and counter lighting which is excessively uneven or of mixed colour temperature. Have a camera with movements, and include a high quality wide-angle lens, flashgun or lamps and filters.

● Studio sets, built from flats, allow unobstructed use of lighting and camera viewpoint. Chosen props mean that you control every detail but avoid a false 'museum' look; do not overlight. For realism with scale models, accurately scale down your viewpoint and maximize depth of field. Use a camera with movements.

● Still lifes (advertising merchandise, technical records, editorial or poster illustration) need a disciplined approach to a totally controlled situation. Decide important subject qualities, pick appropriate non-confusing props and background, build up your lighting. Simplicity throughout is often best. For most work, subject matter must be immaculate. Have prepared foods made up professionally, undercooked for optimum appearance. Expect to use studio flash and a camera offering movements. Bulk catalogue assignments are ideal for using a digital camera linked to a computer with page-layout programme.

● Natural history illustration needs to combine scientific accuracy with strong visual qualities and is helped by specialist subject know-how. Research best natural location and timing to suit subject habits. Pick an informative activity and background. Long focal length lenses are often vital. For some animals or birds, shoot from a hide or use a remote-controlled or subject-triggered camera. Tackle flower/insect close-ups with a macro lens and an off-camera flash. Log subject information.

● Underwater photography ranges from simple aquarium shots to pictures shot at depths. Subjects appear closer and larger, and lens angle of view is narrower than on land. Natural light dims to blue-grey monotone (correctable by filter down to 10 metres, 30 feet). Use flash to reveal true colours, but position it well off-camera. Shoot with a

wide-angle medium- or small-format camera in a domed port underwater housing. Do not expect subject detail much beyond one quarter as far as you can see.

● Aerial photography includes obliques of architecture, highways, archaeology, etc.; vertical surveys for map making; air-to-air shots of other aircraft. Appropriate choice of lighting, filtration and special (infra-red) film helps reveal features not normally visible from the ground. Work from a helicopter or high-wing light aircraft, timing your flight according to light and weather. Use a rollfilm aerocamera or 35 mm SLR, working shutter priority mode (1/500 second or faster). Survey cameras, set vertically within the aircraft and fired remotely, record speed and height data alongside the image.

● Night-sky pictures for general purposes are best shot in clear air, far from town lights. Dawn and twilight offer greatest choice of landscape/starlight/moon balance. For starry skies, use medium- or small-format equipment with a good wide-aperture normal lens and daylight colour film. Exposures beyond a few seconds blur from Earth rotation (unless you have an equatorial mount). Other limitations are film reciprocity failure, the area of your effective lens aperture, and ambient light polluting the sky.

9

Film processing management

Beginners process their films in individual handtanks and their black and white prints in open trays. However, as your volume of work grows and you start to use a range of critical colour processes, you need to think how processing should best be organized. It may be sensible to send everything out to a professional laboratory, or split it so that you still process black and white films and prints, or perhaps aim to become self-sufficient in all your processing and even offer a service to others. The reasons for going it alone in any process include quicker turnaround (particularly if you are some distance from a commercial lab), possibly tighter quality control and long-term saving of costs. Against this, you must afford the necessary equipment and the expense of running it. There must also be a sufficient *regular* volume of work if you are to justify the use of automatic machinery. Above all, you must be able to consistently produce results at least as good as you can buy from an outside laboratory.

Good processing management means understanding the current ways of processing quantities of films and papers, monochrome and colour. This chapter starts off with the main processes themselves and the practical handling points you have to watch. Then it looks broadly at different kinds of equipment designed to get chemicals to act on film or paper – conveniently, consistently and economically – whatever the process. You should also be able to regularly check out your processing in some way which will detect changes and trends before they noticeably start affecting pictures. So you must know the best practical ways of process monitoring for quality control. The chapter also discusses how money can be saved by replenishing developing solutions to extend their working lives, and ecology regulations met in the treatment/discharge of solutions containing silver by-products.

The processes themselves

Processing is rather like modern convenience cooking. The required ingredients are pre-packed, being built into the chemical solutions and light-sensitive emulsions; the procedure is set out by the manufacturers

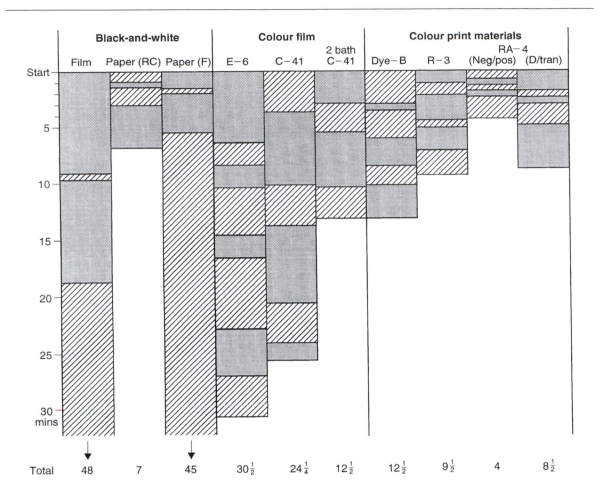

Fig. 9.1 Comparison of the number of stages (including rinses and wash) and total time required for different film and paper processes. These vary according to whether you are processing by hand or using some form of machine processor. They are also updated in detail from time to time. Notice the extended total processing time for fibre-base (F) paper prints, over plastic-based (RC) types

as a sequence of stages. You do not need to understand the chemical detail of what is going on, but it is essential to arrange that each solution is in good condition and has its proper effect. This means organizing timing, temperature and agitation throughout the correct order of steps required for each process. If something goes wrong, you can ruin expensive solutions or be left with images which are too pale or dense, wrong in contrast, off-colour, uneven, stained, scratched or impermanent. In some instances (steps in the wrong order, for example) there may be no final image at all.

Figure 9.1 summarizes some common sequences of stages for various types of film and paper processing. At one time there were almost as many different colour processes as brands of colour materials. Today these have become rationalized, so that virtually all reversal colour film except Kodachrome needs the same process E-6, and colour negative films C-41. Neg/pos colour paper uses process RA-4 and reversal paper either R-3 or a dye-bleach process (Ilfochrome). Shorter versions of several of these processes are available, for example combining certain stages. Some are designed to speed production from mini-lab equipment; others are for convenient one-shot processing by amateurs, rather than longer-term storage in the tanks of large processing machines.

Unless a radically new and important material requiring a different process comes onto the market, manufacturers prefer to make changes gradually, through adjustments to chemical kits in tandem with emulsion updates. This is because machines in commercial laboratories are dedicated to one or other process at a time. Paper processing can always be rationalized 'in house' according to the material the laboratory chooses to print on. However, if customers' films start to arrive needing all kinds of different processing chemistry, costly investment in new machinery may not justify handling the new product. Chemical solutions also often vary in dilution (and sometimes in content) according to whether you intend processing in small tanks or trays, a deep tank sink line, or processing machines with varying kinds of agitation. Machines are convenient but expensive, and suit some situations and processes better than others.

To begin with, bear in mind the different procedures and limitations in processing various kinds of exposed photographic material. The processes summarized below are typical current types. But all of them change in detail from time to time, mostly to reduce times and generally make them more convenient to use.

Black and white silver image negatives

Black and white negative films need only the simple sequence of developer, stop bath, fixer and wash, although they must be handled with the same physical care as is necessary with any other materials for top-quality results. You have a wide choice of developers, from softworking speed-reducing types such as Perceptol through general fine-grain developers D76/ID11 and HC-110 to high-acutance or speed-enhancing types and high pH extreme contrast solutions like line or lith developers.

Not all of these will suit all films, of course. Some developers have specialist functions (for lith films for instance). Also the arrival of 'high tech' grain structure black and white films – Delta grain, T-grain, etc. – has been accompanied by new diluted developers designed to maximize their qualities. D-76 and other traditional developers can still be used but should be well diluted. Decide the two or three developers which, combined with the few films you use most, best suit subject conditions and the required image 'look'. For example, in low intensity, low contrast lighting conditions ISO 400/27° film can be pushed to ISO 3200/36° in speed-enhancing developer provided that you accept coarse grain and loss of tone delicacy. The same film in D76 gives a better compromise between speed, grain, resolution and tonal quality, and is more easily fine-tuned for different subject contrast conditions by adjusting development times. You might, however, prefer a high resolution developer like Rodinal for least grain and maximum tone gradation on slow film, or go for a 'gritty' grain effect by combining it with fast films (see *Basic Photography*, Chapter 11).

Sometimes your choice is influenced by the need for a developer which offers you a range of characteristics according to dilution, or perhaps you have to process on location so it is essential to work on a 'one-shot' basis, discarding the solution after use. On the other hand, for studio work you might have a developer you can keep using for 3 months (with replenishment) in a deep tank. Unlike colour, black and white film processing offers great freedom to choose results through

Image in camera

After developer

After fix

Fig. 9.2 Basic schematic diagram of black and white processing. Development reduces light-struck halides to black silver. Fixing causes the remaining halides to become soluble, so they can be removed from the emulsion by washing

type of solution relative to type of emulsion as well as dilution and timing. It is also possible, with most formulae, to work at any temperature between 18° and 24°C and fully compensate by adjusting time.

Colour slides and transparencies

The first stage of reversal processing (Figure 9.5) forms a black silver negative in each of the film's emulsion layers. (It is the remaining emulsion which later stages turn into a colour positive, then remove all the black silver.) You can therefore adjust the time of this first development to compensate for up- or downrating of film speed when shooting, rather like black and white work. Similarly, the degree of development alters the contrast of your result. However, remember that the range of adjustments open to you is much more limited, for unlike a black and white negative, the processed film is your finished picture. Beyond a certain point the image looks 'wrong', with coarser or flatter colours, pale shadows and a tendency to take on a colour cast which differs according to brand and type. Again, unlike black and white, there is no ability to *choose* developer for finer grain, greater acutance, extra speed, etc. Temperature is also much more critical.

In the E-6 process, designed for the great majority of films having colour couplers within their emulsion ('integral colour couplers') the next stage chemically fogs all remaining silver halides in the film. Then colour developer turns these halides into black silver, forming by-products which join with different colour couplers in each layer to create cyan, magenta and yellow dye images. Colour formation in this way is known as chromogenic development – dye amounts are in direct relation to the amounts of silver the colour developer forms. Sophisticated chemical cross-reactions (such as developer inhibitor release, Chapter 5) enhance image quality at this stage, so colour development must function strictly to specification.

The next stages remove unwanted residues, i.e. the black silver negative and positive images which together still make the film totally opaque. This is done by bleaching the silver back to silver halide and then fixing. (On shortened three-bath E-6 processing bleach and fix are combined, using more complex formulae to preserve their properties when together in solution.) The later stages of bleaching can take place in normal lighting because there is nothing light-sensitive left to fog. As the black fades, you start to see colours for the first time. Soluble by-products and absorbed processing chemicals are then washed out.

If all this sounds complicated, it is far less demanding than the older but still-used K-14 Kodachrome process. Kodachrome has no couplers built in, so each emulsion layer has to be separately fogged and separately cyan, magenta and yellow colour developed.

Colour negatives

The first stage here (Figure 9.7) is colour development, forming black silver and the three different-coloured dyes wherever the emulsions were affected by light. During development (and subsequent silver removal and stabilization) fine changes also occur to the integral colour masks (page 95). Properly carried out, this should give a colour negative matched in contrast range and different absorptions of red, green and

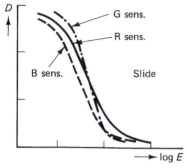

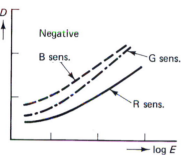

Fig. 9.3 Inaccurate processing can produce 'crossed curves' in the response of (top) colour reversal, and (bottom) colour negative film. The slide here will have a magenta cast to shadows, cyan cast to highlights. Colour prints from the negative will show an increasingly greenish cast in darker tones when correctly filtered for palest parts of the picture. For normally processed reversal colour film curves see Figure 4.15

blue light to 'fit' the characteristics of the same maker's neg/pos colour printing paper. Departures from normal such as lack of tight temperature control, or pushing or holding back to adjust for different ISO speeds (most emulsions, see page 211) or for different lighting contrasts produce problems at the printing stage. Such negatives look all right to the eye but are mismatched to the paper. They may have crossed curves (Figure 9.3), which means that prints have one colour cast in highlights and pale tones and another, different cast in dark tones and shadows. No one set of filter settings can correct this during enlarging. Absolute consistency of film processing is therefore important.

Chromogenic (dye image) monochrome negatives

Dye image monochrome films contain couplers in their several emulsion layers and so conveniently allow you to put these through the same chromogenic processing chemicals as colour negatives. Resulting images are a warm, brownish black – the combined dye layers give a rich tone scale and allow good exposure latitude. However, since image colour is not related to subject colours you can freely alter development times to make ISO speed and contrast adjustment. Where colour processing is not available you can give the film regular black and white processing instead. Negatives then consist of black silver instead of dye. Speed is reduced and grain in overexposed areas is more noticeable than dye image results.

Cross-processing of films

Treating films in a processing sequence designed for another film type gives a variety of results, tabled in Figure 9.4. Sometimes you may use the wrong combination by error. If the result is a black and white negative from colour film you may at least be able to make black and white prints. E-6 or C-41 films given black and white processing can often be salvaged as colour negatives by bleaching the black silver to a silver halide, fogging it to strong light and then giving full C-41 colour negative processing. Check with the manufacturer of your film for current information.

If this film:	Is given this processing:	The result will be:
Regular B & W	E-6 or C-41	Clear film
Slide (E-6 type)	C-41 B & W neg	Contrasty, unmasked colour neg Pale B & W neg*
Kodachrome	E-6 B & W neg	Clear film B & W neg with backing** dye still present
Colour neg (C-41 type)	E-6 B & W neg	Low contrast, cyan cast slide Ghost-thin B & W neg* with mask colour

Fig. 9.4 What happens when you put film through the wrong process. 'Regular' black and white means silver image films, not dye image types designed for C-41

*May be possible to salvage as a colour neg. See text.
**Removable in film strength rapid fixer plus 8 grams/litre citric acid.

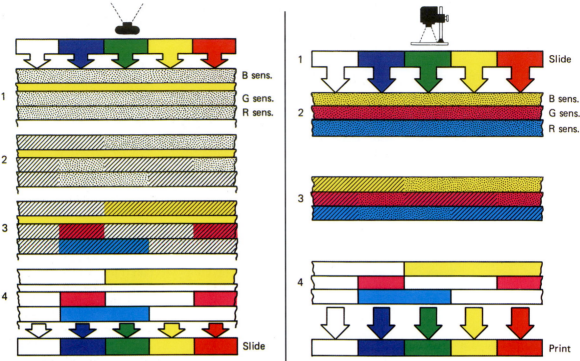

Fig. 9.5 Cross-section (simplified) of reversal colour slide film incorporating couplers. Stage 1: emulsions receive image in camera. 2: after first development. Black silver created where B, G or R sensitive emulsions respond to image. 3: after remaining halides are chemically fogged and developed in colour developer, giving silver and either yellow, magenta or cyan in each layer. 4: after bleaching and fixing away all black silver. The remaining dye-only images reform subject colours

Fig. 9.6 Pos/pos colour reproduction with dye-bleach paper. 1: slide, projected by enlarger. 2: simplified layers, already containing dye with silver halides, exposing to image. 3: after development, black silver negative images form in each layer according to emulsion response. 4: after silver/dye bleaching. Dyes remain only in areas unaffected by development. The print reproduces the colours and tones of the original slide

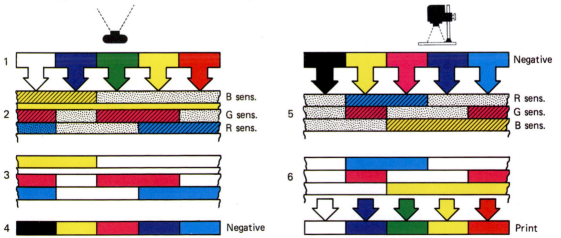

Fig. 9.7 Neg/pos colour reproduction. 1: original image exposed in camera. 2: after colour development the colour negative film carries black silver plus yellow, magenta or cyan coupled dye where emulsion layers have responded to image colours. 3: after bleaching and fixing away black silver. 4: the resulting colour negative. 5: negative exposed onto colour paper, which is then colour developed. Black silver and a coupled dye form according to each emulsion response to exposure. 6: after bleaching and fixing. Seen against its white base, dye layers reform colours of original camera image

Intentional cross-processing is also a way of producing off-beat colour images for posters and editorial illustration, especially in the fashion and pop music business. Transparencies created by giving colour negatives E-6 processing are best pushed two stops to regain otherwise lost contrast. Results typically show a restricted colour range shifted towards cyan, with pale orange burnt-out fleshtones. E-6 film put through C-41 processing and then printed gives images with subject colours coarsened, and harsh in contrast (somewhat like an unmasked dupe).

Results vary according to the brand and particular film you choose to use. It is always best to shoot generously, setting different ISO speed ratings and then ask the lab to give your films clip tests before deciding the best development time. Not all labs offer cross-processing, as this holds up other work. Increasingly too, similar results are possible by digital manipulation – without risk to any of your original shots.

Black and white prints

Fewer developers are designed for printing papers than for films, and they are all more active and fast-working. Choice (which is greater when you work with graded papers than with variable contrast types) centres on the 'colour' of the black silver image they produce. Regular, PQ type developers give neutral black images on both fibre- and RC- (plastic-) based bromide papers. RC papers develop much faster, however, because of developing agents already incorporated into the emulsion which hasten the start of visible image formation. The non-absorbing base also minimizes carry-over of chemicals so that further stages – especially final washing – are much shorter.

Other restrained type developers for chlorobromide emulsion papers give results ranging from cold black to rich brown, according to formula. Generally, you should keep print-development times constant. Too little development gives grey shadows and weak darker tone values; too much begins to yellow the paper base and veil highlights due to chemical fog. After development, stop bath and acid hardening fixer can be the same formula as for films, although the fixer is used at greater dilution.

Prints and display transparencies from colour negatives

The two-solution process used for neg/pos print materials is like a truncated form of colour negative film processing. All colour printing papers have an RC base. During the critical first stage the colour developer produces black silver in exposed emulsion layers and by-products which react with different couplers in each layer to give cyan, magenta and yellow image dyes. See Figure 9.7. This is followed by a bleach-fix stage to convert the silver into soluble compounds you remove in a final wash.

There is no flexibility in timing, and in professional processing kits the developer temperature is critical. It is very important that processing gives print-to-print consistency. Variations create images with colour shifts, poor tone range and stains. They can totally confuse your attempts to control results on the enlarger through filtration and exposure (see Chapter 10).

You can print colour transparencies from colour negatives by using film-based material (for example, 'Duratran') which is handled and

exposed like sheets of neg/pos paper. The same colour print chemicals are used but stages need different timings. This is an effective way to make large-scale transparencies for lightbox display in exhibitions.

Colour prints from slides

Pos/pos colour prints made direct from colour slides and transparencies are processed in two quite different ways, according to paper type. The two most used materials are (1) Ilfochrome, requiring dye-bleach processing; and (2) reversal paper, also known as 'R-type', requiring a quite different processing sequence similar to slide film.

Ilfochrome material has fully formed cyan, magenta and yellow dye layers already present in the red-, green- and blue-responsive emulsion layers. See Figure 9.6. You expose it to your colour slide image through the enlarger. The first stage of dye-bleach processing uses a black and white developer to form a negative black silver image in each emulsion layer according to its response to the light. The second chemical step is a bleach which removes the silver *and the dye where silver is present*. At the next step the by-products of bleaching are made soluble by fixing and finally removed by washing. The remaining unbleached dyes leave you with a positive colour image matching your slide.

The advantage of dye-bleach material is that ready-formed dyes are purer in colour and more permanent than those formed chemically (chromogenically) by coupling. Images have bold, rich colouring well suited to display prints of commercial subjects. However, the material is quite slow to light, due to the light-stopping power of the colouring present, and the bleach chemical is more toxic than most other photographic solutions (see page 212). With some dye-bleach processing kits you can alter the black and white development to adjust contrast. Diluting the solution decreases print contrast and extending the time increases it.

Reversal colour paper has conventional emulsion layers incorporating couplers and needs reversal processing via a series of steps entirely different to dye-bleach. The various stages are effectively the same as shown in Figure 9.5. First, a developer forms black and white negatives and then, the remaining emulsion is chemically fogged and colour developed into black silver plus positive dye images. Later stages bleach/fix and wash away all silver to give you your final print. The chemical solution temperatures are very critical and you are not recommended to control contrast by adjusting first development or to alter the timing of any stage. (Remember that you can also make prints from slides via internegs; see page 253.)

Points to watch

Whatever process you intend to carry out, the key aspects to organize properly are:

> Temperature; timing; agitation; physical handling without damage; and the condition of chemicals.

Temperature

This must be tightly controlled if you expect to handle critical processes with any consistency. Large volumes of each solution hold their tem-

perature longer than small ones, although much depends on the ambient room temperature and how much solution surface area is exposed to the air. Small quantities for 'one-shot' use can be brought to correct temperature quickly, but equally they soon change again if poured into a tank or trough which is colder or warmer. Temperature-controlled water or air-jacketing of your solutions, together with any separate container for the material you are processing, helps to avoid problems.

For black and white hand-processing the temperature needed is within the range of normal (temperate zone) room temperatures. If you have to use a temperature higher or lower than specified, a time/temperature table or graph (Figure 9.8) for your particular solution shows how to adjust timing in compensation. However, do not exceed upper or lower limits – some chemical components of any one solution will be more affected than others, so that processing characteristics change. Colour processing generally functions at higher temperatures than black and white and within narrower tolerances. Variations outside the limits laid down affect the rates of development in different emulsion layers, so you may get a faulty colour balance.

One way of working when conditions make it impossible to maintain one temperature is to use the 'drift-by' technique. This means warming the solution to, say, the upper limit temperature for the start of the processing step, so that although it gradually cools it does not drop below the lower acceptable limit by the end of that step.

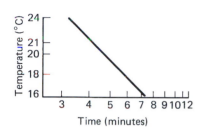

Fig. 9.8 Time/temperature graph for a black and white developer which gives correct density and contrast when used for 4½ minutes at 20°C. Between 16 and 24°C temperature changes can be largely compensated for by altering time

Timing

Accurate timing is as important as accurate temperature. Times given for each step when you hand-process include a 10-second drain period for films (20 seconds for prints) to avoid carry-over of chemical into the next solution. Timings are usually different when you process by machine, depending on how the film is agitated in your type of equipment (see page 216). Increases or reductions in the timing of black and white development (not colour development) stages in colour slide processing push or hold back films to compensate for under- or overexposure. These can be taken to two stops or held back for one stop without much side-effect, provided that it also suits subject contrast. You can go even further with black and white films. A few colour negative films, intended mainly for press photography, can be push-processed to get higher speed ratings by extending colour development time. See Figure 9.9. In all instances films designed to give you the option of push-processing are fast in speed.

Agitation

Controlled agitation, especially in developers, is much more important than it may at first seem. To give too little produces uneven action and

Fig. 9.9 Push-processing of colour negative films by extending colour development time. Only suitable for film types specifically intended to give acceptable results when speed enhanced in this way

ISO 400 film exposed at:	ISO 1600 film exposed at:	Degree of adjustment needed:	=	% time increase in colour dev:
ISO 400	ISO 1600	None		None
800	3200	Push 1		+15.4%
1600	6400	Push 2		+31%

insufficient density in negative highlights. By-products diffuse from emulsions too slowly, forming streamers. Too much agitation can create uneven 'flow marks', particularly in films carrying perforations. Overagitation also allows more fresh developer to reach the emulsion than is intended for the process, giving extra highlight density. In colour films too much agitation disturbs the way by-products are produced in emulsion layers, giving excessive dye formation. All these points are looked after in well-designed processing machines or deep tank lines using automatic gaseous-burst agitation (see page 215). Agitation is often the source of inconsistent results if you are distracted or careless when hand-processing. Follow precisely the agitation specified for your particular processing solution or kit.

Fig. 9.10 Basic chemical mixing unit, for serving roller transport and similar large capacity machines. The built-in pump and hose outputs mixed solution to tanks or reservoirs

Physical handling

Do not forget that you are basically dealing with a thin layer of gelatin, absorbant to liquids (unintentional as well as planned) and especially delicate when wet and swollen. Troubles can begin with liquid splashes or damp hands before processing, or clumsy loading of reels or clips. The material might be damaged from contact with the side of the tank during agitation or poorly maintained rollers in machine transport. The drying process is most vulnerable of all, leaving the emulsion splattered with debris if your water supply is dirty and unfiltered, or the air where it dries contains dust or fluff. Swabbing down film when grit is present produces scratches. Any uneven drying, or splashes when it is dry or nearly dry, leaves indelible uneven patches. Practically all processes incorporate a gelatin hardener at some stage, but this does not remove the need for greatest handling care, plus conscientious cleaning and maintenance of your equipment.

Chemical solutions

Points to watch here are accurate mixing; prevention of contamination; and avoiding the use of exhausted solutions. All normal processing chemicals are packaged ready to be added to water, but mixing demands constant attention, especially when dissolving powders. Component powders or liquids mixed in the wrong order may never dissolve or may precipitate out unexpected sediment. If the temperature of the mixing water is much higher than specified some chemical contents may be destroyed; temperatures too low may not allow some components to dissolve. In any case, only mix powder into about two thirds of your final volume of solution, then, when everything has dissolved, add the remainder. Stirring is essential when mixing. Make sure you do this with a suitable chemically inert and non-absorbing mixing rod – stainless steel or plastic. Do not be excessively energetic about it. Whipping-up ingests larger amounts of air into your solution, which shortens its working life because of increased oxidation. *Observe health and safety recommendations shown on page 294.* Mix in a well-ventilated place, wear gloves and do not lean over the solution you are preparing. This applies especially to bleaches and stabilizers.

Avoid all risks of cross-contamination between solutions when mixing or processing. Thoroughly wash mixing equipment, measures, bottles and tops, and thermometer before changing from the preparation of one chemical solution to another. To be on the safe side, always mix

Developer	Life of working solution	
	Tray	Deep tank (using floating lid)
D76	24 hours	1 month
HC110		
(1 + 15)	24 hours	1 month
(1 + 31)	12 hours	2 weeks
Lith	4 hours	24 hours
D8 (line)	2 hours	2 days
C-41		
(dev)		4 weeks
(others)		8 weeks

Fig. 9.11 Typical developer working life

Film size	Approximate area (m²)
35mm (24)	0.042
(36)	0.056
120	0.05
4 × 5 in	0.013
5 × 7 in	0.023
8 × 10 in	0.052
Every square foot	0.093

Fig. 9.12 The surface area of each popular film/paper size. Use this to calculate when to replenish or discard solution

Fig. 9.13 Replenishment technique. 1: dip a container into the tank of processing solution. Remove more liquid than the measured volume of replenisher (R) you have prepared. 2: pour in all the replenisher. 3: top up again by returning some of the solution you removed originally, then discard the surplus

a kit of chemicals in the same order as the process, starting with the developer. ('Downward' contamination, although undesirable, does occur to some extent during processing. Contamination the other way causes complete havoc – you might have to dump what may be a large tankful of expensive chemicals.) Never let film hangers, thermometer, etc. trail one solution across a container holding another.

Solutions often start to deteriorate as soon as they are left uncovered in contact with air as well as when used to process emulsions. This is where 'one-shot' processing has its main advantage. However, throwing away chemicals after every process is expensive and impractical for large-volume processing and continuous-processing machines. Developer-storage tanks (or deep-processing tanks when not in use) need floating lids to minimize contact with the air. Log the total amount of material you put through one solution and try not to exceed the maximum area recommended by the manufacturers for that volume. As repeatedly used developers become weaker you may be able to compensate by increased processing time, or, better still, work a system of replenishment.

Replenishment

Replenishment means adding chemicals to gain a longer life from repeatedly used black and white and colour developers. Bleachers and fixers can also be replenished and 'regenerated' (see page 225), but stop-baths and stabilizers are relatively long-lasting and cheap, so they are worth discarding completely when used up. Each replenisher solution (or powder) is formulated for a particular developer, designed to replace those of its constituents such as developing agents most used up during processing. It also has to be strong enough to help counterbalance the by-products that film and developer create between them, which accumulate in the solution and slow up development action. Replenisher is designed to be added to the main solution in carefully measured quantities. Too much or too little will seriously alter performance instead of the main aim of keeping processing consistent.

To accurately replenish deep hand-tanks log the total number of processed films or prints in square metres (Figure 9.12). Then add the necessary volume of replenisher, following instructions given with the chemical and relevant to your size of tank. As shown in Figure 9.13, some existing developer will probably have to be taken out of the tank to make room. Deep-tank processing machines (pages 217–220)

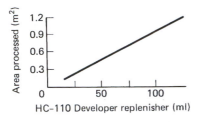

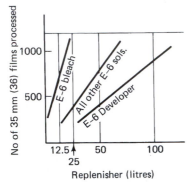

Fig. 9.14 Replenishment rate data. Top: for a black and white developer used in small-volume deep tanks. Bottom: for reversal colour film chemicals used in bulk-volume tanks in a continuous processing machine

automatically inject replenisher from storage containers. Surplus existing solution is designed to overflow and 'bleed to waste'. The amount of replenisher that goes in depends on the rate you set, triggered by the actual length and average width of material passing through the machine as measured by sensors. To be really precise, you need to know how light or dark actual images are. For example, many heavily exposed or white background subject negatives exhaust developing agents more rapidly than darker subjects. With large-volume processing especially, the best way to avoid under- or over-replenishment is by reading what is actually going on in your solution through a process-monitoring system (see page 221).

Sometimes information with a developer replenisher for a deep tank does not quote the rate per area of film. You then simply add it until the tank is topped up to the original solution level. Fixers and bleachers can be replenished with calculated volumes of either fresh amounts of the original chemical or specially formulated replenisher solution. The very action of fixing and bleaching causes silver salts to accumulate in these solutions. Silver can actually be reclaimed and sold (page 227) and the 'regenerated' solution replenished and returned for use in film processing. Eventually, of course, every processing solution, however carefully replenished, approaches a terminal state of exhaustion and must be thrown away. The whole point is to keep it working consistently for as long as possible, so that you get greatest value for money.

Equipment

Highly controlled *machine* processing is ideal for the least flexible, temperature-critical processes such as colour negatives and prints, and reversal colour films and prints. It also suits black and white RC prints. On the other hand, the variety of developer/emulsion combinations you can pick from for black and white negative and fibre-base printing paper still makes hand-processing attractive. Hand-processing is also the easiest way to vary development times for individual sheets or rolls of film, as required for the zone system (page 154).

If you are thinking of some form of machine-processing look first at your volume and pattern of throughput. For small quantities and occasional use a small unit using one-shot chemistry will be best, especially if you can also use the same chemical kit for, say, colour negatives and colour prints. At the other extreme, a large, fully automatic machine accepts exposed material in the darkroom at one end and returns it back dry to the normally lit workroom at the other. However, this equipment will prove inconsistent as well as ruinously expensive to run if you have too little to put through it. Figure 9.15 compares the technical and economic features of manual and machine-processing.

For hand-processing	*For machine-processing*
● Flexibility	● Consistency
● Low capital cost	● Convenience
● Less money committed to chemicals	● Speed of throughput
● Can stand idle at times	● Low cost per film/print (if sufficient
● Suits process manipulation	quantities)
● Less risk of mechanical damage	● Less labour-intensive
	● Can handle long rolls of film/paper

Fig. 9.15 The advantages of hand processing and machine processing

Fig. 9.16 Producing large black and white prints (photo-murals). Lengths from a roll of bromide paper can be overlapped for image exposure, using your enlarger horizontally. Bottom: hand processing by rolling the paper in a sink filled with (diluted) developer. To remain manageable the paper is always rolled towards you. Then the roll is up-ended, reversed, and rolled towards you again. Increasingly inkjet printers, Figure 11.29, are used for mural work. Shading is then preset digitally as part of image data

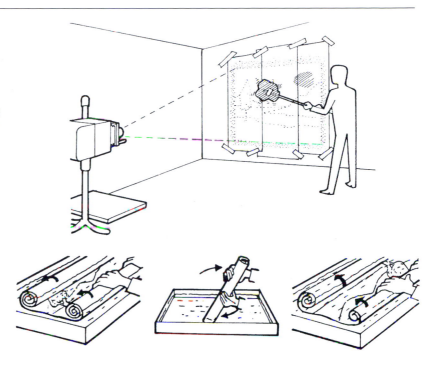

Processing in trays

Manual processing in open trays or troughs is still appropriate for small volumes of black and white non-panchromatic prints or sheet films. It is very flexible: you can easily check results under safe lighting during processing and use relatively small quantities of chemicals, including short-life lith developer. Equipment is cheap too. Very large prints can be rolled through a trough of diluted developer as shown in Figure 9.16. However, trough or tray processing is messy, unhealthy (you breathe in chemical) and not very consistent. Solutions oxidize quickly and it is easy to contaminate one with another. All colour work and any processing needing total darkness is too awkward and unpleasant to be handled this way.

Tanks and tank lines

Small roll or sheet film hand tanks are the cheapest reliable method of processing one to three films at a time (see *Basic Photography*). The next step up is to have a run of deep tanks, each 15 litre capacity (Figure 9.17) set into a temperature-controlled water or air jacket. Each tank contains a separate chemical solution, according to the process you are running, plus a rinse/wash tank. You can process individual sheet film in hangers, agitating them by hand and moving them from tank to tank in darkness. Quantities of sheet film, rollfilms in reels and printing paper can be handled the same way in purpose-made racks. A single rack will accommodate up to 20 or 30 reels of 120 or 35 mm film, or 24 sheets of 4 × 5 inch film.

The best form of deep-tank agitation comes from a gas distributor grid which goes along with the rack. The grid is piped to give out timed bursts of either (inert) nitrogen gas or oil-free compressed air

Fig. 9.17 Basic 15 litre tank sink line. Water jacket (J) encloses all tanks and is fed from thermostatic mixing valve (M) which also supplies wash tank (W). Temperature monitoring unit T has probe directly below critical developer tank (1). If temperature drops, monitor causes solenoid (S) to inject additional hot water. Nitrogen gas or compressed air passes through electronic valve (V) regulating the frequency and duration of each burst. It then supplies flat tube distributor (D) moved from tank to tank along with rack (R) of films on hangers (H). After first stages demanding total darkness you pass the film rack through a trap to the other half of unit, in room lighting. Here another gas/air distributor can take over

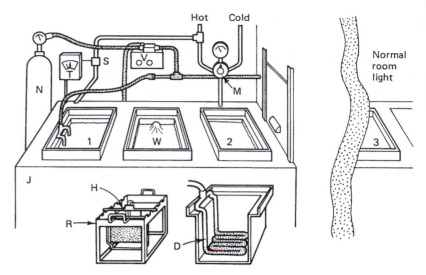

to agitate appropriately whichever solution you are using. Only nitrogen is used for developers; only air for most modern bleach solutions. Consider gas burst agitation essential for deep-tank colour processing. Tank lines are fairly cheap to set up and run for any process, and allow sufficient throughput for smaller professional users. However, someone has to be present to manually handle every batch – reversal processing is especially hard work. You must take care over process control (page 221) and replenishment if you want consistency. A series of large batches easily brings on chemical exhaustion effects with only 15 litres of solution.

Drum processors

The heart of a drum processor is a light-tight cylinder you load with paper (or film in a suitable adaptor). All processing stages then take place in normal light. The cylinder rotates on motor-driven rollers within a water jacket and you pour in a small quantity of processing solution through a light-trapped funnel (Figure 9.18). Within the turning drum the solution spreads rapidly and evenly over the surface of the emulsion. Drum movement backwards and forwards gives agitation; your thermostatic water jacket controls temperature. Notice how, unlike tank processing, where material is totally immersed in solution and given intermittent agitation, drum processors give intermittent immersion and continuous agitation. This may mean changing timings, even though solutions and temperatures remain the same.

Drum processors work on the discard principle – at the end of each step you tilt the drum, discard the used solution, then return it to the horizontal and pour in the next liquid. A few models can be programmed to work automatically, but most are labour-intensive. However, a drum processor is versatile and reliable and also the most economic way to process occasional large colour prints, although it is slow and inconvenient for large quantities of paper or film. Maximum capacity per loading ranges from four to twenty prints 8 × 10 inches or two to ten 120 rollfilms, according to drum size.

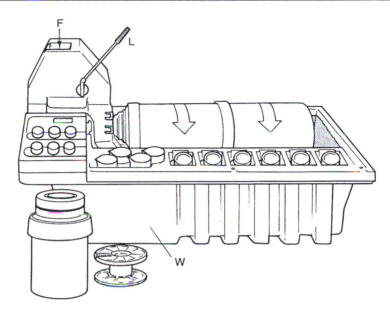

Fig. 9.18 Drum processor. Drums accept print or film (roll or 35 mm on reels) loaded in the dark. Storage containers, graduates of chemical, and drum are all half submerged in a temperature-controlled water jacket (W). Drum couples to motor unit through magnetic lid. Lever (L) is used to tilt drum at end of each stage, discarding used solution down drain. The next chemical is then poured into funnel (F) while drum continues to rotate

Automatic processors

With fully automatic, programmed processors you are moving up into the big league – financially and in terms of throughput. The cost of equipment may be ten times as much as a manual drum system. The four main types are known as rotary discard, roller transport, dip-and-dunk and continuous-strand machines, according to the way they move the material through solutions. Most need large and therefore expensive tanks of processing chemicals which make them uneconomic to run unless you process *at least* a hundred films or 50 prints per week. They are ideally suited to multiple-stage, rigorously controlled colour processes – you can safely leave them like washing machines and do other jobs while they are at work.

Rotary discard machines

Fig. 9.19 Rotary discard processor. Exposed material in batches (lengths or sheets of film, or sheets of paper) wrap around open spools which rotate in an enclosed trough. With the lid shut, solutions are pumped up in turn from temperature-controlled reservoirs. See text

A rotary discard or 'trough' processor is similar to a scaled-up drum machine. However, as Figure 9.19 shows, you clip the films or papers to be processed to the *outside* of an appropriately designed cylindrical frame, emulsion outwards. Typically, a batch ranging from one to 12 rolls of 35 mm film can be loaded at one time, working in the dark. Then you close the lid and work in normal light, starting a preset program which rotates the frame and pumps up a small quantity of each processing solution or water rinse in turn into the trough. At the end of each stage a drain automatically opens to discard the solution. Finally, you open the unit and, like a drum processor, remove the still-wet material for drying.

The advantage of a rotary discard machine is its versatility. With a range of tanks holding the chemicals for different processes and appropriate timing programs you can be processing colour prints one moment and E-6 films half an hour later. The one-shot processing means that there is no need for replenishment and minimal risk of

cross-contamination. However, chemical costs are quite high if you put a lot through the machine and it is more labour-intensive than a roller transport processor. Apart from small studios doing their own colour processing, rotary discard machines have been overtaken by increasingly compact and economically priced roller transport types.

Roller transport machines

These machines contain dozens of slow-moving rollers, turning continuously to transport *individual* films or sheets of paper, usually up and down along a sequence of deep tanks. They may be designed to be built through the darkroom wall (Figure 9.20) and into a lit area. More often film processors offer loading arrangements you can use in normal room lighting. Here a light-tight box at the feed end has armholes fitted with gloves through which you can open a film holder, or unseal a rollfilm, and 'post' the exposed material direct into the machine. Either way you feed your material through dry receiving rollers in darkness and receive it back dry from the delivery end of the machine where it has finally passed through an air-jet drying unit.

The large-volume tanks are thermostatically controlled; the rollers give continuous agitation. Roller speed is the same in all tanks – for the longest stages of processing you have tanks which are deeper or longer than tanks for short stages. You can run the whole machine slower or faster while films to be pushed or held back are passing through the developer stage. (Similarly a paper processor can be slowed to meet the requirements of Duratrans and other special materials.)

Roller transport machines are very convenient to use. You can feed in a mixture of sheets or lengths of film (or sheets or rolls of paper) at any time, unlike batch-loaded processors. However, each machine tends to be dedicated to a particular process. Changing to another is possible but normally means draining and changing expensive volumes of solution, which can be a major operation. Typically a 24-inch wide roller machine designed to process neg/pos colour prints at 20 cm per minute can turn out up to 120 prints 8 × 10 inch every hour.

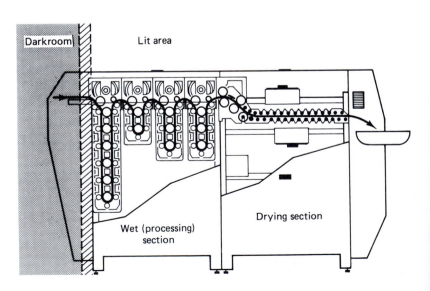

Fig. 9.20 Roller transport processing machine, showing the path taken by sheets of material. This one is designed for colour paper – similar types made for films differ in their roller surface and dryer detail

In deep-tank roller transport machines the chemicals have to be very carefully replenished, usually by automatic injection. You should check process performance every day. With so many rollers in direct contact with the gelatin emulsion regular cleaning and good maintenance are vital. Otherwise chemical by-products, flakes of gelatin, scale or grit build-up on rollers and damage everything you put through. Roller units lift out of the machine as a series of racks. On most processors you must remove racks from developers and rinse them at the end of each day, leaving the surface of the chemical covered by a floating lid.

A few smaller-capacity benchtop roller processors for prints use long shallow trays instead of tanks. They work on the principle of batch chemistry. Here you discard and replace the 2 litres or so of solution when a given maximum amount of material has passed through (say, 25 dye-bleach prints, 8 × 10 inches). A small 10-inch wide machine working at 8.5 cm per minute takes an hour to output this number of prints. See Figure 10.7.

Dip-and-dunk film processors

Also known as 'rack and carriage' or 'rack and tank' processors, these are effectively a robot form of deep-tank hand line. As Figure 9.21 shows, the machine stands in the darkroom and films are suspended from hangers on a motorized lift/carriage unit over a series of tanks. The machine lowers hangers into solution, gradually inches them along the full length of the first tank, then lifts and lowers them into the next solution. The longest stages have the longest tanks, and the solutions are thermostatically heated and pump-circulated. Films on their hangers finally pass along a drying compartment. There is no risk of damage from poorly maintained rollers with a dip-and-dunk processor. Mechanically, the equipment is fairly simple but requires a lot of space (with good headroom) and large volumes of solutions. Machines are also dedicated to particular processes. You can put

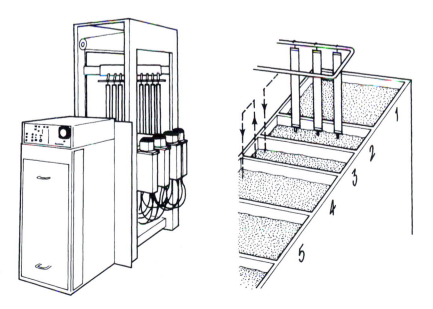

Fig. 9.21 Dip-and-dunk film processor. Machine stands entirely in the darkroom – gantry contains elevator (shown in action, right). Pumps circulate each chemical. Drying cabinet, nearest end, accumulates finished work

through material of mixed sizes at any time by attaching a rack of films to the transport mechanism at the start point of the process. Output ranges from about 40 to 100 rollfilms (120) per hour, according to the size of the machine.

Continuous-strand processors

Machines of this type are designed for processing long lengths of film (aero-survey or movie films, for example) or paper (output from rollpaper printers). They work like roller transport deep-tank units but only have rollers at the top and bottom of each tank (see Figure 9.22). To start up, you must thread the machine with a leader and then attach to the end of this the material you want to process. Other lengths of the same width are attached in turn to the end of previous material, forming one or more continuous strands passing through the machine at constant speed and rolling up dry at the other end. When used for prints, really accurate instrument control of image exposure and light filtration is essential, for it is not very practical to put through test exposures.

You must take the same care over solution replenishment and cleanliness as for deep-tank roller transport processors, although the equipment is internally much simpler. Agitation takes place through movement of the material you are processing through the tanks, but some processors inject gas-burst agitation into key solutions as well. Each machine is dedicated to a particular process. Solutions are continually replenished and recirculated through filter and heater units by pumps. A large paper-processing machine of this kind can produce about 500 8 × 10 inch colour prints per hour.

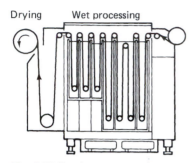

Drying Wet processing

Fig. 9.22 Continuous strand processor, working from a bulk reel of exposed film

Mini-labs

So called 'mini-labs' are typically paired, free-standing, units intended for photographic retail stores – they are able to provide colour negative film processing and printing to one or more fixed sizes on a semi-automatic basis. High-end machines can be very expensive, and contain neg scanning systems which allow monitor screen previews of print results given automatically programmed colour correction, local shading, etc. Prints are exposed onto roll paper, enlarged to sizes between enprint and A4. Minilabs are of value to some studios handling high volume weddings and social events, and needing to turn around proof prints with least delay. They are particularly valid in 'shut-in' locations, such as cruise liners.

Making a choice

There is clearly a great difference between a simple hand-tank and a fully automatic processing machine, although they can both basically run the same process. Similarly, every update in a process which can shave off a few minutes (or, better still, combine solutions without loss of quality) means a substantial increase in output from the bigger machines. Before deciding on what equipment to buy (or whether to use a reliable custom laboratory instead) think hard about each of the following:

Fig 9.23 Minilab units. Left-hand machine processes colour negative films, right-hand unit colour prints these films at various set sizes of enlargement. Both operate in normal lighting

Pattern of workload

Is this steady and consistent, or varied and erratic? Do you want facilities that are flexible, or need to churn out steady quantities using one process only? How important is speed? Would it be best to buy something that has greater capacity than your immediate needs, with an eye on the future? (Perhaps you could also do some processing for other photographers in the first instance.)

Cost

This is not just the capital cost of the equipment but the often high-priced chemicals it uses, plus servicing and spares. Cheapest outlay is on labour-intensive facilities like a hand-tank line, but this will take up a lot of your time. Paying someone else to work it could prove more expensive than an automatic machine.

Installation

Do you have enough darkroom space, suitable water supplies, sufficient ventilation – especially where dye-bleach processing will take place? There may be tough restrictions on the effluent you can tip down the drains, which works against drum discard and trough processors. (Some chemical kits include a neutralizer that you mix with discarded bleach before disposal.) Will the floor stand the weight? Large tanks of chemical or wash water are very heavy. Is the ceiling high enough? Apart from dip-and-dunk needs, large roller processors must have sufficient headroom to enable you to pull out racks vertically for cleaning. Perhaps you should consider a mini-lab as the most compact and self-contained kind of machine for large volumes of small prints?

Troubleshooting

Are you the type to conscientiously maintain good batch-to-batch quality on the kind of equipment you intend to have? For example, it may be best to choose some form of one-shot processing if you are likely to forget to replenish. Are you prepared to wash out racks of rollers thoroughly or trolley-in a heavy cylinder of nitrogen? Above all, if results come out with increasingly green colour casts or some other unexpected effect, will you wish you had used a laboratory or do you have enough persistence and interest to track down the cause and correct it? This is where some form of process monitoring will let you know what is going on. Monitoring can reveal subtle changes before they start to noticeably damage your results and become difficult to rectify.

Process control

The best way to monitor the total effect of your processing system solution condition, temperature, timing, agitation and general handling – is to put through some exposed film. Then by comparing your results

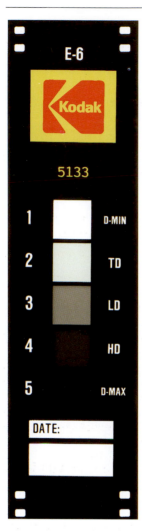

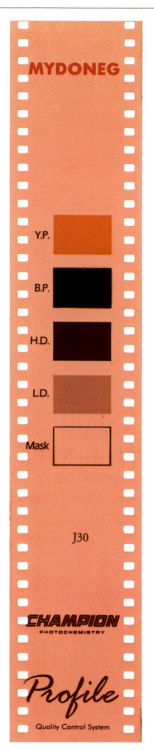

Fig 9.24 Processed monitoring control strips, shown actual size. Left: colour reversal film. Centre: colour negative film. Right: neg/pos colour paper. With films control strip is used to make D_{min} ('mask'on colour neg), LD (low density), HD (high density) and D_{max} readings. These are compared against readings you make from identically exposed strips you put through your own processing solutions. See Figure 9.29. On the print control strip you measure high and low density patches from each of the three colours, plus the black patch for D_{max} and the white patch for D_{min} (or 'stain')

against some of the same film processed under ideal conditions variations can be measured. To do this job properly, you need the following items:

1. An exposed test piece of film or paper to process, plus another identically exposed to the same image and known to be correctly processed;
2. A densitometer instrument to make accurate readings of results; and
3. The monitoring manual or software package issued by the film/processing kit manufacturer to diagnose likely causes of any differences between your results and the reference film.

None of this is cheap, but it is a form of insurance which becomes more valid the larger the scale of your processing. However, there are also some short cuts, as you will see shortly.

Process-control strips

These are strips of film or paper a few inches long exposed by the film manufacturer under strictly controlled conditions and supplied ready for processing in boxes of 10 or 20 or so. Different strips are made for each black and white and colour process in which process control is normally practised. These are normal contrast black and white negative film; reversal colour film; negative colour film; neg/pos and pos/pos colour papers. Each strip has been exposed to a scale of light values (Figure 9.24). Colour strips also contain some coloured patches and (sometimes) a head and shoulders colour portrait image. One strip in each box has been processed by the manufacturer under ideal laboratory conditions to act as a comparative standard.

You must store unprocessed control strips so that changes in the latent image cannot occur. They are best kept in a freezer at −18°C or lower. (Allow them time to return to room temperature before use.) The idea is that one control strip is processed at regular intervals alongside the batch of film you are processing, then checked against the manufacturer's reference strip. Intervals may be once a day, once a week, or even with every batch of film, according to your pattern and volume of processing.

Comparing your processed and reference strip side by side on a lightbox will show you any gross processing errors at once. The eye is quite good at making comparisons, and visual assessment alone may be adequate for confirming that everything is reasonably on-line with black and white negatives and even colour slides and prints. However, you cannot easily judge colour negatives in this way, nor can you detect the often very slight drifts (especially colour) which forecast more serious problems ahead.

To get more information without purchasing further equipment you can subscribe to the manufacturer's laboratory check service, as offered by Kodak, Agfa and Fuji. Here you regularly post off processed strips which are analysed for you and any urgent remedial advice faxed back. You also receive a routine graphic readout and written interpretation of every strip sent in. A service of this kind is excellent, but there is always a delay. Having your own measuring/analysing equipment on hand allows you to make processing corrections immediately.

Fig. 9.25 Manufacturer's processed control strip for black and white film. The two measurement patches, for low and high density readings, also give density difference figures. See plots, Figure 9.28. Fog level is read off the clear part of the film

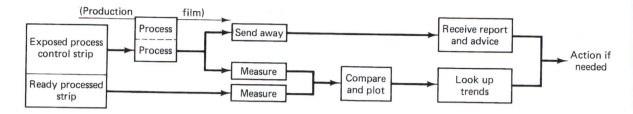

Fig. 9.26 Process control. Chart shows how one of the pre-exposed strips (left) is processed alongside your normal production batch. You then send it away for analysis, or make your own comparison against the manufacturer's ready processed version

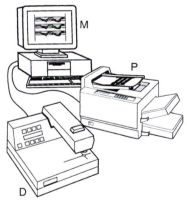

Fig 9.27 Equipment to measure and record processed density values. Area of film to be measured is positioned over reading spot on base of densitometer (D) and density value appears on panel alongside head. Linked to a PC with appropriate software, logged measurements are graphically compared with results from previous processing runs to reveal trends. Data is displayed as a progressive 'clothes line' plot (Figure 9.28) on monitor (M) and prints as hard copy (P)

Reading results

To accurately make spot density readings off the tone or colour patches on your process-control strip you need an instrument called a densitometer (Figure 9.27). This has a transmission illumination head for films (passes light through the film base from below) plus a reflection head which reflects light off print surfaces at a fixed angle. Light-sensitive cells receive the light and make a direct reading of black and white density or they read through appropriate red, green and blue filters in turn to give separate values for cyan, magenta and yellow layer image densities in colour materials. Density values appear on a readout panel.

For black and white film checks you measure two marked patches on the tone scale (Figure 9.25), one a high-density area and the other low. Do this for your reference and your newly processed strips. Then, using a pre-printed chart, mark in the *differences* between reference and processed strip readings for various patch readings; Figure 9.28. The result is often called a 'clothes line plot'. Over a period of time the plotted line will show variations, which should remain within the tolerance limits recommended by the film manufacturer and marked on your chart.

To check out colour, you need more information. With reversal slide processing, for example, you would typically plot readings of minimum density (for stain), a lowish-density patch (for speed), a high-density one (for colour balance and contrast) and a maximum density (for fog). See Figure 9.30. These are repeated for each colour layer, making a total of 12 readings per reversal film control strip. The difference between each reading and that of the equivalent part of the reference strip is logged on a special chart. The procedure is much easier if your densitometer feeds a computer plotter with a program which places each reading you make directly onto a chart displayed on its monitor screen. Plots can then be printed out as hardcopy and archived on computer disk.

Deciding what it all means

Your process-control chart is designed to make variations stand out clearly. Unless something disastrous has happened (developer contaminated with bleach/fix, for instance), plots should not vary greatly. Trends are more important than individual values. Plots which show upward trends indicate overactivity, with too much dye formation in colour materials. Downward trends usually suggest the need for replenishment.

The manufacturer's manual or computer software for the process will reproduce similar patterns and give help and advice on action to be

Fig. 9.28 Monitoring chart for a black and white negative process. Top section would be filled in with high and low density values for the manufacturer-processed reference strip (Figure 9.25). Strips were processed 2–3 times a day, and their high and low density readings logged. The density differences between the two readings were then plotted relative to the DD of the reference strip. The bottom plot shows how far low density readings vary from the low LD of the reference. Downward trend revealed by process strips 11–13 here was countered by added replenisher. See also Figure 9.29

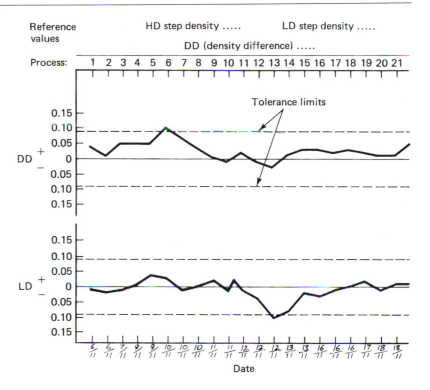

taken. Some software programs automatically sound an alarm, display warnings and written advice when fed with readings which demand immediate action. You can also extend the memorized fault-tracing program with your own experience, so that it ultimately recalls what you did on your own equipment the last time this trend occurred.

Sometimes a process needs a little time to settle down after initial preparation. 'Starter' packs are needed to even out some solutions which are otherwise too 'raw' until a number of films have matured the chemical contents. Often, too, a process remains steady although not matching your reference strip. If processed pictures look good it may be better to leave this situation unchanged rather than tinker and possibly over adjust. Always make any adjustment gradual and allow it time to take effect.

Silver recovery

Film fixing and bleach/fix solutions gradually accumulate an appreciable quantity of soluble silver salts from the materials they have been processing. Used black and white fixer can contain up to 4 g of silver per litre. It is possible to reclaim some of this metal from fixer solution and sell it to a silver refiner. Whether this is worth doing depends on the current value of silver, whether you have sufficiently large tanks and volume of throughput, the cost of the recovery equipment and the time and effort needed to use it. But above all you can be prosecuted if you do not do something to reduce effluent silver polluting public waste treatment systems, as laid down by ecological controls (for example no more than 2 mg per litre discharged to drain). Check with your water

Fig. 9.29 Monitoring chart for a colour negative process. Reference values for the manufacturer-processed strip appear in left-hand column. For each strip put through with film, red, green and blue readings are made from each of high density, low density and D_{min} steps. See Figure 9.24. These are turned into density difference (top), low density (middle) and D_{min} (bottom) comparisons with reference values. Notice how the tolerance limits (shown by broken lines) become narrowest at D_{min}

KEY

———— Thin line — red

———— Medium line — blue

———— Thick line — green

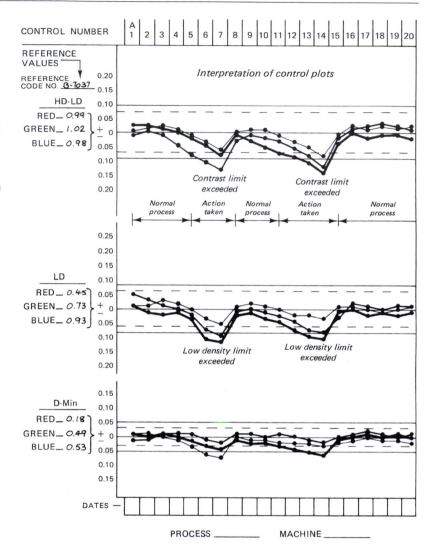

supplier. You can also consult a silver refiner or film manufacturer for current advice. In practice studios and smaller labs often go for a bulk collection service. Big users, processing over 50 000 films a year, can seriously consider on-site *treatment* or on-site *recovery*, and here the two most common methods are metal exchange, which removes silver but destroys the photographic properties of your solution, and electrolysis, which allows the fixer to be regenerated and so reused. Electrolysis is cleaner and less trouble, but needs more expensive equipment.

Metal exchange

When a base metal like iron is left in a solution of silver salts it slowly dissolves and is replaced by metallic silver. The best way of exploiting this in practice is to fill a large plastic container with steel wool (iron), such as pads made for floor-cleaning machines. As shown in Figure 9.31, these stand on a perforated platform a couple of inches above the container bottom, over an inlet pipe for the spent fixer. The solution

Fig. 9.30 Colour film processing faults. (Some of these may differ in detail according to brand and type of film)

Typical film appearance	Probable cause
Colour reversal film	
Too dark, with colour cast	Insufficient first development
Completely black	First and colour developers interchanged, or first developer omitted
Yellow, with decreased density	Fogged in first developer
Yellowish cast	Colour developer fault, e.g. too alkaline
Very light, blue cast	First developer contaminated with fixer
Too light overall	Excessive first developer
Contrasty colour negative	Contamination of first developer. Given colour negative processing
Blue spots	Bleach contaminated
Fungus or algae deposits	Dirty tanks
Scum	Dirt in solutions.
Control plots showing:	
all densities up or down	First developer errors creating speed changes
all low, blue plot least affected	Excessive first development
Colour negative film	
Image light, and with reduced contrast	Underdevelopment
Image dense and very contrasty	Overdevelopment
Streaked and mottled image	Insufficient agitation
Heavy fogging, partial reversal	Exposure to light during development
Reddish-brown patches	Contamination of solutions
Completely opaque, or cloudy image	Bleach or fixer stage omitted
Colour positive, with strong cast	Given reversal processing
Opalescent yellow overall	Exhausted bleacher
Fungus, blue spots	As per reversal transparencies

rises to the top and is bled off to waste. Over several weeks the steel wool converts to grey silver progressively upwards through your tank. When the top appears grey you scoop out the wool as almost entirely silver, which is dried and sold to a refinery.

Electrolysis

Weak electric current is passed between two electrodes at opposite ends of a tank of exhausted fixer, causing silver to plate-out on the cathode electrode. This offers you a convenient method of removing silver without contaminating the solution. The anode electrode is small (Figure 9.31) and often made of carbon while the cathode has a large surface area of stainless steel. Over a period of days the silver grows as grey scaling, which you eventually chip from the cathode and send for

Fig. 9.31 Two methods of recovering silver from a spent fixing bath. Metal exchange technique uses iron (steel wool). In electrolysis current flows from anode (A), plating the silver onto cathode (C)

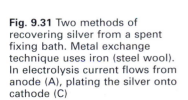

Metal exchange

Electrolysis

refining. After adding fractional quantities of the original fixer chemicals the regenerated solution can be returned back to its original processing function.

Summary: Film processing management

● Today's mainstream chemical processes for silver halide *films* are black and white negative, colour reversal and colour negative types. Dominant *print* processes are black and white neg/pos, colour neg/pos, colour reversal and dye destruction (both pos/pos). Black and white processes allow you to choose developer fixer, etc. fairly freely, although modern dilute developers maximize the qualities of new high tech grain films. Each colour process comes as a planned kit – sometimes in amateur or professional, shortened or regular versions.

● The widest choice of developers exists for black and white processing. Differences include contrast, film speed, grain and resolution. Some are designed for you to dilute and use one-shot, others have long-life performance for use in a deep tank.

● Monochrome print developers are chosen mostly for the image 'colour' they give, especially with chlorobromide emulsions. Fast-developing RC papers can be machine processed.

● Timing of the first stage of reversal colour film processing (black and white development) is adjustable to push or hold back film speed. Colour development times, during which couplers form dye images should be considered inflexible for colour films except for a few fast neg types capable of push processing. Times can also be varied when developing monochrome chromogenic films. Finally, silver is bleached, fixed and washed out.

● Cross-processing colour films gives coarsened subject hues and distorted contrast. Both can be effective for off-beat images.

● Neg/pos colour printing materials include (RC) paper and film base (Duratrans). Colour development is followed by bleach/fix and washing.

● You can also colour print direct from slides, onto dye-bleach or onto chromogenic reversal papers. These two processes are entirely different. Dye-bleach material, which already carries tricolour dyes, has black and white development as its first stage. Then you bleach all silver as well as dye wherever black silver was formed. Results have stronger, purer and more permanent colours than possible with coupled dyes. Reversal chromogenic colour papers need processing sequences broadly similar to slide films.

● For reliable processing look after temperature, timing, agitation, the state of chemicals and the way photographic material is physically handled. Temperature errors beyond acceptable limits change chemical characteristics. Timing is the best way to adjust processing. Insufficient agitation gives unevenness and weak maximum density, but too much creates flow-marks. In all processing, be accurate and consistent.

● Prepare chemical solutions safely, and according to detailed instructions. Do not risk contamination through insufficient rinsing of mixing gear, containers, etc. or sloppy working. Do not use any solution beyond its exhaustion point – use one-shot processing or log what you put through, then replenish or discard. Use replenisher formulated for your processing solution (or some fresh original solution, if recommended). Add it by topping up, or introduce a measured quantity, bleeding off surplus solution.

- Hand-processing of film in deep-tank hand-lines and black and white prints in trays is labour-intensive but justified for small quantities of work. Deep tanks need gas-burst agitation for consistent colour processing. Machines are ideal for larger volumes and the most rigorous colour processes, but automatic equipment is costly to buy and may use large tanks of (expensive) chemicals.

- Drum processors accept paper (or film) for one-shot processing. Basic types are manually controlled, convenient for small batches of material only, but versatile and relatively cheap. More expensive rotary discard machines hold larger batches of material emulsion outwards on a cylindrical frame rotating in a trough.

- Roller transport processors run continuously, accept individual sheets or rolls, and most types can be 'glove box' loaded in room lighting. They also work dry-to-dry. But bear in mind they are dedicated to one process at a time. Deep-tank machines are expensive to buy and fill with chemicals. Some benchtop versions for print processing use smaller quantities of chemical in throw-away batches. All roller units must be cleaned frequently and properly maintained.

- Dip-and-dunk machines avoid dirty rollers scratching films, but require siting in darkrooms with ample headroom. Continuous-strand processors are large-capacity machines accepting lengths of film or paper joined head-to-tail, and drawn through a sequence of deep tanks and dryer, using minimum rollers.

- Mini-labs provide semi-automatic processing and printing onto roll colour paper. They produce a high volume output covering a limited range of sizes.

- In choosing processing equipment, consider whether your work pattern is varied or regular. Are you prepared to pay for convenience, capacity and speed or go for cheaper but more labour-intensive methods? Work out cost of chemicals, servicing, etc. as well as capital investment. Check that you have the right space, ventilation, water supplies. Will your housekeeping and processing control be good enough to ensure consistent results? Can you troubleshoot when something goes wrong?

- Process control allows you to monitor your entire system by regularly processing pre-exposed control strips, then comparing results against a manufacturer-processed strip. You can send off for regular analysis or measure results on the spot using a computer-aided densitometer and diagnostic software.

- Cold-store your unprocessed control strips. Measure transmission density (for films) and reflection density (for paper). Colour materials are measured using tricolour filters. Black and white densities are read off high- and low-density marked patches, colour print results off D_{min} and D_{max}.

- Variations between your densities and those measured off the reference strip are plotted on a process-control chart. Check the pattern of plots produced for 'jumps', or spreadings apart, or trends, for example, upwards (too active), downwards (too exhausted).

- Ecology based laws prohibit you from discharging silver effluent. Use a bulk collection service for spent fixer. Large labs may economically opt for on-site metal exchange treatment, and/or electrolysis silver recovery. The latter allows you to regenerate your fixing solution and put it back to use.

10
Colour printing

This chapter assumes that you are experienced with black and white work but are approaching practical colour printing on silver halide material for the first time. Colour is more demanding because you need all your monochrome skills (cropping to improve composition, judging correct exposure, shading and printing-in) plus the ability to assess 'off-colour' results and make corrections. You must also work in dimmer safelighting and more tightly control exposing and processing conditions. It is important that your colour vision is normal, so have your eyes tested if you find subtle colour differences very difficult to detect.

Starting with types of equipment and practical facilities, the chapter first takes you through pos/pos printing (from slides). From this it is easiest to grasp the practicalities of filtration if you have not printed colour before. However, if you are more concerned with neg/pos printing, turn directly to the next section, which also starts from first principles. The use and advantages of different kinds of colour analyser come next, plus ways of printing additively. Various 'cross-over' techniques are discussed, such as printing transparencies from negatives and negatives from slides, as well as slide duping and the growing practice of colour printing onto silver-halide materials from digital image files. In fact, use of hybrid routes – such as conversion of silver halide to digital, then adjusting and manipulating the image on a computer and returning it to film or printing direct – is now part and parcel of professional photography. Finally, you have to decide the advantages and disadvantages in doing your own colour printing instead of using an outside laboratory, in the light of your own type and volume of work.

Equipment

To colour print you basically need an enlarger with a lamphouse which not only evenly illuminates the film in the carrier (as in black and white) but can also be altered in colour content. Colour adjustment is vital to give you *flexibility* – within reason, you can match the colour

Fig. 10.1 Subtractive filtering lampheads. Left: basic level system using filter drawer between lamp and negative. You need a wide range of Y, M, C acetate filters of different strengths from which to make up a suitable filter pack. Right: dial-in filter head. Each dial controls the strength of one colour filter and is calibrated in relative units, which vary slightly according to manufacturer. See also Figure 10.4

balance of the film image you are printing to suit the batch of colour paper, compensate for enlarger lamp characteristics, etc. Above all, it lets you fine-tune your record or interpretation of the subject.

There are two main ways of controlling illumination colour:

1. Giving one exposure using yellow, magenta or cyan filters in the light path. This is the most common method and known as 'subtractive'. Or
2. Giving three different exposures, separately through blue, green and red filters. This is known as 'additive' printing.

Subtractive filter ('white light') enlarger heads

Most colour enlargers work by introducing different strengths of yellow, magenta and cyan filter between lamp and negative. The cheapest arrangement, which allows you to use a black and white (diffuser) enlarger, is a lamphouse drawer into which you can fit several acetate CP filters chosen from a set of 20 or so. However, it is much easier to use a 'dial-in' colour head, by which three calibrated dials each slide one deep-coloured yellow, magenta or cyan filter increasingly into the light beam. This part-tinted light is then thoroughly scrambled by bouncing it around a white-lined box and passing through a diffuser, so that it reaches the film carrier perfectly even in colour. See page 232.

The stronger the yellow filtering you use, the more blue wavelengths are subtracted (absorbed) from the white enlarger light. Similarly, magenta filtering subtracts green and cyan subtracts red. You can watch the light changing colour as you turn the dials. Altering each control *singly* from zero to maximum units tints the light increasingly cyan, magenta or yellow; increasing filtration on *two* controls together gives red, green or blue. If you advance *all three* controls the light just dims

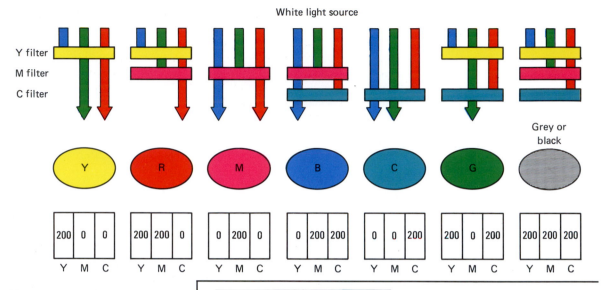

White light source

Y filter
M filter
C filter

Grey or black

Y M C	Y M C	Y M C	Y M C	Y M C	Y M C	Y M C
200 0 0	200 200 0	0 200 0	0 200 200	0 0 200	200 0 200	200 200 200

Fig. 10.2 Above: an enlarger colour head may have only three filters, but by adjusting dial-in controls you can change the light through a wide range of primary and complementary colours. Each primary colour is made by dialling in two filters at a time (shown maximum here). Never use more than two filters at once

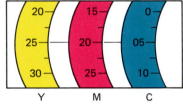

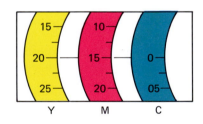

Fig. 10.3 Eliminating neutral density. Left: colour head settings here are utilizing all three filters. Left, below: to avoid unnecessary neutral density the lowest setting has been subtracted from all three controls. Colour remains the same but light is brighter

Fig. 10.4 Side view of a dial-in head. This shows the mechanical arrangement for raising and lowering the filters into the light beam when finger dials (protruding from lamphead, left) are turned. Matt white light-mixing box (M) scatters and directs light down through diffuser (D) to evenly illuminate negative held in a carrier below

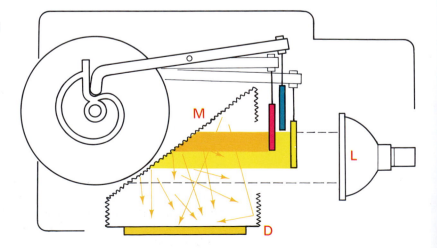

without appreciable colour change. (This is because, when equal, they simply form grey neutral density.)

There is normally no reason for using all three filters at once in a subtractive filter head – they just waste light and extend your exposure time. So if during printing you make changes which bring three values into use you should 'subtract neutral density' by taking away the lowest value setting from each, making one of them zero, as shown in Figure 10.3.

Additive heads

A few enlargers and printers do not use a variable-strength filtering system. Instead they have deep red, green and blue filters, one fixed over each of three lamps or flash tubes or rigged on a moving carrier which positions one filter after the other across the light beam. Every print is given three exposures, and by varying the times for each colour (with flash the number and strength of flashes) you control the effective colour of the light. Additive printing can therefore be said to expose each of the red-, green- and blue-sensitive emulsion layers of the colour paper separately. It is a system which still suits some automatic or electronically controlled equipment, as all adjustments can be made by timing. Again, it is a low cost way of using a black and white enlarger. However, with a sequence of three exposures, shading and printing-in become difficult.

Fig. 10.5 Turret of strong B, G, R filters under enlarging lens for additive colour printing. Notches (not shown) tell you the colour and accurate positioning of each filter in the dark. See page 250

Enlarger essentials

A typical colour head enlarger uses a tungsten halogen lamp with built-in reflector. (More light is needed than given by most black and white heads, due to losses later in the filtering and light-mixing optics.) Power to the lamp should be through a voltage-stabilizing transformer which smoothes out any dips or surges of current caused by other electrical equipment nearby, producing changes of lamp colour temperature. Next in line come three strong yellow, magenta and cyan filters. These slide into the light beam by amounts controlled by three finger dials on the outside casing or solenoids in circuit with some electronic system such as a colour analyser (see page 247). The effect on printing light colour depends on how much of each filter enters the beam – a 130Y filter pushed across one fifth of the light beam has a 26Y effect. Values are shown on finger dials or diodes, typically between 0 and 130 or 200 for each hue.

Filters themselves are *dichroic* types, glass thinly coated with metallic layers which reflect the unwanted parts of the spectrum and transmit the remainder, instead of filtering by dye absorption of light. This gives them a 'narrower cut', a more precise effect on wavelengths, avoiding the usual deficiencies of dyes (page 95). They are also more fade-resistant – important when you keep introducing part of a filter into a concentrated light beam. The head also contains two permanent filters. One is a heat filter to subtract infra-red wavelengths and avoid film overheating, the other an ultra-violet one to absorb any unwanted ultra-violet from the lamp. There may be a separate drawer or shelf within the lamphouse where you can fit an additional CP acetate filter when the filtration you need is beyond the range of the dichroic system. This is occasionally useful for effects or when printing from early colour negatives.

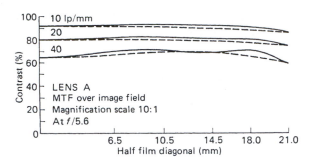
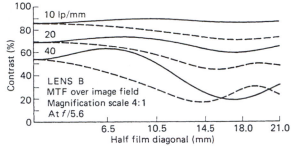

LENS A
MTF over image field
Magnification scale 10:1
At *f*/5.6

LENS B
MTF over image field
Magnification scale 4:1
At *f*/5.6

Fig. 10.6 Modulation transfer function curves for two 35 mm format enlarger lenses. Lens A is a top-of-range design, giving consistently high image quality. Lens B is a budget-price type. However, for small enlargements of only ×4, viewed from normal reading distance, values of 10 lp/mm are the most relevant. Here results are never less than 70% contrast. See also Figure 2.15

Fig. 10.7 Bench-top colour paper processing machine, showing the path taken by prints through troughs containing developer and bleach/fix. Washing and drying takes place outside machine. See Figure 10.8

The light beam is thoroughly mixed and passed through a diffuser large enough to cover the largest size film carrier you will want to use. The remainder of the enlarger – column, movements, timer, masking frame – are basically the same as for black and white printing.

In fact, most enlargers use interchangeable colour or black and white heads. You can even use a colour head for black and white printing – its characteristics are like those of any other diffuser light-source enlarger. Dial out all colour filtration, or use the yellow and magenta filters to control variable contrast monochrome paper (see table in Appendix A, page 292).

Always fit the best enlarger lens you can afford (Figure 10.6), preferably one of at least four elements. All modern enlarging lenses are fully corrected for colour, but it often helps to buy one with a wider maximum aperture than for black and white work. This makes the focusing of masked negatives easier to see and more critical. However, always aim to expose with your lens stopped down to about the middle of its *f*-range for best performance.

Other basic facilities

Figure 10.8 shows most of the other basic items you will need. A colour analyser is a worthwhile investment. Once calibrated, it gives you a good starting point for filtration and exposure settings for each image (see page 246). As with black and white printing, rigorously separate

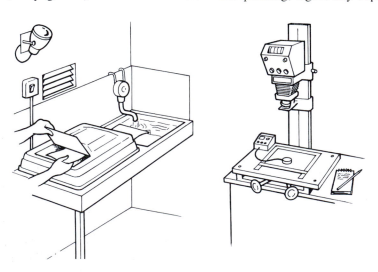

Fig. 10.8 Basic one-person colour printing darkroom (print drying undertaken elsewhere)

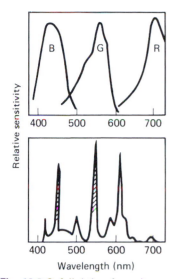

Fig. 10.9 Safelighting for colour printing. Top: spectral sensitivity of the paper's three emulsions. Bottom: spectral emission from sodium type safelight. A filter within the unit absorbs the two shaded bands. Peak emission therefore matches the 'gap' between green and red paper sensitivity. However, level of brightness must remain low to avoid fogging from lower energy bands

'wet' (processing) from 'dry' activities (handling of films and exposing prints). You will be working for longer periods than when film processing, so equip the darkroom with safelighting and efficient ventilation. Safelights for colour printing must be far less bright than monochrome types, passing a mixture of wavelengths to which the eye is sensitive but print material emulsions are least responsive. The result is a very dim amber. Special filtered sodium safelights transmit a yellowy-brown line spectra (Figure 10.9) to exploit a narrow gap between colour paper's red and green sensitivity. These are somewhat brighter than tungsten safelights but more expensive, and they take 10 minutes or so to reach full power. In a large room use a sodium type for general illumination, plus tungsten safelights in key areas such as above the processor, darkroom door, etc. Safelight fog usually gives neg/pos papers pale bluish highlights, uncorrectable by enlarger filtration.

Make sure your printing darkroom is properly ventilated, with air preferably being drawn out of the room through the wall behind the processor. Aim for 10 room air changes per hour; with dye-bleach processing the recommended rate is 15 changes per hour. Health and safety equipment should also include protective gloves for chemical handling and eye wash and a fire extinguisher. See page 294.

Prepare some well-illuminated white-light area where you will always judge your colour tests and prints. This might be near a blackout blind you open to let in daylight. Better still, because it is more consistent, have a bench with daylight matching lamps or tubes overhead. The spectral output of fluorescent tubes is often shown by a 'colour-rendering index'. The closer the CRI is to 100, the more suitable the tube is for colour viewing. Do not use anything less than 90 CRI. If you know that finished work will be shown only in tungsten lighting, using lamps of this colour temperature instead.

Print materials

Colour print materials are of three main types:

1. Chromogenic neg/pos ('C' type) such as Ektacolor or Fujicolor, designed for printing from negatives;
2. Chromogenic pos/pos, reversal ('R' type) material such as Ektachrome or Fujichrome papers; and
3. Dye-bleach pos/pos material such as Ilfochrome.

Both (2) and (3) are for printing from slides or larger format transparencies. Each material needs completely different processing (see page 210). For paper prints use material with an opaque white, resin-coated base, but several types are also made on translucent or transparent base versions, used for display transparencies, visual aids. etc. (see page 253). Most printing papers come in a selection of surface finishes – typically glossy, lustre or semi-matt. Although there is no range of contrast grades as such, some papers intended for direct commercial and advertising uses are made with slightly higher contrast than 'medium' contrast papers for portraiture and pictures for newsprint reproduction.

All colour printing materials have multi-layer emulsions sensitive to the three primary colours of the spectrum. However, unlike camera

Fig. 10.10 Colour printing suite for three colour enlargers, sharing one high output roller-transport paper processor. Machine outputs dry prints to an area where there is white light illumination to judge results

materials, most papers have emulsions in reverse order, with the red-sensitive cyan-forming layer on top. A slight amount of image diffusion is inevitable in the bottom layer but is more hidden if this is yellow instead of the heavier cyan. Emulsion colour sensitivities have steep, well-separated peaks corresponding to the maximum spectral transmissions of the three dyes forming the film image. Remember, printing paper does not receive light from the same wide range of subject colours as camera film – everything is already simplified to combinations of three known dyes. In part of the spectrum (Figure 10.9) print material sensitivity can be sufficiently low to permit the use of safelights which would fog colour film.

Characteristics of the same manufacturer's colour negative films are taken into account in the design of neg/pos print materials. The two are 'keyed' in terms of contrast and the effects of integral colour masking used in the film (pages 95–98). Cross-printing maker A's negatives on maker B's paper may need heavier filtration, but the result, with its mixed use of dye characteristics, may well suit your style of work.

Because of slight variations in manufacture, a few brands of colour-print material are labelled with filter and exposure changes relative to other batches, like sheet colour film. So be prepared to adjust filtration and/or timing between finishing one packet and starting another if they are different batches (see Figure 10.21). Whenever you buy a stock of paper try to ensure that it is all from the same batch. Take care over storing printing materials too. Like all other colour emulsions, they need properly controlled conditions. Keep your stock sealed and located in a refrigerator at 10°C or less, but prevent moisture from condensing on the cold emulsion surface by allowing it time to reach room temperature before use.

Paper size	Form of packing	Time to reach 21°C	
		From 2°C	From 10°C
20.3 × 25.4 cm (8 × 10 in)	100 sheet box	3 hours	2 hours
40.6 × 50.8 cm (16 × 20 in)	50 sheet box	2 hours	2 hours
8.9 cm (3.5 in) × 240 m	Roll	6 hours	4 hours
20.3 cm (8 in) × 80 m	Roll	7 hours	4 hours

Fig. 10.11 Recommended warm-up times when you remove printing paper from cold store

Pos/pos colour printing

The two main advantages of printing from positive film images instead of negatives are:

1. You can see what you are aiming to get. The film is easy to judge for colour balance, portrait expression, lighting, etc. Your print should retain the best of these features yet also allow you to manipulate cropping, colour and density.
2. Working this way should give you the best of several worlds – you can not only make prints but have a transparency which can be projected and which is also the preferred form of colour image for mechanical reproduction on the printed page.

However, transparency film has no integral masking, and its contrast is greater than a negative because it is designed to look good as an end in itself rather than suit colour paper. Both these features limit your print quality. For example, contrasty slides, especially when due to harsh lighting, can give disappointing results. Print material processing also involves more stages (chromogenic) or is more toxic (dye-bleach) than neg/pos paper (see page 204).

The best kind of slide for printing pos/pos is moderate or low in contrast, evenly lit and not overexposed. In fact, the deeper colour highlight detail of slight *underexposure* is often an advantage because you can lighten results somewhat during printing, whereas nothing can bring back the bleached detail of an overexposed image. Make sure your film is spotlessly clean. Any debris on the slide prints as black, which is much more difficult to spot-out than the white specks this would produce on neg/pos prints.

Practical procedure

Set up your film in the enlarger, stop down and initially set the filtration as recommended by the paper manufacturer for your brand of slide. Test first for correct exposure, then for colour. Have some device which covers the paper in the masking frame and lifts one segment at a time. If possible, keep repeating the same part of the image by repositioning the masking frame. If you do not have an analyser, Figure 10.23, you can get correct settings most quickly by giving each segment different filtration *and* a range of exposures. See Figure 10.12. Vary each band of exposure by about 50% around what you estimate (or measure) to be correct. Try to keep exposure time within 5–30 seconds, making changes outside this range by altering lens aperture instead. This way you avoid colour shifts due to reciprocity failure (see pages 243–245).

Process your material (Chapter 9) and examine dry results under your standard viewing light to judge density and colour. Remember that the darkest segment has had least exposure (Figure 10.13). Isolate your best exposure result and compare colour with your transparency. If the test looks, say, too yellow, reduce your yellow filtration. If it looks too green, reduce yellow and cyan equally – but if one of these is down to 00 filtration already you can add magenta instead. Avoid having a neutral density situation through using all three filter colours (page 232). Filtration changes of 10 units have a barely discernible effect. Expect to alter 20 units at a time, or 30–40 for more effect – all bigger steps than

Fig. 10.12 Technique for getting maximum test information from one full sheet of colour paper. Use four hinged flaps of opaque card (white on top) so only one quarter of the paper (P) is exposed at one time. Set filtration for the film type as recommended by paper manufacturer. 1: lift flap one and expose three bands for different exposure times, shading with card. 2: with all flaps protecting the paper, switch on the enlarger again. Shift the masking frame so that the strip of image exposed at stage 1 now falls on flap two. Increase or reduce filtration by appropriate units in one direction. 3: switch off enlarger, lift flap two, and expose three exposure bands again. Continue for flaps three and four. Processed sheet will show four filtrations at three exposure levels. Keep notes

Fig. 10.13 A result of using the test technique above, printing a transparency on pos/pos Ilfochrome paper. Nearest strip, right, was filtered 20Y; then 20Y 40C; then 60Y 40M; and finally 60Y 40C. Each strip received 7 seconds exposure bottom, 14 seconds middle, and 21 seconds top. From this it was decided to filter 20Y 10C and give 20 seconds

Required effect on final print	When using pos/pos printing materials	When using neg/pos printing materials
Lighter image	Increase exposure or (locally) print-in	Reduce exposure or (locally) shade
Darker image	Reduce exposure or (locally) shade	Increase exposure or (locally) print-in
Less blue	Reduce M + C, or increase Y	Reduce Y, or increase M + C
Less green	Reduce Y + C, or increase M	Reduce M, or increase Y + C
Less red	Reduce Y + M, or increase C	Reduce C, or increase Y + M
Less yellow	Reduce Y, or increase M + C	Reduce M + C, or increase Y
Less magenta	Reduce M, or increase Y + C	Reduce Y + C, or increase M
Less cyan	Reduce C, or increase Y + M	Reduce Y + M, or increase C
White borders	Fog paper edges	Cover paper edges with easel masks

Fig. 10.14 Controlling results in (white light) colour printing

you normally need in neg/pos colour printing. Get used to making notes of filter and exposure time settings on the back of prints or in a notebook. Having reset your filtration, check whether the changes will necessitate any adjustments to exposure. Calculate this from the manufacturer's table (Figure 10.18) or read it with an analyser.

Shading and printing-in

The technique for darkening or lightening chosen parts of the print appear strange at first if you are used to printing negatives. You shade pale parts to make them darker and give heavy areas more exposure to lighten them. Print borders, where edges of the paper are under edges of the masking frame, come out black. White borders must be fogged in after image exposure, covering the main area of the print with black paper just as you would if printing *black* borders neg/pos (see *Basic Photography*). You can make local colour corrections by shading with filters. For example, if part of an outdoor shot includes shadow excessively blue-tinted by blue sky, shade this area with a CC 10Y filter. (Do not use CP acetate – this upsets definition when used between lens and paper.) If your shading also makes the shadow *darker* than you need, lighten it back by printing-in the area with extra exposure through a hole in a card covered by the same filter.

If prints show excessively harsh contrast you may have to lower the contrast of your slide by masking it with a faint black and white contact printed negative (see page 167). As a quicker solution (although more limited in effect) try 'flashing' the paper after exposure. Remove the film from the enlarger, cover the lens with an ND2.0 filter and repeat your exposure time. With dye-bleach materials you may reduce image contrast by developer dilution.

Making a pos/pos 'ring-around'

Making a print chart such as Figure 10.15 helps you as a beginner to recognize the direction and degree of filtration needed to correct errors. Pick a slide which includes some pastel hues and grey or white. An easy-to-judge subject such as a portrait with softly lit Caucasian skin tones works well. Make the best possible correctly exposed and filtered small print first, then increase filtration (or reduce complementary colour filtration) by steps of – say – 20 or 30 units and make other small prints with casts progressively in the directions magenta, blue, cyan, green, yellow and red. Mount them on card, each captioned with the amount of filtration you must subtract from your enlarger setting to get

Subtract 50Y+50C

Subtract 50C

Subtract 50Y

Subtract 50M+50C

Subtract 50Y+50M

Subtract 50M

Fig. 10.15 Part of a pos/pos ring-around chart. The print in the centre has correct filtration; the others need the changes in filtration shown to bring them back to correct colour. You can make further 'inner' rings using lesser settings. Where you cannot subtract filters, add the complementary colour instead. For example, add 50Y instead of subtracting 50M 50C; or add 50Y 50C in place of subtracting 50M. See Figure 10.17, facing page. Reproduction in printer's inks here is only a guide – make your own chart using actual prints

Fig. 10.17 Right: colour relationships (of light). Complementary colours are shown opposite their primaries – cyan opposite red, for example. Any one colour can be made by adding equal amounts of the two colours either side of it. See also Figure 10.2

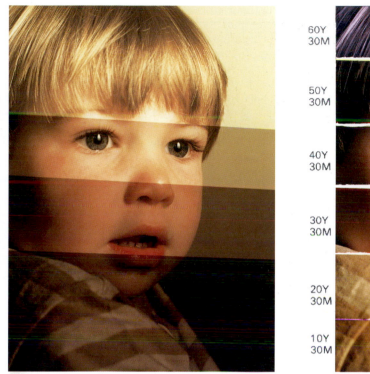

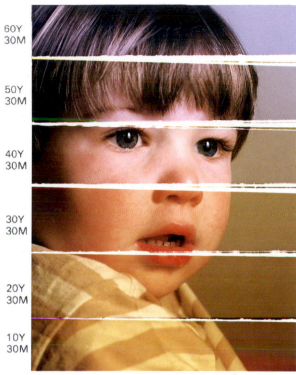

60Y
30M

50Y
30M

40Y
30M

30Y
30M

20Y
30M

10Y
30M

Fig. 10.16 Testing a neg/pos colour enlargement. First test for exposure (above left). Times here, top-to-bottom, were 5, 10, 15, and 20 seconds. Next check out colour (above right) by exposing segments with hinged card flaps. Vary your filtration in opposite directions, as shown by settings. Final print was exposed at 40Y 30M, giving 12 seconds

a correct print. Have the chart near your print viewing light to help to identify the hue and strength of colour casts when judging test strips from any other slides.

Neg/pos colour printing

The advantage of making colour prints from colour negatives rather than slides is that you get better results from a wider range of subject lighting conditions. The information encoded within a properly exposed integral-masked colour negative allows you to make greater adjustments of colour and tone during printing, without unwanted side-effects such as poorer shadow or highlight quality. However, colour negatives are not easy to judge. The tinted mask and complementary image colours make colour balance impossible to assess except in the broadest terms, and negatives often look denser than they really are. It helps to check negatives looking through a piece of unexposed but processed colour negative film of the same brand – the start or end of a rollfilm, for example. The mask colour filters your eye and discounts the mask density present in the negative. Avoid negatives which record important shadow detail faint or non-existent. As in black and white printing, when you shade these areas the image tones they contain will print artificially flat and will also probably show a colour cast.

Practical procedure

To contact-print your negatives, proceed as for black and white, projecting an even patch of light on the enlarger baseboard and fitting

your strips of film into holding grooves under the glass of a contact-printing frame. Stop down two to three stops. If you are printing these colour negatives for the first time, without any analysing aid or previous notes, try setting 40Y 30M. (Cyan filtration is rarely used in neg/pos printing, except for effects.) Lay a half sheet of paper under part of the set of negatives representative of the whole and give a series of doubling exposure times roughly based on what you would give black and white paper. Note down filtration and exposure on the back of the sheet. When your test is processed and dried, judge it under your viewing light. If it is wildly out on exposure you may have to test again, but get density as correct as possible (at least to suit the majority of negatives on the sheet) before you go on to assess colour.

Visual colour assessment is quite a challenging task at first. The rule is *to reduce a colour cast, reduce complementary colour filtration*. So you must always remember the 'double-triangle' diagram (Figure 10.17), which relates primary and secondary colours. If your test looks too *green*, for example, reduce the *magenta* filtration. This turns your enlarger light greener, which makes the neg/pos colour paper give a more magenta print. So what was originally 40Y 30M might be changed by 10M to 40Y 20M for a moderate change of colour. A 05 unit difference of filtration gives a just perceptible alteration; use 20 or more for bigger steps.

If there is not enough filtration already present for you to reduce further, then *add* filters *matching* the print cast. For example, a test filtered 50Y 40M 00C may look about 10 units too yellow. You cannot reduce enlarger settings by 10B (= 10M + 10C) because there is no cyan filtration present, so change to 60Y 40M 00C instead. With each change of filtration check out from the manufacturer's data (Figure 10.18) whether you also have to compensate exposure.

Once you have a good set of contact prints you can choose which shot you are going to enlarge, and set up this negative in the enlarger. Filtration is likely to remain the same as for the contact print version, but retest for colour as well as for exposure.

Shading and printing-in

Shade or print-in chosen areas which otherwise print too dark or light, using the same technique as for black and white printing. Sometimes, however, pale neutral areas of your picture tend to pick up too much colour when darkened by extra exposure. This is where it helps to have a selection of gelatin CC filters (not acetate CP type) to use between lens and paper. If the part you are printing-in tends to pick up, say, yellow, then print-in through a hole in a card covered by a pale yellow filter such as a CC 10Y. Alternatively, add equivalent extra yellow units to your filter head just while you give this extra exposure. Again, when shading a shadow area which has an unwanted greenish tinge, use a green CC filter, such as a 30G (or 30Y + 30C), as your dodger. If this filter is too strong, use it for *part* of your shading and change to an opaque dodger the rest of the time. If negatives are too contrasty or too flat to print well, pick a paper of lower or higher contrast if available, or try cross-printing on another manufacturer's paper. Alternatively, add a weak black and white mask to reduce or increase contrast (see page 165).

Filter strength	Filter colour		
	Yellow	Magenta	Cyan
05	× 1.1	× 1.2	× 1.1
10	× 1.1	× 1.3	× 1.2
20	× 1.1	× 1.5	× 1.3
30	× 1.1	× 1.7	× 1.4
40	× 1.1	× 1.9	× 1.5
50	× 1.1	× 2.1	× 1.6

Fig. 10.18 Filter change effect on printing exposure. Based on Kodak CC Y, M and C-2 filters. When changing filters, divide your exposure time by the factor of the filter you remove, then multiply by the factor of the new filter. If two filters are altered together, multiply their factors first. This applies whether printing slides or negatives

Making a neg/pos ring-around

A set of differently filtered versions of the same picture made on your equipment forms a visual aid for judging filter changes. This is especially useful since you are working in 'negative colours'. Pick an evenly lit, accurately exposed negative of an easily identifiable subject. It must have been shot on the correct stock for the lighting (unless you habitually use some other combination) and should include some area of neutral tone or pale colour. Make one print with correct colour and density, then change filtration by steps of 10, 20 and 30 units in six directions in turn – blue, cyan, green, yellow, red and magenta. See Figure 10.19. Remember to correct exposures as necessary so that all prints match in density. Caption each print with the *difference* in filtration between it and the correct colour version. (The visual colour change this difference produces remains a constant guide, no matter what negative you print.) You must obviously process all prints with great consistency, preferably as one batch. Mount up results logically in chart form and keep them in your print-viewing area.

Use your ring-around by comparing any correctly exposed but off-colour test print from another negative against the chart to decide which print most closely matches it in colour cast. Then read from the caption how much to remove from the test print filtration to get a correct print. Remember to avoid neutral density (page 232) and adjust exposure as necessary for the changed filtering. Sometimes your test will fall between two of the ring-around 'spokes', in which case estimate a combination of the two captions and subtract this from your filtration instead. For example, if test filtration of 40Y 40M matches a chart cast captioned 10Y, change to 30Y 40M; but if it looks somewhere between 10M and 10R (which is 10Y + 10M), subtract 10Y 20M, resulting in 30Y 20M.

Additional points to watch

If you are only used to black and white there are two further aspects you must remember when subtractively printing all types of colour print material (neg/pos and pos/pos). One is concerned with batch-to-batch variations and the other with reciprocity failure.

Changing batches

Occasionally, in the middle of colour printing, you finish one box of paper and have to start another which you find is of a different batch with different 'white light' filter and/or exposure recommendations printed on the label. The rule with filtration is (1) subtract the filter values on the old package from your enlarger head settings. Then (2) add the values on the new package to the enlarger. See Figure 10.21. Where the new pack shows a different exposure factor, divide the new exposure factor by the old one and multiply your previous exposure time by the result. (See also page 251.)

Exposure time and reciprocity failure

All colour printing materials suffer from low-intensity reciprocity failure (i.e. greatly reduced image brightness cannot be fully compen-

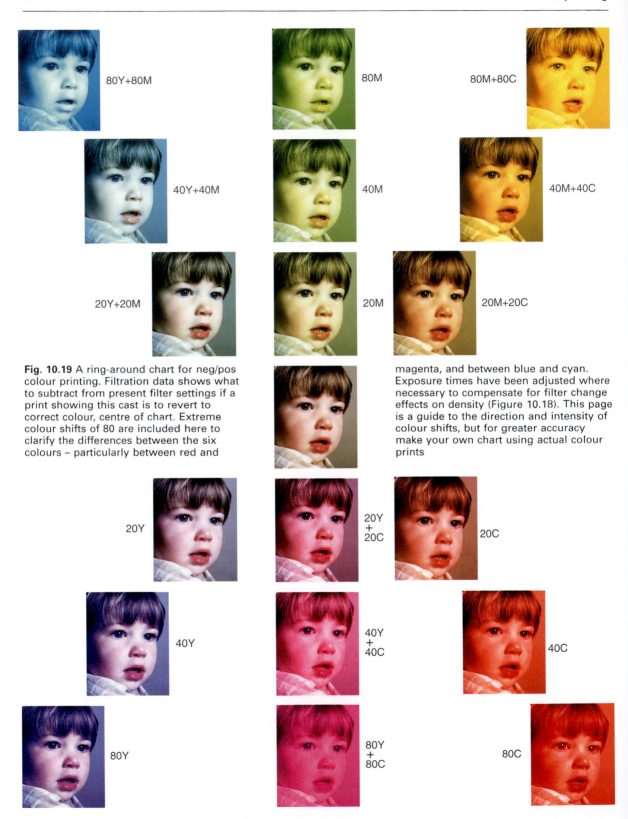

80Y+80M

80M

80M+80C

40Y+40M

40M

40M+40C

20Y+20M

20M

20M+20C

Fig. 10.19 A ring-around chart for neg/pos colour printing. Filtration data shows what to subtract from present filter settings if a print showing this cast is to revert to correct colour, centre of chart. Extreme colour shifts of 80 are included here to clarify the differences between the six colours – particularly between red and magenta, and between blue and cyan. Exposure times have been adjusted where necessary to compensate for filter change effects on density (Figure 10.18). This page is a guide to the direction and intensity of colour shifts, but for greater accuracy make your own chart using actual colour prints

20Y

20Y + 20C

20C

40Y

40Y + 40C

40C

80Y

80Y + 80C

80C

Fig. 10.20 Chart mapping the relationship of filter colour and strength. Strongest filtration is furthest from the centre. Using combinations of filters you can change the colour of light in directions between the main 'spokes' – for example, choosing yellowish orange (10R + 20Y) or reddish orange (20R + 10Y). Filter values hold good for CC filters used in shooting or printing; also for the relative strengths of filters in a colour head enlarger. To make up red, green and blue use combinations of yellow, magenta and cyan filters

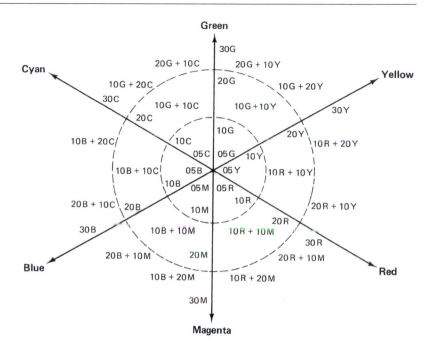

sated for by extending exposure time). Emulsions become effectively slower with the long exposures for stopped-down images from dense negatives or slides, or at great enlargement ratios. For example, a ×4 enlargement at *f*/11 may need 7 seconds. When you raise the enlarger four times as high for a ×16 result the calculated or light-measured exposure becomes 112 seconds. However, at this long exposure the print appears underexposed, and if you further increase the time, results become correct density but show changes in colour balance and contrast due to different responses in each emulsion layer.

The best way to avoid trouble is to aim to keep all exposure times within about 5–30 seconds by altering the lens aperture whenever possible. So in the example above you would do better to give the big enlargement 28 seconds at *f*/5.6. Colour enlargers designed for large prints therefore need to have powerful light sources. They may have a diaphragm near the lamp so you can easily dim the illumination for smaller prints without changing colour content. You will also find some neg/pos papers with reciprocity characteristics specially designed to give best performance with long exposures, i.e. big prints.

Colour/exposure analysing aids

The less filter calculation and guesswork you have to do, the faster you get to a good colour print. There is a choice of several analysing aids, from viewing filters to expensive colour video. They include the most basic kinds of colour printing testers (for example, a geometric grid of small colour filters through which you make a test print on part of a sheet of colour paper). The patch which prints most neutral grey guides you to the filtration needed. All the devices described below are designed for neg/pos printing, and most also work for pos/pos printing.

Fig. 10.21 When changing from one paper batch to another in the middle of colour printing, compare the paper labels. Differences here guide you to reset filtration and exposure time so that results remain unchanged. See text

	Previous print			New print		
Paper label	50Y 40M 00C Exposure factor 70			30Y 25M 00C Exposure factor 90		
Enlarger setting	60 – 45 – 0 Y M C	Old subtracted 10 – 5 – 0 Y M C		40 – 30 – 0 Y M C		
Time	(dial: 0 10)	$\times \dfrac{\text{New EF}}{\text{Old EF}}$		(dial: 0 13)		

Viewing filters

If you view a faulty test print through a filter of appropriate colour and strength you can tell the best change to make to enlarger filtration. Look through CP acetates, as used for filter drawer enlargers, or buy sets of similar filters (Figure 10.22) in cardboard mounts. Have the print under your standard viewing light and hold the filter about midway between print and eye. Do not let it tint everything you see and do not stare at the print through it for more than a few seconds at a time – keep flicking it across and back. Viewing too long allows your eye to start adapting to the colour.

If your test print is too 'warm' in colour, try looking through blue, green or cyan filters; for 'cold' prints, try yellow, magenta or red. As with colour transparencies (page 118). viewing through a filter tints the appearance of highlights far more than shadows. So only judge appearance changes to your print's lighter middle tones. Having found which viewing filter makes these tones look normal, read off the required enlarger filter changes printed on its cardboard mount. (Neg/pos colour printing changes appear one side and pos/pos changes on the other.) Alternatively, if you are viewing through CP filters and printing neg/pos the rule is: *remove from the enlarger filtration the same colour but half the strength of your viewing filter.* For example, if a test print with a green cast shows corrected midtones viewed through a 20M filter, remove 10M from the enlarger. If this is impossible, add 10Y + 10C.

Fig. 10.22 Colour print viewing filters. You need a set of six of these triple filter cards. Each card has filters which are the same colour but differ in strength. Pick the filter which best corrects your test print cast

Electronic analysers

There are a great number of electronic analysers available. All make tricolour measurements of your negative or slide and read out the most likely filter for your enlarger and paper batch. They also measure exposure. Most analysers are for 'on-easel' use – they have the advantage of measuring the same image light that will eventually expose the paper. Some analysers are 'off-easel'. They work separately, like a densitometer used for process monitoring (page 224), and allow you to measure your film images outside the darkroom before printing. One skilled user can therefore serve a number of enlargers.

Off-easel analysers have to be programmed for the characteristics of the particular enlarger through which your film will be printed. Then they compare readings of each negative against a memorized standard

Fig. 10.23 On-easel colour analyser, with image-reading probe. Rows of knobs under the readout window are for pre-programming. Four-way switch on left is selector for measuring the three colours, and the brightness, of the image to be printed

negative for which correct filtration and exposure are known. This kind of equipment best suits large laboratories employing many staff and turning out volume work.

Using on-easel analysers

A unit such as that shown in Figure 10.23 sits on the bench beside your colour enlarger. The plug-in probe, which rests on the masking frame, has a small spot-reading aperture. This ducts light through a fibre-optic tube to light-sensitive cells inside the unit. A choice of either blue, green, red or colourless filters are brought into play over the cells by turning a four-way selector marked Yellow, Magenta, Cyan or 'Exposure'. The analyser again works by comparing its tricolour readings from the film image you are about to print against memorized readings from an image for which you know the filtration and exposure.

You must start by programming the analyser for your 'standard' image. This should be on the same type of film as you will be printing, and preferably shot under similar lighting. Set up the film and its known filter settings in the enlarger, focus the image and stop down to the *f*-number used when you last printed it. Then position the probe to receive light from an area chosen for reference – preferably a midtone grey or a pale Caucasian flesh tone (see below). Selecting 'Yellow', press the yellow programming button until the readout diodes show zero. This procedure is repeated for the Magenta and Cyan controls. Using the 'Exposure' selector setting, press the exposure programming button until the readout shows the number of seconds you gave for a correct print. Now the analyser is ready to use. Further programming adjustments are only needed if you change paper batch, enlarger lamp or lamphouse light-scrambling box.

Set up your unknown negative in the enlarger, position the probe to read an appropriate mid-grey or flesh tone and switch to yellow assessment. Change the enlarger's yellow filtration until the analyser reads out zero. Then follow a similar routine to adjust magenta or cyan readings (remember to eliminate neutral density). Finally, switch to exposure and read off the number of seconds to give.

If your enlarger filtration is altered electronically it is possible to link the analyser to the head so that settings are made directly. Plug-in modules can be pre-programmed for any different paper batch characteristics you may have to use. You can also switch your analyser circuitry from neg/pos to pos/pos printing mode.

Spot, or integrated readings?

Spot-reading negative analysis, like spot-reading camera exposure, is very selective and accurate provided that you intelligently choose which part of the picture to read. Your master negative and the unknown one to be printed should ideally contain directly comparable subject elements. A mid-grey is ideal. (Never analyse from dark shadows or specular highlights – both extremes of the tone scale can be deceptive for colour.) The most difficult images to read are unfamiliar technical subjects, paintings, artwork, etc. Here it helps enormously to have included a grey scale (page 155) in your picture to give the analyser something reliable to read. Place the card near the edge of the frame where you can crop it out,

Fig. 10.24 Example of 'subject failure'. Figure is too pale and magenta because an integrated reading of the negative is too influenced by the dark green background here

Fig. 10.25 Basic layout of a 'closed loop' lamphouse system. S: sensor for illumination colour. C: control unit. M: motors to adjust the zero position of filters so that lighting colour is always consistent. N: negative

Fig. 10.26 Colour print evaluating lamphead. You clip a processed test print of a neutral grey tone over a measuring window in the lamphouse. Sensors compare print with negative, and readout or make any needed filter/exposure adjustments

and evenly light it at the same intensity and colour temperature as your main subject. When there is nothing tangible to measure, an integrated reading may give better results.

Integral readings are based on the assumption that if all the image light is scrambled, the resulting 'average' equals mid-grey. You take a reading with a strong diffuser over the enlarging lens. Often this is built into a special probe which replaces the spot-reading probe. Hold it up close to the lens when you make both standard negative and unknown negative readings. No judgement is involved in making an integrated reading, but, like general camera readings, the method fails when most of the picture contains a large unimportant area different in colour or brightness to a smaller main subject. Classically, a small white cat on a large green lawn gets printed by this assessment technique as a magenta cat on grey-green grass. In the same way, a studio portrait with a large red background prints with cyan flesh tones, because integrated analysis is over-influenced by so much red. Despite 'subject failures' of this kind, integrated measurement works quite well for average subjects. Most beginners find it is the easiest method to use.

Self-correcting systems

Several professional colour enlargers have built-in systems for self-correcting colour filtration. To begin with, the lamphouse may include a 'closed loop' in which tricolour sensors in the lower part of the mixing box (Figure 10.25) measure the colour content of light reaching the negative. It detects whether any changes have occurred since the enlarger was set up – perhaps through a lamp change, changing to a larger format mixing box, or just the slow effects of ageing throughout the system. The information feeds back and causes small compensating adjustments to the zero position of the filters. So each time you start up the enlarger it runs through a brief light-checking program, ensuring that any filter values you use will have exactly the same effect on the image as last time.

Other systems go further and set filters for you by evaluating a test print. You first have to expose an enlargement test strip, choosing a suitable mid-grey area of your film image or using a grey negative supplied. After processing and drying, the paper test strip is either clipped over a window on the side of the lamphouse (Figure 10.26) or, in some systems, is placed in a special holder replacing the film carrier. Here sensors compare its greyness against a built-in reference grey patch, both being illuminated by the light of the lamphouse itself. Sensor circuitry determines what filter and exposure changes are needed to correct any difference between the two for your next print. Test analysis of this kind checks all your variables – from lamp to processing chemicals – and can be repeated more than once to finely tune results before your final print.

Video aids

Video analysers are off-easel systems which may consist basically of an inverted enlarger colour head (forming a lightbox for your film image) viewed by a special closed-circuit colour video camera with zoom macro lens. See Figure 10.30. The tricolour channels of the video system must closely match the relative colour sensitivities of the three

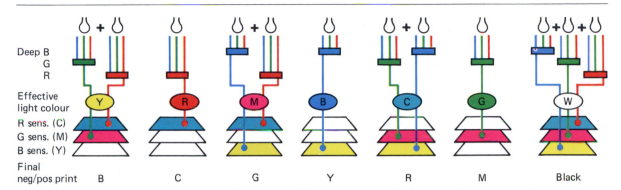

Deep B
G
R

Effective
light colour

R sens. (C)
G sens. (M)
B sens. (Y)

Final
neg/pos print B C G Y R M Black

Fig. 10.27 Additive printing. Above: how separate B, G, R exposures affect the three colour-sensitive layers of neg/pos colour paper, giving different coloured results. These are extreme examples, giving intense colour values or (with three equal exposures) neutral tone. In practice some exposure is always given through all three filters

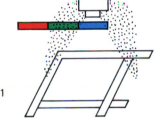

1

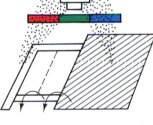

2

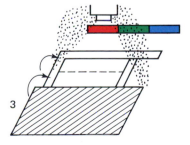

3

Fig. 10.29 The processed print above shows nine different patches – the result of 10 seconds blue, then 10, 15, 25 seconds green, then 5, 7, 10 seconds red exposure. See plan on right. Final print was given 10 seconds B, 10 seconds G, 6 seconds R.

Fig. 10.28 Left: exposing the 'patch chart' test of the above enlargement when additive printing. 1: whole image is exposed using blue filter. 2: same sheet is then exposed in strips for different times through green filter. 3: finally strips are exposed (at right angles) through red filter

10B	10B	10B
25G	15G	10G
10R	10R	10R
10B	10B	10B
25G	15G	10G
7R	7R	7R
10B	10B	10B
25G	15G	10G
5R	5R	5R

emulsion layers in photographic colour paper (page 235). Your picture appears on a colour monitor, and, by turning a switch, colour negatives are presented as high-quality positive colour images. So it becomes easy to evaluate picture content, portrait expressions, etc. and you can zoom in to preview how different kinds of cropping might look.

These features alone make video a useful tool for selecting colour and black and white negatives for printing when contact prints are not available. For colour analysis, adjust filtration on the lightbox until the picture on the screen looks at its best, then transfer these settings to your enlarger. Like all off-easel systems, video analysers have to take into account your enlarger characteristics and current paper batch data, programmed in and held in a memory. Equipment of this kind is still very expensive.

Printing additively

It is not essential to use yellow, magenta and cyan filters to control the enlarger light. Instead, you can give three separate exposures through deep blue, green and red filters and control print colour by the relative time you give through each one. As Figure 10.27 shows, you effectively expose the colour paper one emulsion layer at a time. Today only a few enlargers work on this 'tri-colour' principle, although it still forms the cheapest way of colour printing using a black and white enlarger. (You only need three gelatin filters, positioned in sequence under the lens.) Often colour printing machines used in laboratories for both pos/pos and neg/pos work function this way. The same additive principle is used in a film recorder to 'write' digital images onto colour film (Figure 10.39). Here blue, green and red displays are exposed one at a time in sequence onto one frame of film.

When making a colour print additively the best way to test for colour and density is to expose a 'patch chart'. For example, enlarging a colour negative onto neg/pos colour paper, Figure 10.28 shows how you might first expose a whole test sheet through the *blue* filter for 10 seconds. Then without moving paper or image, give strip exposures of 10, 15 and 25 seconds with the *green* filter replacing the blue. Finally, give strip exposures of 5, 7 and 10 seconds at right angles to the green set through the *red* filter. The processed test then shows the results of nine different combinations.

After judging your result, adjust colour according to the principle that when working neg/pos you *increase* exposure through the filter(s) *matching* the unwanted print cast, or *decrease* exposure through the filter(s) *complementary* to the cast. So if the best patch on your neg/pos print is too magenta (i.e. too much light has affected the paper's green-sensitive emulsion), make the green filter exposure shorter.

Altering exposure through any one filter also affects overall density. Imagine that you have a neg/pos print given 15 seconds blue, 20 seconds green and 10 seconds red, which appears too blue. You might decide to compensate by increasing blue exposure to 20 seconds, so the previous exposures of 15 + 20 + 10 = 45 seconds are changed to 20 + 20 + 10 = 50 seconds. The increased total will mean that the print is darker as well. If you want it to remain the same density, each of these exposure times will have to be cut proportionally to keep the total 45 seconds, yet still give the required colour change. You do this by

Fig. 10.30 Video colour negative analyser. Negative (in enlarger negative carrier) fits over light-box base. Internal video camera gives positive colour image on monitor. You adjust colour balance, and cropping, until video image looks correct

multiplying each exposure by the original total divided by the new total, which in this case is 45 divided by 50 = 0.9. So your final exposure times become 18 seconds blue, 18 green and 9 red.

On the other hand, if you just want to make your print darker or lighter without any colour change, do this by either (1) opening up or stopping down the lens aperture, or (2) changing all three exposure times equally by multiplying or dividing them by the same amount. Remember that no subtraction of neutral density is needed in additive printing.

Batch changes (additive printing)

Packets of paper carry 'tri-colour factors' for additive printing. These might read, for example, R60 G80 B60. When you change batches you use these factors to recalculate the three filter exposures just as you would for exposure time adjustments in white-light printing. In other words, to find each filter's new exposure:

$$\text{New exposure time} = \text{old exposure time} \times \frac{\text{new exposure factor}}{\text{old exposure factor}}$$

For example, if you previously gave 20 seconds green filter exposure using a box of paper stamped Green 80 and have to change to a new box with a 100 green factor, the new exposure to give is 20 seconds multiplied by 100 divided by 80, which is 25 seconds. Similarly, calculate new red and blue filter exposures from the factors for these colours also shown on the boxes.

Unusual printing equipment

Flash-source enlarger

An enlarger can have a group of flash tubes instead of a tungsten continuous light source. See Figure 10.31. Some tubes are permanently filtered deep blue, others green or red. You measure colour and exposure with an on-easel probe, having input paper characteristics data into its electronic control unit. Exposure is programmed additively – the number of flashes from various tubes contributing to final image colour. For example, to increase the yellow content of the light, red and green flashes pulse more often. Light from the multisource head is then scrambled and diffused before reaching the film carrier. There are no moving parts – the analyser is wired direct to the head. In focusing mode most tubes come on and pulsate rapidly to give almost continuous light. Flashes can also be dimmed and fast-pulsed over a longer period to produce the same density and colour but allow you time to shade and print-in (not possible with other additive systems).

Roll paper holders

Instead of using sheet paper it makes sense to work with paper in rolls for runs of prints. Rolls are cheaper to buy and easier to machine process than an equivalent number of sheets. Exposed material is then fed through either a roller transport or continuous-strand processor (see page 218). You need a roll paper easel to fit onto your enlarger baseboard in place of the regular masking frame. It accepts a paper roll

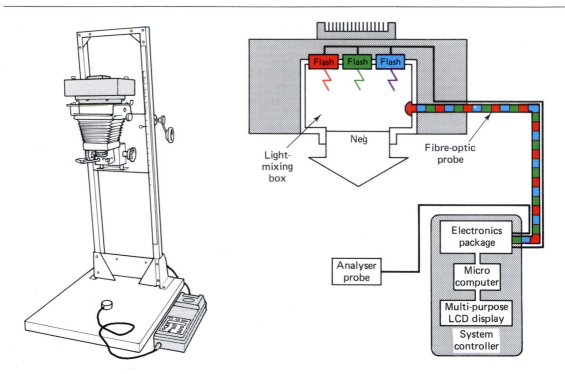

Fig. 10.31 Flash-source colour
enlarger. On-easel analyser
measures image colour and
intensity. Microcomputer relates
this to paper characteristics,
programs number of flashes from
each (filtered) tube, and monitors
total light via fibre-optic
connection to head

loaded (in darkness) into a feed compartment on one side, led across
under a maskable exposing frame and into a take-up compartment. A
white-faced opaque blind covers over the paper emulsion. This protects
it from fogging when you have white light on in the darkroom, and also
allows focusing and composing the image under the enlarger. The blind
opens when you are ready to expose, then afterwards closes and
triggers the wind-on of a preset length of paper. All this is controlled by
a hand switch or a foot switch on the floor.

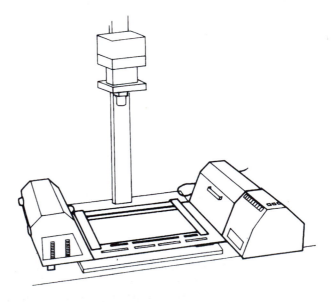

Fig. 10.32 A roll paper holder in
position on an enlarger
baseboard. Unit has motordrive.
A white-faced blind covers the
emulsion surface except during
exposure

Bulk-printing machines take the use of roll paper a stage further in terms of speed and convenience. Totally enclosed including the enlarger head they can be loaded (in the dark, or using darkroom-loaded cassettes) and then used in a normally illuminated room like a work desk. Typical maximum paper capacity is 275 feet and you can turn out over 250 8 × 10 inch prints per hour.

With any roll paper system you need a really accurate filtration/ exposure analysing system if a variety of pictures have to be printed. If you want to see tests, make one exposure from a strip across every film image in the batch you have to print, then process this (short) length of paper and assess results. Make notes of any necessary changes to the settings for each individual shot, then run off your quantities of prints.

Other colour lab procedures

Display colour transparencies

By using colour print emulsions coated onto sheets and rolls of film you can make enlargements for various kinds of public display. Some of these materials (Duratran, for example) are neg/pos working and processed in RA-4 colour chemicals, although given longer times than paper. Others (such as Ektachrome Overhead or Ilfochrome display film) work on a pos/pos basis, allowing you to print direct from a colour transparency but requiring appropriate R-3 or dye-bleach reversal processing.

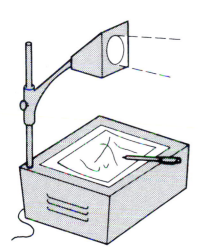

Fig. 10.33 An overhead projector. Transparencies and objects placed on the lightbox are imaged large scale onto distant screen

Print film materials are made with various bases, designed for different applications. With a clear base film type, for example, you can make standard 10 × 10 inch transparencies used as visual aids on an overhead projector (Figure 10.33) for group audiences at sales presentations, teach-ins, etc. Large, clear film transparencies can also be displayed on any lightbox fitted with a diffuser, and since they can be 'stacked' this is a simple way of sandwiching together several images, or image plus text, to form composites. Print film on a translucent self-diffusing base allows your enlarged image to be displayed either on a lightbox or just in front of bare strip lights – for billboards, illuminated panels at exhibitions, gallery shows, shops, restaurants, etc. This can be a very effective way to make and show high quality colour images – and also means that you no longer need a large camera to make large colour transparencies.

All print film material is much more expensive than paper-based products of equivalent size. It is handled in a similar way to paper, but before exposing insert a sheet of matt black paper between the film and your white masking easel, to avoid light reflecting back through the base. When making tests you must view and judge your processed results against the same lighting system to be used when the work is finally displayed. Overhead projector transparencies, for example, must be much paler than transparencies destined for lightbox displays.

Colour internegatives from slides

As an alternative to printing a slide or any other colour transparency directly onto a pos/pos material you can turn it into a colour negative, then print this on neg/pos paper. Results are excellent provided that you

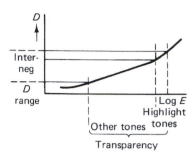

Fig. 10.34 Internegative colour film. Characteristic curve of one of the three matching emulsion layers shows how correct exposure records your colour transparency shadows and midtones with lower relative contrast than highlights on the copy negative

Fig. 10.35 35 mm copying systems. Left: simple tube attachment incorporating 1:1 close-up lens. (Transparency being copied is backed up by opal plastic diffuser, not shown.) Centre: copier containing flash unit and modelling lamp. Swing-over unit (M) is a meter with downward-facing sensor. Controls raise or lower internal flash tube plus monitor lamp to compensate for different density slides. Right: inverted head from a colour enlarger forms a tungsten lightbox for copying. Controls here adjust colour balance

have a good-quality original and prepare your negative on internegative colour film designed for this purpose.

Interneg materials have three special characteristics:

1. Blue, green and red sensitivities in narrow bands keyed to the maximum yellow, magenta and cyan absorption of these colours by the image dyes in colour film. In this respect, interneg film is more like printing material than general-use camera films.
2. The yellow, magenta and cyan image dyes it forms chromogenically are (like other colour negatives) keyed to the response of neg/pos colour paper. However, interneg material has additional integral colour masking which compensates for deficiencies in the colour dyes of your *original* as well as the dyes formed within its own layers (see page 95).
3. By combining low contrast with slower, slightly higher contrast emulsions in each colour-sensitive layer, interneg film has an unusual characteristic curve, looking like that in Figure 10.34. Correctly exposed, the film records the shadows and midtones of slides within its low contrast region (compensating for the inherent high contrast of images designed for projection). However, slide highlights fall on the steeper part of the curve so that contrast and brilliance here is largely retained. You avoid the veiled, flattened lighter tones which are often the hallmark of a copy negative. Results are similar to the use of a highlight mask (page 167) but built in .

You can expose onto internegative 4 × 5 inch sheet film under the enlarger by contact printing or better still (less dust problem) projecting an image to fill this format. For example, locate the film in a regular 4 × 5 inch double-sided sheet film holder on the enlarging easel. Have white paper loading into one side, so that you can position and focus your projected image, then turn over the holder and withdraw the sheath when you are ready to expose onto the film.

Alternatively, use a copy camera arrangement. Here, for example, you can expose 35 mm slides onto 35 mm interneg film by means of 1:1 imaging over a tungsten lightbox. See Figure 10.35. Try to avoid

making your internegs smaller than the original and then enlarging them back as prints. Size change should be progressive for best optical quality. Internegatives are processed with the same chemistry as that used for regular colour negative films.

Dupe slides from slides and transparencies

Using low contrast 35 mm reversal duplicating colour film, you can make colour slides from other slides and transparencies. Work with a 35 mm camera and macro lens in conjunction with one of the copying devices shown in Figure 10.35. The camera's TTL light reading takes close-up imaging into account. Some copiers contain their own light sources – either flash (suits daylight film) with modelling light for focusing and exposure-metering, or a tungsten light enlarger lamphouse used upside-down. Simpler copying attachments have to be pointed towards a suitable source. They hold the slide at the far end of a tube containing optics for 1:1 imaging. Since camera and subject are firmly locked together you can hand-hold even quite slow shutter-speed exposures. The most elaborate copiers incorporate a device by which you can introduce a small amount of even white light into the lens during exposure. This light has the effect of reducing recorded image contrast in the same way as controlled 'flashing' does during enlarging (see page 170). Overdone, shadows start to fog-in and look grey.

No slide reproduced in these ways will quite match the sharpness and tone gradation of an original shot, so it is always better to run off a series of slides from the original subject if you know that several copies will be wanted. Nevertheless, you can definitely improve slides which have a colour cast by duplicating them through a complementary colour filter, see Figure 10.36. For example, the green cast of fluorescent lighting is greatly reduced by a 20M or 30M filter. (Shadows tend to reproduce slightly overcorrected and highlights undercorrected.) You can also improve on a slightly dense, underexposed slide by giving extra exposure while copying it. Copiers have other useful functions for special effects such as sandwiched slides, double exposures, etc. Duplicating film is processed in regular E-6 colour reversal film chemistry.

Colour prints from black and white negatives

By printing black and white negatives on neg/pos colour paper you can produce results which look like toned prints. The image can be one colour overall or different areas of the paper can be given different colours or made to graduate from neutral to a colour (see Figure 10.37). Sandwich your negative with a piece of unexposed, processed colour negative film. Its yellowish mask avoids the need for heavy filtration to get a neutral result, so you then have a wider range of filter options for print colouring.

First, you must establish the filtration for a neutral black and white result. Make a series of exposure tests across several pieces of paper each given large (50-unit) filter changes. Then, depending on the colour and intensity of cast in your result, work back with progressively smaller changes until you reach neutrality. Now you select the image colour of your print by appropriate filtration – for example, reducing yellow or increasing cyan to get a warm tint. For a change

Fig. 10.36 Correction of cast by slide copying. The slide, near right, was shot in fluorescent lighting and shows a characteristic green cast. In making the 1:1 copy, far right, a CC30M filter has produced correction

Fig. 10.37 Colour print from a black and white negative. The graduated coloured tones in the picture below were created by hand shading, then printing back with changes in the Y + M filtration. Effects are similar to selective toning but more muted and subtle. (By Tim Stephens, courtesy Faber and Faber)

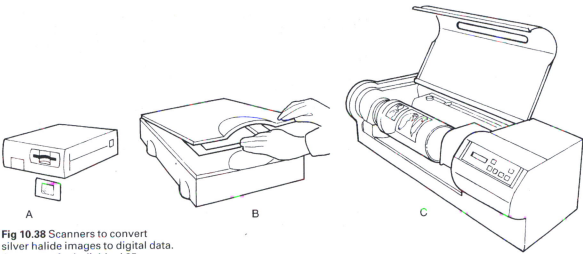

Fig 10.38 Scanners to convert silver halide images to digital data. A: scanner for individual 35 mm slides or negatives. B: flatbed scanner, accepts reflective media such as prints up to A4. Most offer transmission illumination adaptors to accept film transparencies too. C: drum scanner. Film or (unmounted) prints are taped to revolving cylinder, lit by transmission or reflection. See also Figures 11.19–21.

Fig 10.39 Film recorder, converts digital data to images on silver halide film. D: flat-faced high resolution monochrome display tube fed from the digital data. Gives slow image scan, one line at a time. For colour images each of the three digital files is displayed in turn and exposed additively through its appropriate R, G or B filter held on a rotary turret (F). Macro lens (M) images on to a frame of the film held in camera body (C). Each triple exposure may take several minutes. Images can be recorded in negative or positive form

of tint in *chosen* areas, shade these parts during the main exposure, then alter filtration and print them back in again. With care you can achieve quite subtle, graduated results, such as a winter landscape greeny-grey at the bottom becoming blue-grey towards the top. It is also possible to work by hand-tinting chosen areas of black and white (large-format) negatives, which then print in complementary colour.

The digital lab – hybrid systems

The photographer-support role played by the lab is undergoing huge changes as new digital methods of image-making appear. Far from *reducing* lab importance the introduction of digital imaging has expanded their range of roles – modern labs often have as many computers as enlargers, and increasingly accept work in the form of disks with the same ease as exposed film.

Every new electronic advance brings its own advantages and limitations in terms of image quality, cost and time. Finding the best trade-off between these conflicting factors often means combining electronic and silver halide methods, to take advantage of their best features. (Today's silver halide processes after all still reflect 150 years of improvement, and offer outstanding image quality at low cost.) You can therefore expect to work with hybrid systems for some time to come. Your exposed silver halide film image may even be processed, converted to digital files held on a disk or CD, manipulated electronically, then returned back to film which is conventionally processed and enlarged onto colour paper. Several alternative routes are possible, see Figure 10.40, their viability changing each time a new technical development takes place.

Silver halide to electronic

Where the subject has been shot on a silver halide film camera your processed negative or transparency will need to go through some form

of scanner if you need it to become a *digital image file*, stored on disk. The equipment might be a 35 mm or a rollfilm dedicated scanner, a flatbed scanner designed for 4 × 5 inch film as well as prints, or a drum scanner. See Figure 10.38. Of these a drum scanner offers best resolution and productivity, but is the most expensive. Scanning typically takes about 1–3 minutes, controlled by software in the computer to which the scanner is connected.

It is important too at this point to match the resolution setting for your scan to the anticipated size and resolution (dpi) of your final print. For example, in aiming for 300 dpi on a 10 inch wide colour print you might scan in a 35 mm slide at 2000 dpi (takes up an 18 Mb file, uncompressed) or a 6 × 6 cm transparency at 1200 dpi (23 Mb file) or 4 × 5 in transparency at 600 dpi (20.5 Mb file). Once scanned-in your picture in its new form as a digital file is available for digital processing, various types of printout, transmission through the Internet, etc. See chart below.

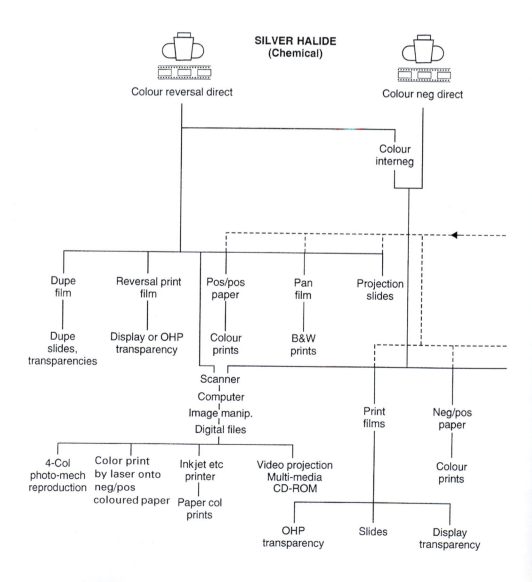

Some roll paper minilab colour printers (Figure 10.41 for example) first scan each negative, then pass the digital file through an image processing station where computer software automatically makes corrections to density, contrast and colour balance, displaying changes on a monitor screen. Then this image data is transferred to an output section – a printer containing red, green and blue lasers. The light sources are moderated by the digital image information as they scan as a combined focused spot of light over the surface of a roll of silver halide neg/pos colour paper. Finally the exposed paper goes through a conventional RA-4 chemistry roller processor.

Electronic to silver halide

Modern labs also provide 'writing to film'. This is the opposite of scanning-in – a film recorder unit inputs your digital file data from a disk, card, etc. and outputs a high resolution colour image optically exposed onto silver halide film. See Figure 10.39. The film then needs

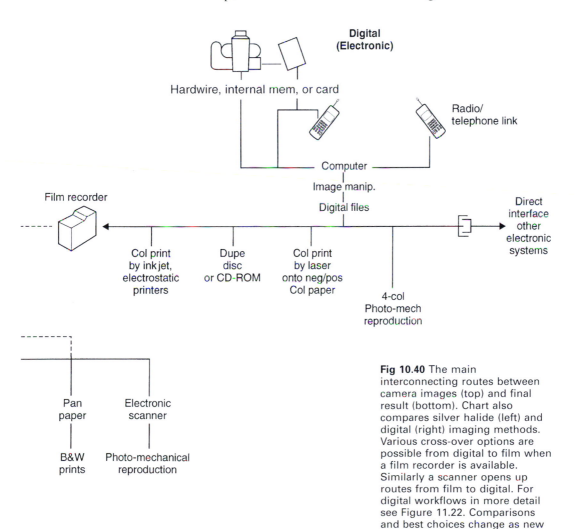

Fig 10.40 The main interconnecting routes between camera images (top) and final result (bottom). Chart also compares silver halide (left) and digital (right) imaging methods. Various cross-over options are possible from digital to film when a film recorder is available. Similarly a scanner opens up routes from film to digital. For digital workflows in more detail see Figure 11.22. Comparisons and best choices change as new technology develops

normal E-6 or C-41 processing according to the stock you have loaded. A film recorder operates automatically in a light-proof cabinet fitted with a 35 mm or 70 mm motordrive back, or sheet film holder. Since each image takes several minutes of scanning, having a motordrive back allows a full length of film of different images to be exposed and wound on, controlled solely by the computer, for example, overnight.

Direct conversion from digital to silver halide image is now an important way of printing large size high resolution colour prints. Several digital printers ('Light-jet', Durst Lambda, HK 'Photo Writer') are designed to function direct from any suitable disk-stored image data. Like the mini-lab printer described above, a light-tight unit houses R, G and B lasers moderated by the disk's R, G and B digital signals. The three sources merge into a spot of light which moves backwards and forwards across the surface of a wide roll of colour paper or display film, see Figure 11.30. Total exposure time depends upon the output resolution you have set, as well as size. Typically a 40 × 50 inch image takes 5 minutes to expose at 305 dpi – significantly faster and less messy than an inkjet printer, page 286.

The advantage of these direct digital printers, especially for murals, is that huge darkrooms and horizontal enlargers become unnecessary; and provided your digital file contains sufficient data the image resolution is excellent since the (overlapping) scan lines reveal no pattern, and total absence of enlarger optics eliminates hazards like resolution fall-off at the corners of your image. The picture can be instantly changed in size, as can the type of wide-roll silver halide print material the unit has been loaded with – colour or black and white, on paper or display film base.

Thanks to all this 'hybrid' work labs can still run RA-4, C-41 and E-6 chemical processing machines alongside their new digital electronic systems. Additional non-silver halide activities come within the lab's orbit too – computerized image manipulation, for example, plus printout by inkjet or dye sublimation. See page 279. Many of these services demand very expensive high-end equipment, and are only financially viable for large custom labs and bureaux servicing professional photographers.

Fig 10.41 Some photographic printing systems combine the quality and cheapness of conventional silver halide materials with the image control and manipulation possible by digital means. Unit here uses CCD to read complete films of their images, which pass through analogue to digital convertor into digital memory. Each image file is next adjusted for colour balance, contrast, areas needing shading etc., as revealed by monitor viewing or under automatic control of software. The corrected file then drives lasers which scan an optical image back on to regular silver halide paper

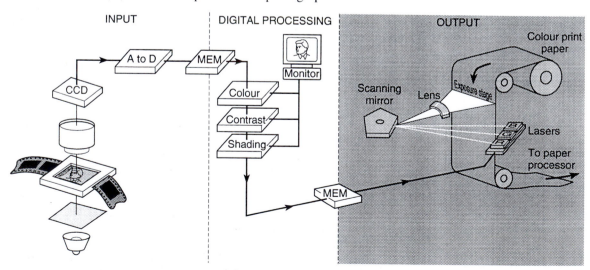

Is it worth doing it yourself?

This chapter has ranged widely from the use of a basic colour enlarger to bulk printers and costly digital systems. The question remains, is it worth doing your own colour printing when many excellent custom laboratories offer this service? You first have to decide whether there is sufficient volume of work to justify outlay on equipment and chemicals. Again, the task of top-quality professional colour printing together with digital procedures is best handled as a full-time job – whoever does it really needs to keep in daily practice. (Both printing staff and the cost of setting up might be a shared facility by a cooperative of photographers serving different markets.) However, a small user-run darkroom is less likely to have all the quality control facilities of a commercial laboratory (see page 221). Also, as with film processing, your smaller throughput and less automatic equipment mean a greater risk of inconsistent results.

A good custom laboratory aims to give professional photographers as personal a service as possible. Often you can discuss test prints with the member of staff handling your printing, and the larger laboratories offer all kinds of specialist services such as montaging, duping, digital retouching, etc. On the other hand, colour printing 'in house' means that you can most easily retain control over the complete job, from initial planning to final image. This is important when (1) you are aiming for a particular style or 'mood', or (2) pictures are highly technical and you need intimate experience of the subject to judge colour accuracy. You also have greater opportunities to experiment.

When you are planning a colour job clearly establish what will eventually be needed – prints, transparencies for reproduction, slides, large display transparencies, black and white – in order to shoot on the right film or in the most appropriate digital form in the first place. Someone may need black and white prints off pictures shot on reversal colour material. You might then have to scan-in these transparencies to form digital data and print via this, or mask before making black and white internegs. Results will inevitably be more expensive and probably of poorer technical quality than if pictures had also been taken with black and white film in the first place. This highlights again the advantages of using a camera with interchangeable backs both for film and for digital imaging, see page 58.

Summary: Colour printing

● Subtractive, 'white-light' enlarger heads use different strengths of yellow, magenta and cyan filters, two (but not three) colours at a time. Additive enlargers/printers control print colour via differences in exposures through each of deep blue, green and red filters.
● Typically, an enlarger for white-light printing has a tungsten halogen lamp (voltage-stabilized); dichroic filters to move into the beam; heat and ultra-violet-absorbing filters; a mixing box to scramble light before it reaches the film carrier; and a good-quality four- to six-element lens. Used for black and white printing, the yellow and magenta filters will control variable-contrast paper too.
● Darkroom facilities beyond black and white requirements include an analyser, appropriate safelights, increased ventilation. Have a white-

light viewing area for judging colour tests.

● The main types of colour print materials are chromogenic neg/pos and reversal pos/pos; also dye-bleach pos/pos. Colour sensitivities of each 'set' of emulsion layers correspond to peak transmission of the three image dyes in colour film. Similarly, print materials are keyed to the contrast and masking (if any) of the same manufacturer's film. Store in refrigerated conditions.

● When printing pos/pos you can see what you are aiming to get, and your film image has other roles – e.g. slide projection. However, avoid contrasty and thin (overexposed) originals. Debris prints black.

● Test your pos/pos print first for exposure, then colour. Increasing the exposure lightens the print, and to reduce a cast, reduce filtration matching it in colour. Shading darkens and printing-in makes areas lighter; do either through a colour filter to help correct tinted shadows or highlights. Contrasty films print better if masked, 'flashed' or (dye-bleach materials) the print is given less first development. A ring-around print set forms a filtration visual aid. Always judge prints dry.

● Colour negatives are difficult to assess, but working neg/pos suits wider ranging subject conditions and allows greater adjustment of colour and density. Avoid negatives that are underexposed. To reduce a print cast, decrease complementary filtration; shading and printing-in follow black and white practice. Changing filtration has a stronger effect in neg/pos than the same filter shift in pos/pos printing. A ring-around set shows the influences of filtration and exposure.

● If and when a new batch of your colour print material varies in its filter or exposure recommendations (1) subtract the old batch recommendations from your enlarger settings; then (2) add the new ones. Also (3) divide the new batch exposure factor by the old one and multiply your previous exposure time by the result.

● Avoid long exposure times – reciprocity failure upsets colour and contrast, although some colour papers are made specially for long exposure (large print) conditions. Where possible, widen the aperture instead.

● Viewing filters provide a simple test-print colour-analysing aid. Add to the enlarger half the strength of the filter making pos/pos midtones look correct (complementary colour if neg/pos). Electronic analysers work 'on-easel' or 'off-easel' serving several enlargers, make integrated or spot readings of colour and exposure. They compare characteristics of film images to be printed against a standard image for which settings are known.

● Most on-easel analysers have a (fibre-optic) spot probe. Once programmed from part of your known 'standard' negative (or slide), it measures a similar tone on unknown film images and reads out the enlarger settings to make. Change plug-in memory modules for different batches of material.

● Integrated (scrambled-light) measurements give better results when it is difficult to know where to take a spot-reading. However, large but unimportant colour/tone areas can cause 'subject failure'.

● Closed-loop enlargers use sensors in the illumination mixing box to feed back and maintain the system's zero filtration colour content, counteracting lamp ageing and other changes. Video analysers can present negatives as positives and preview how filtration changes will alter final print appearance.

● Basic additive colour printing demands simplest gear, although it is also difficult to shade or print-in. Colour is controlled by the proportion of three separate exposures through deep blue, green and red tri-colour filters. You can use a 'patch chart' test, then (neg/pos) adjust colour by increasing exposure through filter(s) matching any unwanted print cast. To keep print density the same after colour adjustments, change all three exposures proportionally to maintain the previous total. When you change batches, follow the *tri-colour* factors given. Multiply each exposure time by the filter's new batch exposure factor divided by its old one.

● Flash-source colour enlargers use numerous blue, green and red tubes and expose additively, controlled directly by an on-easel analyser.

● Using roll paper reduces material costs for volume print production and suits machine processing. A roll paper holder incorporates the masking frame – the paper remains covered while you are setting up or focusing.

● Enlarge onto print film for display transparencies, or OHP projection visual aids. Make colour negatives from slides and transparencies on interneg film. Its colour sensitivity, double masking and the contrast of highlights relative to other tones bridge the characteristics of your positive film original and neg/pos colour paper. Dupe colour slides are made on low contrast duplicating stock using a 1:1 ratio camera set-up. You may correct for colour casts or a degree of underexposure in the original by filtering and exposure adjustments while copying.

● Prints made from black and white negatives onto colour paper can be given a toned image appearance. Establish filtration for neutral black and white. Then vary colour and intensity across chosen areas by shading, changing filtration and printing-in.

● The modern colour lab handles a mixture of silver halide and digital systems – scanning film images onto disk; writing digital images to film; printing out on silver halide colour paper from digital files. Bureaux may also offer non-silver forms of printout, e.g. inkjet.

● Work out whether doing your own colour printing is viable. Is there sufficient volume to ensure consistency, justify capital cost and staffing? Own printing offers tighter control of style, and greater accuracy with records of specialized subject matter. If you choose a custom laboratory instead work closely with their staff. When shooting pictures try to use the silver halide material or digital system which gives results in all the final forms you know will be needed, in the most direct way.

11
Extending photography

This chapter contains four main topics. They help to show how photography is extending in different directions – integrating with other disciplines to the point where the very term is becoming difficult to define. In one direction, for example, photography can mean home-spun kinds of printmaking which rely greatly on manipultive skills and imagination but need only simple chemicals and equipment. Working with liquid emulsion, or gum-bichromate processes, as well as lifting or transferring pictures from Polaroid materials, all come under this heading. Results are generally 'one-off' or at most limited editions, and of particular interest to artist photographers.

In complete contrast, photography also links closely with ink printing processes – so-called 'photomechanical' reproduction – which allow printing presses to output vast quantities of pictures in magazines, books, etc. This is a long-standing association. For most of the twentieth century processes like photolitho, letterpress and gravure called for cameras and chemical and physical procedures similar to traditional 'wet' photography. Now, however, many of the pre-press stages (those which take place before presses begin to turn) are handled by digital means, controlled by computer. One spin-off from this change is the development of electronic tools, which have helped to make modern digital photography possible. Once in the form of digital data images can easily be manipulated, transmitted, and interfaced with other electronic channels. The central role of computers in linking cameras, scanners, film-recorders, and various forms of image printer is therefore further reviewed here.

Finally, mixing techniques still further, there is 'multimedia'. This is the umbrella term within which photography and digital technology combine with audio-visual slide and video projection, sound and lighting effects and inter active CD-ROM computer programs to create new forms of image presentation.

'Hand-made' image processes

Everyone buys printing papers as packaged products, ready for use. There is a range of types and surfaces of course, but they all give an

inherent quality to your pictures you accept as normal and 'photo-graphic'. To get something physically different, look at the possibilities of light-sensitizing your own choice of artist's papers (or any other suitable material), or in transferring colour images onto them from instant pictures.

Liquid emulsion

It is possible to mix up your own emulsion from chemicals such as silver nitrate, potassium bromide and gelatin (formula – page 294). However, preparation is time consuming and it is extremely difficult to get consistent batch-to-batch results. Instead, you can buy containers of ready-to-use gelatin emulsion Rockland USA or Silverprint or Fotospeed UK. Then, working under bromide paper safe-lighting, you coat your chosen base material and allow it to dry before exposing it under the enlarger and processing (gently) in the normal way.

The type of surfaces you can coat include drawing paper, wallpaper, canvas, wood, plaster, most plastics and glass. Do not try to emulate the smooth qualities of commercial photographic paper. Your evenness of coating and the richness of image tones will not compare – and, in any case, there is no point. Use the 'hand-made' look to your advantage. For example, coat a sheet of paper only in the centre and let the emulsion trail off into brush strokes around the edges. Try coating three-dimensional objects like egg- or seashells, fragments of stone, ceramic tiles or plates. Since the coating is thin and transparent it takes

Fig. 11.1 This ordinary white ceramic wall tile was coated with ready-made emulsion, then exposed to a negative under the enlarger and processed in bromide paper developer. Rapid drying caused the emulsion to pucker and wrinkle, which helps to relate surface and image here. Pick a surface to print on which relates in some way to your subject. Try to display results lit in the same manner and direction as the original lighting. (By Lorry Eason)

Fig. 11.2 For this picture, Lorry Eason brushed drawing paper over with liquid emulsion in a deliberately uneven fashion. Paper was left uncoated around the edges. When dry the sheet was exposed under the enlarger, then processed normally

Fig. 11.3 Gum-bichromate print contact printed from an enlarged negative onto sensitized drawing paper. See page 268

Fig. 11.4 Coating and exposing a ceramic tile with ready-made emulsion. 1: liquefying the bought emulsion in hot water. 2: coating the prepared tile surface. 3: after drying, the sensitized tile is exposed (on black paper) to the image from the enlarger

on all the texture and colour of whatever base material you use. (*Note*: Gelatin cannot be fire glazed into the surface of ceramics like normal ink-printed designs, which are applied by special transfer.) Choose a picture which suits the nature of the unusual base, both in subject matter and visual design. Highly textured materials need simple images. Sometimes it is worth converting your continuous-tone image into line first by copying it on lith film.

The emulsion itself comes in a light-tight plastic container in solid jelly form. You have to turn it into a coatable liquid by warming the top part of the container in hot water (Figure 11.4). This only takes a few minutes, but in fact holding it at 50°C for about 3 hours improves emulsion sensitivity and maximum black as well as liquefying it. Do not let the gelatin warm beyond about 55°C though or it 'overcooks' and loses adhesive power. With most papers and unprimed canvas you can coat the emulsion on directly, using a flat brush and criss-crossing your strokes. Small three-dimensional objects can just be dipped in emulsion. Always coat some emulsion onto one or more small extra pieces of the same base material, which you can then use later for exposure tests.

Direct application to an absorbent surface means that emulsion (and subsequent processing chemicals) penetrate deeply and improve image richness. However, it quickly uses up expensive emulsion, sometimes unevenly, and there is more risk of staining. So highly porous materials such as plaster and earthenware are best sized first with a thin coating of clear phenol varnish diluted 1:1 with naphtha, or try a commercial boat varnish. Give primed canvas a coating of dilute flat wall paint.

Having coated your base surfaces in the darkroom, leave them for several hours in darkness until fully dry. Then use some test material first under the enlarger to make an exposure series. Process in regular print developer and fixer, wash gently and air dry. Once your final result is produced, materials such as ceramic or metal can be sealed over with matt clear varnish to help protect the image.

Gum prints

The so-called 'gum-bichromate' contact printing process (dichromate is in fact used today) also allows you to pick your own paper or cloth base material. However, instead of silver you end up with an image consisting of watercolour or gouache in any hue you choose. This process also makes it easy to scrub out details or alter tones on individual prints, so that both in its physical handling and visual result the gum-bichromate

Gum*

Powdered gum arabic	350 g
Hot water to	1 litre
Powdered watercolour pigment as required for colour and density	

Sensitizer

Potassium dichromate crystals	50 g
Warm water to	500 ml
Store in dark-tinted container	

Mix 2 parts gum to 1 part sensitizer before use

*Add anti-fungus agent if gum to be stored more than a few hours.

Fig. 11.5 Gum-bichromate formulae. Take care when mixing the sensitizer, see health and safety page 294

process comes close to fine art printmaking. It is possible (but difficult) to produce a run of matching prints – so you will do better to regard each gum print as a one-off hand-made image. Gum bichromates are labour intensive but use relatively low cost chemicals, and their watercolour content gives interesting 'unphotographic' image quality.

No silver halides are needed. You coat good-quality drawing paper with gum arabic mixed with your choice of artist's water-based colour pigment, plus potassium dichromate which hardens the gum when heavily exposed to ultra-violet radiation. (Ammonium bichromate is occasionally used instead of potassium dichromate, being slightly faster but more expensive.) Either way light-sensitivity is far too slow to use for enlarging, so you work from an enlarged photographic negative contact printed using a bright ultra-violet-rich light source. 'Development' consists of gently washing away the pigmented gum from the unhardened, lighter areas of the print.

Work from a final image size negative, either continuous tone or half-tone screened (page 272) up to 250 lines/inch. You can make the former by enlarging a slide onto 8×10 inch pan film, or start from an existing negative via an enlarged positive (on a sheet cut from a wide roll of darkroom film or even on RC bromide paper). Then contact print this back onto normal contrast non-colour-sensitive darkroom film. Subjects with soft, directional lighting work best, but remember the process is not good at reproducing fine detail so pick images with bold shapes. The printing negative should not have a density range much beyond 0.5 unless you intend printing with several layers (see below).

Size your paper surface first using one or two coatings of 10% gelatin flakes. Then tape the wet paper on all four sides onto hardboard

Fig. 11.6 Gum-bichromate printing. 1: taping wet, sized paper to hardboard with paper tape. 2: coating a mixture of pigmented gum and dichromate solution onto the dry, stretched paper. 3: when redried, paper surface is faced with film negative and thick glass. 4: long exposure to blue-rich light. 5: exposed print is removed from board, floated face down in warm water. 6: gum, pigment and dichromate dissolve away where they received no light. Local areas can be swabbed lighter with cottonwool, or by brushing

Fig 11.7 Emulsion lift technique. Top: Polacolor print soaked for 5 min in hot water begins to frill. Centre: freed from its backing paper the emulsion membrane can be rolled on to a pencil. Gently agitate in clean warm water to remove unwanted bits. Bottom: float emulsion on water surface, withdraw receiving paper from underneath it and draw out with image in contact. Adjust shape with watercolour brush, then tape paper to flat surface to dry out flat.

and leave it to dry so that it stretches tightly. Mix your dissolved and cooled gum solution with pigment and combine it with dichromate solution under weak tungsten light. (You must *always* wear gloves when mixing or using dichromate – this chemical's toxic content can be absorbed through the skin.) Note down how much pigment your coating contains – you cannot judge final colour here because of the dichromate's orangey tint. Either lightly outline in pencil the area of paper you want to coat or treat the whole surface with your mixed warm solution, brushing it on with cross-hatch strokes. Coat several sheets because you will want to use some as exposure test strips. Finally, leave your sensitized material to dry in the dark.

To expose, clamp the negative firmly down over the paper, under glass. Expose to a bright ultra-violet sunlamp, or daylight, for several minutes – if your negative is on RC paper give hours rather than minutes. Process by inserting the print into a tray of plain 27°C water, then letting it float undisturbed face down. Gradually, all the orange dichromate and unhardened gum dissolves out. Using a series of three or four trays, this takes 15–60 minutes. During processing you can work out dark shadows with a soft brush, or scrub out or texture entire areas with a stiff one. See Figure 11.3.

Most gum prints gain depth and contrast by several printings. You do this by recoating the dried print with sensitizer, drying and then exposing the same negative over again. (Some registration system is essential – you cannot judge the position of first image detail through the dichromate.) It is quite common to give four or more printings, varying the colour and intensity of your pigment. The final dry print is quite tough and can be dry-mounted and spotted or locally tinted by watercolour on a brush.

Emulsion lift

Emulsion lift simply means 'floating off' the emulsion layer from a processed Polacolor instant print and (like a water-based transfer) repositioning it on a fresh base. During this procedure you can stretch, crease and tear the membrane, or just settle it straight onto a textured or transparent surface. The creases and tears become quite dominant, so you need to consider this feature when planning your shot. See Figure 11.8.

Shoot on peel-apart material using a large or medium format camera fitted with an instant picture back. Rather than photograph your subject direct it is often easier first to produce a transparency on regular material and then camera copy or enlarge this onto the Polaroid stock. Either way leave your resulting Polaroid print for at least 24 hours to harden its emulsion before you begin emulsion lift.

As Figure 11.7 shows, you just need one tray of near-boiling water in which to detach the image from its instant picture receiving paper, and another of warm water to manipulate and float the membrane onto its new base. If your chosen receiving paper tends to buckle during drying secure all four edges to a flat surface with gum strip, then cut out the print when fully dry.

Image transfer

This again uses peel-apart instant picture material, but with its processing time curtailed so that the image has only developed on the

Fig. 11.8 Image produced by
'emulsion lifting' Polaroid material.
Since creases, folds, and frayed
edges are inherent in this process
plan and use them as an integral part
of your picture. This can also be a
start point for the creation of com-
posite pictures, provided you let the
emulsion dry thoroughly before
adding further lifts. By Alastair Laidlaw

Fig. 11.9 An image transfer,
using the (processed) negative half
of peel-apart instant picture material
rolled immediately into contact
with water-colour paper.
Characteristically, colours become
more muted. Your receiving material
is best first soaked in distilled water,
then blotted off. By Alastair Laidlaw

Fig 11.10 Image transfer technique. Top: slide or transparency on light-box is copied on peel-apart Polacolor material. After pulling through the rollers material is only allowed 10 sec before peeling print and negative apart. Centre: print part discarded, the paper negative is pressed face down on pre-dampened watercolour paper, and rolled evenly with ink roller for approx 1 min. Bottom: leave 30 sec then gently peel off. Leave to dry. Spot-in any blemishes using watercolours.

negative sheet but not yet formed a positive on the receiving sheet. Then, as shown in Figure 11.10, you peel the two sheets apart. The original receiving paper is discarded and the negative sheet rolled into tight contact with dampened watercolour paper. After about one minute you gently peel away the negative, leaving a positive image on the new base, which is left to dry.

Damp paper transferring diffuses your image slightly, but this can be used for effect, Figure 11.9. 'Dry' transfer is more uncertain and difficult than it sounds – it is easy to leave part of the image behind and form pinholes and other minor blemishes. Images with many dark shadows are most likely to leave bits stuck to the negative. Colour balance is also changed because some of the red layer will have migrated to the Polaroid receiving paper and been lost. You may therefore have to compensate by shooting with a reddish filter over the lens. For hit-or-miss reasons like these it makes sense to work by copying an existing transparency. You can then repeat yourself easily, making adjustments to timing and physical technique.

Reproduction on the printed page

Photography has become the most heavily used form of printed illustration. This is largely because of the fine quality with which it can be reproduced by inks on modern printing presses. Were it not possible to ink-print pictures into newspapers, brochures, magazines or books, or onto billboards, packaging, showcards and a thousand other forms, there would be little market for professional photography at all.

Until the 1980s 'photomechanical' reproduction involved numerous specialist tasks, mostly based on the use of massive repro cameras and wet photographic processes, in order to turn the photographic print or transparency into a form which could be run off in ink on a printing press. Today, however, this pre-press activity has been revolutionized by electronic methods of working – changes which are feeding back into photography itself and so encouraging moves from silver halide towards digital imaging.

Three systems

Traditionally the three main methods of reproduction in the printing trade are letterpress, photogravure and lithography. Letterpress uses a raised printing surface (Figure 11.11), like a typewriter. It is the oldest form of printing, originated for letter forms and later for pictures hand-engraved on wooden or metal blocks – areas to print pale being etched or gouged out. Letterpress is still used for a few newspapers, magazines and books.

Photogravure works in the reverse way. Areas to print dark are etched as hollows into metal, then filled with a thin ink and the whole top surface wiped clean. When the gravure surface comes into contact with absorbent paper, the ink filling each hollowed-out cell is transferred into the paper fibres. Gravure cylinders are expensive and relatively slow to prepare, but they can give good-quality results on only average paper and because they stand up to very large printing runs they are used for some weekly magazines, newspaper supplements, etc. Gravure (in a flat-bed print machine form) is also chosen for some art books because of the rich

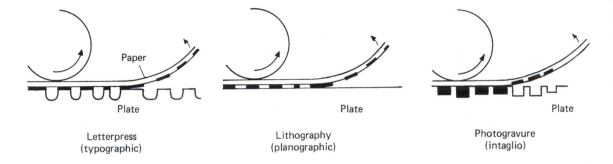

Letterpress
(typographic)

Lithography
(planographic)

Photogravure
(intaglio)

Fig. 11.11 The three main methods of ink-printed reproduction. Although lithography here is shown transferring ink direct to paper, normally the ink image is taken off onto a large rubber roller which then meets the paper. This is called offset lithography

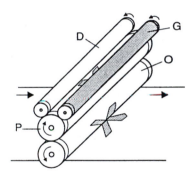

Fig 11.12 Principle of offset lithography press: (D) Dampening roller. (G) Roller carrying greasy ink. (P) Printing plate with image. (O) Large rubber offsetting roller transfers image ink to moving paper

11.13 Halftone printed images appear to have a range of greys but in fact these are made up of pure black and pure white dots, in different proportions. The pattern below is about 16 times coarser than would be used normally. View the page from about 6 metres away to see these patches as a grey scale

tone range it reproduces, particularly in black and white. But cost of plate preparation, and what is often a short print run on high quality paper, again makes the resulting publication expensive.

Lithography originated about 200 years ago when artists drew on the flat surface of limestone – a porous rock. It is based on the fact that greasy ink and water repel one another. Today called photolithography, it uses a thin porous metal sheet treated so that the areas to print dark will not retain moisture. The surface is then wetted, rolled over with greasy ink (which only holds in the non-porous areas) and printed onto paper. As Figure 11.12 shows, on the press the thin litho sheet is wrapped around the outside of a cylinder. It comes into contact with a waterdamping roller, then greasy ink rollers, and finally a larger rubber roller which transfers the ink from plate to paper. (This 'offsetting' means that the litho plate never comes into direct contact with the paper, card, tin, etc. It can print at speed with minimum wear.) The vast majority of modern newspapers, brochures, posters, packaging and books (including this one) are printed by offset photolithography.

Note that none of these three systems lends itself to equipment cheap enough and small enough to allow desktop unit printing. For this you must turn to devices such as dye-sublimation or inkjet printers, see page 285.

Halftone dots

As you can see from Figure 11.11, letterpress and lith printing at least are all-or-nothing processes. The paper either receives a full loading of ink or remains white. To reproduce the range of greys in a photograph, *tones* are turned into a fine pattern of *dots* of different sizes. Take a look at any black and white photograph in this book through a magnifier and you will find that a mid-grey area is really a mosaic of black dots and clear spaces, about 50:50 in ratio. Darker tones contain more black than white, while pale greys are the reverse. So this clever use of pure black and pure white to give a wide range of 'halftones' is based on your eye's inability to resolve fine detail. Dot patterns of about 133 per inch (5–6 per millimetre) or finer merge into what appears to be an even

10% 20% 30% 40% 50% 60% 70% 80% 90%

Fig. 11.14 Part of the picture on page 7 reproduced here screened at 40 instead of 150 lines to the inch. Coarse screening clearly shows up the structure of reproduction and destroys fine detail

Fig. 11.15 Four-colour printing, greatly magnified. Top: when each screen is set to the best angle most dots of colour fall adjacent, not on top of each other. Patterns formed are also least assertive (central area here represents even, dark grey). Bottom: if one or more separations are made with screen rulings at incorrect angles a patchy moiré pattern results. View this page from distance

tone at normal reading distance (see Figure 4.12). The same eyesight limitation is exploited when spotting prints and in additive screen colour films (page 98).

To turn the continuous tones of a monochrome photograph into a halftone image for printing, the picture used to be camera copied onto high contrast film, through a glass screen carrying a fine soft-edged ruled grid and positioned in front of the emulsion. Shadow parts of the original picture recorded as a pattern of *small* dots, while in highlight areas they spread into a pattern of *large* ones (more light to pass through the screen in these parts). This halftone negative was then contact printed by light onto the appropriate printing surface, made temporarily light-sensitive. Later this was treated to form a raised (letterpress) or hardened (lithography) surface, ready for the press to reproduce the original image with ink dots.

Today a halftone dot image is still said to be 'screened', but this is now generated electronically by computer software (such as Post-Script). Your photograph, scanned-in or otherwise supplied as a digital file, and with its data moderated by the software program, controls a fine laser beam in an 'image-setter' machine. Here the screened image is scan-exposed onto high contrast film or light sensitized printing plate material. See Figure 11.18.

Digital methods offer a vast range of dots per inch settings (according to the effective size of laser spots set and the number of lines scanned per inch). Basically the more dots in the screened image the finer the detail shown. However, a major limiting factor here is the paper your halftone reproduction will be printed on.

The pages of this book are printed on paper which will take 150 lines to the inch. If it were printed on cheaper stock (or on newsprint, which is still more absorbent) such fine ink dots would smudge and clog together, destroying tone separation. Coarser screens of about 80 lines may be the best that newsprint will accept, and consequently fine detail will suffer. Screens for huge poster images can be scaled up to something as coarse as 10 lines, because results will be viewed from great distances. See Figure 11.14.

Photogravure uses a screening system for halftones, but this does not affect tone reproduction in the same way. Unlike the other processes, more ink is deposited from deep cells of identical area in the etched metal and less from shallow ones, so the build-up of densities is truly graduated from dark to light, not an optical illusion.

Four-colour reproduction

To print a colour photograph by any of these mechanical printing processes the monochrome procedure has to take place at least four times. The image is 'colour separated' into red, green and blue records by photographing (for example, digitally) or by scanning an existing colour print or transparency through filters of these colours. See Figure 11.19. Each RGB screened separation is printed in cyan, magenta or yellow process ink respectively, superimposed together with a fourth, pale, image in black ink. The black printer gives added tone and body to shadows, shown in Figure 11.16. It is exposed, without filter, at the same time as the other separations, or generated by combining digital data from the other three. (Printing colours are

Fig. **11.16** How four-colour
reproduction of a 35 mm slide is
built up. Top row: the cyan,
magenta and yellow images
printed separately. (Notice the
printer's colour patches, right,
later trimmed off.) Bottom left, the
black printing image. Bottom
centre: cyan, magenta and yellow
images printed together but
without the black. Bottom right:
the three colours plus black.
Notice the extra body this gives to
shadows, impossible from three
coloured inks alone

Fig. **11.17** The black and white
photograph, right, is reproduced
here using four-colour printing.
Results show improved tone
range – compare with single-
colour reproduction on page 155.
This is not as good as duotone,
however and 'drifts' in printing
can make unwanted tints appear

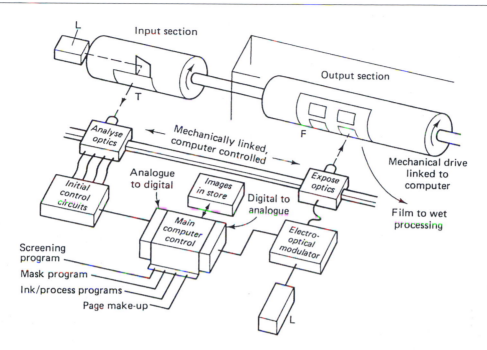

Fig 11.18 Schematic outline of components used for pre-press electronic scanning. Original colour transparency (T) is scanned by light source (L) in the input section. The four-colour signals produced can be stored and manipulated, then exposed in halftone dot form on to graphic arts film (F) in the light-tight output section. Normally a batch of originals are all scanned in at one time, light source and sensing system moving along the transparent cylinder. See Figure 11.19. Software programs adjust data between analysing and exposing stages, creating appropriate halftone screens, colour and contrast masking etc, to achieve optimum separation images for the printing press

designated CMYK. The 'K' stands for black but using its last letter instead of the first to avoid confusion with blue.) When you view all these coloured and black dots on the printed page your eye's limited resolution fuses them into a dominant hue in each area, just like viewing screened colour film or TV.

To minimize dots actually falling on top of each other and the formation of assertive moiré patterns, the program rotates the screen to different angles between the making of each separation. This produces the complex mixture of so-called four-colour dots you can see through a magnifying glass from reproduced colour photographs.

Bear in mind that computer monitor screens, like TV, create colours by mixtures of RGB phosphors. At the printed reproduction stage CMYK inks cannot exactly match every possible colour displayed by RGB, such as the most saturated primary hues. This difference is a problem when you are manipulating colour images and judging results on a computer workstation monitor. You need to add an electronic 'colour management' unit to the system, by which you smooth out mis-matches when RGB data will later be converted to CMYK separations; similarly between various components of your equipment chain – digital back, monitor, scanner, film-writer, etc.

Duotone reproduction

Monochrome remains the 'poor relation' of photomechanical reproduction: most modern improvements have benefited colour. However, it is possible to greatly improve the reproduction of a black and white photograph by running the paper through the press twice and printing (in register) from two versions of the same halftone image. One version may carry delicate highlight detail down to darker midtones; the other is paler but more contrasty, carrying well-separated tones from midtones into rich black shadows. Collectively, this duotone printing

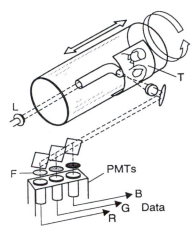

Fig 11.19 Drum scanner, internal optics. Light from source (L), ducted along fibre optic tube, focuses on to tiny area of original transparency (T) taped around transparent drum. Drum rotates and optical section tracks through it to scan every part of the image. Transmitted light passes out to sensor unit also tracking alongside drum. Here three 45° semi-reflective mirrors split and direct light through R, G or B filters (F) on to photo-multiplier tubes. PMTs output analogue tri-colour signals which then pass through an A/D converter

gives good tone separation over a much wider range of values than is possible from one impression alone. (It is similar to the effect of the black printer in colour reproduction and multiple build-up of dye in gum-bichromate printing.)

Anything from two to four or more impressions can be used, with corresponding increase in cost and ever smaller improvements in image reproduction. The separations can differ in density, contrast and the 'colour' of the ink in which they are printed. Inks can be different shades of neutral grey, black, brownish black, etc. When superimposed these will reproduce most of the subtleties of even a rich chlorobromide photographic paper.

Monochrome can also be reproduced using four-colour printing techniques. This makes sense when high quality black and white and colour pictures must print on the same sheet. For monochrome the yellow, magenta and cyan impressions all carry the same image, and, together with the black printer, build up a good tone range in visually neutral density. However, unlike duotone, any misregistration or 'drift' during a printing run can introduce startling bits of colour or casts into a colourless illustration.

Scanners

Preparing highest quality four-colour and other separations is still a specialist task. Some firms, such as service bureaux, specialize in 'reproduction' or 'origination' and then pass on their product as electronic files or film ready for other (printing) firms to use. Large printing houses have their own origination departments. At one time all this meant was that you, as a photographer, could regard your tasks as done and leave everything else to the experts. But developments in digital methods have progressed 'down the line' to the point where it is important for photographers to understand something of how scanners convert pictures to digital files. After all, scanners have become companions to desk-top computer workstations – both tools now being used with almost the same frequency as colour enlargers and darkroom processors.

Drum scanners. As discussed earlier, the conversion of photographic originals into halftone separations was once done by copying through a large process camera. A ruled screen held a set distance from the film created the required soft-edged light pattern; in four-colour work contrasts and colour were adjusted by registering photographic film masks with the original (see page 165). However, electronics first made possible the use of much more efficient drum scanner recorders (Figure 11.19). Here an original colour transparency or negative is taped to a clear perspex drum and rear-illuminated by a tiny point of light. An extension of the cylinder in a lightproof housing may carry the photographic process film ready to receive the four separation images.

As the cylinder rotates, the analysing light spot gradually moves along the cylinder, progressively scanning every part of the transparency. A colour-sensor unit with photomultiplier tubes to read RGB values tracks along in parallel outside the cylinder, turning the changing light values it receives into a long stream of electronic signals. Passed through an A/D converter to turn it into digital form this data is

translated into screened colour separation signals by computer software programs. Meanwhile, at the exposing end of the cylinder a small beam of light focused on the separation film dims and brightens according to signals received. The exposing optics track along the rotating cylinder, gradually exposing each of the black and white film separations which will finally give cyan, magenta, yellow and black printing images.

The analysing unit (which, incidentally, also accepts prints, bouncing a light spot off the surface) feeds to the exposing unit through circuitry which allows the operator to carry out almost limitless contrast masking and dye-deficiency masking. The system will also electronically generate the required high resolution dot shape to suit known printing/ink/paper conditions. Most modern scanner/recorders now have separate input and film exposing output halves, Figure 11.18. The scanner part can then produce digital files on computer hard disks or CCDs which can be used for image distribution and use with a wide range of display and printout devices.

Flat-bed scanners. As a lower cost approach today's compact flat-bed scanners and desktop film scanners use CCDs – large numbers of minute light-sensitive receptors – instead of photomultiplier tubes. As Figure 11.20 shows, a typical flat-bed is about the size of a photographic lightbox with an A4 platen. It contains a linear array, a row of several thousand CCD elements to scan any print or document placed face down on a top glass plate. During scanning a light source and mirror unit gradually moves down the length of the picture, reflecting lines of image data onto this CCD array in the base of the box. Single pass colour scanners use arrays of filtered red, green and blue; others make three scans, each time changing the colour of the light. The analogue signals then pass to an A/D converter for conversion to digital data. Typical time needed to scan, say, an 8 × 10 in colour print may be between 1 and 12 mins according to the resolution you set, see below. Some flat-beds include a light transmitting optical system so you can scan-in film originals. All can give good results from large-format transparencies up to 8 × 10 in, but for 35 mm formats only the highest resolution (and more expensive) flat-bed scanner will do.

Desktop scanners. Most desktop film scanners (Figure 11.21) are designed for 35 mm or for rollfilm size originals. Some use a linear sensor – a row of filtered CCDs moving in steps across the rear-lit film (taking between 30 seconds and 5 minutes per 35 mm frame) or one row of unfiltered CCDs making three passes with the light changed between RGB. Alternatively the scanner has a matrix block CCD sensor, which is able to capture the full film image each time in a series of RGB exposures.

Using a flat-bed or desktop scanner demands fewer skills than a drum unit, but you must still carefully use your computer to set the resolution of the scan (in pixels per inch) to suit the precise size and resolution of your intended print. Any later unforeseen change in this final aim will mean going back and rescanning your original.

Use of scanners has now expanded well beyond photomechanical reproduction. They are a key computer peripheral – a way in to digital 'processing' of your photographic image, working with PhotoShop and similar manipulative software programs; similarly for

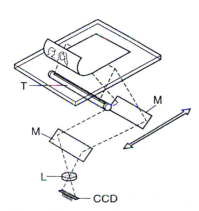

Fig 11.20 Interior of flatbed scanner (see Figure 10.38). Original print, face down on glass top, is scanned by light from tubular source (T) which moves together with a mirror under the glass. From here light is reflected to a second, stationary, mirror and lens unit (L) down on to a linear CCD array

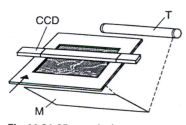

Fig 11.21 35 mm desktop scanner. Light from source (T) is reflected through the mounted film image, which slowly tracks under linear array CCD sensor

entering images onto the Internet. (Notice the similarity between the way CCD sensors function in scanners and in digital backs for cameras.)

Supplying photographs for reproduction

Despite the aids and controls possible when your pictures are reproduced on the printed page, you still get best quality with least trouble and cost by having a technically good original in the first place. When supplying an image for reproduction try to meet all the following requirements:

1. *Size*. Avoid large differences in size between original and final reproduction. To take an extreme example, a 35 mm transparency for a 12-sheet poster, or a 12 × 15 inch print for a 2 × 2.5 inch book illustration are difficult to handle. Adjustments may even mean having to go through an intermediate copying stage, with consequent loss of quality. Remember, too, in shooting, that when the final reproduction will be small you should keep your picture content broad and simple.
2. *Form*. Colour originals are still preferred in the form of transparencies, partly for their greater saturation and colour fidelity and partly just because of long-standing print technology bias. Original transparencies always tend to reproduce better than duplicates. If you have prints, don't supply them mounted – they may have to be wrapped around a scanner drum.
3. *Grain and surface*. Image grain pattern depends mostly on the original's emulsion speed and the reproduction ratio. It may be worth enlarging your picture or reducing it to final size to see what contribution grain will make to detail or mood. Do not submit prints with a surface finish texture such as lustre or stipple. The pattern may interfere with the screening process. Glossy (especially when glazed) gives greatest tone range, especially in the shadows.
4. *Contrast*. Film has a longer tone range than can be reproduced by photomechanical printing, especially on cheap paper and/or using a coarse screen. So try to limit contrast, preferably by shadow-filling when lighting. If you have to send in a contrasty image, indicate whether you want the printer to bias best reproduction towards highlight or shadow areas, since you cannot have both. However, do not send in flat grey prints for reproduction either. It is important to keep well-separated tones, especially in shadow and highlight detail. Printing on excessively low contrast bromide paper tends to merge tones within either or both these extremes. It is often better to print on slightly harder paper but shade and print-in. In general, a rich tone range print which looks good in photographic terms will reproduce best.
5. *Exposure and colour balance*. Pitch the exposure of slides and transparencies to give sufficient detail and saturation in highlight areas, even if this means dense shadows. With neg/pos materials avoid the kind of detailless grey or distorted colour shadows in prints resulting from underexposed negatives. Colour shots with a colour cast may just be possible to improve in colour reproduction but at the cost of general tone and colour accuracy. Always take care

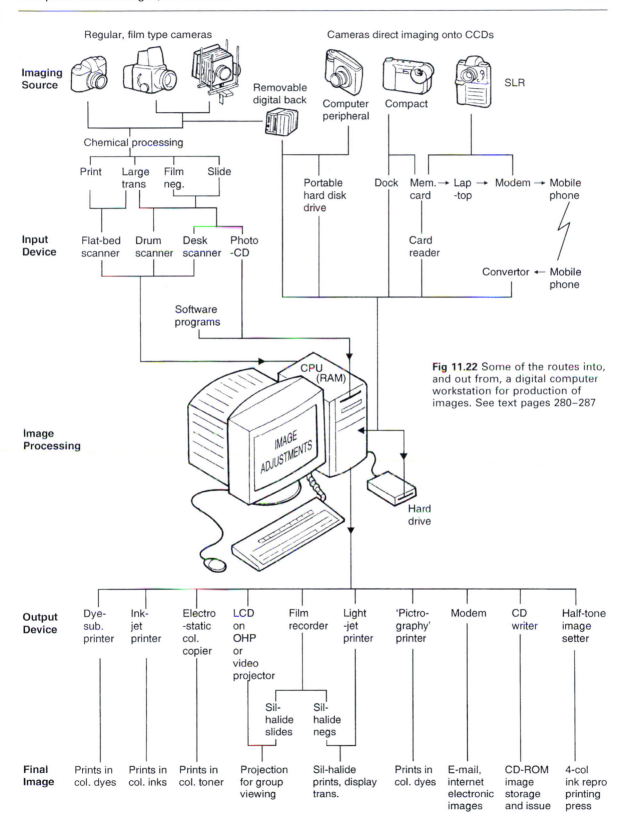

Imaging Source

Regular, film type cameras

Cameras direct imaging onto CCDs

Removable digital back

Computer peripheral

Compact

SLR

Chemical processing

Print Large Film Slide
 trans neg.

Portable hard disk drive

Dock Mem. → Lap → Modem → Mobile
 card -top phone

Input Device

Flat-bed scanner Drum scanner Desk scanner Photo -CD

Card reader

Convertor ← Mobile phone

Software programs

CPU (RAM)

Fig 11.22 Some of the routes into, and out from, a digital computer workstation for production of images. See text pages 280–287

Image Processing

IMAGE ADJUSTMENTS

Hard drive

Output Device

Dye-sub. printer | Ink-jet printer | Electro-static col. copier | LCD on OHP or video projector | Film recorder | Light-jet printer | 'Pictro-graphy' printer | Modem | CD writer | Half-tone image setter

Sil-halide slides Sil-halide negs

Final Image

Prints in col. dyes | Prints in col. inks | Prints in col. toner | Projection for group viewing | Sil-halide prints, display trans. | Prints in col. dyes | E-mail, internet electronic images | CD-ROM image storage and issue | 4-col ink repro printing press

in selecting your best originals to send for reproduction. Make sure that your lightbox, or top viewing light for prints, gives correct colour temperature and is sufficiently bright. When you judge a transparency on a lightbox always mask off glare from around the edges of the picture using wide opaque card. This makes a great difference to the detail you can see in the film's darkest areas.

Computer-based images, an overview

Digital (electronic) and silver halide (chemical) photography increasingly challenge one another as 'best route' at every stage between subject and final image. Of the two, electronics advance most rapidly, reaping the advantages of a huge computer-based industry to bring out a constant stream of products better in performance and lower in price than ever before. Against this, silver halide technology is by no means static either. Chemists research and introduce new emulsions which are faster in speed, have higher resolution, better image dyes and need simpler, shorter processes. So for some considerable time the two forms of image recording will co-exist – silver halide materials chosen for their fine image quality, relatively low price and responsiveness to the craft skills deeply ingrained in every experienced photographer, and digital methods for their liquid-free no-darkroom convenience and easy interfacing with other electronic media.

Digital imaging is essentially computer based. So in order to overview how electronics are extending photography it makes sense to place the computer at the heart of the system (Figure 11.22) and then look at its most relevant range of 'inputs' and 'outputs'.

Inputs

Processed silver halide film exposed in a regular photographic camera is still the main way of inputting images into a computer system. As discussed on page 276, the picture then has to be turned into digital data by one or more means. A desk scanner will accept and digitalize 35 mm slides or negatives. A flat-bed scanner digitalizes prints, even rigid mounted prints, and many types handle larger format transparencies too. Higher-band, although also much more expensive, a drum scanner will handle negatives or transparencies of practically all sizes and also (unmounted) prints. Alternatively you might have your film images written to a CD-ROM disk – a low cost step offered by most labs. This provides excellent storage for large numbers of pictures at different resolutions, retrievable in digital form just by inserting the disk into your computer's CD-ROM drive. With all scan-in systems remember that you have to make the correct settings (pixels per inch) to suit the resolution of your intended print outputting device and planned image size. See page 105.

Another main inputting system is the direct camera imaging of your subject onto a CCD – in other words use of a digital camera or digital back. As discussed on pages 55–58, a digital camera may be cabled direct to the computer, or record into the camera's internal memory system or onto a memory card. The internal or card systems will later need to read image data into the computer via a camera cable, camera 'docking' unit, or card reader. For press work with a high resolution

Fig. 11.23 Image processing software can uniquely adjust digital image details. The original shot of Florence reproduced 'straight' (above) has depth of field extending from foreground through to distant background. In the top right digital print the same picture has had its background detail softened electronically. The other print (bottom right) has its foreground made unsharp instead. The edge line between sharp and unsharp has to be traced out on the computer monitor screen. But since the you can greatly enlarge detail and fill the screen with a few pixels at a time, complex outlines become easy to follow. Such post-production techniques are becoming commonplace. See page 284.

small format CCD single lens reflex camera, images can be played back on location (for editing purposes) on a laptop computer screen. From here chosen pictures are routed as necessary through a modem and transmitted by radio telephone to a suitable receiving point wired to the newspaper's computer system.

For high resolution CCD camera imagery you are more likely to fit a multi-million pixel digital back onto your existing rollfilm or 4×5 in camera. This may be a 'single-shot' type suitable for flash or moving subjects and containing a matrix (area-array) CCD faced with a mosaic of tiny red, green and blue filters. Alternatively you might use a 'three-shot' back which achieves higher image resolution by using a matrix without integral filters. To shoot colour it needs a sequence of three exposures through a filter system over the camera lens which changes through red, green, blue for each picture. Yet another camera back system uses a tri-linear array – a narrow bar carrying three rows of CCDs separately coated with RGB filters making one scan across the image focal plane, like a flat-bed scanner, Figure 3.30. (Neither three-shot nor scanning backs suit scenes involving movement.)

Digital data feedout from a camera back is wired direct into the computer memory system, or when working on location it can be captured using a battery-powered portable hard disk system. Bear in mind that high resolution image capture systems create huge image files.

The computer workstation

The computer is at the centre of any digital photography system. (Some point-and-shoot digital cameras will simply connect directly to a printer to output pictures you have taken, but this then cuts out a huge range of controls over results known as 'image processing'.) One of the great strengths of working with an image in digital form is the way its data can be adjusted at the computer stage. Your final result can be previewed on its desktop (the monitor screen) and, provided you 'save' (record in memory) your original input image, you can step back to where you started any time you make a mistake or change your mind.

A computer setup for digital imaging work consists of several units of hardware, typically:

1. *The computer CPU itself.* This box-like central processing unit contains the motherboard and processor chip. It must also have a CD-ROM fast drive and ample RAM (random access memory). The compact disk drive allows input of any photographic images you have had converted to CD-ROM and, most importantly, software operating programs such as PhotoShop which come in this form, see page 284. Digital imaging demands more RAM than is needed for simple word processing. Memory chips rise in multiples of 2, 4, 8, 16, 32, or 64 Mb; a total of at least 96 megabytes RAM is desirable. Without this there will be frustratingly long delays in bringing large images on screen and in effecting every change. Each high resolution image from a medium- or large-format digital back can alone take up files of 32 Mb or more. Bear in mind that RAM is temporary storage, so when the computer is switched off everything

stored in RAM is lost. Therefore each time you start up all the image data and the software program you are using must be in-put into RAM. Any work or program you finally wish to keep has to be 'saved' before switching off – either to the computer's internal hard disk (preferably storing at least 1 Gb) or to a removable storage disk such as Syquest or Jaz (Figure 5.23).

2. *The computer monitor* should have at least a 17 inch screen. Otherwise you have to keep moving various elements being shown around the screen, and find that things get covered up. Contrast, Brightness and Colour settings need to be set so that the monitor matches characteristics of your output system as far as is possible. This will mean that by looking at the screen image you can visually predict final printed results. Software programmes known as 'colour management systems' help to eliminate discrepancies, by standard-

Fig 11.24 'Tool box' icons which appear alongside your working image on the computer screen when using Adobe Photoshop editing software. Mouse clicking on to a chosen tool allows you to select, crop, paint or erase scanned-in photographs in many different ways

Fig. 11.25 Computer monitor screen appearance during 'drag and drop' digital processing, using Photoshop software to alter elements in a scanned-in image. Right hand figure has been cloned, enlarged, and is being dragged to a new position where it will be 'pasted' in place. The mouse was first clicked on the 'move' icon, top corner in toolbox, left, causing the move tool (presently displayed in the sky) to appear. This will be shifted by moving the mouse until it overlaps the cut-out figure. Keeping the mouse button pressed then allows you to drag the figure to anywhere else in the picture and leave it there by releasing the button. Finally its outline is cleaned up ('eraser tool') and soft edged to blend in realistically with immediate surroundings. Thumbnails of what you have chosen as separate parts of the picture are displayed, filed as separate layers, bottom right

izing the way each colour appears on the screen and when printed on paper (for example, by inkjet). The monitor must be capable of a 24-bit display in order to show photographic quality images.

3. *The mouse* enables you to move a cursor or visual elements around the screen, 'click' onto a tool box icon (Figure 11.24), choose from the screen's menu bar or select a command option. The computer keyboard, although less used, allows you some special commands and the ability to shortcut certain actions, as well as write in words to title image files, etc.

4. *Peripheral devices* include a drive for removable hard disks, and memory card reader (Figure 3.27). You might also have a graphics tablet and stylus as a higher precision substitute for the mouse. Some units – scanner, direct digital camera, printer – need connection to the computer through a SCSI (pronounced scuzzy) interface. This is a small cabled device which allows high speed communication of data between computer and peripheral.

Image processing

The computer is your image processing workstation, but it only works given the electronic 'tools' provided by whatever software program you install (typically fed in from CD-ROM). Once combined with the image(s) you have also input, software such as 'PhotoShop' sets out the picture on the monitor with a tool bar down one side and a range of options you can 'pull down' from a menu bar at the top. See Figure 11.25.

Hundreds of changes – from subtle invisible mending to bizarre surrealist constructions – are now possible. Examples include:

● Removing a colour cast, either overall or locally, resulting for example from mixed lighting.
● Correcting converging verticals.
● Limiting depth of field to give a chosen part greater emphasis. See Figure 11.23.

Fig 11.26 Two ways of projecting digital images direct, for group audiences. A: liquid crystal display panel located on an ordinary overhead projector lightbox and fed by images direct from computer. B: single self-contained unit which projects images stored as digital data on any computer PC floppy disk, shown being inserted

Fig 11.27 Thermal dye-sublimation printer, showing principle by which colour prints are output on paper from digital files. Receiving paper (P) fits under full-width roll of doner plastic coated with consecutive panels of cyan, magenta and yellow dyed wax. Sandwich passes under a bar of heated pins, each of which vaporizes and transfers tiny spots of colour according to scan data from image file. After each single colour is printed the wax roll shifts relative to the receiving paper, to bring its next colour into the same printing position and so build up a full colour print

● Erasing spots and blemishes – scanned-in cracked and torn antique prints can be reproduced like new. To do this you greatly enlarge the pixels in blemished areas, then 'paste-in' colour and tone from copies of adjacent pixels, so that when the image is returned to its original size no defects can be seen.
● A new, separately shot background introduced behind a figure or object.
● Reducing the gap between two figures by cropping off some of the space between them and pasting the two halves seamlessly together again.
● Introducing movement blurr into chosen parts – making the wheels of a car photographed stationary appear to have been turning, for example.
● Replicating a shot of a single product so that it seems to show a whole group of products, differing in colour and size.

At every stage if an error is made you should be able to step back to the previous stage, or return your image to its original appearance. Finally the work is 'saved' to hard disk (either the internal or a removable type) and given a file name separate from its original file.

Image outputting

As Figure 11.22 indicates, you can print out your final digital image from the computer in a wide range of ways. Digital colour printers – often desk-top size – print onto paper using processes such as dye-sublimation or inkjet. You can also write to film, so forming a silver halide negative or transparency (page 259) from which conventional colour prints are enlarged; or print direct onto a wide roll of silver halide paper or display film using a digitally modulated tri-colour laser system, see Figure 11.30.

Other outputting options include electrostatic colour photocopier machines (fed with electronic data from the computer). Working through a modem too you can output your image as e-mail, or publish it on the Internet. Equally image data can be fed to a halftone imagesetter for conversion to printing plates run on a four-colour ink printing press for mass reproduction, pages 275–276. Publishing can also take the form of CDs, professionally made from a master disk of your digital images. This is becoming an effective low cost way of issuing portfolios, stock shot catalogues, etc. to anyone possessing a CD player, provided there is some form of protection against copyright

Fig 11.28 A thermal dye sublimation desktop printer for colour images up to A4. See also Figure 11.27

Fig 11.29 Ink-jet printer for poster size colour prints size AO. Such machines take up little floor space, and avoid physically arduous darkroom techniques for making big enlargements with silver halide materials (Figure 9.16)

infringement. A further form of output is direct to a digital projector or data display panel on an OHP (Figure 11.26). This will project what you saw on your monitor onto any large external screen for group viewing, in the same way as a slide or overhead projector.

Printing by dye-sublimation. A good dye-sublimation printer can output near-photographic quality colour images up to about A4 size. As shown in Figure 11.27, these desktop machines use a full paper width donor ribbon carrying a series of (print size) areas of transparent cyan, magenta and yellow dye. In the print head a heating element the width of the paper vaporizes dye onto the paper surface so that after three passes the paper builds up a full colour image. The used donor ribbon with its remaining dyes winds onto a take-up spool and is later thrown away. You must use special paper – the action of the dyes then merge pixel dots together into pattern-free areas of colour and tone. A problem with dye-sublimation printing is the relatively high cost of donor ribbon and paper, plus litter from spent ribbons. An A4 colour print takes about 1½ minutes to produce.

Printing by inkjet. These printers vary greatly in image quality and price. They range from desktop 'bubble jets' for A4 size prints, to expensive types of printing machine (Figure 11.29) able to turn out mural size images on a range of sheet material including quality watercolour paper and acetate. For colour printing they use a set of four cartridges, each containing cyan, magenta, yellow and black liquid ink. Under the control of the image data from your computer each ink is forced into a tiny nozzle by heat or pressure. The heated ink forms a tiny bubble at the end of the nozzle which transfers, merging with others, to the image receiving sheet. The printing head moves rapidly backwards and forwards across the width if the print like the shuttle in a weaving machine, paper advancing minutely after each pass. High-end inkjet printers can turn out excellent photographic quality images on a wide variety of papers (made for the purpose by most silver halide paper suppliers as well as paper manufacturers). They need careful maintenance however, including regular nozzle cleaning.

Printing by light. So called 'light-jet' printers also use a moving printing head, but this issues a spot of light instead of inks, focused onto a roll of regular silver halide coated photographic paper or display film in a light-tight consol unit. See Figure 11.30. The light spot is formed from the combined paths of three (RGB) laser sources, each one modulated by digital data from the computer. Light-jet printing must of course be followed by processing in machines with RA-4 chemistry or whatever is appropriate for the photographic material you used. This need, plus their high capital cost, means that light-jet printers are most often located in custom labs. See page 260.

Other digital colour printers such as Fuji's 'Pictrography' expose the image with one pass of a row of tri-colour laser diodes onto a special light-sensitive donor paper. This is dampened with a small amount of water and heated to create a full colour dye image which is transferred under pressure and heat to a receiving paper. Some forms of laser printer machine function by using an electrostatic (Xerox type) drum. Instead of receiving its image optically, from an original placed face down on a glass plate, the digital data output from your computer controls light emitting

diodes or a laser beam which scans the image onto the electrically charged drum surface. The drum rotates, picking up coloured toner in areas unaffected by light and passing them on to receiving paper. Four passes (CYMK) are made in this way to build up a full colour print.

Both these machines are costly, but form compact automatic office units, chemical-free and able to output up to A3 size prints at 1–2 min intervals. Quality varies with price but at the top end resolution of 400 dpi is possible, giving results virtually indistinguishable from silver halide colour prints.

The future of digital methods

Taking a general view, the various stages of digital photography now follow an accepted pattern – from the ways of imaging your actual subject through to finalizing the resulting work. But being new technology (which hardly existed before the early 1990s) much of the hard- and software giving highest quality results still remains costly. It is also subject to new improvements all the time. 'Best routes' and 'best buys' can become out of date within just a few months.

It is reasonable to forecast that eventually most still photography will be done by electronic means, but we will be getting our hands wet in 'archaic' liquid processing for some time to come. The essence of photography remains the making of pictures by light, and this will always rely, as now, on having 'a good eye'. Your ability to see pictures, organize subjects, viewpoint and lighting, and decide appropriate image sharpness and exposure still remains vital. It matters much less whether you image onto an electronic chip or chemicals coated onto film.

Multimedia

Computers with appropriate software programs allow the presentation of still photography to be integrated with video, sound, lighting, LCD projection, and various interactive devices in what has become known

Fig 11.30 Light-jet printer: the light-tight cabinet is loaded with a 4 ft wide roll (P) of regular silver halide material – monochrome or colour paper, or display colour film. Image data from digital disk controls light intensity from R, G and B lasers which feed through mixing box (M) to a moving exposure head (H). This focuses the combined light into a tiny spot on the paper's sensitive surface. Like an ink-jet system the head moves backwards and forwards as the paper slowly rolls forward. A print 50 inches long takes 10 minutes to expose. It is then processed as if having been made normally using an enlarger

Fig 11.31 Multiple slide AV presentation. A 48-projector AV theatre with multi-track sound. Show is run from the control console containing tape and computer gear

as 'multimedia'. Audio-visual (AV) meaning the use of banks of 35 mm slide projectors, is well established as a powerful way of creating spectacular, high quality forms of image presentation for conferences, exhibitions, prestige tour introductions for visitors to museums, etc. This form of multi-projection (Figure 11.31) still offers a dramatic form of communication – large scale pictures dissolve, mix and snap-change. The wrap-around screen can carry a changing patchwork of different pictures one moment and the next a full-width panorama appearing as one image.

Such AV programmes are time based, with projector cues triggered by reel-to-reel tape or CD which also carries sound tracks. But the mechanical complexity of slide projectors, where one blown lamp or a jammed slide can disrupt a show, can make a presentation of this kind fraught with difficulty, particularly if it must be left running unattended for long periods. Improvements in computer-controlled large screen video projection, plus editing software which can, for example, dissect a scanned-in image and allocate its parts digitally to several projectors, have revolutionized the production of complex shows. High quality still images, moving images, sound, and effects commands can all be played out from a single videodisc. Other projection equipment (including liquid crystal display projectors) allow images to be sourced direct from your computer's hard disk.

At the same time interactive forms of presentation are possible – both in an audience situation and the kind of one-to-one programme (often in CD form) by which individuals view material on computer screen and relate with it through displayed touch-sensitive response panels. If you are an ambitious photographer working in either a commercial or fine art field, it is important to keep in touch with future multimedia developments. Knowledge here will help you build new markets for your photography; it also enables you to present your work in the most effective form of installation at gallery shows.

Summary: Extending photography

● 'Hand-made' printing allows you to break away from the regular appearance of photographic prints, e.g. coating prepared liquid silver halide emulsion on two- (or three-) dimensional surfaces. Relate image content to the texture and character of your chosen base.
● Gum-bichromate, a non-silver process gives a final image in one or more chosen watercolour pigments. Coat your choice of (sized) paper with a gum/pigment mixture, sensitized with potassium dichromate. Contact print onto it from an enlarged film negative, using ultra-violet-rich light. During hot water 'processing' you can lighten shadows or scrub out parts by hand.
● Polaroid materials allow you to 'emulsion lift' the colour image from an instant print, detaching it as a (creased, torn, etc.) membrane to a different kind of support. Alternatively 'image transfer' from the part-developed negative of peel-apart material by rolling this sheet into tight contact with dampened watercolour paper.
● The three traditional systems of reproducing photographs on the printed page are letterpress (raised surface), lithography (water-repelling greasy ink) and photogravure (ink-retaining hollows). Pre-press preparation is predominantly by digital methods today.

● For letterpress or litho reproduction continuous-tone photographs are converted into a fine pattern of halftone dots. Your eye's limited resolution reads purely black and white dots as a full tone range, according to ratio and distribution.

● Duotone reproduction of black and white pictures enriches tone range and density but needs at least two halftone separations and two runs through the press. The finer the halftone screen ruling, the greater the detail, provided that it suits the paper being used.

● To reproduce full colour requires at least four separations, printing in yellow, magenta, cyan and black inks. (Screens rotated to different angles.) Scanners convert picture information into a stream of signals representing the four separations. While in digital form images can be masked for contrast and colour, retouched, and screened, then re-exposed back onto process film as halftone dot separations.

● Image scanners now have many roles beyond pre-press work. Desktop flat-bed types convert print and (neg or pos) film originals to digital data for computer processing; similarly desk-top 35 mm or rollfilm scanners. Resolution settings must be appropriate for your planned size of final printout.

● Photographic originals supplied for reproduction should avoid major differences from final size; be capable of being drum scanned; avoid surface texture; have a tone range appropriate to the style of image; avoid underexposed shadow detail or burnt out highlights.

● Digital, computer-based imagery steadily improves, as will (to a lesser extent) silver halide imaging. Electronic and chemical systems will co-exist for some time. For instance, a good trade-off between cost and quality is to shoot on film, scan, electronically process, then print out on silver halide material. Silver halide photography will also retain its devotees wherever craft skills and handwork are more important than speed and economy, e.g. fine-art prints.

● Inputs to computer-based imaging systems used by photographers include silver halide originals (either scanned-in direct or on CD-ROM), also digital data direct from a CCD camera or back, or via a digital camera's hard disk or memory card. This chain may include transmission by phone.

● The computer workstation needs operating software and image data. Ample RAM is essential if you are manipulating high resolution files for outputting big prints. Plan ahead – avoid excessive resolution levels which slow down operations and fill up disk space. Have a good size monitor and a colour management software program to match its screen image appearance to final printout. Peripheral devices include a drive for removable hard disks; memory card reader; graphics tablet, etc.

● Image manipulation software such as PhotoShop allows hundreds of image changes – many the equivalent of traditional chemical or masking treatments plus precise 'bending' of tone range, cut-and-stick seamless retouching or montage, special effects.

● Computer output can be fed to printers including dye-sublimation, inkjet and electrostatic types; also to halftone image setters, CD writers, film recorders (for subsequent printing by silver halide means). Images can be played out to digital projection devices for group viewing.

● Dye sublimation printers can give good quality but are limited in size of output; materials tend to be expensive. Inkjet printing is more versatile and (top-end machines) able to output large, photographic quality colour images on a range of bases. Light-jet printers expose

direct onto any wide format light-sensitive silver halide paper or
display film, then given conventional chemical processing. Other
machines (Pictrography) expose digital images using RGB light onto
heat processed donor paper to automatically output colour prints.
Similarly electrostatic photocopy type printers work by receiving
digital image data direct from computer.

● 'Multimedia' integrates photography, video, audio, etc. in computer-
controlled presentations. Much is developing electronically from what
was previously limited to multi-projector audio-visual installations.
This includes interactive computer software – a promising market for
professional photography.

Appendices

A: Optical calculations

Formulae below relate to lenses, and make use of the following international symbols:

F = focal length
U = distance of object from lens (measured from front nodal point*)
V = distance of image from lens (measured from rear nodal point*)
D = total distance between object and image, ignoring nodal separation
O = object height
I = image height
M = magnification

(*Warning: these distances are difficult to measure accurately with telephoto and inverted telephoto lenses, because the nodal points may be well in front or behind the centre of the lens. See page 28).

You can calculate focal length, or image and object distances, or magnification, when other measurements are known:

$$F = \frac{UV}{U + V} = \frac{V}{M + 1} = \frac{MU}{M + 1} = \frac{MD}{(M + 1)^2}$$

$$U = \left(\frac{1}{M} + 1\right)F = \frac{D}{M + 1} = \frac{VF}{V - F}$$

$$V = (M + 1)F = \frac{DM}{M + 1} = \frac{UF}{U - F}$$

$$D = U + V = (M + 1)U = \left(\frac{1}{M} + 1\right) = \frac{F(M + 1)^2}{M}$$

$$M = \frac{V}{U} = \frac{I}{O} = \frac{D - U}{U} = \frac{V}{D - V} = \frac{F}{U - F}$$

Bear in mind that when you are using an enlarger or projector the 'object' refers to the negative or transparency; the 'image' is that projected on the baseboard or screen.

Depth of field

When the object distance is great relative to focal length, the simplest way to calculate depth of field is to work from hyperfocal distance (see Glossary). This gives sufficient accuracy for most practical purposes.

f = f-number

c = diameter of circle of confusion

$$H = \text{hyperfocal distance} = \frac{F^2}{f \times c}$$

Distance from lens
to nearest part of object in focus $= \dfrac{HU}{H + U}$

Distance from lens
to farthest part of object in focus $= \dfrac{HU}{H - U}$

Exposure increase in close-up work

Owing to the effect of the inverse square law when the lens is located much beyond one focal length from the image plane, exposure time indicated by an external meter should be multiplied by

$$\frac{V^2}{F^2} \ or \ (M + 1)^2 \ or \ \left(\frac{U}{U - F}\right)^2$$

Of these the middle formula is easiest to apply; remember that M is the height of an object divided by its image height on the focusing screen.

Supplementary lenses and focal length

Assuming that the supplementary lens is placed very close to the main lens:

S = focal length of supplementary lens*

When using a converging supplementary:

$$\text{Combined focal length} = \frac{S \times F}{S + F}$$

When using a diverging supplementary:

$$\text{Combined focal length} = \frac{S \times F}{S - F}$$

Cosine law

Illumination across the field of a lens reduces as the fourth power of the cosine of the angle made between the portion of field and the axis. This means that less light is received at the corners of the frame in the camera than at the centre – noticeably so with wide-angle lenses of non-retrofocus construction. With neg/pos photography the effect of the camera lens is often compensated for by the cosine law effect on the enlarger lens. But with pos/pos printing corner darkening is cumulative.

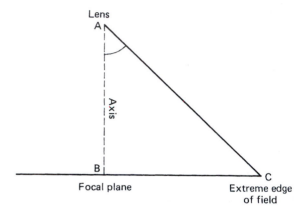

Light filtration for Ilford multigrade IV black and white paper, using a colour head enlarger

Paper grade effect	Durst (max 170M) head	Durst (max 130M) head	Besseler; Chromega; Vivitar; De Vere	Meopta
00	150Y	120Y	199Y	150Y
0	90Y	70Y	90Y	90Y
½	70Y	50Y	70Y	70Y
1	55Y	40Y	50Y	55Y
1½	30Y	25Y	30Y	30Y
2	0	0	0	0
2½	20M	10M	05M	20M
3	45M	30M	25M	40M
3½	65M	50M	50M	65M
4	100M	75M	80M	85M
4½	140M	120M	140M	200M
5	170M	130M	199M	–

*In same units as F. If in dioptres, divide dioptre value into one metre to get S.

B: Chemical formulae: health and safety

Chemicals picked out with asterisk (*) need careful handling, see safety advice page 294.

Monobath
Single-solution combined developer and fixer for black and white films. Gives a set degree of contrast. Works on basis of active developer components developing fully during long inertia period before fixer begins to affect film. May cause dichroic fog with some film types.

Water (hot)	750 ml
Sodium sulphite (anhydrous)	60 g
Hydroquinone	30 g
Sodium hydroxide*	25 g
'Phenidone'	3 g
Sodium thiosulphate (crystals)	150 g
Cooled water, to make	1 litre
Before use, add 40% formaldehyde*	10 ml

Process to completion – about 6 minutes at 20°C.

Reducers for black and white silver image materials
Reducer R-4a is a subtractive reducer for over-exposure. Increases contrast, also removes veil due to fog.

Stock solution A
Water	250 ml
Potassium ferricyanide	38 g
Water, to make	500 ml

Stock solution B
Water	1 litre
Sodium thiosulphate (crystals)	480 g
Water, to make	2 litres

Mix one part solution A, four parts solution B and 27 parts water just before use. When reduction is sufficient, halt action by transferring film/paper to tray of running water. Finally wash fully.

Reducer R-8 is a proportional reducer. Reduces density and also slightly reduces contrast.

Water (about 32°C)	600 ml
Ferric ammonium sulphate	45 g
Potassium citrate	75 g
Sodium sulphite (anhydrous)	30 g
Citric acid	20 g
Sodium thiosulphate (crystals)	200 g
Water, to make	1 litre

Use at full strength. Treat negative for 1–10 minutes (18–21°C), then wash fully. For slower action dilute 1 + 1.

Reducer R-15 has a super-proportional effect, reducing mostly high density areas and therefore lowering contrast.

Stock solution A
Water	1 litre
Potassium persulphate	30 g

Stock solution B
Water	250 ml
Sulphuric acid (10% sol)*	15 ml
Water, to make	500 ml

Use two parts A and one part B. Pre-treat negatives in liquid hardener, then wash. Reduce by inspection, then fix and wash fully.

Iodine bleacher
For total erasure of image, to 'shape-out' subjects on prints; can also be applied on tip of brush to convert black specks to white (these can then be spotted-in normally).

Warm water	750 ml
Potassium iodide	16 g
Iodine*	4 g
Water, to make	1 litre

Keeps well. Apply undiluted with brush or cottonwool. To remove the intense brown stain, rinse and treat in a small quantity of print fixing bath (10 minutes). Discard fixer. Wash fully.

Intensifiers for black and white silver materials
Intensifier IN-4 is a proportional type (chromium intensifier). Strengthens image without much change of contrast.

Stock solution
Water	500 ml
Potassium dichromate*	90 g
Hydrochloric acid (concentrated)*	64 ml
Water, to make	1 litre

Use one part stock and ten parts water. Preharden negative. Then bleach the black image in reducer, wash for 5 minutes, and redevelop in regular bromide paper developer. Work in white light (but not direct sunlight). Finally rinse, fix and wash. Can be repeated to increase the effect.

Intensifier IN-6 is a sub-proportional intensifier. Strengthens paler densities more than high density areas, so it reduces contrast. Works best with fast speed negative materials.

Stock solution A
Distilled water (about 21°C)	750 ml
Sulphuric acid (concentrated)*	30 ml
Potassium dichromate*	23 g
Distilled water, to make	1 litre

Stock solution B
Distilled water (about 21°C)	750 ml
Sodium metabisulphite	3.8 g
Hydroquinone	15 g
Wetting agent (Kodak Photo-Flo)	3.8 g
Water, to make	1 litre

Stock solution C

Distilled water (about 21°C)	750 ml
Sodium thiosulphate (crystals)	22.5 g
Water, to make	1 litre

For use add two parts B to one part A, stirring continually. Then, still stirring, add two parts C and one part A. Wash negative for 5–10 minutes, treat in hardener for 5 minutes, then wash again for 5 minutes before intensifying. Treat negative for up to 10 minutes (20°C) with frequent agitation. When using a tray, treat only one piece of film at a time and discard solution afterwards. Finally wash negative for 15 minutes.

Black and white silver halide emulsion

Chlorobromide enlarging type. Normal contrast, warm black tones.

Solution A

Water	750 ml
Gelatine	25 g
Potassium bromide	53 g
Sodium chloride	15 g
Cadmium chloride	2 g
Hydrochloric acid (30% sol)*	2.5 ml

Solution B

Water	1400 ml
Silver nitrate*	100 g

Solution C

Water	250 ml
Gelatine	150 g

Bring all the above solutions to 60°C. Then, under amber safelighting, add solution B to solution A in three separate and equal parts at intervals of 5 minutes. Some 5 minutes after the last addition, add solution C.

Ripening Hold the emulsion at 60°C for 30–45 minutes, covered from all light.

Coating additions. Cool the emulsion (but keep it liquid enough to coat paper – about 40°C). Then make the following additions (quantities here per litre of emulsion).

Potassium bromide (10% sol)	2 ml
Chrome alum (10% sol)	15 ml
Formalin (40%), 1 part plus 3 parts water*	40 ml
Alcohol (rectified spirit)	10 ml
Glycerine	10 ml
Sulphuric acid, 1 part in 10 parts water*	3 ml

Once prepared, the emulsion can be stored in an opaque container in a refrigerator. For coating, follow information as for commercial emulsion, page 265.

Gum-bichromate formulae

See page 267.

Handling and using chemicals safely

Most common chemicals used in photography are no more dangerous to handle than chemicals – oven cleaners, insect repellents, adhesives – used as a matter of course around the home. However, several of the more special-purpose photographic solutions such as bleachers, toners and intensifiers do contain acids or irritant chemicals which must be handled with care. These are picked out with an asterisk (*) in the formulae given on this and the previous page. Your response to direct contact with chemicals may vary from finger staining to direct irritation such as inflammation and itching of hands or eyes, or a skin burning or general allergic reaction which may not appear until several days later. People who suffer from any form of skin disease, or from allergic conditions such as hay fever or asthma, should be particularly careful as their skin tends to be more sensitive.

The following guidelines apply to all photographic chemical processes:

● Avoid direct skin contact with all chemicals, especially liquid concentrates or dry powders. Do this by wearing thin plastic (disposable) gloves, and using print tongs when lifting or manipulating prints during processes in trays.

● Avoid breathing in chemical dust or fumes. When weighing or dissolving dry powders work in a well-ventilated (but not draughty) area. Don't lean over what you are doing, and if possible wear a respiratory mask (the fabric type as used by bikers is inexpensive).

● Be careful about your eyes. When mixing up chemicals wear eyeshields, preferably the kind you can wear over existing spectacles. (Remember not to rub an eye with a chemically contaminated gloved hand during processing.) If you do splash or rub an irritant into your eye rinse it with plenty of warm water immediately. Keep going for at least 10 minutes – it is important that the eye surface be washed and not just the eyelids. Install a bottle of eye-wash somewhere close to where you are working.

● Keep things clean. Liquid chemical splashes left to dry-out turn to powder which you can breathe in or get on your hands or clothes, as well as damaging films and equipment. Similarly don't leave rejected test prints, saturated in chemical, to dry out in an open waste bin close to where you are working. To prevent chemicals getting on your clothes wear a PVC or disposable polythene type apron.

● Labels are important. Carefully read warnings and procedures, the chemical manufacturer has printed on the label or packaging, especially if you have not previously used the product. When a product is, or contains, a chemical which may be dangerous the manufacturer must by law publish a warning. The warning notice may incorporate a symbol (three internationally adopted symbols are shown opposite) plus a risk statement and safety statement advising you of any simple first-aid actions to follow if necessary.

● Clearly label the storage containers for chemicals and stock solutions you have made up yourself. Never, ever, leave photographic chemicals in a bottle or container still carrying a food or drink label. Conversely don't put food in empty chemical containers.

● Keep chemicals and food and drink well separated. Even when properly labelled keep all your chemicals well out of reach of children – never store them in or near the larder. Avoid eating in the darkroom, or processing in the kitchen where food is prepared.

● Chemical procedure. Where a formula contains an acid which you must dilute from a concentrated stock solution, always slowly add the acid to the water (adding water to acid may cause splattering). Don't tip one tray of chemical solution into another of a different kind, as when clearing up – cross-reaction can produce toxic fumes.

● In rooms where chemicals are handled and processing machines run every day you may need to install an extra local ventilation system. Make sure this draws fumes *away* from you, not towards you.

TOXIC CORROSIVE IRRITANT

C: Batteries

Batteries are vital power sources for most kinds of cameras, power-winders, hand flash units, and exposure or colour temperature meters. So battery failures mean breakdowns that can ruin a shooting situation, especially when on location, unless you can anticipate problems. Each of the main types of battery has different practical characteristics.

Alkaline Good staying power, as needed for micro-motors and camera circuitry, as well as flash units and meters. Virtually leak-proof. Good shelf life, and still work quite well at low temperatures.

Nickel cadmium (Ni-Cad) These batteries are rechargeable. Batteries and charging gear are expensive, but with two batteries and a charger you should always have fresh battery supplies. However, Ni-Cads need charging more often than you would have to replace alkaline types, so you may be caught out by your batteries 'dying' on a shoot. Ni-Cad batteries do not have infinite life, and need recharging more frequently as they age. Since these batteries deliver high amperage they can damage components in some electronic circuits, and so should only be used if specifically recommended by the equipment manufacturer.

Silver oxide Very suitable for LED displays in camera viewfinders, etc. Gives constant voltage throughout a long life.

Lithium Covers a number of individual types, all of growing importance. Has a long storage life. However, unless your equipment is specifically designed for lithium batteries their useful life may be short. They must be effectively leak-proofed – never leave an exhausted lithium battery in any equipment.

Storing batteries
Remember, batteries work by chemical reaction, which is speeded up by high temperature and slowed down in the cold. Warm storage reduces life – the spare batteries in your pocket are probably losing power almost as fast as those in your camera. At low temperatures many batteries become sluggish. Outside on a cold day you may have to raise battery temperature with body heat to gain sufficient power to run your equipment. By the same token batteries sealed into a polythene bag and stored in a refrigerator or freezer have greatly extended shelf life.

Battery care
● Always check the polarity of batteries before fitting. Make sure they face the appropriately marked terminals.
● As far as possible, when you load a battery run a (cleaned) pencil eraser over both contacts. Complete the process by rubbing the contacts on clean paper. This can improve performance by 50%.
● Never attempt to recharge batteries other than Ni-Cad types.
● Don't attempt to open battery cases. Don't throw any battery into the fire. Keep batteries away from young children.
● It is always best to remove batteries before storing equipment for more than a week or so. Avoid leaving any exhausted battery in any equipment, and change your batteries at least once a year.

D: Business practice digest

To run a photographic business successfully you have to master certain management skills, even though you may work on your own. Some of these activities are specifically photographic but most apply to the smooth running of businesses of all kinds. If you are inexperienced try to attend a short course on managing a small business. Often seminars on this theme are run by professional photographers' associations. There are also many user-friendly books and videos covering the principles of setting up and running your own business enterprise.

The main areas you need to understand are as follows:

Book-keeping

This may sound the dullest aspect of professional photography. But without well-kept books (or computer data) you soon become disorganized, inefficient, and can easily fall foul of the law. Good records show you the financial state of your business at any time. They also reduce the work the accountant needs to do to prepare tax and similar annual returns, which saves you money.

Basically you need a separate bank account for your business activities. This alone gives you a primitive form of income and expenditure account. You should also have a financial diary or computer disk into which all receipts and expenditure are entered, daily. Do this conscientiously, because by recording everything each day you enable your accountant to prepare and check really accurate figures for your annual returns.

To cover small purchases – tools, tape, stamps, taxi fares, etc. – withdraw a lump sum of cash from the bank. Keep this in a 'petty cash' box and gradually replace it with dated receipts as it is spent. As the lump sum runs low, total up the chits and file them, then draw this sum from the bank to re-establish the cash float. A petty cash system saves cluttering up your main records with small entries. It also points up the vital need always to retain every relevant receipt – big or small.

You also need to keep records of all your main items of equipment. This forms an inventory (against fire or theft), but more importantly you can agree a 'depreciation' rate for each piece with your accountant. For example, a camera may be given a reliable working life of five years, which means that its value depreciates by a set amount each year (effectively this is the annual cost to your business of using the camera, and part of your overheads when calculating trading profits for tax purposes).

Another vital record is your negative/transparency registers – perhaps one based on date order as jobs are done, and one listed in client name or subject description order. Good computer accountancy software will allow you to pick out all three types of information from the same database.

Charging for jobs – costing

Knowing what to charge often seems more difficult than the technicalities of shooting the pictures. Charging too much loses clients; charging too little can mean periods of hard work for nil profit. Some photographers charge by knowing 'the going rate for the job', based on what competitors are charging and what your client will expect to pay. This may be valid in the top echelons of the market, where time taken and materials consumed are minor elements in the charge relative to the visual approach and individuality of the photographer. However, for most businesses you need a more organized system of determining charges – based on costing.

Costing means identifying and pricing everything you have paid out in doing each job, so that by adding a percentage for profit you arrive at a fair fee. This should prevent you from ever doing work at a loss, and provided you keep costs to a minimum the fee should be fully competitive. Identifying your costs means you must include indirect outgoings ('overheads') as well as direct costs like film and paper. Typical overheads include rent; electricity; telephone; water; cleaning; heating; building maintenance; stationery; petty cash; equipment depreciation and repairs; insurances; bank charges; interest on loans; and accountancy fees. Also include the salary you pay yourself, as well as any staff. With costs spread over a working year (excluding your own and public holidays) you can work out a business cost per day, or even per hour.

When it comes to costing, you base your fee on three elements added together:

1. What the business cost you to run during the time period you were working on the job.
2. Direct outgoings which you incurred in shooting (such as the photographic materials; travel; accommodation and meals; models, hire of props; lab services; and any agent's fee).
3. The percentage profit you decide the business should provide. Profit margin might be anywhere between 15 and 100%, and might sometimes vary according to the importance of the client to you, or to compensate for unpleasant, boring jobs you would otherwise turn away.

Often photographers charge by pre-agreed day rate plus the cost of materials and other direct expenses. Knowing what the business costs you to run, plus experience of how long it takes to set up and shoot and process various kinds of pictures, should allow you to quote a reasonably accurate final price. However, have some broad agreement with your client on the likely number of pictures you can be expected to complete in one day, bearing in mind the particular subject and shooting conditions. Otherwise people often press you to produce quantity at the expense of quality. Then, later, they complain.

Commissioning forms

When someone asks to commission you to take photographs it is sensible practice to fill in a commissioning form. Design this so that it has spaces for subject and location, likely duration of shoot, agreed fee and agreed expenses. It also specifies what the picture(s) will be used for and any variations to normal copyright ownership. Small print on the form spells out details such as cancellation fees, the extent of a 'working day', and so on. Signed by the client it serves as a simple written contract. The form therefore avoids difficulties, misunderstandings and arguments at a later date – which is in everyone's interests.

Job sheets

One good way of keeping track of a job in progress (especially when several people are working on it at different times) is to use a job sheet system. A job sheet is a form the client never sees but which is started as soon as any request for photography comes in. It follows the job around from shooting through printing to retouching and finishing, and finally reaches the invoicing person's file when the completed work goes out. The job sheet also carries the job instructions, client's name and telephone number. Each member of the team logs the time spent, expenses, materials, etc. in making their contribution. Even if you do all tasks single-handed, running a job sheet system will prevent jobs being accepted and forgotten, or completed and never charged for.

Invoicing

It often looks a trifle hasty to invoice your clients at the same time as sending the pictures. But then invoices sent months later may confuse their accounting system, and makes you look inefficient. Usual practice is to invoice about a week after delivery, and follow this by statements (just invoice number, date and fee) on the last day of each subsequent month. Some firms only pay on statements.

Uneven cash flow is the most common problem with small businesses. Clients (especially advertising agencies) are notorious for their delay in paying photographers. Often they wait until they are paid by *their* clients. It is therefore advantageous to have one or two regular commissions which might be mundane, but are paid for promptly and even justify a special discount.

Releases

Anyone who models for you for a commercial picture should be asked to sign a 'model release' form, facing page. (This can be photocopied off the page and used for jobs). The form in fact absolves you from later claims to influence uses of the pictures. Clients usually insist that all recognizable people in advertising and promotional pictures have given signed releases – whether against a fee or just for a tip. The exceptions are press and documentary type shots where the people shown form a natural, integral part of the scene, and are not being used commercially.

Copyright

Be on your guard against agreements and contracts for particular jobs which take away from you the copyright of the resulting pictures. In most countries today the copyright in a photograph remains with the photographer (unless he or she is working as the salaried employee photographer). This is important when it comes to reprints, further use fees, and general control over who else may use a picture. If an agreement permanently deprives you of potential extra sources of revenue – by surrender of transparency or negative, for example – this should be reflected by an increased fee. A commissioning form will help clarify the situation to both parties before you begin.

Promoting yourself

Like any other service industry, professional photography needs energetic marketing if it is to survive and flourish. The kind of sales promotion you need to use for a photographic business which has no direct dealings with the public naturally differs from one which must compete in the open market place. However, there are important common features to bear in mind too.

Your premises need to give the right impression to a potential client. The studio may be an old warehouse or a high-street shop, but its appearance should suggest liveliness and imagination, not indifference, decay or inefficiency. Decor and furnishings are important, and should reflect the style of your business. Keep the place clean. Use equipment which looks professional and reliable.

The business name, logo, notepaper and packaging design, along with all your printed matter, should have a coherent house style. Take great care over your portfolio of specimens of work too. Make sure this is well presented, and specially selected and ordered to suit the interests of the particular prospective client. Include tear-sheets from publications, etc. where your pictures have been used, to help inspire confidence. Talk clients through the collection of pictures, adding relevant information they will want to know. If you don't feel up to this kind of salesmanship then employ a good agent who will take the work around on your behalf.

Remember that you yourself need to project energy, enthusiasm and interest, skill and reliability. Take similar care with anyone you hire as your assistant. On location arrive on time, in professional looking transport containing efficiently packed equipment. If you want to be an eccentric this will ensure you are remembered short term, but your work has to be that much better to survive such an indulgence. Most clients are arch-conservatives at heart. It is a sounder

MODEL RELEASE FORM

To

In consideration of your agreeing to pay me my fee for posing for photograph(s) taken or to be taken by you, I hereby acknowledge and agree:

that the entire copyright (which includes all rights of reproduction) in the photograph(s) belongs to you.

that you and/or your licensees or assignees are entitled to make whatever use of the photograph(s) and all reproductions thereof, either wholly or in part, in any manner or form whatsoever and in any medium and either separately or in conjunction with other photograph(s), part or parts of photograph(s), drawings or other forms of illustration you or they decide.

that the said photograph(s) whether or not retouched, altered or worked up, and all reproduction thereof, and any statements and/or words published in conjunction therewith or in relation thereto shall be deemed to represent and refer to an imaginary person AND NOT MYSELF

that unless my name is published, used or referred to in connection with the publication of the photograph(s), neither the photograph(s) nor any reproduction thereof nor any statement or words published or reproduced in conjunction with or in relation thereto shall be deemed to be attributed to me PERSONALLY.

* I am over 18 years of age.

* I am *not* over 18 years of age but my parent/guardian has agreed to my undertaking this work and to the use of this/these photograph(s) as mentioned herein. I have read and fully understand the terms of this contract. I authorize you to pay my fee for posing viz.

*to my agent

* to me ... Address ..

Signed ...

Date of
sitting(s) ..

* Delete whichever does not apply Job Number ...

policy to be remembered for the quality of your pictures rather than for theatrical thrills thrown in while performing.

During shooting give the impression that you know what you are about. Vital accessories left behind, excessive fiddling with meters, equipment failures and a feeling of tension (quickly communicated to others) give any assignment a kiss of death. Good preparation plus experience and confidence in your equipment should permit a relaxed but competent approach. In the same way, by adopting a firm and fair attitude when quoting your charges you will imply that these have been established with care and that incidentally you are not a person who is open to pressure. If fees are logically based on the cost of doing the job, discounts are clearly only possible if short cuts can be made to your method of working.

E: Colour conversion filter chart

Locate the colour temperature of your subject light source in the left-hand column. In the right-hand column find the colour temperature to which your film is balanced. Use a straight edge to connect these two figures (see example) and read off the number of the correction filter you need from the middle column. In the example shown a subject in 5500K daylight exposed onto type B tungsten film requires use of an 85B filter.

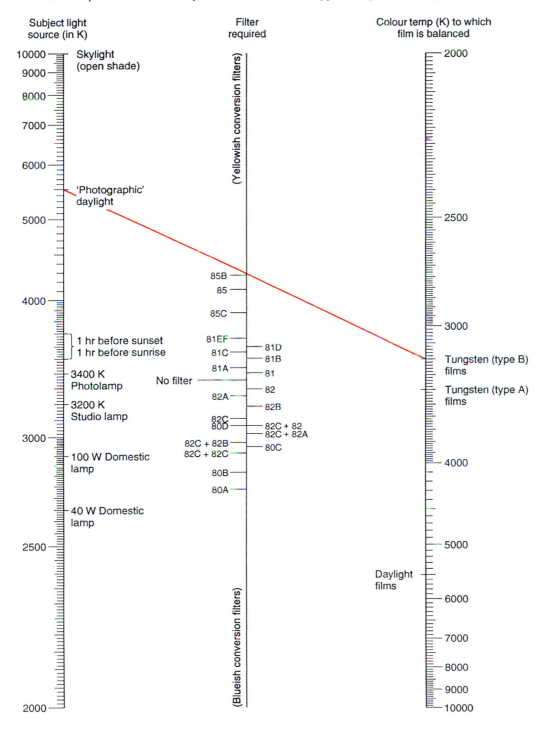

Subject light source (in K) | Filter required | Colour temp (K) to which film is balanced

(Yellowish conversion filters)

(Blueish conversion filters)

10000
9000 Skylight (open shade)
8000
7000
6000
'Photographic' daylight
5000
4000
 85B
 85
 85C
1 hr before sunset 81EF
1 hr before sunrise 81C 81D
 81A 81B
3400 K Photolamp No filter 81
 82A 82
3200 K Studio lamp 82B
 82C
3000 80D 82C + 82
100 W Domestic lamp 82C + 82B 82C + 82A
 82C + 82C 80C
 80B
 80A
40 W Domestic lamp
2500
2000

2000
2500
3000
Tungsten (type B) films
Tungsten (type A) films
4000
5000
Daylight films
6000
7000
8000
9000
10000

Glossary

aberrations Optical errors in a lens which limit its capabilities – causing the images it forms to differ from subject appearance, usually in small details.

accelerator Chemical ingredient of developer to speed up the otherwise slow activity of developing agents. Normally an *alkali* such as sodium carbonate, borax, or (high-contrast developers) sodium hydroxide. Also known as 'activator' or 'alkali component'.

acid Chemical substances with pH below 7. Because acid neutralizes an alkali, acidic solutions are often used to halt development – as in *stop bath* or *fixer*.

acutance Physical measure of how the transition from high density to low density reproduces in a developed film which has been exposed to a high contrast (test chart) subject.

A/D converter A device used to convert analogue (continuously variable) signals to digital (discrete steps) data.

adaption Ability of the eye to change its sensitivity to light (generally, or in different colour receptors). Adaption occurs naturally when there is a change in the colour or intensity of the subject light.

adaptor ring Narrow threaded ring which fits the front rim of a lens to allow use of accessories of a different ('step-up' or 'step-down') diameter.

additive colour processes Processes which represent subject colours by adding together different quantities of primary coloured light – red, green and blue.

additive printing Printing onto colour paper by giving separate red, green and blue light exposures.

AE Automatic exposure metering.

AE lock (AE-L) Control for holding a particular automatic exposure reading in the camera's memory.

aerial perspective Sense of depth conveyed by changes of tone with distance. Typically seen in a rolling landscape when atmospheric haze is present.

AF Autofocus.

AF illuminator Infra-red source, in camera flashgun or built into body, used to illuminate subject and assist the image-measuring autofocus lens mechanism.

AF lock (AF-L) Locks an autofocus lens in its present focus setting.

alkali Chemical substances with pH above 7. Solution feels slippery to the touch, can neutralize acid. See also *accelerator*.

aliasing Also known as 'jaggies'. A rough edge effect seen most clearly on diagonal lines in an electronic image. Created by low pixel resolution. Forms a noticeable 'staircase' appearance due to the large square pixels present. Becomes invisible in high resolution (small pixel) images.

ambient light General term covering existing subject lighting, i.e. not specially provided by the photographer.

anaglyph Method of viewing stereo pairs by which left-hand and right-hand positive stereo images are presented overlapped and in contrasting colours (typically deep red and deep green). You view these results through spectacles with green and red eyepieces, so that each eye sees only its respective image and you experience one 3D picture.

anastigmat lens Lens corrected to be largely free of astigmatism (totally so at one subject distance), and having minimal curved field.

angle of view Angle, formed at the lens, between lines from the extreme limits of a (distant) scene just imaged within the diagonal of the picture format. Varies with focal length and format size.

anhydrous (anhyd) Dehydrated form of a chemical. More concentrated than the same substance in crystalline form.

ANSI speed number American National Standards Institute number designating the light sensitivity of a printing paper.

anti-halation Light-absorbing dye present in film to prevent reflection or spread of light giving 'haloes' around bright highlights. Disappears during processing.

aperture preview SLR camera control to close the lens diaphragm to the actual setting used when exposing. For previewing depth of field.

aperture priority mode You set the lens aperture you require and the camera sets the appropriate shutter speed, to give correct exposure according to the camera's built-in metering system.

apochromat (apo) lens Lens highly corrected for chromatic aberration at three wavelengths (usually blue, green and red) instead of the customary two. Also dispenses with the need to correct your focus setting when taking infra-red pictures.

APS Advanced Photographic System. System of amateur easy-load cameras and film 24mm wide, introduced in 1996.

archival processing Procedures during processing aiming for the most stable image possible.

artificial light General term for any man-made light source. Artificial-light film, however, normally refers to tungsten illumination of 3200 K.

ASA American Standards Association, responsible for ASA system of speed rating. Doubling the ASA number denotes twice the light sensitivity. Now replaced by *ISO*.

aspheric contour A shape not forming part of a sphere. In lens manufacture this is physically difficult because most grinding/polishing equipment functions with spherical action.

auto-bracketing A rapid series of pictures taken by the camera automatically, each giving a slightly different exposure.

autochrome Early colour transparency (plate) system, using a mosaic of additive colour filters.

autofocus System by which the lens automatically focuses the image (for a chosen area of subject).

Av Aperture value. Auto-exposure camera metering mode. You choose the aperture, the meter sets the shutter speed. (Also known as aperture priority mode.)

B setting See *bulb.*

bag bellows Short, baggy form of bellows used on view cameras for a wide-angle lens. Allows camera movements otherwise restricted by standard lens bellows.

barndoors Set of folding metal flaps fitted around front of spotlight. Controls light spill or limits beam.

barrel distortion Aberration by which the image of a square is more magnified at the centre than at its edges – forming a shape like the cross-section of a barrel.

baryta paper See *fibre-based paper.*

baseboard camera Camera with fold-open baseboard, which supports lens and bellows.

between-lens shutter Bladed (or 'leaf') shutter positioned between elements of a lens, close to aperture.

bit Short for binary digit. The smallest unit of digital information in a computer, a 1 or a 0.

bit depth The number of bits used to represent each pixel in a digital image. (Determines its colour or tone range.)

bitmapped An image formed by a grid of pixels. The computer assigns a value to each pixel – ranging from 1 'bit' of information (simply black or white) to as much as 24 bits per pixel (assigning x, y coordinates, and Value, see page 88) for full colour images.

bleacher Chemical able to erase or reduce image density.

blooming The electronic equivalent of flare. Leakage of charge between CCD elements caused by gross overexposure forms streaks or haloes around bright image highlights.

blooming, of lenses See *lens coating.*

blue-sensitive Emulsion sensitive to the blue region only of the visible spectrum. Also known as 'ordinary'.

bounced light Light which is reflected off an intermediate surface before reaching the subject. If the surface is relatively large and matt surfaced the resulting illumination will be soft in quality.

bracket In exposure, to take several versions of a shot giving different exposure levels. See also *auto-bracketing.*

brightness range The difference in luminance between darkest and lightest areas of the subject or image. Combined effect of lighting ratio and subject reflectance range.

bromide paper Printing paper with predominantly silver bromide emulsion.

bulb Also 'brief'. The B setting on a shutter – keeps the shutter open for as long as the release remains pressed.

bulk film Film sold in long lengths, usually in cans.

burning-in See *printing-in.*

byte Standard measurement of digital file size. One byte represents 8 binary digits, allowing 255 possible numerical combinations (different sequences of 1s and 0s). One kilobyte is 1024 bytes and so on. See also *grey level.*

C-41 Processing chemicals and procedure used for the vast majority of colour (and monochrome chromogenic) negative films.

cable release Flexible cable which screws into the camera shutter release. Allows shutter to be fired (or held open on 'B') with minimal shake.

capacitor Unit for storing and subsequently releasing a pulse of electricity.

cast Overall bias towards one colour.

CCD element A single light-sensitive area within a CCD able to record a unique image detail. Known also as a photosite. The distance between the centres of two adjacent CCD elements is known as their element pitch.

CD-ROM Compact disc, read-only memory. Similar in appearance to 5.25 in audio CD, able to carry large

quantities of computer compatible digital data, including images and application software programs.

CdS Cadmium disulphide. Battery-powered light sensor cell, widely used in exposure hand meters.

characteristic curve Graph relating exposure to resulting image density, under given development conditions. Also known as H and D curve.

chlorobromide paper Warm-tone printing paper. Emulsion contains silver chloride and silver bromide.

chromogenic process Colour process which uses dyes chemically formed during processing to create the hues of your final image. Results contain no silver.

CI See *contrast index.*

Cibachrome Outdated product name for dye-bleach colour print material now known as Ilfochrome.

CIE Commission Internationale de l'Eclairage. Originator of a standard system for precise description of colours.

circles of confusion Discs of light making up the image formed by a lens, from each point of light in the subject. The smaller these discs the sharper the image.

clearing time The time taken in a fixing bath for a film emulsion to lose its milky appearance.

click stops Aperture settings which you can set by physical 'feel' as well as by observing a printed scale.

close-up lens Additional element added to the main lens, to focus close objects.

cold-light enlarger Enlarger using a fluorescent tube grid. Gives extremely diffused illumination.

C-MOS More recent, and potential successor to CCD as an electronic imaging light-sensor. Advantages include higher pixel count, less battery power consumption and lower cost.

CMYK Cyan, magenta, yellow (and black). The first three are the basic subtractive colour dyes formed in most colour emulsions, and for printers' inks. (As pure black is unobtainable by combining CMY inks it is added as a '4th colour' in printing, to improve image body and contrast.)

colloidal silver A suspension of finely divided silver particles – e.g. coating the bottom of trays and deep tanks containing used developer, or covering the emulsion itself as 'dichroic fog'.

colour development A step in processing (or toning) in which coupler compounds become coloured where development is taking place.

colour head An enlarger lamp-head with a CMY colour printing filtering system built in.

colour separation exposures A series of three separate exposures, taken through deep red, green and blue filters onto panchromatic black and white film. By recombining these images in appropriate final dyes, inks or pigments, all the colours of the original scene can be recreated.

colour management system (CMS) Electronic calibration program to ensure uniformity of colour appearance of digital images across input/monitor/output devices. Should ensure that what you see on the monitor matches what you finally receive printed out.

colour temperature Way of defining the colour of a (continuous spectrum) light source, in kelvins. Equals the temperature, Absolute scale, at which a metal black body radiator would match the source in colour.

complementary colours Resulting colour (cyan, magenta or yellow) when one of the three primary colours (red, green or blue) is subtracted from white light. Also called 'subtractive primaries', 'secondary colours'.

compression Compression of digital image data, to reduce storage requirements or transmission speed across networks. Can be 'lossless' or 'lossy (allowing greater compression at the expense of resolution. See also *JPEG.*

condenser Simple lens system to concentrate and direct light from a source, e.g. in a spotlight or enlarger.

contact print Print exposed in direct contact with negative, therefore matching it in size.

contrast index (CI) A measure of contrast used by Kodak. Determined, in simple terms, by drawing an arc 2.0 (baseline) units long cutting the material's characteristic curve and centred on a point which is 0.1 units above minimum density. The slope of the straight line joining these two points is the contrast index. You give it a numerical form by continuing the straight line until it cuts the baseline, then quote the tangent of the angle made. Typically a film developed to a CI of 0.56 should print well on grade 2 paper, using a diffuser enlarger.

control strips Pre-exposed strips of film or paper used to test the accuracy and consistency of processing.

coupled dyes Compounds which have reacted to the (by)products of colour development to form visible colours.

covering power The area of image considered of useful quality that a lens will produce. Must exceed your camera picture format, generously so if movements are to be used.

CPU Central processing unit. The main box-like part of a computer, containing its processor chip and motherboard.

cropping To trim one or more edges of an image, usually to improve composition.

cross front Camera movement. Sideways shift of lens, parallel to film plane.

CWA Centre-weighted average. Exposure measured by averaging out picture contents, paying more attention to central areas than corners.

CRT Cathode ray tube.

D log E curve See *characteristic curve*

D max Maximum density.

D min Minimum density.

dark current Spurious electrical charge which progressively builds up in CCD elements without exposure to light. Creates 'noise'.

darkslide Removable plastic or metal sheet fronting a sheet-film holder or film magazine.

daylight film Colour film balanced for subject lighting of 5500 K.

DCS Digital camera system. The designation used by Kodak/Nikon for their range of SLR digital cameras.

dedicated flash Flash unit which fully integrates with camera electronics. Sets shutter speed; detects film speed, aperture, light reading, subject distance, etc.

dense Dark or 'thick', e.g. a negative or slide which transmits little light. Opposite to 'thin'.

densitometer Electro-optical instrument for reading the densities of a film or paper image.

density Numerical value for the darkness of a tone. The log (base 10) of *opacity*.

depth mode Automatic-exposure camera program which aims to preserve as much depth of field as possible in selecting aperture and shutter speed settings.

depth of field Distance between nearest and furthest parts of a subject which can be imaged in acceptably sharp focus at one setting of the lens.

depth of focus Distance the film (or printing paper) can be positioned either side of true focus while maintaining an acceptably sharp image, without refocusing the lens.

developing agent Chemical ingredient(s) of a developer with the primary function of reducing light-struck silver halides to black metallic silver.

desktop The computer monitor screen, i.e. on which is displayed your working image together with menus, tools and other digital processing controls.

diaphragm Aperture formed by an overlapping series of blades. Allows continuous adjustment of diameter.

diffraction Change in the path of light rays when they pass close to an opaque edge.

diffusion transfer process Any process by which a positive photographic print is made by physically transferring silver, or dyes, from the exposed material onto a receiving surface.

digital Something represented by, or using, numbers. A string of pulses of either 0 or 1 values only. Images in digital form are relatively easy to manipulate electronically, edit and re-record without quality losses. Also used in photography as a general term to differentiate forms of image sensing, processing, etc. which function by electronic rather than chemical means.

digital lenses Lenses, normally for medium- or large-format cameras, designed to give appropriately high optical image resolution and flat field to match the performance of high-end matrix or linear array digital (CCD) sensors.

DIN Deutsche Industrie Normen. German-based system of film speed rating, much used in Europe. An increase of 3 DIN denotes twice the light sensitivity. Now replaced by *ISO*.

dioptre Reciprocal of a metre. The dioptric power of a lens is its focal length divided into one metre.

dodging See *shading*.

DPI Dots per inch. A measure of the image resolution of an electronic scanner or printer.

drum scanner Highest quality scanner for transparencies, negatives and prints. Originals are mounted on the curved surface of a rotating transparent drum, read by a fine beam of transmitted or reflected light line by line and gradually advancing in very fine increments.

dry mounting Bonding a photograph to a mount by placing dry, heat-sensitive tissue between the two and applying pressure and heat.

drying mark Uneven patch(es) of density on film emulsion, due to uneven drying. Cannot be rubbed off.

DTP Desk-top publishing.

DX coding Direct electronic detection of film characteristics (speed, number of exposures, etc.) via sensors in the camera's film-loading compartment.

dye-bleach processes Colour processes by which three even layers of ready-formed dyes are destroyed (bleached) in certain areas. The dyes remaining form the final coloured image.

dye-image film Film in which the final processed image comprises dyes, not black silver.

dye-sublimation A desk-top digital printing process which uses tiny heating elements to evaporate CMY pigments from a plastic carrier band, depositing these smoothly onto a receiving surface such as paper. See page 286.

dye transfer process Assembly colour print process. Three final-size black and white positives are printed from colour separation negatives (or from a colour negative printed through tri-colour filters) on matrix films. After gelatin-hardening development and hot water treatment the film's hardened gelatin forms relief 'printing plates'. You soak each positive separation in a complementary dye, Y, M or C, then squeegee them in turn onto a sheet of receiving paper to transfer their dye images. Excellent quality, but requires a high degree of control to achieve objective results.

dynamic range Electronic terminology for the maximum tone range that a recording medium can capture.

E-6 Processing chemicals and procedure used for the vast majority of colour slide/transparency films.

easel See *masking frame*.

edge numbers Frame number, film type information, etc., printed by light along film edges.

effective diameter (of lens aperture) Diameter of light beam entering lens which fills the diaphragm opening.

electronic flash General term for common flash units which create light by electronic discharge through a gas-filled tube. Tubes give many flashes, unlike expendable flashbulb systems.

emulsion Mix of light-sensitive silver halides, plus additives, and gelatin.

emulsion lift Term referring to the process by which the image-carrying top surface of a Polaroid print is removed from its paper base, physically manipulated and resited on a new (paper or film) support. See page 296.

EV Exposure value.

exposure-compensation dial Camera control effectively overriding film-speed setting (by + or – exposure units). Used when reading difficult subjects, or if film is to be 'pushed' or 'held back' to modify contrast.

exposure latitude Variation in exposure level (over or under) which still produces acceptable results.

exposure zone One of the 0-IX one-stop intervals into which the exposure range of a negative is divided in the zone system.

extension tube Tube, fitted between lens and camera body, to extend lens-to-film distance and so allow focusing on very close subjects.

*f***-numbers** International sequence of numbers, expressing relative aperture, i.e. lens focal length divided by effective aperture diameter. Each change of *f*-setting halves or doubles image brightness.

false colour film Film designed to form image dyes which give a positive picture in colours substantially different to those in the subject – e.g. Infra-red Ektachrome.

fast Relative term – comparatively very light-sensitive.

ferrotype sheet Polished metal plate used for glazing glossy fibre-based prints.

fibre-based paper Printing paper with an all-paper base.

field camera Traditional type view camera, often made of wood. Folds for carrying on location.

file Like an office file of related documents this digital term means a package of related digits – for example, one photographic image.

file size Volume of digital data. Determined by (a) chosen image resolution and (b) the dimensions of your final image.

fill-in Illumination that lightens shadows, so reducing contrast.

film holder Double-sided holder for two sheet films, used with view cameras.

film pack Stack of sheet films in a special holder. A tab or lever moves each in turn into the focal plane.

film plane The plane, in the back of the camera, in which the film lies during exposure.

film speed Figure expressing relative light sensitivity. See *speed point*.

filter (optical) Device to remove (absorb) selected wavelengths or a proportion of all wavelengths.

filter (electronic) A device built into a software program, or added as a 'plug in', to alter a digital image in some specific way. Examples – blur, sharpen, dispeckle, distort shape.

filter factor Factor by which exposure should be increased when an optical filter is used. (Does not apply if exposure was read through lens plus filter.)

fisheye Extreme wide-angle lens, uncorrected for curvilinear distortion.

fixer Chemical solution which converts silver halides into soluble salts. Used after development and before washing, it removes remaining light-sensitive halides, so 'fixing' the developed black silver image.

flare Unwanted light, scattered or reflected within lens or camera/enlarger body. Causes flare patches, degrades shadow detail.

flashbulb Older type of flash source. Usable once only and ignited by simple battery/capacitor system.

flashing Giving a small extra exposure (to an even source of illumination) before or after image exposure. Lowers the contrast of the photographic material.

flash memory e.g. Smart Media or Compact Flash. Card system able to remember image data, even when power is turned off. Used to store images in many compact digital cameras, and removable to plug into card reader, lap-top computer, etc.

flat A subject or image lacking contrast, having minimal tonal range. Also the name for a temporary structure used in the studio to simulate a wall.

flat-bed scanner Lightbox type device able to convert photographic prints, artwork or transparencies up to about 8 × 10 (including mounted originals) into digitalized data for inputting to computer.

fluorescence The visible light radiated by some substances when stimulated by (invisible) ultra-violet light.

focal length Distance between a sharp image and the lens, when the lens is focused for an infinity subject. More precisely, between this image and the lens's rear nodal point.

focal plane Plane on which a sharp-focus image is formed. Usually at right angles to lens axis.

focus hold See *AF lock*.

focus priority See *trap focus*.

fog Unwanted veil of density (or bleached appearance, in reversal materials). Caused by accidental exposure to light or chemical reaction.

format or 'frame' General term for the picture area given by a camera.

FP sync Camera shutter flash synchronization circuit designed to suit FP ('focal plane') flashbulbs, now discontinued.

gamma Tangent of the angle made between the base and straight-line portion of a film's characteristic curve. Once used as a measure of contrast.

gelatin Natural protein used to suspend silver halides evenly in an emulsion form. Permits entry and removal of chemical solutions.

glossy Smooth, shiny print-surface finish.

gradation Variation in tone

graded papers Printing papers of fixed contrast. You must purchase a packet or box of each of the different grades you need.

graduate Calibrated container for measuring liquids.

grain Clumps of processed silver halides forming the image. Coarse grain destroys detail, gives a mealy appearance to even areas of tone.

grey level Each discrete tonal step in an electronic image, encoded in its digital data. Most electronic images contain 256 grey levels (= 8 bits) per colour.

grey scale Set of tones, usually in steps from minimum to maximum density. Grey scales are available on paper or film base. They can be used to lay alongside subjects to act as a guide in final printing. Grey scales exposed onto photographic material act as process control strips.

guide number Number for simple flash exposure calculations, being flashgun distance from subject times *f*-number required (ISO 100/21° film). Normally relates to distances in metres.

hard Contrasty – harsh tone values.

hard disk Digital memory device, often permanently housed inside the computer but also in removable form (e.g. Syquest, or type III PC card).

hardener Chemical which toughens the emulsion gelatin.

hardware Equipment. In digital photography the computer, film scanner, digital back, etc., rather than the software programs needed to run them. Similarly in silver halide photography items such as the camera, enlarger, processor, rather than film or paper.

high key Scene or picture consisting predominantly of pale, delicate tones and colours.

highlights The brightest, lightest parts of the subject.

histogram The tonal range of an image shown graphically as a chart containing a series of vertical bars. See page 170.

HMI Hydrargyrum Medium Arc Iodide. Specialist continuous type light source, flicker-free and with a daylight matching colour temperature.

holding back Reducing development (often to lower contrast). Usually preceded by increased exposure. Also called 'pulling'. Term is sometimes used to mean *shading* when printing.

hot shoe Flashgun accessory shoe on camera; it incorporates electrical contacts.

hue The colour – blue, green, yellow, etc. – of a material or substance.

hyperfocal distance Distance of the nearest part of the subject rendered sharp with the lens focused for infinity.

hypo Abbreviation for sodium hyposulphite, the fixing agent since renamed sodium thiosulphate. Also common term for all fixing baths.

icons Graphical representation on the computer screen of a file or application (e.g. tool box for image

manipulations, page 283). Typically accessed by locating your cursor on a chosen icon and double clicking the mouse.

image setter Digital output device. A high resolution laser exposes image data, typically in screened form, onto photographic film which is then used to make ink printing plates.

incandescent light Illumination produced from electrically heated source, e.g. the tungsten wire filament of a lamp.

incident light Light reaching a subject, surface, etc.

incident-light reading Using an exposure meter at the subject position, pointed towards the camera, with a diffuser over the light sensor.

infinity A subject so distant that light from it effectively reaches the lens as parallel rays. (In practical terms the horizon.)

inkjet printer Digital printer forming images by using a very fine jet of one or more inks.

instant-picture material Photographic material with integral processing, e.g. Polaroid.

integral tripack Three-layered emulsion. Term still often applied to modern colour emulsions which may utilize many more layers but are still essentially responsive to red, green and blue.

internegative Intermediate negative – usually a colour negative printed from a colour transparency in order to make a neg/pos colour print.

Internet Global connection system between computer networks, for two-way flow of information.

interpolation Increasing the number of pixels in an electronic image file by 'filling in' the missing colour information from the averaged values of surrounding pixels. Image definition is reduced. May be necessary if an image was scanned in at insufficient resolution for your final print size.

inverse square law With a point source of light, intensity at a surface is inversely proportional to the square of its distance from the source: i.e. half the distance, four times the intensity.

inverted telephoto lens A lens with rear nodal point well behind its rear element. It therefore has a short focal length but relatively long lens-to-image distance, allowing space for an SLR mirror system.

IR Infra-red. Wavelengths longer than about 720 nm.

IR focus setting Red line to one side of the lens focus-setting mark, used when taking pictures on IR film. See page 81.

ISO International Standards Organization. Responsible for ISO film speed system. Combines previous ASA and DIN figures, e.g. ISO 400/27°.

joule See *watt-second*.

JPEG Joint Photographic Experts Group. Standard image data compression scheme used to reduce the file size of digital images. Known also as 'lossy' compression because of the permanent loss of some data during the process.

kelvin (K) Measurement unit of colour temperature. After scientist Lord Kelvin.

keylight Main light source, usually casting the predominant shadows.

kilowatt One thousand watts.

kilobyte One thousand bytes of data.

large format General term for cameras taking pictures larger than about 6 × 9 cm.

laser printer Normally refers to digital printers using the xerographic (dry toner) process, although several other devices such as light-jet employ laser technique.

latent image Exposed but still invisible image.

latitude Permissible variation. Can apply to focusing, exposure, development, temperature, etc.

LCD screen Liquid crystal display screen. Commonly used for laptop computer monitors; small playback or viewfinder screens attached to compact digital cameras; or used as a transparent frame on an overhead projector to form a 'data projector' for presenting large images direct from computer memory. Also the source of electronically energized black lettering, symbols, etc. used in a camera's viewfinder or top-plate readout.

leafshutter See *between-lens shutter.*

LED Light-emitting diode. Gives illuminated signal (or alphanumeric information) alongside camera viewfinder image, and in other equipment displays.

lens coating Transparent material deposited on lens glass to suppress surface reflections, reduce flare and improve image contrast.

lens hood, or shade Shield surrounding lens (just outside image field of view) to intercept side-light, prevent flare.

light meter Device for measuring light and converting this into exposure settings.

light trap Usually some form of baffle to stop entry of light yet allow the passage of air, solution, objects, according to application.

lighting ratio The ratio of the level of illumination in the most strongly lit part of the subject to that in the most shadowed area (given the same subject reflectance throughout).

line image High contrast image, as required for copies of line diagrams or drawings.

linear array CCD sensor comprising a narrow row of RGB bar-filtered photosites. This scans across the image (within a camera or flat-bed scanner, for instance) driven by a stepper motor.

linear perspective Impression of depth given by apparent convergence of parallel lines, and changes of scale, between foreground and background elements.

line pair (lp) One black line plus the adjoining white space on an optical test chart pattern.

lith film Highest contrast film. Similar to line but able to yield negatives with far more intense blacks.

log E scale Range of exposures expressed on a logarithmic scale (base 10). Here each doubling of exposure is expressed by an increase of 0.3.

long-peaking flash Electronic flash utilizing a fast stroboscopic principle to give an effectively long and *even* peak of light. This 'long burn' allows an FP shutter slit to cross and evenly expose the full picture format, at fastest speeds.

lossy compression See *JPEG.*

low key Scene or picture consisting predominantly of dark tones, sombre colours.

luminence Brightness. The amount of light energy emitted or reflected.

M Medium-delay flashbulb. Flash sync connections marked M close the circuit before the shutter is fully open. Sometimes found on vintage cameras. Do not use for electronic flash.

macro lens Lens specially corrected to give optimum definition at close subject distances.

macrophotography See *photomacrography.*

magnification In photography, linear magnification (height of object divided into height of its image).

manual override The capability to operate an automatic camera in a manual, i.e. non-automatic mode.

masking General term for a wide range of methods of selectively modifying tone, contrast and colour rendering of existing negatives or transparencies before printing or reproduction. Achieved through sandwiching a parent image with film bearing positive or negative versions made from it and having controlled tonal characteristics. Also achieved electronically, e.g. during scanning for photomechanical reproduction.

masking frame Adjustable frame which holds printing paper during exposure under enlarger. Also covers edges to form white borders.

mat, or overmat Cardboard rectangle with cut-out opening, placed over print to isolate finished picture.

matrix array A CCD sensor in the form of a flat grid of photosites. Therefore allows the full image in the camera to be captured instantaneously, i.e. moving subject matter, or use of flash. Also known as an area array.

matt Non-shiny, untextured surface finish.

maximum aperture The widest opening (lowest *f*-number) a lens offers.

ME Multiple exposure control. Allows superimposition of pictures in the camera.

megabyte One million bytes of data.

microphotography Production of extremely small photographic images, e.g. in microfilming of documents.

midtone A tone midway between highlight and shadow values in a scene.

mired Micro-reciprocal degree. Unit of measurement of *colour temperature*; equal to one million divided by colour temperature in kelvins.

mirror lens Also 'catadioptric' lens. Lens using mirrors as well as glass elements. The design makes long focal length lenses more compact, less weighty, but more squat.

mirror lock (ML) Enables the viewing mirror of an SLR camera to be locked in the 'up' position while the shutter, etc. is used normally. Used to avoid vibration; or to operate motor drives at fastest framing rates; or to accommodate some extreme short focal length lens.

mode The way in which a procedure (such as measuring or setting exposure) is to be carried out.

modelling light Continuous light source, positioned close to electronic flash tube, used to preview lighting effect before shooting with the flash itself.

modem MOdulator/DEModulator. Converts digital data to analogue signals and as such is the unit which connects your computer to a non-digital telephone system for transmission of information by audio means.

moiré pattern Coarse pattern formed when two or more patterns of regular lines or textures are superimposed nearly but not exactly in register. Term derived from pattern effects when layers of moiré silk are overlapped.

monochrome Single colour. Also general term for all forms of black and white photography.

monorail camera Metal-framed camera, built on rail.

motor drive Motor which winds on film after each exposure.

MTF Modulation transfer function. A measure of the ability of an imaging system (lens, or recording medium, or both) to resolve fine detail.

Multimedia Presentation method (often interactive) integrating still images, video, text and audio components. Ranges from theatrical scale shows to CD-ROMs produced for use by individuals on personal computers.

ND Neutral density. Colourless grey tone.

neutral density filter Colourless grey filter which dims the image by a known amount.

nodal points Two imaginary points on the lens axis where it is crossed by the principal planes of the lens (given that the same medium, e.g. air, is on both sides of the lens). Rotating a lens about a vertical axis passing through its rear nodal point leaves the image of a distant subject stationary – a principle exploited in panoramic cameras.

normal (or 'standard') lens Lens most regularly supplied for a particular camera; typically has a focal length equal to the diagonal of the picture format.

notching code Notches in sheet film, shape-coded to show film type.

object The thing photographed. Often used interchangeably with *subject*.

offset lithography High volume, ink-based mechanical printing process, by which ink adhering to image areas of a lithographic plate is transferred (offset) to a 'blanket' cylinder before being applied to paper or other suitable receiving surface. See page 272.

OHP Overhead projector. Lightbox with lens and 45° mirror unit supported above it. Projects large transparencies etc. onto a screen for group viewing.

one-shot processing Processing in fresh solution, which is then discarded rather than used again.

opacity Incident light divided by light transmitted (or reflected, if tone is on a non-transparent base).

open flash Firing flash manually while the camera shutter is held open.

ortho Orthochromatic sensitivity to colours. Monochrome response to blue and green, insensitive to red.

OTF Off the film. Light measurement of the image while on the film surface during exposure – essential for through-the-lens reading of flash exposures.

outputting Creating an actual print or transparency of some kind from a digital image (Image quality and size mainly determined by file size.)

pan and tilt head Tripod head allowing smooth horizontal and vertical pivoting of the camera.

pan film Panchromatic sensitivity. Monochrome response to all colours of the visual spectrum.

panning Pivoting the camera about a vertical axis, e.g. following horizontal movement of subject.

parallax Difference in viewpoint which occurs when a camera's viewfinding system is separate from the taking lens, as in compact and TLR cameras.

PC lens Perspective control lens. A lens of wide covering power on a shift (and sometimes also pivoting) mount. See *shift lens*.

PCMCIA card Also known as a PC card and established by the Personal Computer Memory Card International Association. A small digital storage device about the size of a credit card containing (type I and II) solid state or (type III) small hard disk memory system. Can be removed from one device (e.g. digital camera) to another (e.g. computer processing unit.)

PE Continental code for resin-coated paper. See *RC paper*.

PEC Photo-electric cell. Responds to light by generating minute current flow. Used in older, non-battery hand meters.

pentaprism Multi-sided silvered prism. Reflects and converts laterally reversed image on the focusing screen of an SLR camera to a right-reading form.

PF Power focus control. Manual focusing performed electronically by pressing buttons or a lever on the camera body. (Like controlling electrically driven windows in a car.)

pH Acid/alkalinity scale 0–14, based on hydrogen ion concentration in a solution. 7 is neutral, e.g. distilled water. Chemical solutions with higher pH ratings are increasingly alkaline, lower ones acid.

photoCD A Kodak designed CD format for storing photographs as digital files. Typically one disc may contain up to 100 images, each one stored in five levels of resolution.

photoflood Bright tungsten studio-lamp bulb. Often 3400 K.

photogram Image recorded by placing an object directly between sensitive film (or paper) and a light source.

photomacrography Preferred term for extreme close-up photography giving magnification of ×1 or larger, without use of a microscope.

photomicrography Photography through a microscope.

PhotoShop An industry standard computer software program for manipulating digital photographic images.

photosite See *CCD*.

pincushion distortion Aberrations by which the image of a square is less magnified at the centre than at its edges – forming a shape like a nineteenth century pincushion.

pixel Abbreviation of 'picture element'. The smallest element capable of resolving detail in a light-sensitive (i.e. CCD) device, or displaying detail on a monitor screen. Digital images are composed of thousands or millions of pixels – the eye merges these differently coloured spots into areas of continuous tones and additively formed colours.

PMT Photomultiplier tube. Light sensing devices long established in use in drum scanners.

polarized light Light waves restricted to vibrate in one plane at right angles to their path of direction.

polarizing filter Grey-looking filter, able to block polarized light when rotated to cross the plane of polarization.

Polaroid back Camera magazine or film holder accepting instant-picture material.

polycontrast See *variable-contrast paper.*

positive Image with tone values similar to those of the original subject.

PQ Developer using phenidone and hydroquinone as developing agents.

preservative Chemical ingredient of processing solution. Preserves its activity by reducing oxidation effects.

press focus Lever on most large-format camera shutters. Locks open the shutter blades (to allow image focusing) irrespective of any speed set.

primary colours Of light: red, green and blue.

printing-in Giving additional exposure time to some chosen area, during printing.

program, programme, or P Setting mode for fully automatic exposure control. The camera's choice of aperture and shutter settings under any one set of conditions will then depend on its built-in program(s).

program back Data imprinting camera back with additional camera control features such as auto-bracketing, time-lapse, and exposure program display.

program shift 'Program' mode allows the camera to select both shutter and aperture settings, but the shift control allows user to bias it towards faster shutter speeds, or smaller apertures ('speed' or 'depth').

May also be biased automatically, when you fit either a wide-angle or a telephoto lens.

pulling See *holding back.*

push-processing Increasing development, usually to improve speed or increase contrast.

RAM Random access memory. Integrated circuits providing a temporary data store in a computer, etc., to allow rapid data access and processing. Data held on RAM is lost when the computer is switched off. See also *ROM*.

rangefinder Optical device for assessing subject distance, by comparison from two separate viewpoints.

rapid fixer Fast-acting fixing bath using ammonium thiosulphate or thiocyanate as fixing agent.

RC paper Resin (plastic) coated base printing paper.

rebate Unexposed parts outside a film's picture areas.

reciprocity failure Breakdown of the usual reciprocal exposure relationship between time and intensity (twice the exposure time compensates for an image half as bright, and vice versa).

reciprocity law Exposure = intensity × time.

reducer Chemical able to reduce the density of a processed image. (Paradoxically the term 'reducing agent' is also applied to developing agents.)

reflected-light reading Measuring exposure (usually from the camera position) with the light sensor pointing towards the subject.

refraction Change in the direction of light as it passes obliquely from one transparent medium into another of different refractive index.

relative aperture See *f-number.*

replenisher Solution of chemicals (mostly developing agents) designed to be added in controlled amounts to a particular developer, to maintain its activity and compensate for repeated use.

resampling See *Interpolation.*

restrainer Chemical component of developer which restrains it from acting on unexposed halides.

retrofocus lens See *inverted telephoto lens.*

reversal system Combination of emulsion and processing which produces a direct image of similar tonal values to the picture exposed onto the material.

RGB Red, green, blue. The primary colours of light. The tri-colour (additive) filter colours used in digital cameras, scanners, etc. to record the full spectrum of image colours. Images are also reformed on computer monitors, TV screens, and additive photographic colour materials (Polachrome) by means of primary coloured phosphors or filter mosaics.

ring flash Circular electronic flash tube, fitted around the camera lens.

rising front Camera front which allows the lens to be raised, parallel to the film plane.

rollfilm back Adaptor back for rollfilm.

ROM Read only memory. Form of digital memory which can only be read from – cannot be over-

written. The basic instructions that make a computer work, permanently installed at the factory, are stored in ROM. See also *RAM.*

safelight Working light of the correct colour and intensity not to affect the light-sensitive material in use.

saturated colour A strong, pure hue – undiluted by white, grey or other colours.

scanners A variety of computer input devices, able to convert an existing image into a stream of digital data. See *Flat-bed, Drum,* etc.

screen ruling (Also screen frequency). The number of rows of dots in a halftone image within a given distance – normally quoted in lines per inch (lpi).

SCSI Small Computer Systems Interface. Cabled hardware used between a computer and peripheral devices. Allows data to be transferred at high speed. (Cable length is, however, restricted).

second curtain sync Camera synchronization for electronic flash whereby contacts are closed just before the second blind of the FP shutter starts to close. With long duration exposures this means that flash records sharp detail at the *end* of exposure, and blur trails due to any movement record during the earlier part – e.g. moving objects in pictures 'head up' their blur, and do not record as if moving backwards.

secondary colours See *complementary colours.*

selective focusing Precise focus setting and shallow depth of field, used to isolate a chosen part of a scene.

self-timer Delayed-action shutter release.

shading Blocking off light from part of the picture during some or all of the exposure.

shadows In exposure or sensitometric terms, the darkest important tone in the subject.

sheet film Light-sensitive film in the form of single sheets.

shift camera General term for a bellowless, wide-angle architectural camera with movements limited to up/down/sideways shift of the lens panel. No pivots or swings.

shift lens Wide-covering-power lens in a mount permitting it to be shifted off-centre relative to film format.

shutter priority mode You set the shutter speed and the camera sets the appropriate aperture to give correct exposure according to the built-in metering system. Also known as *Tv mode.*

signal-to-noise ratio In digital analogue data the ratio of valid information to unwanted electrical interference. (Roughly equivalent to fog level on silver halide film.) The S/N ratio should always be as high as possible.

silver halides Light-sensitive compounds of silver plus alkali salts of a halogen chemical – e.g. bromine, chlorine, iodine. Now also used as a general term for photography using chemical coated film and paper, to differentiate it from newer

electronic methods of photography, i.e. utilizing CCD light sensors.

slave unit Flash unit which reacts to light from another flash and fires simultaneously.

SLR Single-lens reflex.

snoot Conical black tube fitted over spotlight or small flood. Restricts lighting to a small circular patch.

soft (1) Low contrast. (2) Slightly unsharp or blurred.

software In digital photography programs or 'applications' which tell the computer how to manage and present data in a way best suited to what you want to achieve.

spectrum Radiant energy arranged by wavelength. The visible spectrum, experienced as light, spans 400–700 nm.

speed mode Automatic exposure camera program aiming to preserve as much freezing of action as possible in selecting shutter speed and aperture.

speed point Point on a photographic material's characteristic curve used to determine the speed rating of a film (or paper). For example, in current ISO and DIN systems two points (M and N) are shown on the material's characteristic curve. M lies where processed density is 0.1 above fog. N lies 1.3 log exposure units from point M in the direction of increasing exposure, and development time is picked which makes N correspond to a processed density of 0.8 greater than M. When these conditions are satisfied the exposure at M is the numeral value from which the speed rating is calculated.

spot meter Hand meter, with aiming viewfinder, to make spot exposure readings.

spot mode Narrow-angle exposure reading of the subject with a TTL meter. The small area measured is outlined on camera's focusing screen.

spotting Retouching-in small white specks or hairs, generally on prints – using water colour, dye or pencil.

still life General term for an inanimate object, set up and arranged in or out of the studio.

still video A now largely outdated electronic camera system producing an analogue signal recorded onto an internal floppy disk. Overtaken by modern digital camera devices.

stock shots Photographs taken for long-term picture library use (and often sold time and again over the years). Stock shots are catalogued under thousands of cross-referred subject types. They are increasingly marketed as CD-ROMs containing 100 or so images per disk.

stock solution Chemical stored in concentrated liquid form, diluted for use.

stop bath Acidic solution which halts development, reduces fixer contamination by alkaline developer.

strobe Inaccurate general term for electronic flash. Strictly means fast-repeating stroboscopic lamp or flash.

subject The thing being photographed. Term used

interchangeably with object, although more relevant to a person, scene or situation.

subtractive colour processes Processes which represent subject colours by superimposed cyan, magenta and yellow images. Each of these layers subtract unwanted quantities of red, green or blue respectively from white light.

super-sampling Chopping an analogue signal range into more digital steps than are required in the final data. (In digital cameras this helps to improve image shadow detail.) Results in an enlarged file.

supplementary lens. See *close-up lens.*

sync lead Cable connecting flashgun to shutter, for synchronized flash firing.

synchro-sun Flash from the camera used to 'fill-in' shadows cast by sunlight.

T setting 'Time' setting available on some large-format camera shutters. Release is pressed once to lock shutter open, then pressed again to close it.

tele-extender Supplementary lens system fitted between camera lens and body, to increase focal length. Also reduces the lens aperture.

telephoto Long focal length lens with shorter back focus, allowing it to be relatively compact.

tempering bath Large tank or deep tray, containing temperature-controlled air or water. Accepts drums, tanks, bottles or trays to maintain their solution temperature during processing.

tinting Applying colour (oils, dye, water colours) to a print by hand.

TLR Twin-lens reflex.

tone curve In digital photography a graph, displayable on the computer monitor, representing the ratio of input to output image tone ranges. (A 'no change' situation is represented by a straight line at 45°.) Acts as a control guide when modifying contrast, or density, or the individual tone ranges of each colour channel, e.g. to alter colour balance. See page 171.

toning Converting a black silver image into a coloured compound or dye. The base remains unaffected.

transparency Positive image on film. Term includes both slides and larger formats.

trap focus Autofocusing mode by which the camera shutter remains locked until an object moves into the lens's zone of sharp focus.

TTL Through-the-lens camera reading, e.g. of exposure.

tungsten-light film Colour film balanced to suit tungsten light sources of 3200 K.

Tv mode Time value exposure mode. Used on some cameras to designate *shutter priority mode.*

uprating Increasing your film's speed setting (or selecting a minus setting on the exposure compensation dial) to suit difficult shooting conditions.

Usually followed up with extended development.

UV Ultra-violet. Wide band of wavelengths less than about 390 nm.

UV filter Filter absorbing UV only. Appears colourless.

value Term used in the Munsell colour system. It refers to a colour's luminance factor or brightness.

variable-contrast paper Monochrome printing paper which changes its contrast characteristics with the colour of the exposing light. Controlled by filters.

videodisc A video signal plus sound, recorded on a flat, circular disc (similar in size to an old vinyl LP audio disc). A read-only device played out through a TV or by TV projection.

viewcamera Camera (usually large format) in which the image is viewed and focused on a screen in the film plane, later replaced by a film holder. View-cameras are primarily used on a stand. See also *field camera.*

viewpoint The position from which the camera views the subject.

vignetting Fading off the sides of a picture into plain black or white, instead of having abrupt edges.

warm tone A brownish black and white silver image. Often adds to tonal richness.

watt-second Light output given by one watt burning for one second. Used to quantify and compare the power output of electronic flash (but ignores influence of flash-head reflector or diffuser on exposure).

wetting agent Detergent type additive, used in minute quantity to lower the surface tension of water. Assists even action of most non-acid solutions, and of drying.

white light Illumination containing a mixture of all wavelengths of the visible spectrum.

wide-angle lens Short focal length lens of extreme covering power, used mostly on cameras to give a wide angle of view.

working solution Solution at the strength actually needed for use.

X Electronic flash. Any flash sync socket and/or shutter setting marked X is for electronic flash. (Also suits flashbulbs at exposures $\frac{1}{8}$ second or slower.)

zone system System embracing subject brightness range, negative exposure, development and printing, to give you control over final print tone values. Ideally allows you to pre-visualize and decide the tonal range of your result at the time of shooting.

zoom lens Lens continuously variable between two given focal lengths, while maintaining the same focus setting.

zooming Altering the focal length of a zoom lens.

Picture credits

Index